Women with 2020 Vision

Women with 2020 Vision

American Theologians on the Voice, Vote, and Vision of Women

JEANNE STEVENSON-MOESSNER, EDITOR

WOMEN WITH 2020 VISION

American Theologians on the Voice, Vote, and Vision of Women

Copyright © 2020 Fortress Press, an imprint of 1517 Media. All rights reserved. Except for brief quotations in critical articles or reviews, no part of this book may be reproduced in any manner without prior written permission from the publisher. Email copyright@1517.media or write to Permissions, Fortress Press, PO Box 1209, Minneapolis, MN 55440-1209.

Unless otherwise noted, all photos and documents are from the collection of Jeanne Stevenson-Moessner. Used with permission.

Cover image: Oil painting, unknown artist, from the Stevenson-Moessner collection, Fondren Library, SMU. Image courtesy of the author.

Cover design: Alisha Lofgren

Print ISBN: 978-1-5064-6813-6

eBook ISBN: 978-1-5064-6814-3

*To the women of the shadows,
unseen but not invisible*

CDV (*carte de visite*) of an unknown African American woman. Name of owner or photographer on backside: VanRiper.

Contents

Acknowledgments	ix
List of Contributors	xiii
Prologue: Stones and Stories of Remembrance Jeanne Stevenson-Moessner	xxi

Part I. Past: Hindsight Is 2020

1. Blindfolds Removed: The Perspicacity of Sojourner Truth, Harriet Beecher Stowe, and Elizabeth Cady Stanton — 3
 Jeanne Stevenson-Moessner

2. Dreams Deferred ... Visions Realized: The Struggle for African American Women's Rights — 23
 Teresa Jefferson-Snorton

3. Reason, Emotions, and the Right to Vote: How History Got Neuroscience Wrong, and the Implications for Full Inclusion of the "Other" — 37
 Barbara J. McClure

4. Claiming Our Inheritance — 59
 Kimberly L. Detherage

Part II. Present: Clearly Seeing Where We Are

5. Seeing through American Indian Eyes: A Vision of Balance and Equity — 83
 Michelle Oberwise Lacock and Carol Lakota Eastin

6. Power to Vote, No Power to Protect — 103
 Sophia Park

7. Caring for Victims of Human Trafficking: A Contemporary Example of Emancipation — 119
Francesca Debora Nuzzolese

8. Pan-African Women of Faith: Lifting Our Voices and Votes to End Hunger and Poverty — 139
Angelique Walker-Smith

Part III. Future: Envisioning What's Next

9. The Art of Feminism in the Framework of Confucian Harmony — 157
Insook Lee

10. Between the Ballot and the Bullet: Women's Suffrage, Liminality, and the Arc of the Moral Universe — 173
Mary Elizabeth "Beth" Toler

11. Lutheran Visionaries: The Public Square and the Church — 193
Judith Roberts and Mary J. Streufert

Epilogue: Women with 2020 Vision: A Summary of New "Sightings" — 209
Jeanne Stevenson-Moessner

Appendix A — 217

Appendix B — 221

Appendix C — 223

In Memoriam — 227

Name Index — 229

Subject Index — 235

Acknowledgments

An acknowledgments page is a recall of blessings. It is an invocation of thanks for those who have shown favor. I first want to acknowledge the ancestors in the abolition, suffrage, and women's movements. When my daughter was only a few months old and it was election time, I put her in a carrier on my back and took her with me to the polls. I remember whispering to her, "Don't ever take this power to vote for granted." Even then, I knew it was a hard-won victory for women. Thank you to all the contributors to this book who have stood with me "upon the mount of vision" where our ancestors left us.[1] I am particularly indebted to Bishop Teresa Jefferson-Snorton for her assistance in organizing this volume and for her wisdom throughout the creative process.

Secondly, I want to recognize the editors of Fortress Press who have renewed my faith in the God of the second chance. Will Bergkamp and Scott Tunseth gave the manuscript "a second look," saw its value, and tirelessly rushed it into production. Rachel Reyes, Assistant Production Editor; Heidi Mann, copyeditor; and Sydnee Thompson, proofreader, adeptly accompanied this volume through production. A special thanks to Amy Invernizzi of Palgrave Macmillan, who supported this work and encouraged me with her magnanimity. Russell Martin, Samantha Dodd, Rebecca Howdeshell, and John Milazzo orchestrated the DeGolyer Library Exhibition for the Centennial of Women's Suffrage and photographed some of my collection items for this book.

I have often heard the term "essential angel" used for someone who not only stands close by but ensures that the work gets done. This would be Kelsey Spinnato, a woman gifted in Hebrew Bible and in editing. It was my incredibly good fortune to have her assigned to me as a research assistant while she began her dissertation at Southern Methodist University. Thank you as well to Lane Davis and Matthew Esquivel who also were my research assistants while completing their doctoral work at SMU.

1. Anna Howard Shaw, "Eulogy to Susan B. Anthony" (speech, Rochester, NY, March 15, 1906), https://tinyurl.com/yx25tmap.

On any given phase of this book, memories plopped into my pool of consciousness, and I remember the concentric circles of support that I as an individual have received. At the time of my son's car accident and death, the circles tightened. Among those who have walked with me in my particular grief are Martha Robbins, Ellen Klyce, Ashley and John Remmers, Evon Flesberg, Lucy Walt Wepfer, Nancy McLemore, Claire Hughes, Blanche Montesi, Lee Hendrix, LeNoir and Barry Culbertson, Mary Stewart Hall, Amy Fowler, Sara Staley, Anne and Robert Sayle, Linda and Dale Wlochal, Leon Hammond and Ellen Brady, Nancy and Eddie Foster, Charlotte and Terry Algood, Andy and Kathy Dearman, Eugenia Walker, Connie Nelson, Alice Dudas, Flo Seger, Melinda Rhett, Judy Stones, Horace and Liz Houston, Julie and Jim Gross and family, Bob and Connie Twining, Eileen LeMay-Stapf, Mary Lynn Neuhaus and Jim Jerrard, Kathy Armistead, classmates/colleagues/former students from St. Mary's Episcopal School, and members of the Compassionate Friends. To the members of Wesleyan Hills United Methodist Church in Memphis, Tennessee, under the leadership of Rev. Dr. Susan Sharpe, who scooped us up and cared for me and my family—you became home base.

To the members of First Presbyterian Church in Dallas who brought food and encouragement, to my colleagues at Perkins School of Theology who did everything possible—including teaching my classes—to those dear friends who organized memorial services at Perkins Chapel in Dallas and at Nativity Catholic School in Dubuque, Iowa, to all those who came to the services to offer a visible circle of care around us, I am filled with gratitude and strength.

While this particular book has focused on issues in the United States, I have been broadened in my worldview by colleagues from the International Academy of Practical Theology. To the hospitality of Riet Bons-Storm in the Netherlands, Stephanie Klein in Luzerne, Switzerland, Evi and Tobias Nicklas of Regensburg, Germany, the Borgens in Norway, and Nancy Ramsay of the United States, I am indebted.

Feminist colleagues in Dallas help me push against the boundaries of my consciousness and work to add more dimensions to the concentric circles of my life. Susanne Scholz, Susanne Johnson, Pat Davis, Bonnie Wheeler, Helen LaKelly Hunt, and Beka Miles keep the conversations lively.

As always, my family has surrounded me with support and love: the Ayres, the Gills, the Moessners, the Brenners, and the Stevensons. My husband, Dave, my daughter, Jean, and granddaughters RhyLee Jean and Vida are at the heart of this family.

As with many of my colleagues who are women, our task in our adult years

has been to individuate by learning more about our authentic selves. We become increasingly aware of early pressures put upon us by society in general or by our own subculture in particular. How do we self-differentiate from those around us? How do we become the person God created us to be in the midst of all our networks? This volume is ultimately an illustration of that and a testament to the strong, individuated individuals who, nevertheless, found the power of *we*.

<div style="text-align: right">
Jeanne Stevenson-Moessner

April 5, 2020

Dallas, Texas
</div>

List of Contributors

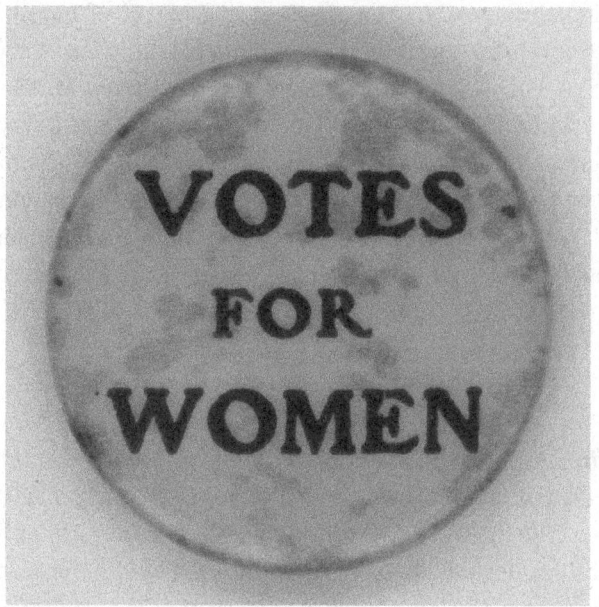

Original 1910s Women's Suffrage Pin.

Kimberly L. Detherage, BA, JD, currently serves as the pastor of St. Mark African Methodist Episcopal Church in Jackson Heights, New York. In June 2010, Rev. Detherage became the first female pastor in the church's 184-year history. Detherage is an attorney engaged in the general practice of law. She is the immediate past president of the International Women in Ministry of the African Methodist Episcopal Church (2008–2016) and currently serves as the president of the Corona East Elmhurst Clergy Association. She is the coauthor of the clergy sexual misconduct policy in the *Doctrine and Discipline of the African Methodist Episcopal Church*. Detherage serves as the dean of the New York Conference Ministerial Institute, which prepares students in ministry for ordination. She also serves on the New York Conference Board of Trustees and is a member of the Board of Examiners. Detherage received her bachelor of arts degree from Boston College, her juris doctor degree from Boston College Law School, and her master of divinity degree from Emory University.

Carol Anuklik Lakota Eastin (Lakota-French, Yakama-Irish), MA, MDiv, is an ordained United Methodist elder and fellow in the American Association of Pastoral Counselors. She was the founding pastor of Dayspring United Methodist Church, an American Indian congregation in East Peoria, Illinois, and served as cochair of the task force for the United Methodist Act of Repentance with Indigenous People in 2012. She serves as a teacher in the Native American Course of Study of the United Methodist Church and as a leader in the youth program of the Native American International Caucus. Anuklik Lakota Eastin serves as a district superintendent in the Illinois Great Rivers Annual Conference. Part of a clergy couple, she has one son and one granddaughter.

Teresa Jefferson-Snorton, MDiv, MTS, DMin, is the fifty-ninth bishop and the first female bishop in the Christian Methodist Episcopal (CME) Church since its founding in 1870. She is presiding bishop of the Fifth Episcopal District, which includes the states of Alabama and Florida. Her first episcopal appointment was to the Eleventh Episcopal District in East Africa. She is the chair of the board of trustees of Miles College (Fairfield, Alabama), chair of the board of directors of the Miles Foundation Service Corporation, and ecumenical officer and endorsing agent for the CME Church. Bishop Jefferson-Snorton is the founder of the empowerment conference "The Phenomenal Women's Summit" and founder of the Academy of Public Theology, a theological education program for clergy and laity. Jefferson-Snorton is president of Churches Uniting in Christ, vice-chair of the National Council of Churches of Christ in America, chair of the Family Life Committee of the World Methodist Council, and a member of the Central Committee of the World Methodist Council and of the Pan-Methodist Commission. She is a member of the advisory board for Candler School of Theology at Emory University, the board of trustees of the Interdenominational Theological Center, and the board of trustees of the Phillips School of Theology.

Michelle "Morning Star Spirit" Oberwise Lacock (Lakota, English, Scottish, Irish, and German), MME, MBA, MDiv, DMin, is an Association of Clinical Pastoral Education (ACPE) supervisor and ordained United Methodist clergyperson (Northern Illinois Annual Conference). She is appointed to Advocate Aurora Health as supervisor of clinical pastoral education in Milwaukee, Wisconsin. She serves as chair of the advisory board of directors of the North Central Jurisdiction United Methodist Native American Course of Study. She is published in the *Journal of Supervision and Training in Ministry* and is a contributor to *Women Out of Order: Risking Change and Creating Care in a Multicultural World* (Fortress Press, 2009). She is married with four adult children and two grandchildren.

Insook Lee, ThD, is professor and the director of the Master of Arts in Pastoral Care and Counseling program at New York Theological Seminary. She is a certified fellow in the American Association of Pastoral Counselors (AAPC), an ordained minister of word and sacrament in the Presbyterian Church, U.S.A., and a former president of the Society of Pastoral Theology. She is an editorial board member of the *Journal of Pastoral Theology* and book review editor of the *Journal of Pastoral Care and Counseling*. Her research interests include Confucian feminist pastoral psychotherapy, intercultural and interreligious dialogue, multiple identities, and Zen meditation and psychotherapy. In general, her research projects aim to promote the partnership between Asian pastoral theologies and Western liberal feminist pastoral theologies. She is the mother of two grown-up children, a son and a daughter, and a grandmother of two granddaughters.

Barbara J. McClure, PhD, is associate professor of pastoral theology and practice at Brite Divinity School at Texas Christian University. McClure's work includes developing a holistic approach to religious engagement that is grounded in theories of human flourishing, public theologies, and a "synergistic" theological anthropology that accounts both for biology and for social construction in context in the development of persons. Prior to joining the Brite faculty, McClure spent seven years teaching at Vanderbilt University Divinity School. She has written two books—*Moving Beyond Individualism in*

Pastoral Theology, Care and Counseling: Reflections on Theory, Theology and Practice (Wipf & Stock/Cascade, 2010) and *Emotions: Problems and Promise for Human Flourishing* (Baylor University Press, 2019)—as well as a number of chapters and journal articles. She is the proud mother of two strong young women, Anna and Miriam.

Francesca Debora Nuzzolese, ThD, is a pastoral theologian and practitioner who fulfills her calling by engaging the academy, communities of faith, and the humanitarian sector. She has held tenured teaching positions in the United States and is currently involved in theological and psychospiritual education in Europe and the Middle East. Her main teaching areas are pastoral theology, spiritual formation, pastoral care, counseling, and trauma care. She is involved in private psychotherapeutic practice and spiritual direction and consults with nongovernmental organizations on sustainability of care for antitrafficking practitioners and first responders in the European refugee crisis. As a scholar, activist, and clergyperson, Nuzzolese is committed to the organic integration of theory and pastoral praxis and issues of faith and social justice. The current focus of her research is the phenomenon of traumatization in which both humans and the planet are caught due to the convergence of socioeconomic, political, and environmental forces. In her upcoming book, *The World as a Trauma Zone*, she draws from her work with victims of exploitation and dislocation and seeks to construct a pastoral theological response in the form of radical imagination.

Sophia So-hee Park, BS, ThD, is associate professor of pastoral clinical mental health counseling at Neumann University in Aston, Pennsylvania. Her worldviews, scholarship, and clinical work are informed by her own upbringing in seven countries and as a Korean American immigrant woman raising bicultural children in the US. Her writings focus on the challenges faced by immigrant families, especially on the identity formation of children growing up in two or more cultural contexts, and can be found in *Sacred Spaces, Journal of Pastoral Theology*, and *Women Out of Order* (Fortress Press, 2009). She serves as the diversity liaison for the *Journal of Pastoral Care and Counseling* and on the advisory board for Institute of Collective Trauma and Growth and

for Culture-In-Motion. Her professional work in youth ministry, chaplaincy, addiction treatment centers, and counseling as a licensed marriage and family therapist informs her teachings, her writings, and especially her mothering of four children into young adulthood.

Judith E. B. Roberts, BS, MA, serves as Evangelical Lutheran Church in America (ELCA) program director for racial justice. The work of the ELCA Racial Justice Ministries educates, equips, and engages leaders to analyze the systems of racism and identify solutions that create equitable outcomes within and outside of the ELCA. Roberts is the former director of adult programs for the National Conference for Community and Justice of Connecticut and Western Massachusetts, a human relations organization dedicated to fighting bias, bigotry, and racism in America. She has also worked for the William Winter Institute for Racial Reconciliation at the University of Mississippi. The Winter Institute fosters reconciliation and civic renewal wherever people suffer because of racial discrimination or alienation and promotes scholarly research, study, and teaching on the impact of race and racism. She serves ecumenically on behalf of the ELCA. She is the former co-convener for the Joint Action and Advocacy working group of the National Council of Churches (NCC) and a taskforce member of the NCC's Truth and Racial Justice Task Force.

Jeanne Stevenson-Moessner, Dr.theol, is professor of pastoral care and pastoral theology at Perkins School of Theology at Southern Methodist University (SMU), an ordained Presbyterian minister (PCUSA), a Fellow in the American Association of Pastoral Counselors, a member of the International Academy of Practical Theology, a Henry Luce III Fellow, a McCord fellow at the Center for Theological Inquiry, guest professor at the University of Lucerne, and a former president of the Society for Pastoral Theology. President of the SMU Faculty Senate (2016–2017) and a member of the SMU Board of Trustees (2016–2017), she is a graduate of Vanderbilt University, Princeton Theological Seminary, and the University of Basel, Switzerland. She coedited a volume that transformed the field of pastoral theology, *Women in Travail and Transition: A New Pastoral Care* (Fortress Press, 1991), followed by three

additional pioneering volumes in pastoral care of women. Stevenson-Moessner and her husband have a wonderful adult daughter, Jean; a beloved son, David, who passed away in January of 2015; and two precious granddaughters.

Mary J. Streufert, PhD, serves as director for Justice for Women in the Evangelical Lutheran Church in America (ELCA). Through research, networks, teaching, and facilitation, she works with others to develop and advance theological and social analysis, discussion, and action to address intersectional sexism in church and society. Streufert contributes to the development of gender justice social policy and teaching in the ELCA and serves as the Lutheran World Federation Women in Church and Society North American regional coordinator. She edited *Transformative Lutheran Theologies: Feminist, Womanist, and Mujerista Perspectives* (Fortress Press, 2010) and has written articles, chapters, and encyclopedia entries on Lutheran and feminist theology on a variety of theological and social subjects. Prior to working within the ELCA, Streufert held a Lilly Fellowship in Humanities and Theology at Valparaiso University.

Mary Elizabeth "Beth" Toler, ThD, LMFT, is associate professor of clinical counseling at Moravian Theological Seminary in Bethlehem, Pennsylvania. As an ordained American Baptist minister, Toler brings diverse expertise from the ministry, clinic, and classroom. Her pastoral experience includes parish and campus ministry, hospital chaplaincy, and work in psychiatric facilities. Toler's clinical experience includes over fifteen years of private practice counseling for individuals, couples, and families. In addition to her private practice, Toler currently cofacilitates clergy colleague groups for the Episcopal Diocese of Pennsylvania and serves on the Psychotherapy Commission of ACPE and as president of the *Journal of Pastoral Care and Counseling*. Her active writing and research focus is on the methodological and practical implications of integrating religion and spirituality into the counseling process.

Angelique Walker-Smith, MDiv, DMin, is the first female president of the Historic Black Church Family of Christian Churches Together (CCT). Rev. Dr. Walker-Smith is senior associate for Pan-African and Orthodox Church Engagement at Bread for the World. She is CCT's first female president, from any of the families: Historic Black, Catholic, Historic Protestant, Orthodox, and Evangelical-Pentecostal. She is also known for her role as ecumenical representative of the National Baptist Convention USA, Inc. Walker-Smith formerly served as the executive director of the Church Federation of Greater Indianapolis for nineteen years, overseeing a broad range of ecumenical activities. Her diverse background also includes years of experience with the National Council of Churches and the World Council of Churches (WCC)—including serving as moderator of the WCC Tenth Assembly Justice Plenary—among others. A graduate of Kent State University, she earned her master's degree from Yale University Divinity School in 1983 and went on to become the first African American woman to graduate from the Doctor of Ministry program at Princeton Theological Seminary.

Prologue: Stones and Stories of Remembrance

JEANNE STEVENSON-MOESSNER

Theology has a shadow side. Religious beliefs and theory can be applied in a way that takes away the dignity, rights, and authenticity of an individual or a group. When this occurs, a penumbra, or absence of light, obscures the worth and equality of the individual or group. Theology also has a history of women and men in the academy, in ministry, and in forces for justice who, by devoting their lives to advancing the freedom and personhood of all humankind, act as rays of light shining on the pall of oppression. This volume captures a historic victory in 1920, when women in the United States won the right to vote. In this same volume, we are obligated to tell the counternarrative, a subtle plot against the more obvious one of suffrage. The resistance to abolition and suffrage among slaveholders, churches, Congress, and state legislatures was vicious. In addition, there have been accusations that the shadow side of the antislavery movement and the women's movement revealed instances of classism as well as racism and sexism.[1] Rosalyn Terborg-Penn explains that "black women, in their struggle for the right to vote, fought racism and sexism simultaneously and revealed several things about the nature of their struggle as woman suffragists."[2]

In spite of this counterplot, many women worked hard through their conventions, letters, petitions to Congress, speeches, books, demonstrations, and willingness to march and sometimes die for an equal vote in a government "for the people." According to Susan Ware in *Why They Marched*, "Suffragists were women ready and willing to say 'we'. Without that consciousness, there was no reason for them to join the suffrage movement."[3]

1. Debra Gold Hansen, *Strained Sisterhood: Gender and Class in the Boston Female Anti-Slavery Society* (Amherst: University of Massachusetts Press, 1993).
2. Rosalyn Terborg-Penn, *African American Women in the Struggle for the Vote, 1850–1920* (Bloomington: Indiana University Press, 1998), 2. Terborg-Penn elaborates on multiple levels of consciousness in these women: "Racism did not limit white women and sexism did not limit African-American men" (*African American Women in the Struggle for the Vote*, 2).
3. Susan Ware, *Why They Marched: Untold Stories of the Women Who Fought for the Right to Vote* (Cambridge, MA: Belknap, 2019), 10.

With all the difficulties, they were a sisterhood. In 1834, poet Sarah Louisa Forten, an African American, wrote "An Appeal to Women" for *The Liberator* newspaper:

> We are thy sisters,—God has truly said,
> That of one blood, the nations [God] has made.
> Oh, christian woman, in a christian land,
> Canst thou unblushing read this great command?
> Suffer the wrongs which wring our inmost heart
> To draw one throb of pity on thy part;
> Our "skins may differ," but from thee we claim
> A sister's privilege, in a sister's name.[4]

Women with 2020 Vision is a volume commemorating the one-hundredth anniversary of the American government recognizing and externally validating women's birthright to vote, which happened in 1920. This is an important and noteworthy milestone in this country's history. The women's movement in the United States, including the suffrage movement, is a story whose plot line contains narratives and counternarratives of the development of women's empowerment, a story that has not reached its climax or conclusion.

As Bishop Teresa Jefferson-Snorton wrote in a letter,

> The Women's Movement in America, including the Suffrage Movement, is a story that must be told and retold and reflected upon in light of the current sociopolitical-theological realities. This volume brings together voices of diverse women who have been a part of the ongoing gender justice work in our country. Their voices will reflect on the past and what we have learned from it. Their voices will examine current themes around the empowerment of women. Their voices will cast a hopeful vision for the future.[5]

4. Sarah Louisa Forten, "An Appeal to Women," *The Liberator*, February 1, 1834. The antislavery newspaper was published in Boston by William Lloyd Garrison. Forten's poem had four stanzas. The stanza cited is the third. All four stanzas were placed on the title page of "An Appeal to the Women of the Nominally Free States," a paper researched by Angelina Grimké and given final form by Lucretia Mott, Lydia Maria Child, Abby Kelly, and Grace Douglass. The sixty-five-page pamphlet was issued following the 1837 Anti-Slavery Convention of American Women in New York City.
5. Teresa Jefferson-Snorton, private correspondence, April 16, 2019.

The contributors to this volume include Asian Americans, American Indians, Italian Americans, and African Americans. Most are in theological or ecclesiastical positions. They understand well the Christian grounding of the early abolitionist and women's movements.[6]

Women with 2020 Vision will focus primarily on the last half of the nineteenth century, with an emphasis on the movements for abolition and suffrage following the Seneca Falls Convention of 1848. However, we work in tandem with researchers and scholars who have focused on an earlier period, particularly preceding and immediately following the Anti-Slavery Convention of American Women on May 9, 1837. In the introduction to *Turning the World Upside Down*, Dorothy Sterling highlights not only the radical nature of the gathering but also its interracial nature:

> In an age when True Women (always capitalized) were required, on Biblical authority, to be silent and submissive, they met for three days in New York's Third Free Church at the corner of Houston and Thompson Streets to speak and act independently for the abolition of slavery. They were uncomfortably conscious of violating a powerful taboo.... The convention in the little church on Houston Street was not only the first public meeting of U.S. [white] women. It was also the first interracial gathering of any consequence. Black women from the Colored Ladies' Literary Society of New York, the Rising Daughters of Abyssinia, and the Female Anti-Slavery Societies of Philadelphia sat and worked alongside their white sisters.[7]

At the subsequent meeting in Philadelphia in 1838, mob violence occurred as black and white women walked the streets together, arm in arm. During the first night of the conference, after the full day's agenda, the angry mob burned down Pennsylvania Hall, the site of the convention.[8]

6. Helen LaKelly Hunt, *And the Spirit Moved Them: The Lost Radical History of America's First Feminists* (New York: The Feminist Press at CUNY, 2017), 135–36.
7. Dorothy Sterling, introduction to *Turning the World Upside Down: The Anti-Slavery Convention of American Women Held in New York City, May 9–12, 1837* (New York: The Feminist Press at CUNY, 1987), 3–4.
8. Hunt, *And the Spirit Moved Them*, 155.

1911 National Association Opposed to Woman Suffrage (NAOWS), New York City, reprint.

Nevertheless, as chapters in this volume will reveal, the struggle for the vote, both before 1920 and afterward, was much more complicated for African American women. As Terborg-Penn stated succinctly, "The struggle for suffrage among African American women was different from that of white women and African American men, because racism did not limit white women and sexism did not limit African American men."[9] In addition, class ideologies among lower-class, middle-class, and upper-class women and understandings of womanhood led to divisions within the women's suffrage movement.[10]

9. Terborg-Penn, *African American Women in the Struggle for the Vote*, 2.
10. Hansen, *Strained Sisterhood*, 154–56.

Original 1913 print, Women's Suffrage Starvation Wages.

On this we can agree: women have always had the right to vote. From such diverse voices as John Stuart Mill and Cokie Roberts, the absolute right of both women and men to vote has been affirmed. In his essay written originally in 1869, John Stuart Mill clearly stated "that the principle which regulates the existing social relations between the two sexes—the legal subordination of one sex to the other—is wrong in itself, and now one of the chief hindrances to human improvement; and that it ought to be replaced by a

principle of perfect equality, admitting no power or privilege on the one side, nor disability on the other."[11] In a recent interview for NPR on this subject, 150 years after Mill, Cokie Roberts commented on four issues that will be covered in this volume: resistance to women's suffrage even by women themselves, the shadow side of the suffrage movement as it pertains to African American women, the grim situation for Native Americans, and the cost as well as the benefit of the suffrage movement.[12] Now, one hundred years later, the movement for the validation and viability of women continues.

In 1896, a Norwegian immigrant, Helga Estby, and her daughter, Clara, left their homestead in Spokane, Washington, to walk 3,500 miles on foot across the United States to New York City to win a $10,000 wager. While in Boise, Idaho, they attended a suffrage meeting led by Mrs. Laura Jones, a witty, logical, and convincing suffragette.[13] That same year, Idaho followed Wyoming and Colorado by voting statewide to recognize women's right to vote. Although much of the publicity and publications about the suffrage movement has focused on the eastern states and conventions held there, it is vital to note the active network of suffrage clubs across the continent.

It would be an interesting study to analyze the voting patterns across the United States as individual states approached ratification of the Nineteenth Amendment. Wisconsin was the first state to ratify the amendment, doing so on June 10, 1919; Tennessee became the thirty-sixth state to ratify it, making suffrage for women legal in the country. The ratification process required the approval of thirty-six states, and this was accomplished with Tennessee's vote. The following states belatedly ratified the Nineteenth Amendment: Virginia (1952), Alabama (1953), Florida and South Carolina (1969), Louisiana and Georgia (1970), North Carolina (1971), and, very belatedly, Mississippi (1984). Yet the ratification of the Nineteenth Amendment did not automatically mean women could vote. Women like Fannie Lou Hamer were prevented from exercising this right for lack of a driver's license or birth certificate, or due to poll taxes or literacy tests—requirements many African Americans in the South were not able to meet. Even today, for example, there are Ameri-

11. John Stuart Mill, "The Subjection of Women," in *On Liberty; Representative Government; The Subjection of Women: Three Essays* (London: Oxford University Press, 1912), 427.
12. Cokie Roberts, interview by Steve Inskeep, "Cokie Roberts on the History of Women in Politics," *Morning Edition*, NPR, May 23, 2018, https://tinyurl.com/tbw4xwz.
13. Linda Lawrence Hunt, *Bold Spirit: Helga Estby's Forgotten Walk across Victorian America* (Moscow: University of Idaho Press, 2003), 110.

can Indian reservations in states like Utah, South Dakota, and North Dakota whose tribal members are impeded from voter registration for various reasons, including lack of street addresses and birth certificates.[14] The struggle to have a vote and voice in government is not finished.

An original 1914 postcard showing a map of the United States and the progress being made in the suffrage movement at that date

14. Ellen Brady (MD) in discussion with the author, January 11, 2020.

There could be comparable volumes written by women in the United Kingdom, remembering the 1897 National Union of Women's Suffrage Societies (NUWSS) formed and led by Millicent Fawcett or the 1903 Women's Social and Political Union (WSPU) formed and led by Emmeline Pankhurst. The NUWSS "Mud March" of 1907, the hunger strike of activist Marion Wallace Dunlop in 1909, the arrest and force-feeding of Lady Constance Lytton in 1910, the death of Emily Davison in 1913, and the arrests and deaths of other suffragists are all parts of that narrative. Finally, in 1928, women over twenty-one years old in the United Kingdom received the vote on the same terms as men in the Representation of the People Act. In other countries such as Belgium, the suffrage movement took twists and turns. Although women in Belgium had been allowed to vote in municipal elections since World War I, they were not allowed to vote in parliamentary elections until June 26, 1949.

This book is dedicated to all the women of the shadows whose names did not appear here. We will never know the identities of all those silenced. We may also never know the many voices or outbursts of resistance that occurred in the ordinary places of life. For example, at a banquet in Columbia, South Carolina, in 1913, Pearl P. gave a "Toast to the Suffragette":

> For 8000 years woman has surrounded herself with a colossal vanity; she has seen herself thru a golden haze, as a beautiful and beloved creature, as a queen enthroned in the hearts of men, as the still quiet voice whose influence governs the world. . . .
>
> For the last twenty five years perhaps a million [w]omen have been forced to enter the commercial wolrd to support themselves and chuldren; woman was astounded to find that man's chivalry extended to tha drawing room chiefly; . . . Someway the insipient film began lifting fron her eye she looked about woth a clearer vision. . . . She looked forth—and what did she see? A great pageant of sin, whiskey and immorality stalk nakedly by unhampered by the hands that cast the vote; she found that the laws would not give her a right to <u>her own child</u>.[15]

15. Pearl P., "Toast to the Suffragette" (in the author's possession). Refer to the appendix of this volume for an image of the original letter, which is two-and-a-half pages. All spelling is true to the original.

Pearl P. bemoans the fact that $52,000 can't be raised to build a Women's Building to protect working girls, nor can $10,000 be found to build a decent house for rescue orphans. Meanwhile, the men of Richland County consumed $130,000 worth of whiskey, and the men of South Carolina imbibed half a million dollars' worth in the month of March alone, as substantiated by the Express Company. The text of this original letter is in Appendix A.

There are surely many more Pearl P.s who used whatever platform was available to support the well-being of women and children. In this case, Pearl P. was also raising awareness of the choices men were making and the values embedded in those choices. It is my hope that continued research on the nineteenth-century abolition and women's rights movements will uncover more of these women of the shadows.

It seems appropriate to address the overt and covert activism, conservative and disruptive pedagogies, and respectful and transgressive practices that have brought us this far. In doing so, we honor the women and men who have labored for the vote, championed equal rights, and encouraged the voice of women. In the Hebrew Bible, there are various stories of individuals or groups placing stones of remembrance, sometimes called memorial stones or standing stones. For example, when the Hebrew people successfully passed over the Jordan River, Joshua commanded that twelve stones be set up as a memorial of the passage, the story of which would be told as a lesson for their children. We are doing something similar in this volume: placing piles of actual stories in front of us lest we forget the vicissitudes, the valor, and the victories of those who walked before us in our ongoing journey toward equality.

Bibliography

Forten, Sarah Louisa. "An Appeal to Women." *The Liberator*. February 1, 1834.

Hansen, Debra Gold. *Strained Sisterhood: Gender and Class in the Boston Female Anti-Slavery Society*. Amherst: University of Massachusetts Press, 1993.

Hunt, Helen LaKelly. *And the Spirit Moved Them: The Lost Radical History of America's First Feminists*. New York: The Feminist Press at CUNY, 2017.

Hunt, Linda Lawrence. *Bold Spirit: Helga Estby's Forgotten Walk across Victorian America*. Moscow: University of Idaho Press, 2003.

Mill, John Stuart. "The Subjection of Women," in *On Liberty; Representative*

Government; The Subjection of Women: Three Essays. London: Oxford University Press, 1912.

Roberts, Cokie. Interview by Steve Inskeep, "Cokie Roberts on the History of Women in Politics." *Morning Edition*. NPR. May 23, 2018. https://tinyurl.com/tbw4xwz.

Sterling, Dorothy. *Turning the World Upside Down: The Anti-Slavery Convention of American Women Held in New York City, May 9–12, 1837*. New York: The Feminist Press at CUNY, 1987.

Terborg-Penn, Rosalyn. *African American Women in the Struggle for the Vote, 1850–1920*. Bloomington: Indiana University Press, 1998.

Ware, Susan. *Why They Marched: Untold Stories of the Women Who Fought for the Right to Vote*. Cambridge, MA: Belknap, 2019.

PART I
PAST: HINDSIGHT IS 2020

In *Women with 2020 Vision*, we first look back. In chapter 1, Jeanne Stevenson-Moessner reflects on three very different women of the nineteenth century: Sojourner Truth, Elizabeth Cady Stanton, and Harriet Beecher Stowe, who each had blindfolds lifted to see the diabolical bondage of women as well as the savagery of slavery. How did such diverse women work in collaboration for suffrage and in resistance to misapplied Christian ethics, which created slaves of custom, creed, and color? How did they navigate differences?

Chapter 2 explores the shadow side of the 1920 victory for women to vote: African American women were not beneficiaries of the victory as historic sexism, racism, and politics tried to separate them from the ballot box. Bishop Teresa Jefferson-Snorton traces not only the resistance to African American votes but the line of determined women who never lost sight of the vision of equality.

Using recent neuropsychological research, in chapter 3 Barbara McClure refutes the common distinctions between cognitive and emotional functions and shows the relevance of these findings for the suffrage movement. There was a common assumption at the time that women's natural inferiority, reproductive function, passive nature, and inferior brains did not equip them to be rational selves. In a similar way, Euro-American cultural constructions were imposed on African American men, also seen as inferior and irrational, as the Fifteenth Amendment became a contentious issue. This chapter explores the roots of resistance in ancient philosophy and Christian theologies to movements for the full inclusion of women.

In chapter 4, Kimberly Detherage elaborates on the understanding that black people did not *secure* their right to vote until 1965 with the passage of the Voting Rights Act. In addition to the biblical account of Zelophehad's daughters (Mahlah, Noah, Hoglah, Milkah, and Tirzah), who claimed their inheritance as women and as daughters, Detherage highlights other women, like Maria Stewart, Shirley Chisholm, and Stacey Abrams, who have continued the struggle to claim the inheritance of women of color. Their truth is self-evident: all men and all women are created equal.

> **FOR SALE,**
> To a purchaser in the country.
> **A stout Negro Girl,**
> brought up to the manners of a plantation. En
> quire of the printers.
> April 8.

1799 Baltimore newspaper *Federal Gazette* and Baltimore Daily Advertiser with front page slave ad for "a stout Negro Girl," brought up to the manners of a plantation. Enquire of the printers. April 8.

1. Blindfolds Removed: The Perspicacity of Sojourner Truth, Harriet Beecher Stowe, and Elizabeth Cady Stanton

JEANNE STEVENSON-MOESSNER

A *negative limit* is a boundary or impasse that cannot be traversed. It is a line that in all truth and honesty we do not want to cross. This term is in common parlance among feminists. It is when we reach this negative limit in our experience that "blindfolds are removed," sometimes gradually but more often dramatically or tragically. When I was a young single adult sitting in a crowded Memphis auditorium to hear a speaker my church had recommended, my negative limit was reached when the speaker, Bill Gothard, instructed us as follows: "Wives are to submit to their husbands—even if they are beaten to a bloody pulp—in the hope that their husband might be won to Christ."[1] It was as if I ran into a brick wall or impasse and slowly had to rethink the nature of the God I was serving, the veracity of the Bible I loved, and the commitment to be a Christian. The abuse and misuse of the book of Ephesians, specifically Ephesians 5, by the speaker tore the blindfolds from my eyes.

Each of the three women highlighted in this chapter—Sojourner Truth, Harriet Beecher Stowe, and Elizabeth Cady Stanton—had blindfolds removed, which resulted in their commitment to and passion for the freedom of slaves and the vote for all people. The purpose of this chapter is to examine the intersection of the lives of these three extraordinary women, who each contributed in distinctive ways to the fight for equal vote, voice, and possibilities for women. My research is driven by the quest to see how they found commonalities amid the differences of their lives. This chapter is built on the assumption that all three women had their "blindfolds removed" to see

1. Bill Gothard, speech on chain-of-command theology and Ephesians (lecture, Basic Youth Conflicts, Memphis, TN, 1972).

the savagery of the treatment of slaves and the diabolical bondage of women as well as the possibilities of the right to freedom and the right to enfranchisement, which includes the right to vote. Is there something in their common vision that would enlighten those of us today who continue the struggle against the exploitation of others? What was the connection among these three women? What were other commonalities that drew such dissimilar women together? How did they navigate differences?[2]

Original *carte de visite* (calling card) of Sojourner Truth (Brady's National Photographic Portrait Galleries, NYC and Wash., DC), ca.1870s.

2. Isabelle Kinnard Richman, *Sojourner Truth: Prophet of Social Justice* (New York: Routledge, 2016), 112. Richman discusses their different positions on the Fifteenth Amendment, which granted suffrage to black males. Truth supported it while Stanton opposed it. I have been unable to find Stowe's position.

Original cabinet card, Harriet Beecher Stowe, printed by Rodgers.

Original signed *carte de visite*, Elizabeth Cady Stanton, 1902.

Sojourner Truth

Sojourner Truth, née Isabella Baumfree, knew nothing but slavery as a child. She was an infant when her brother, age five, and her sister, three, were sold away from her parents, leaving them inconsolable. Among Isabella's earliest memories was the new house of her master, Charles Ardinburgh, which he had built for a hotel. "A cellar, under this hotel, was assigned to his slaves, as their sleeping apartment, –all the slaves he possessed, . . . sleeping . . . in the same room. She carries in her mind, to this day, a vivid picture of this dismal chamber," with loose boards on the floor over the uneven earth, which was often muddy, with splashing water and noxious vapors.[3] The slaves slept body to body across the damp floor, lying on a little straw and a blanket, as if they were horses. Servitude in degradation was the life she knew. In her *Book of Life*, however, she comments on the dispelling of "the mists of ignorance" and the removal of the shackles of body and spirit:

> As the divine aurora of a broader culture dispelled the mists of ignorance, love, the most precious gift of God to mortals, permeated her soul, and her too-long-suppressed affections gushed from the sealed fountains as the waters of an obstructed river, to make new channels, bursts its embankments and rushes on its headlong course, powerful for weal or woe. Sojourner, robbed of her own offspring, adopted her race.[4]

I am suggesting that her blindfolds of bondage were removed to see "the divine aurora" of a broader culture after the mists of ignorance imposed on her by a lack of freedom began to evaporate over time. Her adoption of her race is seen in her tireless efforts to improve the sanitary conditions for the freed slaves who gathered in Washington. She assisted the National Freedman's Relief Office, Freedman's Village, Freedman's Hospital, and orphanages for freed children to compensate for the lack of foresight by the US government. Who had thought ahead about how the freed slaves would exist, live, and support themselves when they left plantations, masters, and over-

3. Olive Gilbert, *Narrative of Sojourner Truth: A Bondswoman of Olden Time, with a History of Her Labors and Correspondence Drawn from Her Book of Life*, ed. Nell Irvin Painter (New York: Penguin, 1998), 10. The book was first published in the United States in 1850.
4. Gilbert, *Narrative of Sojourner Truth*, 131.

seers? Sojourner Truth instigated a petition to both the House and Senate to address these issues, whereby the freed slaves could be given land that they so rightfully deserved in order to support themselves. After all, hadn't their unpaid labor boosted the economy of the nation? This is an example of perspicacity, which, among other things, can be described as sagacity and sharp-sightedness.

Harriet Beecher Stowe

Harriet Beecher Stowe was raised as a minister's daughter in a home and church where she heard her father, Lyman Beecher, deliver graphic sermons on the evil of slave trading.[5] Lyman Beecher came from a long line of ministers. Harriet's pious mother died when she was four; thus, Harriet was not unfamiliar with hardship.[6] Her father was called to Lane Theological Seminary in Cincinnati in 1832, when Lane Seminary was a hotbed of abolition.[7] At the time the Beecher family moved there, Theodore Weld was a student and radical abolitionist at Lane. Harriet, like her sister Catharine, was more committed to education than the issue of slavery.[8]

In 1833, Harriet made a trip from Cincinnati to Kentucky with a teacher named Miss Dutton. It was there that Harriet came in contact with slaves of the South. In the biography written by Harriet's son, Charles Edward Stowe commented that Miss Dutton realized later that scene after scene in *Uncle Tom's Cabin* came from that visit to Kentucky.[9]

While in Cincinnati, Harriet witnessed proslavery mobs pull down houses of respectable and law-abiding blacks. She knew the office of Mr. J. G. Birney, editor of *The Philanthropist*, had been ransacked and demolished by those angered by his liberation of his slaves in Alabama. She had a desire to do something.[10] Meanwhile, her husband, Professor Stowe, and her brother, Henry Ward Beecher, conveyed a fugitive slave girl at night in a covered

5. Charles Edward Stowe, *Life of Harriet Beecher Stowe: Compiled from Her Letters and Journals* (Cambridge, MA: Riverside, 1889), 152.
6. Stowe, *Life of Harriet Beecher Stowe*, 2.
7. Stowe, *Life of Harriet Beecher Stowe*, 53.
8. However, eventually both women were influenced by Weld and became abolitionists.
9. Stowe, *Life of Harriet Beecher Stowe*, 72.
10. Stowe, *Life of Harriet Beecher Stowe*, 88.

wagon on back roads for twelve miles to safety.[11] Many escaped slaves were at risk with the passage of the Fugitive Slave Act, an 1850 law requiring that all escaped slaves, upon capture, be returned to their masters/owners. Relatives and friends wrote letters to Harriet, pleading for her to help. As noted in her biography, the tipping point came when Harriet read a particular letter from a sister-in-law that said, "Now, Hattie, if I could use a pen as you can, I would write something that would make this whole nation feel what an accursed thing slavery is."[12] According to her son, Harriet rose, crumpled the letter, and said, "I will write something. I will if I live." This became *Uncle Tom's Cabin* and was a best seller in the nineteenth century, second only to the Bible. The book came to Harriet in creative bursts; for example, while she was taking communion in Brunswick, the scene of the death of Uncle Tom passed like a vision through her mind.[13] Whatever blinders society had put before Harriet dropped away when she saw the complicity of the Christian church in promoting slavery. She went so far as to accuse the church of being "responsible for the sin of slavery."[14] When a backlash came from anti-abolitionists in response to the publication of *Uncle Tom's Cabin*, Harriet wrote a rebuttal that included "The Influence of the American Church on Slavery," a brilliant exposé of misinterpretation of Scripture, law, Christian communion, Christian morality, Christian servitude, and martyrdom. Sixty-three erudite pages later, she concludes, "In the last judgment will [Christ] not say to you, 'I have been in the slave-prison, –in the slave-coffle. I have been sold in your markets; I have toiled for naught in your fields; I have been smitten on the mouth in your courts of justice; I have been denied a hearing in my own church,–and [you] cared not for it.'"[15]

Her son said that the publication and popularity of *Uncle Tom's Cabin* made the enforcement of the Fugitive Slave Act virtually impossible.[16] Harriet's method was not to describe a scene but to place the reader in the position of onlooker. If someone rushed into your kitchen and described a train wreck, you might look up from your coffee and say, "How terrible." However,

11. Stowe, *Life of Harriet Beecher Stowe*, 93.
12. Stowe, *Life of Harriet Beecher Stowe*, 145.
13. Stowe, *Life of Harriet Beecher Stowe*, 148.
14. Stowe, *Life of Harriet Beecher Stowe*, 151.
15. Harriet Beecher Stowe, *A Key to Uncle Tom's Cabin: Presenting the Original Facts and Documents upon Which the Story Is Founded. Together with Corroborative Statements Verifying the Truth of the Work* (Boston: Jewett, 1853), 256.
16. Stowe, *Life of Harriet Beecher Stowe*, 154.

if "you stood at that instant by the wreck, and saw the mangled dead, and heard the piercing shrieks of the wounded, you would be faint and dizzy with the intolerable spectacle. So, 'Uncle Tom's Cabin' made the crack of the slave driver's whip, and the cries of the tortured blacks ring in every household in the land, till human hearts could endure it no longer."[17] Abraham Lincoln allegedly called her the woman who started the Civil War.[18] This is only one example of the perspicacity, or astuteness and clear-sightedness, of Harriet Beecher Stowe.

Elizabeth Cady Stanton

While doing research in Speer Library in Princeton, New Jersey, I discovered a pamphlet from 1860 titled *The Slave's Appeal* lying in an open box, waiting to be found.[19] The author was E. Cady Stanton, and the publisher was the Anti-Slavery Depository. The pamphlet was a theological treatise, an attempt to reexamine the Decalogue, or the Ten Commandments, in the light of slavery. The language was graphic and disturbing. Taking the commandments in consecutive order, the author illustrated how each one had been violently broken. For example, the injunction "Thou shalt not kill" was abused in this way:

> "Thou shalt not kill." Go to, now, take God's image, put out its eyes, cut off its ears, knock out its teeth, burn, and brand, and scarify, and catmaul its flesh! hang it on trees, or head downwards in deep pits, choke it in stocks, hunt it with pikes and guns, and bows, and hounds! Make it a target for your cruel jests, your spite, your spleen! use all your hellish arts to blot out if you can, the faintest vestige of immor-

17. Stowe, *Life of Harriet Beecher Stowe*, 155.
18. Daniel R. Vollaro, "Lincoln, Stowe, and the 'Little Woman/Great War' Story: The Making, and Breaking, of a Great American Anecdote," *The Journal of the Abraham Lincoln Association* 30, no. 1 (Winter 2009): 18–34, https://tinyurl.com/wujr6hr.
19. Elizabeth Cady Stanton, *The Slave's Appeal* (Albany: Anti-Slavery Depository, 1860). This document was omitted from the list of appeals, speeches, and so on in the appendix to the first volume of *Elizabeth Cady Stanton as Revealed in Her Letters, Diary, and Reminiscences*, ed. Theodore Stanton and Harriot Stanton Blatch (New York: Harper & Brothers, 1922). Biographer Elisabeth Griffith erroneously calls another document "A Slave's Appeal" in her book *In Her Own Right: The Life of Elizabeth Cady Stanton* (New York: Oxford University Press, 1984), 101. However, the selection cited by Griffith can be located in an address by Stanton to the Judiciary Committee of New York State on February 18, 1860.

tality; then, in white robes, from God's altar, on each returning Sabbath day, with holy unction, read to the kneeling saints!! "Thou shalt not kill."

The author was indeed Elizabeth Cady Stanton, who once was a member of the Presbyterian Girls' Club. While in this Christian club, she and other young girls raised money through baking, sewing, and canning for a man to attend Auburn Theological Seminary. Faithful to the end, the girls bought him a new black suit, cane, and silk hat for graduation. Afterward, they were instrumental in getting him an invitation to preach in their church. When he began to preach an admonitory sermon on 1 Timothy 2:12 KJV, "But I suffer not a woman to teach, nor to usurp authority over the man, but to be in silence," the girls left in shock. The blindfolds began to be loosened.

In her autobiography, Stanton referred to a wounding that many of us women have experienced: our parents regret that we were not boys. Stanton was in a family with four girls and one boy. Stanton wrote, "The first event engraved on my memory was the birth of a sister when I was four years old. . . . I heard so many friends remark, 'What a pity it is she's a girl!' that I felt a kind of compassion for the little baby. . . . I did not understand at that time that girls were considered an inferior order of beings."[20] When she was eleven years old, her older and only brother died. She entered the chamber with the coffin, and she saw her father desolate. She went to comfort him and sat on his knee. She recalls, "At length he heaved a deep sigh and said: 'Oh, my daughter, I wish you were a boy!' Throwing my arms around his neck, I replied: 'I will try to be all my brother was.'"[21] She carried this burden throughout her life.

It is important to note that the abolition movement, the temperance movement, and the suffrage movement, as well as the later branches of the women's movement, grew out of Evangelical religion. According to Alice Rossi, the roots of American feminism have been traced to the revivalist Charles G. Finney.[22] There are complex reasons for this connection between Evangelical revivalism and feminism; one reason "is an implicit leveling force

20. Elizabeth Cady Stanton, *Eighty Years and More: Reminiscences 1815–1897* (Rahway, NJ: Mershon, 1897), 4.
21. Stanton, *Eighty Years and More*, 20–21.
22. Alice S. Rossi, "Social Roots of the Woman's Movement in America," in *The Feminist Papers from Adams to de Beauvoir* (New York: Columbia University Press, 1973), 241–81.

in vital Evangelical religion."[23] In fact, according to historian Donald Dayton, the 1830s' abolitionism gave rise to the women's rights movement.[24] The same arguments used against slavery could be applied to support egalitarian treatment of women. From the position of being treated as an inferior human and from the viewpoint of humiliating degradation, a perspective born of suffering, a perception of injustice, and a passion for equal rights began to connect the movements to free the slave and the woman.

My earlier work offers a theological trajectory of Elizabeth Cady Stanton from her early contact with Evangelical revivalism to her work as reformer, then revolutionary.[25] The theological trajectory of Stanton's beliefs and life may be informative for understanding other women in the nineteenth century who transitioned from pious disciple to reformer or revolutionary. At any rate, Stanton's blind faith in the brand of Evangelical religion in which she was raised was the starting point of the continuum that segued into her becoming the religious revolutionary who helped orchestrate *The Woman's Bible*. Needless to say, the 1 Timothy passage was not included!

Stanton, at age fifteen, was exposed to Charles Finney's brand of Evangelicalism at the Great Troy Revival in 1831. After receiving six weeks of his preaching, she sat on the "anxious bench" and later converted.[26] She became ill, unable to sleep, obsessed with judgment and damnation. Her family took her on a vacation to recover. Subsequently, she became critical of Charles Finney and chose skepticism. However, "the Great Revival created around Elizabeth Cady an environment conducive to reform."[27] She was exposed to many reformers in her cousin Gerrit Smith's home: abolition agents as well as temperance advocates. It was there she met abolitionist Henry Stanton.

23. Donald W. Dayton, "The Evangelical Roots of Feminism," in *Discovering an Evangelical Heritage* (New York: Harper & Row, 1976), 86.
24. Dayton, "The Evangelical Roots of Feminism," 89.
25. Jeanne Stevenson-Moessner, "Elizabeth Cady Stanton, Reformer to Revolutionary: A Theological Trajectory," *Journal of the American Academy of Religion* 62, no. 3 (Fall 1994): 673–97.
26. Griffith, *In Her Own Right*, 21.
27. Griffith, *In Her Own Right*, 21.

THE WOMAN'S BIBLE
Editor
ELIZABETH CADY STANTON

Carrie Chapman Catt, President of the National Suffrage Association, one of the Revising Committee.

In the early nineties a group of leading Suffragists decided that the "Christian Bible, the Christian religion and the Christian ministry were the greatest obstacles to the spread of woman suffrage."

They concluded that the Bible should be rewritten from the woman's standpoint, but they could not persuade any scholars to make the desired changes in the translation, and so they were compelled to take the English version as it stood, and say how it should have been written.

(See preface to Woman's Bible.)

A Committee of "women of liberal ideas" was selected, and a portion of the Bible assigned to each one for revision. Mrs. C. C. Catt, the president of the National Suffrage Association; Miss Alice Blackwell, now editor of the leading suffrage magazine; Mrs. Robert Ingersoll, and other well known suffragists, were on the Committee. Mrs. Elizabeth Cady Stanton acted as editor and the book was copyrighted in her name.

(See title page.)

The first volume was issued in 1895, the second in 1898, and two more editions have been printed. This Woman's Bible was distributed as a suffrage tract.

In their comments the Committee claim that the Bible is not inspired, that Christ is not divine, that the keeping of Sunday has done harm, and that the Christian Church and the Christian ministry have been agents of evil.

The Woman Suffrage Association is the only political body to hold its convention meetings on Sunday. At the convention in Chicago in February, 1920, the social reception to the delegates was held on Sunday evening. In May, 1920, the women who invaded Connecticut to try to force Governor Holcomb to call a special session, met in New York on Sunday and had a big political dinner on that day. Thus the party today lives up to the theory "that much injury has been done to the world" by the keeping holy the seventh day.

(Page 66.)

The following quotations will be enough to show why the book was written and what it teaches.

"That even the most enlightened nations are not yet out of barbarism is due to the teachings of the Bible." (Page 209.)

"The truth of the matter is that whatever progress woman has made in any department of effort, she has accomplished in opposition to the so-called inspired 'Word of God'; and this Book has been of more injury to woman than any other book which has ever been written." (Page 202.)

"It does not need a knowledge of Greek or Hebrew to show that the Bible degrades women. We have made a fetich of the Bible long enough. The Bible has been the great block in the way of civilization." (Preface Volume 2.)

"The Bible has been and will continue to be a stumbling block in the way of the truest civilization." (Page 187.)

"The Bible always has been, and is at present, one of the greatest obstacles in the way of the emancipation and advancement of the sex." (Page 201.)

"Women especially need enlightenment as to the true nature of the Bible. Their religious nature is warped and twisted, which fact is the greatest stumbling block in the path of equal suffrage today." (Page 143.)

"Priestly power has done more to block woman's way to freedom than all other earthly influences combined." (Page 111.)

The attacks on ministers are too numerous and long to quote, but again and again women are urged to throw off these old superstitions, to free themselves from the authority of the churches, "to leave the priestly mendicants who demand their devotion and their dollars" and to stop giving their time and money to support that man-made religion, Christianity.

The Divinity of Christ is denied and the statement made: "That thousands of people have lived since the time of Jesus as good, as tender, as loving, as true, as faithful as He."
(Page 115.)

They say that "The widow should have been blamed and not commended for casting in her mite, for 'self-development is a higher duty than self-sacrifice should be woman's motto.'"
(Volume 2, Page 131.)

"No institution in modern civilization is so tyrannical and so unjust to woman as is the Christian Church." (Page 205.)

"Christianity feeds and fattens on the sentiment and credulity of women." (Page 207.)

"Why should women obey a man's religion!"

"Our religion is the real source of women's disabilities."
(Page 79.)

"The Episcopal Church is most demoralizing. Whole congregations of educated men and women, day after day, confessing themselves miserable sinners." (Page 98.)

"The struggle of today among the advanced of our sex is to regain what has been lost since the establishment of Christianity." (Volume 2, Page 22.)

"The civilization of Moslem Spain far surpassed that of Christian Europe." (Page 206.)

Saint Paul is spoken of as the most stultifying influence in the history of civilization, and the following couplet is often quoted:

"This doctrine of Jesus as set forth by Paul,
If believed in its fullness would ruin us all."

The future woman suffragists are thus described: "A countless host of women will move in majesty down the centuries. These are the mothers of the coming race who have locked the door of the Temple of Faith and thrown the key away." (Page 196.)

This is the teaching of National Suffrage Leaders.

Are you willing for women who hold these views to become political powers in our country?

The Woman's Bible, editor Elizabeth Cady Stanton, Original Broadside (first elected in 1990).

Before they met each other, both Elizabeth Cady and Henry Stanton had heard the famed and fiery evangelist Charles Finney preach. Henry had heard Finney preach in 1830 in Rochester, New York. Finney gathered a group of young men to propagate the gospel and to proclaim that conversion resulted in good works (i.e., the doctrine of Christian perfectionism). Henry joined the Finney Holy Band and was sent to Lane Theological Seminary in Ohio for training.[28] In 1835, Henry became a member of an abolition strike force called the Band of Seventy. Slavery was an ill of society, a sin framed as servitude. He proposed marriage to Elizabeth about this time and in doing so, "offered Elizabeth an alliance of affection and abolitionism."[29]

Immediately after their marriage, the two sailed to England to attend the World Anti-Slavery Convention of 1840, which was held in London. The last shred of any blindfold for Elizabeth Cady Stanton was stripped away when the American female delegates and observers were denied seats at the convention. This was also the *negative limit* for Lucretia Mott, who spoke her mind as a feminist. That night, Mott and Stanton walked arm in arm down the London streets planning a women's rights convention upon return to the United States, and "thus a missionary work for the emancipation of women in the 'land of the free and the home of the brave' was then and there inaugurated. As the ladies were not allowed to speak in the Convention, they kept up a brisk fire morning, noon, and night at their hotel on the unfortunate gentlemen who were domiciled at the same house."[30] If her blindfolds were not already removed before this point, her vision became clear at the 1840 Convention. In what has been called her "public period," Elizabeth began to advocate against a variety of social ills and for:

> fair property laws for widows, an end to prostitution, redress for abused wives, free-thought, and woman's control over the frequency of sexual intercourse in marriage. These issues could best be subsumed under one code in her "Address to the Legislature of New York on Women's Rights," February 14, 1854: "Would not one code answer for all of like needs and wants? Christ's golden rule is better than all the special legislation that the ingenuity of man can devise: 'Do

28. Rossi, "Social Roots of the Woman's Movement in America," 256–59.
29. Griffith, *In Her Own Right*, 28.
30. Elizabeth Cady Stanton, Susan B. Anthony, and Matilda Joslyn Gage, eds., *History of Woman Suffrage*, vol. 1, 1848–1861 (New York: Fowler and Wells, 1881), 61–62.

unto others as you would have others do unto you.' This, men and brethren, is all we ask at your hands. We ask no better laws than those you have made for yourselves."[31]

The perspicacity of Elizabeth Cady Stanton consisted of discernment, insight, and perception–delivered with fierceness. She had a bright legal mind, although she was not formally trained as such. How sad that her lawyer father never appreciated this.

Connecting the Three Women

In commenting on the Seneca Falls Convention of 1848, Alice Rossi labels the two organizers of the convention, Lucretia Mott and Elizabeth Cady Stanton, "Moral Crusader feminists"–women who excelled in protests, activism, and public meetings. These feminists are markedly different, according to Rossi, from "Enlightenment feminists," who work individually on books and lectures.[32] If Harriet Beecher Stowe could be counted among the Enlightenment feminists, then Moral Crusader feminist seems an apt category for Elizabeth Cady Stanton. In retrospect, we would need a unique genre for Sojourner Truth. In her *Book of Life*, she was seen as a "sibyl and prophetess" and as an "ancient saint" and "ancient philosopher."[33] Isabelle Kinnard Richman describes Sojourner Truth as a prophet of social justice and "a religiously inspired mystic."[34] I would concur that we had a prophetess in our midst.

What were the commonalities that drew such dissimilar women together–dissimilar not only in class and ethnicity but in their genre of engagement in their endeavors for justice? The more obvious commonalities were these: an empathy with those suffering, a fearlessness born of passion, perspicacity emanating from shrewdness, the experience of having the blindfolds removed, and a life heavily influenced by religion.

I had hoped in my research to find a time all three women were together

31. Stevenson-Moessner, "Elizabeth Cady Stanton, Reformer to Revolutionary," 677.
32. Rossi, "Social Roots of the Woman's Movement in America," 246–47.
33. Gilbert, *Narrative of Sojourner Truth*, 170, 181, 202, 219.
34. Richman, *Sojourner Truth*, 4.

in one convention or other venue. My research has not shown this as true. Instead, here are the times that two of the three met:

- 1850–At the 1850 National Women's Rights Convention in Worcester, Massachusetts, Mary Butler contends that Sojourner Truth heard Stanton give a speech.[35] However, Griffith writes that Stanton was not able to attend due to a pregnancy but wrote a letter to the convention. The letter was read aloud.[36]
- 1853–Truth visits Harriet Beecher Stowe at her home on May 29, 1851, in Andover, Massachusetts. Truth stayed in Beecher's home for several nights, making a keen impression on some of the clerics who were dining there on the night of her arrival. Stowe wrote of this time together in an *Atlantic* article in April 1863.[37] The article is also the source of the description of Truth as a "Libyan sibyl." Truth asks Stowe to write a favorable review of her *Narrative*. Stowe writes of Truth:

 > Sojourner stayed several days with us, a welcome guest. Her conversation was so strong, simple, shrewd, and with such a droll flavoring of humor, that the Professor [Calvin Ellis Stowe] was wont to say of an evening, "Come, I am dull, can't you get Sojourner up here to talk a little?" She would come up into the parlor, and sit among pictures and ornaments, in her simple stuff gown, with her heavy travelling-shoes, the central object of attention both to parents and children, always ready to talk or to sing, and putting into the common flow of conversation the keen edge of some shred remark.

- 1866–Both Elizabeth Cady Stanton and Sojourner Truth attended the eleventh National Women's Rights Convention in New York on May 10, 1866. Truth stayed with the Stantons.[38]
- 1867–Elizabeth Cady Stanton and Sojourner Truth speak at the first annual meeting of the American Equal Rights Association, held in New York City at the Church of the Puritans on May 10, 1867. Stanton opens

35. Mary G. Butler, *Sojourner Truth: From Slave to Activist for Freedom* (New York: Rosen, 2003), 61.
36. Griffith, *In Her Own Right*, 65.
37. Harriet Beecher Stowe, "Sojourner Truth, the Libyan Sibyl," *The Atlantic* (April 1863): 473–81.
38. Griffith, *In Her Own Right*, 125.

and calls the meeting to order. Susan B. Anthony gives the first speech. Then Lucretia Mott introduces Truth, who speaks next. Truth seems to speak twice at the event.[39]

- 1869–1871–Elizabeth Cady Stanton personally meets Harriet Beecher Stowe in Stowe's "sanctum, surrounded by books and papers." Interestingly, other than this line about Stowe, Stanton mentions only her negative exchange with Stowe's sister Catharine, who was opposed to women's suffrage. Nothing more of her interaction with Harriet is mentioned.[40]
- 1869–Stanton tried to recruit Stowe to write for *The Revolution*, but Stowe declined.

The Fifteenth Amendment was ratified on February 3, 1870, granting African American men the right to vote. This event, and the overall issue of the right to vote for black men, was the reason for the split in the women's movement. It broke the unified momentum.

Differences

It is during 1867–1870 that the different emphases in the work of Sojourner Truth, Elizabeth Cady Stanton, and Harriet Beecher Stowe become evident. Many but not all in the women's suffrage movement resisted the Fifteenth Amendment, which would only allow black men to vote. Once again, this excluded women of all ethnicities. Singling out male privilege was part of the exclusionary tactics seen as abhorrent and sinful. Stanton was in this camp. On the other hand, Truth could not turn against the empowerment of her own race. In fact, after the emancipation of slaves, she devoted the latter part of her life to caring for the hordes of displaced former slaves who crowded the streets of Washington–starving, unsheltered, unemployed. As her *Book of Life* documents, her speaking engagements, particularly in churches, focused on the need for help for the displaced freedmen, women, and children who needed their own land in the western part of the United States; with their own land, which they had well earned as recompense for

39. Elizabeth Cady Stanton, Susan B. Anthony, and Matilda Joslyn Gage, eds., *History of Woman Suffrage*, vol. 2, 1861–1876 (New York: Source Book, 1881), 182–228.
40. Stanton, *Eighty Years and More*, 264.

their unpaid labor as slaves, they could support themselves and be self-sufficient.

According to the biography written by her son, Harriet Beecher Stowe's literary life took off in 1852. She wrote thirty books and numerous articles before 1881.[41] Although Stanton asked her to write for *The Revolution* newspaper in 1869, Stowe refused; their understanding of womanhood differed at that point. The Enlightenment feminist, the Moral Crusader feminist, and the prophetess of social justice parted ways.

Tipping Points

In 2006, Tarana Burke, a civil rights activist from the Bronx, founded the MeToo movement to raise awareness of sexual assault and abuse. In 2017, the hashtag associated with the movement was used to tweet about Harvey Weinstein accusations. Katherine Kendall, involved in the latter movement, commented in a private telephone interview with me on a necessary momentum that a movement must gain in order to reach a *tipping point*, to tip the scales in the favored direction.[42] We witnessed this as Weinstein came to trial and was convicted. My question to Kendall was the following: "How do you account for the strength of the [#MeToo] movement?" She replied:

> Earlier [the stories of sexual abuse] got snuffed out. The *New York Times* reported on Roger Eugene Ailes, they reported on Bill O'Reilly. I really think there was a tipping point. It was like a feeling in the air . . . it was an invisible moment like a dam was going to break, and it did. . . . [It was] an invisible swell, although sometimes visible. . . . It seems that [when] the story broke [regarding Weinstein], it had enough energy behind it before it broke that when it did, it really exploded. It was a cultural watershed moment. . . . There is a powerful strength in numbers. I came to support [Rose McGowan and Ashley Judd] . . . that was what my heart was telling me to do: support

41. Stowe, *Life of Harriet Beecher Stowe*, 490–91.
42. Katherine Kendall in taped interview with the author, February 3, 2020. Kendall has been interviewed on a number of stations including CNN, PBS NewsHour, Court TV, Grabien, and Popcorn Talk and for a number of magazines such as *The Guardian*, *The Observer*, and *The Washington Post*. She was one of "The Silence Breakers" in claims of Harvey Weinstein's sexual harassment of young actresses.

> other women. The first women who spoke were really at risk. I was in the early first ten [women who accused Weinstein]. I didn't know the #MeToo movement was going to have a resurgence. I came to help other people when you know their story is true. It is bravery to stand behind someone. The bravery of the women [who reported Bill Cosby and others] . . . they were breaking the myth for us.

Division in the ranks of a movement has a slowing effect and may prevent the tipping point from occurring. As racism was pitted against sexism in 1870, it is possible momentum was lost. Many questions are raised by the 1870 referendum. If the Emancipation Proclamation issued by President Lincoln was effective January 1, 1863, and the Thirteenth Amendment was ratified in December of 1865, why were not all freed slaves given the right to vote? Was there any intent to divide the sexes by this additional empowerment of men over women? We may never know. We do know that this exclusionary measure prevented the women's movement from reaching its tipping point. The women became divided over the issue of the Fifteenth Amendment. The dam did not break for them.

In my first teaching position at the graduate level in the late 1980s, I was appointed as cochair of the racism and sexism committee. It was made up of one other faculty member and about seven students. The students insisted that we focus on one "ism" or the other (racism or sexism) and refused to deal with both. I began to see a binary occur that was created also in the referendum in 1870: either black men or all women, either racism or sexism.

Perhaps what the experience of these three remarkable women—Truth, Stowe, and Stanton—can teach us most is the need to focus on the intersectionality of all forms of oppression. As we look back on the nineteenth century and see the continuity of movements toward freedom, we can see the detrimental impact of constructing a hierarchical arrangement of oppression, thus creating discontinuity and competition. Kimberlé Williams Crenshaw coined the term *intersectionality* in 1989 to confront racism in the feminist movement and sexism in the civil rights movement. Intersectionality is a framework or a lens through which to see multiple oppressions. As Nancy Ramsay has stated,

> I have embraced intersectionality as a theory that helps students and faculty better understand and engage with the complex, constructed, and intersecting simultaneity of identity and its entanglement with

asymmetries of power. The theory helps us out of the quagmire of identity politics that was built on modernist approaches to social identity as additive, essential, and inevitably vulnerable to debates about hierarchical arrangements of oppression. It refuses such divisive hierarchies even as it insists on analysis of the simultaneity of oppressive forces of intersecting asymmetries of power.[43]

Having looked back to the nineteenth century, we can learn from our predecessors how to reach or fail to reach a tipping point in our work toward justice. Blindfolds to the subtle as well as flagrant asymmetries of power, and blinders to the microaggressions and machinations of power plays of oppression, will need to be thrown to the winds as "we stand upon the mount of vision" that our ancestors saw before us.[44]

Bibliography

Butler, Mary G. *Sojourner Truth: From Slave to Activist for Freedom.* New York: Rosen, 2003.

Dayton, Donald W. "The Evangelical Roots of Feminism." In *Discovering an Evangelical Heritage,* 85–98. New York: Harper & Row, 1976.

Gilbert, Olive. *Narrative of Sojourner Truth: A Bondswoman of Olden Time, with a History of Her Labors and Correspondence Drawn from Her Book of Life.* Edited by Nell Irvin Painter. New York: Penguin, 1998.

Griffith, Elisabeth. *In Her Own Right: The Life of Elizabeth Cady Stanton.* New York: Oxford University Press, 1984.

Ramsay, Nancy. "Intersectionality and Theological Education." In "The Intersectionality in Theological Education: Engaging Complexity, Activism, and Multiple Consciousness." Edited by Jeanne Stevenson-Moessner. Special issue, *Religious Studies News* (April 2015): 7–10.

Richman, Isabelle Kinnard. *Sojourner Truth: Prophet of Social Justice.* New York: Routledge, 2016.

43. Nancy Ramsay, "Intersectionality and Theological Education," in "The Intersectionality in Theological Education: Engaging Complexity, Activism, and Multiple Consciousness," ed. Jeanne Stevenson-Moessner, special issue, *Religious Studies News* (April 2015): 7.

44. Anna Howard Shaw, "Eulogy to Susan B. Anthony" (speech, Rochester, NY, March 15, 1906), https://tinyurl.com/yx25tmap.

Rossi, Alice S. "Social Roots of the Woman's Movement in America." In *The Feminist Papers from Adams to de Beauvoir*, 241–81. New York: Columbia University Press, 1973.

Shaw, Anna Howard. "Eulogy to Susan B. Anthony." Speech delivered at Rochester, NY, March 15, 1906. https://tinyurl.com/yx25tmap.

Stanton, Elizabeth Cady. *Eighty Years and More: Reminiscences 1815–1897*. Rahway, NJ: Mershon, 1897.

———. *Elizabeth Cady Stanton as Revealed in Her Letters, Diary, and Reminiscences*. Edited by Theodore Stanton and Harriot Stanton Blatch. New York: Harper & Brothers, 1922.

———. *The Slave's Appeal*. Albany: Anti-Slavery Depository, 1860.

Stanton, Elizabeth Cady, Susan B. Anthony, and Matilda Joslyn Gage, eds. *History of Woman Suffrage*. Vol. 1, 1848–1861. New York: Fowler and Wells, 1881. eds. *History of Woman Suffrage*. Vol. 2, 1861–1876. New York: Source Book, 1881.

Stevenson-Moessner, Jeanne. "Elizabeth Cady Stanton, Reformer to Revolutionary: A Theological Trajectory." *Journal of the American Academy of Religion* 62, no. 3 (Fall 1994): 673–97.

Stowe, Charles Edward. *Life of Harriet Beecher Stowe: Compiled from Her Letters and Journals*. Cambridge, MA: Riverside, 1889.

Stowe, Harriet Beecher. *A Key to Uncle Tom's Cabin: Presenting the Original Facts and Documents upon Which the Story Is Founded. Together with Corroborative Statements Verifying the Truth of the Work*. Boston: Jewett, 1853.

———. "Sojourner Truth, the Libyan Sibyl." *The Atlantic* (April 1863): 473–81.

Vollaro, Daniel R. "Lincoln, Stowe, and the 'Little Woman/Great War' Story: The Making, and Breaking, of a Great American Anecdote." *The Journal of the Abraham Lincoln Association* 30, no. 1 (Winter 2009): 18–34. https://tinyurl.com/wujr6hr.

2. Dreams Deferred... Visions Realized: The Struggle for African American Women's Rights

TERESA JEFFERSON-SNORTON

When the women's suffrage movement ended with the right for women to vote in 1920, African American women were not beneficiaries of the victory. The dream for African Americans to be fully afforded all rights as American citizens was once again deferred, as it had been repeatedly since emancipation became the law in 1865.

Through the Jim Crow era and into the civil rights movement, African American women's voices were part of the ongoing efforts to gain full rights for black people. This chapter will track some of these efforts and the dynamics that challenged those voices. It will then identify some of the specific ways in which women's voices made the difference in bringing the vision to fruition, including stories of African American women who played key roles in the actualization of having voice through the vote.

Dreams Deferred: Black Women's Role in the Suffrage Movement

Historic sexism and politics were the primary drivers that continued to separate African American women and the ballot box after the historic victory for women's suffrage in August 1920. The role of women in American culture was still dominated by patriarchal values, sexist oppression, and exclusion of women from mainstream life outside of the home. Obtaining the right to vote did very little to shatter the perceptions that a woman's place was in the home. Little regard was given for the ongoing marginalization of African Americans, who continued to struggle to enjoy freedom and be regarded as persons of worth. Through the voice of her fictional character Nanny, author Zora Neale Hurston described the place of black women as "de mule uh de

world" (the mule of the world).[1] Women's voices, including those of African American women, continued to be excluded in the public sector, the political arena, and the corporate world. If women were engaged outside of the home, it was as teachers, nurses, secretaries, and other supporting roles that afforded them little recognition and access to power and decision-making.

A 1953 postcard of the headquarters of the National Association of Colored Women, Inc., 1601 "R" Street NW, Washington, DC.

Although African American women like Sojourner Truth, Harriet Tubman, and Ida B. Wells were active in the abolitionist movement of the mid-1800s, their advocacy was not just for equal rights and the vote for women but also for the enfranchisement of all African Americans. Unlike white women, their efforts for the right to vote were also tied to the rights of all African Americans, who were still enslaved in America with the few exceptions of those free blacks primarily in the urban north.

Sojourner Truth's beliefs in equal rights for women are embodied in her speech at the women's rights convention in 1851, which later became known as "Ain't I a Woman?" This speech provides a poignant contrast between her

1. Zora Neale Hurston, *Their Eyes Were Watching God* (New York: HarperCollins, 2006), 14.

life as a black woman and the life of white women.² Truth (born as Isabella Baumfree, a slave) escaped from bondage and became one of the noted voices of both the abolitionist movement and the women's suffrage movement. In a speech in Boston in 1871 at the second annual convention of the American Woman Suffrage Association, Truth argued that women's rights were essential not only to their own well-being but "for the benefit of the whole creation, not only the women, but all the men on the face of the earth, for they were the mothers of them."³

Harriet Tubman (born Araminta Ross) was an escaped slave who became known for her extensive work on the "Underground Railroad," an abolitionist movement to assist fleeing slaves in finding their way to freedom in the northern states or in Canada. Tubman's activism beyond these freedom expeditions was solidified in her work with the US Army during the Civil War. She served as a spy and as a leader of "colored" troops as they mobilized for war in the South. Harriet Tubman scholar Kate Clifford Larson chronicles Tubman's suffrage work alongside suffragist Susan B. Anthony and philanthropist Emily Howland in the latter years of Tubman's life.⁴ Tubman's legacy included the passion for equal rights for women because she understood that women's rights were intertwined with the liberation of the slave and the dismantling of the oppressive systems in America.

Ida B. Wells was a journalist best known for her exposure of the problem of lynching in America. Wells was born into slavery and was freed via emancipation. Wells's activism led to her becoming one of the founders of the National Association for the Advancement of Colored People (NAACP) in 1909, along with W. E. B. DuBois and other advocates for racial justice. Wells and a white colleague named Belle Squire organized the Alpha Suffrage Club in Chicago in 1913 not only to further voting rights for all women but also to prepare and encourage black women to run for office and engage in civic opportunities.⁵ The challenges Wells faced in her advocacy for women's rights are embodied

2. Sojourner Truth, "Ain't I a Woman?" (speech delivered at a Women's Convention, Akron, OH, May 29, 1851), https://tinyurl.com/tpu7gor.
3. Sojourner Truth, quoted in Jean H. Baker, ed., *Votes for Women: The Struggle for Suffrage Revisited* (New York: Oxford University Press, 2002), 52.
4. Kate Clifford Larson, *Bound for the Promised Land: Harriet Tubman, Portrait of an American Hero* (New York: Ballantine, 2004), esp. chapter 13, which covers this period in Tubman's life.
5. Patricia A. Schechter, *Ida B. Wells-Barnett and American Reform, 1880–1930* (Chapel Hill: University of North Carolina Press, 2001), esp. chapter 4, which describes Wells-Barnett's civic engagement beyond the antilynching movement.

in an account of a parade she was to participate in with the National American Woman Suffrage Association (NAWSA) in Washington, DC: Wells wanted the African American women to march alongside the white women in the parade but was told that the delegations would be segregated. Wells boldly waited on the sidelines until the white Illinois delegation marched past and then joined them in the march.[6] Wells's determination and insistence on equality within the suffragist movement became a beacon for African American women and a nuisance for the white women leading the suffrage movement and eventually led to her being labeled a "race agitator" by the US government.[7]

In addition to these formerly enslaved women, women like Mary Church Terrell were among those advocating for women's suffrage in the early twentieth century. Terrell was one of the first African American women to earn a college degree, which she did in 1884. A teacher, Terrell was a charter member of the NAACP, which was founded in 1909, and of the Colored Women's League of Washington, founded in 1894. She was also one of the founders and the first national president of the National Association of Colored Women, founded in 1896. More than a decade later, she also helped found the National Association of College Women (1910). Terrell, who was biracial, was able to form friendships and alliances with white women in the suffrage movement (e.g., Susan B. Anthony, Lucretia Mott, and Elizabeth Cady Stanton) and the NAWSA. Terrell's specific goal was to organize black women in America to tackle issues of lynching, the disenfranchisement of the race, and the development of educational reform.[8] Terrell was one of the few African American women who were allowed to attend NAWSA's meetings, and she often spoke specifically about the injustices and issues within the African American community. Yet the NAWSA would not even allow the African American women to form their own chapter of the organization. Soon Terrell shifted her energies to the work of the NAACP and was among those who helped integrate restaurants in Washington, DC.

6. Lorraine Boissoneault, "The Original Women's March on Washington and the Suffragists Who Paved the Way," Smithsonianmag.com, last updated January 23, 2017, https://tinyurl.com/ycls-bjsg.
7. Paula J. Giddings, *Ida: A Sword among Lions: Ida B. Wells and the Campaign against Lynching* (New York: Amistad, 2009), 5–10.
8. Gloria M. White, "Mary Church Terrell: Organizer of Black Women," *Integrated Education* 17 (1979): 2–8.

Photograph of Ida B. Wells, African-American early civil rights leader, co-founder of the NAACP.

DEDICATION CEREMONIES

IDA B. WELLS HOMES
38th ST. and RHODES
Sunday, OCTOBER 27th 1940
· · · 2:30 P.M · · ·
Parade along South Parkway

HON. EDW. J. KELLY Mayor SPEAKER

CHICAGO HOUSING AUTHORITY

Ida B. Wells Homes, October 27, 1940. This public housing project in the Bronzeville neighborhood on the South Side of Chicago had more than 860 apartments and almost 800 row houses and garden apartments constructed for African-Americans. Original poster.

Truth, Tubman, Wells, and Terrell are just a few of the African American women who took up the banner for women's suffrage, even as the freedom of African Americans was yet to be won or accepted. Yet despite their tireless efforts, the white women of the suffrage movement did not hold the black

women's plight in high enough regard to risk their own success. White women knew they would need the support of white politicians and legislatures to gain support for the Nineteenth Amendment, which would grant women the right to vote.[9] Rather than advocate for enforcement of the Thirteenth (1865), Fourteenth (1868), and Fifteenth (1870) Amendments to the Constitution along with their own proposed amendment, the white suffragists chose to ignore the racial component of the struggle. The ongoing segregation and voter suppression that came to be known as "Jim Crow" deferred African American women's dreams of equality and the vote until the Civil Rights Act (1864), more than forty years after 1920, when the Nineteenth Amendment was passed.

The Struggle Continues: "Sick and Tired of Being Sick and Tired"

The struggle for equality for African American women continued for the next several decades. During the First and Second World Wars, segregation remained the order of the day and Jim Crow was practiced overtly and covertly. For African American men, voting, though legal through constitutional amendment, continued to be elusive because of the emergence of poll taxes, property ownership requirements, literacy tests, and all kinds of maneuvers to disqualify them from exercising this right. Equality for African American women was elusive as well, with basic civil rights and the dismantling of Jim Crow becoming the primary goal of both male and female activists in the middle of the twentieth century.

Rosa Parks is a notable name in this period of African American history. Though not the first to be arrested for refusing to sit in the back of the bus, Parks became a household name associated with the birth of the modern civil rights movement.[10] Anecdotal accounts about her arrest on December 1, 1955, for refusing to move to the back of the bus in Montgomery, Alabama, say that the seamstress was tired and thus would not get up or give up her seat to white passengers. The more accurate version of that day is that Parks,

9. Brent Staples, "How the Suffrage Movement Betrayed Black Women," *New York Times*, July 28, 2018, https://tinyurl.com/yah9qs2n.
10. Claudette Colvin, a fifteen-year-old activist in Montgomery, Alabama, refused to give up her bus seat on March 2, 1955.

who had been trained by the NAACP, deliberately defied the "separate but equal" assumption embedded in the rules for public transportation in the South. Her action triggered the Montgomery Bus Boycott, which led to the formation of the nonviolent movement of the Southern Christian Leadership Conference (SCLC) led by Dr. Martin Luther King Jr. Although Parks was not specifically advocating for voting rights for African American women, she is a modern icon of the quest for equal rights and justice for all in America. She was obviously tired of the status quo.

Fannie Lou Hamer was a key figure representing the vital role played by black women in the post-1920s suffrage movement. Hamer was a voting rights and women's rights activist and community organizer in Mississippi in the 1960s. Hamer and the Student Nonviolent Coordinating Committee (SNCC) organized Mississippi's Freedom Summer. It is reported that Hamer did not even realize she had the right to vote until SNCC volunteers began working in her community in 1962 to register black people to vote in Mississippi. Hamer was also cofounder of a grassroots organization dedicated to preparing African American women to run for political office. Beginning in 1962, and for nearly a decade, Hamer risked her life to vote and register others to vote in Mississippi. She is credited as coining the phrase "I'm sick and tired of being sick and tired" when asked why she worked so hard for justice and equality.[11] In spite of being fired from jobs, arrested, shot at, beaten, harassed, and threatened, Hamer continued her work for equal voting rights and for women's rights. Hamer's work included advocacy for healthcare, which emerged out of a personal experience of being sterilized without her consent when she had an unrelated surgery in 1961.[12] Hamer also organized black farm workers in Mississippi and advocated for their rights at the state and federal level. And although unsuccessful, she ran for the US Senate in 1964 and Mississippi's State Senate in 1971. Hamer's untiring efforts for justice stand as a premier model of how one transforms fatigue and hopelessness into action and hopefulness.

11. Gloria J. Browne-Marshall, *Race, Law, and American Society: 1607 to Present* (New York: Routledge, 2007), 131.
12. Chana Kai Lee, *For Freedom's Sake: The Life of Fannie Lou Hamer* (Champaign: University of Illinois Press, 2000), 80–81.

Mrs. Fannie Lou Hamer, State Senator, District 11–Post 2, November 2, 1971. Original poster.

The Reemergence of Hope

The intensity of the civil rights movement eventually led to the adoption of the Civil Rights Act in 1964 and the Voting Rights Act in 1965. The Voting Rights Act of 1965 changed the lives of African American men and women by removing all kinds of barriers to black enfranchisement that had become

common in the South. It banned poll taxes, literacy tests, and other measures that had effectively prevented African Americans from voting. This act alone effectively gave some measure of success for those who had struggled for so long for voting and equal rights for African American women (and men).

According to the US Department of Justice, the Voting Rights Act of 1965, originally set to expire in 1970, was amended in 1970, 1975, 1982, 1992, and 2006.[13] In 2013, certain provisions of the Voting Rights Act were ruled unconstitutional by the US Supreme Court under the assumption that the Fourteenth Amendment to the Constitution affords those voter protections and they are therefore unnecessary in the Voting Rights Act. Since that Supreme Court ruling, several bills have been introduced in Congress to restore the protections of voter rights from gerrymandering and redistricting.

The clearest emergence of hope for equality for African American women is located in their growing presence in elected positions. Local governments across the country have elected African American women as mayors, city councilpersons, commissioners, judges, and other officials, including Muriel Bowser, who was elected mayor of Washington, DC, in 2015. State governments have elected black women to their legislatures and other statewide positions, including lieutenant governor. Those lieutenant governors include the following:

- Jennette Bradley, Ohio, 2003–2005
- Jennifer Carroll, Florida, 2011–2013
- Jenean Hampton, Kentucky, 2015–2019
- Sheila Oliver, New Jersey, elected in 2018
- Juliana Stratton, Illinois, elected in 2019[14]

We await the day when an African American woman is elected governor of one of the fifty states. In 2018, Stacey Abrams of Georgia was defeated by a narrow margin in her bid for governor. Accusations of illegal purging of voter rolls in predominantly African American precincts throughout the state are cited as a reason for Abrams's defeat.

The United States Congress is another venue where the enfranchisement

13. "History of Federal Voting Rights Laws," The United States Department of Justice, last updated July 28, 2017, https://tinyurl.com/yc83l8xf.
14. This list was gleaned from "List of Minority Governors and Lieutenant Governors in the United States," Wikipedia, accessed November 30, 2019, https://tinyurl.com/uf5ma93.

of African American women as voters and participants in the political process is clear. During Reconstruction, several African American men were elected to Congress, but their presence was obliterated by the emergence of Jim Crow laws. However, since 1968, a total of forty-seven African American women have been elected to the United States House of Representatives and the United States Senate. A majority of these pioneering women have been elected to the House, indicative of the ongoing difficulty for African American women to be elected in statewide elections like those for the US Senate. As of 2018, there have been 1,974 persons elected as United States senators, only ten of whom have been African American, and only two of those have been women—Carol Moseley-Braun and Kamala Harris. Below is a list from the records of the office of the historian for the US House of Representatives of some of the notable African American women elected to Congress:[15]

- *Representative Shirley Chisholm*—elected in 1968 as the first African American congresswoman. She represented New York, and in 1972 she sought the Democratic nomination for president.
- *Senator Carol Mosely-Braun*—elected in 1993 as the first African American woman senator, representing Illinois for one term.
- *Representative Barbara Jordan*—represented Texas for three terms in the House of Representatives between 1973 and 1979.
- *Representative Maxine Waters*—representing California for fifteen consecutive terms (first elected in 1991).
- *Delegate Eleanor Holmes Norton*—serving her fifteenth term as a congressional delegate from the District of Columbia.
- *Representative Sheila Jackson Lee*—representing Texas in Congress for the thirteenth consecutive term (first elected in 1995).
- *Representative Cynthia McKinney*—elected in 1992 as the first African American congresswoman from Georgia. She served six terms in the House between 1993 and 2007, except the term from 2004 to 2005, making her one of only a few congresswomen to serve nonconsecutive terms.
- *Representative Terri Sewell*—elected in 2011 as the first African American congresswoman from Alabama. She is currently serving in her fifth term.

15. "Women of Color in Congress," United States House of Representatives History, Art & Archives, accessed November 30, 2019, https://tinyurl.com/y3vt8ysy.

- *Senator Kamala Harris*—elected to the Senate in 2016, making her the second African American woman to serve as senator. She represents California and campaigned briefly for the Democratic presidential nomination during the 2020 election cycle.
- *Representative Jahana Hayes*—elected in 2018 from a majority white congressional district in Connecticut. She is the state's first African American congresswoman.

Conclusion

These women, along with the rest of their African American female congressional colleagues, are testimonies to the sacrificial efforts of Sojourner Truth, Harriet Tubman, Ida B. Wells, Mary Church Terrell, Rosa Parks, Fannie Lou Hamer, and so many others. They represent the reality of what happens when a dream is deferred but refuses to die. They embody the faith of those who refused to take no for an answer. They are the epitome of what it means to never lose sight of the vision, no matter how far off it seems, nor how long it may take to become reality.

While the struggle for the rights of African American women is not over, progress has been made. We look to the next generation of emerging leaders to pick up the banner and continue to be voices against racism, sexism, oppression, marginalization, and injustice. We need to see the passing of the Equal Rights Amendment in order to ensure equal pay for women and an opportunity for economic security and parity. We need to see the health disparity gap closed for women of color. We need to see several more glass ceilings broken by talented African American women. There is much work to do, but thanks be to God for those who refused to stop even when they were "sick and tired."

The impact of African American women getting the right to vote—though delayed for all practical purposes from 1920 until 1965 in most states—is undeniable. The enfranchisement of a marginalized group of people discriminated against because of both race and gender was a monumental accomplishment and a life-changing event.

Katherine was born in 1900. She was sixty-five years old when she voted for the first time. She was a day worker with a third-grade education. She had never tried to vote because she did not read very well. But in November 1965, she placed her purse on her arm and her hat on her head and, wearing

her "Sunday dress" proudly, went to the polls to cast her ballot. That day, as I watched my grandmother walk down the county road to the polling place, I decided that I could not wait until I was old enough to vote.

Mama Katherine Snorton, grandmother of Bishop Teresa Jefferson-Snorton.

Bibliography

Baker, Jean H., ed. *Votes for Women: The Struggle for Suffrage Revisited.* New York: Oxford University Press, 2002.

Boissoneault, Lorraine. "The Original Women's March on Washington and the Suffragists Who Paved the Way," Smithsonianmag.com, last updated January 23, 2017, https://tinyurl.com/yclsbjsg.

Browne-Marshall, Gloria J. *Race, Law, and American Society: 1607 to Present.* New York: Routledge, 2007.

Giddings, Paula J. *Ida: A Sword among Lions: Ida B. Wells and the Campaign against Lynching.* New York: Amistad, 2009.

"History of Federal Voting Rights Laws." The United States Department of Justice. Last updated July 28, 2017. https://tinyurl.com/yc83l8xf.

Hurston, Zora Neale. *Their Eyes Were Watching God.* New York: HarperCollins, 2006.

Larson, Kate Clifford. *Bound for the Promised Land: Harriet Tubman: Portrait of an American Hero.* New York: Ballantine, 2004.

Lee, Chana Kai. *For Freedom's Sake: The Life of Fannie Lou Hamer.* Champaign: University of Illinois Press, 2000.

"List of Minority Governors and Lieutenant Governors in the United States." Wikipedia. Accessed November 30, 2019. https://tiny url.com/uf5ma93.

Schechter, Patricia A. *Ida B. Wells-Barnett and American Reform, 1880–1930.* Chapel Hill: University of North Carolina Press, 2001.

Staples, Brent. "How the Suffrage Movement Betrayed Black Women." *New York Times.* July 28, 2018. https://tinyurl.com/yah9qs2n.

Truth, Sojourner. "Ain't I a Woman?" Speech delivered at a Women's Convention, Akron, OH, May 29, 1851. https://tinyurl.com/tpu7gor.

White, Gloria M. "Mary Church Terrell: Organizer of Black Women." *Integrated Education* 17, (1979): 2–8.

"Women of Color in Congress." United States House of Representatives History, Art & Archives. Accessed November 30, 2019. https://tinyurl.com/y3vt8ysy.

3. Reason, Emotions, and the Right to Vote: How History Got Neuroscience Wrong, and the Implications for Full Inclusion of the "Other"

BARBARA J. MCCLURE

A 1912 postcard: "The Only Way to Make a Woman Hold Her Tongue"

In 1848, several hundred people gathered in Seneca Falls, New York, to begin the US fight for women's suffrage. Despite the fact that Frederick Douglass was there (in fact, he was the only African American in attendance) and that he played a critical part in getting Elizabeth Cady Stanton and Lucretia Mott's twelve-item Declaration of Sentiments approved by attendees, the group was mostly female and overwhelmingly white.[1] In addition, because Stanton had begun her activism as an ardent abolitionist and Susan B. Anthony had been advocating for the same, rights for freed enslaved people and the fight for women's rights—including the right to vote—competed for dominance.

The competition was about power and prominence. Stanton and Anthony reprinted the 1848 proceedings and amplified their own importance as founders of the movement, despite the fact that Anthony had not even been there.[2] In the late 1880s, Stanton and Anthony cowrote a three-thousand-page multivolume work they called *History of Women Suffrage*, emphasizing their own importance in the fight for women's suffrage.[3] In that huge

1. Alicia Ault, "How Women Got the Vote Is a Far More Complex Story Than the History Textbooks Reveal," Smithsonianmag.com, April 9, 2019, https://tinyurl.com/u3cvfr8.
2. Lisa Tetrault, *The Myth of Seneca Falls: Memory and the Women's Suffrage Movement: 1848–1898* (Chapel Hill: University of North Carolina Press, 2014), 9.
3. Ault, "How Women Got the Vote."

set, they left out the contributions of African Americans entirely. The split between African American suffragists and white women's fight for the vote began in 1869 at an American Equal Rights Association meeting. There Stanton "decried the possibility that white women would be made into the political subordinates of black men who were 'unwashed,'" the implication being that black men were uncivilized and "bestial."[4] On those grounds, Stanton argued against the Fifteenth Amendment, which gave men the right to vote regardless "of race, color, or previous condition of servitude."[5] In other words, in nineteenth-century America, the struggle for suffrage often went hand in hand with other social and political goals: although women cooperated in the effort to abolish slavery and to secure Native American land rights and promoted temperance, when it came time to grant men of color the right to participate in political processes, the lines of demarcation between groups became clear, and the fight for white women's suffrage and the rights of people of color became divided.[6] Stanton argued that the right to vote must be prioritized and that white women's vote must be the focus as they, according to Stanton's flawed reasoning, are "educated and therefore intelligent."[7] She also argued that "the safety of the nation as well as the interests of women demand that we outweigh this incoming tide of ignorance, poverty and vice [from the inclusion of black suffragists], with the virtue, wealth and education of women of the country."[8] Another activist for the white women's vote, Paulina Wright Davis, argued that allowing the vote to men of color would mean that American democracy would be corrupted, since, she feared, elections would be determined not by "reason" but by "impulse or passion, bribery or fraud."[9] Rooted in both power and fear of the

4. Martha S. Jones, "The Politics of Black Womanhood, 1848–2008," in *Votes for Women: A Portrait of Persistence*, ed. Kate Clarke Lemay (Princeton, NJ: Princeton University Press, 2019), 37.
5. "15th Amendment," Interactive Constitution, accessed February 5, 2020, https://tinyurl.com/y4gdosgx.
6. The fight for black voting rights generally meant black men, and the press for women's rights generally meant white women. Thus, black women's rights were eclipsed by these other two concerns, and women found themselves struggling for visibility and support. It is fair to say, then, that the white American women were racist and the black men sexist. Indeed, even after black men received the right to vote by the Fifteenth Amendment, white suffragettes did not always protest the poll taxes, literacy tests, and so-called grandfather clauses that kept many black men away from the polls.
7. Tetrault, *The Myth of Seneca Falls*, 19.
8. Elizabeth Cady Stanton, quoted in Tetrault, *The Myth of Seneca Falls*, 19.
9. Tetrault, *The Myth of Seneca Falls*, 28.

other, then, the fight for suffrage was often based on views of human nature that are derived from patriarchal principles based on property and reproduction and the assumed (lack of) ability to reason among women and people of color.

Pitting "Emotions" against "Reason," and the Fight for Inclusion

For most of Western history, women and other marginalized groups have been assigned an inferior–passive–nature.[10] Women's primary function was reproductive, and that could only be safeguarded by retreat into the private domain of household drudgery, which also meant political exile. Thus, "virtually silenced by male fiat between ancient Greek times and the eighteenth century, [women] had hardly any chance to introduce the tactic of moral reasoning–the first feminist tactic–against the male establishment."[11] In fact, common assumptions about rightful male leadership in the household and women's "natural" inferiority meant that women's "proper place" was in the household, and even if women *were* granted the right to vote, they were expected to "double the existing vote"–to vote as their fathers or husbands directed them.[12]

10. It is worth noting here that Aristotle and his colleagues did not believe that all people can be truly fully human. Women and slaves, for example, lack the requisite rational capacities and the freedom, leisure time, and material well-being to achieve full humanity or wisdom (Raymond A. Belliotti, *Happiness Is Overrated* [Lanham, MD: Rowman & Littlefield, 2004], 13). The "sage" discussed by everyone from Plato to the Stoics and the Christian theologians' understanding of the saved or wise soul was typically male, monied, and educated. The ways these philosophers viewed men and women were imbued with the assumptions born of a deeply patriarchal and class-oppressive political system. Plato even posited a kind of reverse evolution. A man who failed to live a life of reason could be punished by reincarnation as a woman or an animal (Plato, Timaeus, 92c, cited in James Averill, "Inner Feelings, Works of the Flesh, the Beast Within, Diseases of the Mind, Driving Force, and Putting on a Show: Six Metaphors of Emotion and Their Theoretical Extensions," in *Metaphors in the History of Psychology*, ed. David E. Leary [Cambridge, MA: Cambridge University Press, 1990], 109).
11. Ruby Reimer, "The Feminist Challenge to Western Political Thought," *Polity* 14, no. 4 (1982): 723. Augustine understood a woman to be in the image of God only if she had a husband (Genevieve Lloyd, *The Man of Reason: "Male" and "Female" in Western Philosophy*, 2nd ed. [Minneapolis: University of Minnesota Press, 1984], 30).
12. Corrine M. McConnaughy, *The Woman Suffrage Movement in America: A Reassessment* (Cambridge, MA: Cambridge University Press, 2013), 11. As an early twentieth-century minister counseled brides, "Your duty is submission–'Submission and obedience are the lessons of your life and peace and happiness will be your reward.' Your husband is, by the laws of God and of man,

The assumptions that women's "natural" place was in the home and that their primary roles were as domestics and the bearers of offspring were rooted, of course, in the assumptions of what it meant to be "female." Giving women the right to vote, argued Massachusetts Institute of Technology professor William T. Sedgwick in 1914, "would mean a degeneration and a degradation of human fiber which would turn back the hands of time a thousand years."[13] Other academics, scientists, and doctors agreed with Sedgwick that women should not vote because they are not, quite literally, made for it. The leading idea was that mental exertion would jeopardize women's reproductive abilities. Indeed, in the early twentieth century, "nearly every element of the female anatomy was seen as disqualifying, starting from the very top: their brains."[14]

According to the mainstream science of the time, women were considered to have "inferior brains, which made them unsuited to the rigors of voting," says one scholar of the women's suffrage movement.[15] She goes on to note that "anti-suffrage cartoons poked fun at women's reasoning ability . . . which showed the interior of a woman's head filled only with letters, puppies, hats, chocolates, and the faces of admiring young men."[16] If women were out voting and participating in politics and *thinking*, their ovaries (considered the most valuable part of them) would atrophy.[17]

your superior; do not ever give him cause to remind you of it" ("Advice to a Bride," *The Lady's Book* 4 [1832]: 288, quoted in William F. Ogburn and M. F. Nimkoff, *Technology and the Changing Family* [Boston and New York: Houghton Mifflin, 1955], 167). Indeed, the patriarchal order of the household is magnified in the governance of village, church, and nation. At home was the father, in church was the priest or minister, at the top were the town fathers, and above all was "God the Father" (Barbara Ehrenreich and Dierdre English, *For Her Own Good: 150 Years of the Experts' Advice to Women* [New York: Anchor/Doubleday, 1979], 7).

13. Marina Koren, "Why Men Thought Women Weren't Made to Vote," *The Atlantic*, July 11, 2019, https://tinyurl.com/rm3enlg.
14. Koren, "Why Men Thought Women Weren't Made to Vote."
15. Marina Koren, "The Pioneering Female Doctor Who Argued against Rest," *The Atlantic*, July 6, 2019, https://tinyurl.com/vjrq2z3.
16. Koren, "The Pioneering Female Doctor."
17. A century later, people continue to consider womanhood a handicap: "While racial, ethnic, class, and sexual divisions have been significantly challenged, the belief that gender divisions are normal and natural is still an underlying frame for modern social life" (Judith Lorber, "Using Gender to Undo Gender: A Feminist Degendering Movement," *Feminist Theory* 1, no. 1 [2000]: 80). Indeed, recently "a male physicist said at a conference that men outnumber women in physics because women are just worse at it" (Koren, "Why Men Thought Women Weren't Made to Vote"). And "in 2017, Google fired a male software engineer who posted a memo to an internal message board arguing that women's underrepresentation in the technology industry could

Those resistant to granting women the right to vote argued that "the same qualities they thought made women good at maintaining the home and raising children—sentimentality and compassion—would also make them unreliable, overly tenderhearted voters."[18] "The very qualities which do such good in moulding character would be ill applied to public action," one critic wrote. The same anti-suffragist continued,

> Our votes are determined by two forces, sentiment and reason: the former quality preëminently woman's, the latter man's; the former a quality of the heart, the latter of the head. Now it is generally admitted that the heart of the people is right, and that the mistakes of a democracy are mistakes of the head; right purpose, but not right judgment. Thus, though our government has been that of men exclusively, we have still had too much of the womanly quality.[19]

The thinking that put emotion and reason in opposition and competition has deep roots in the Greco-Roman philosophical traditions that have heavily influenced current Western thought. In a well-known metaphor depicting the relationship of reason to the passions, Plato compared the soul to a chariot guided by a charioteer and led by two horses: one horse represents the appetites or desires in the lowest, basest part of the soul. This "appetitive" soul is impulsive and stubborn and must be controlled. It is "a dark, crooked, lumbering animal, shag-eared and deaf, hardly yielding to whelp and spur."[20] The other horse represents the spirited part of a person's soul. The "spirited" part of the soul is noble and can be used by the rational mind, represented by the charioteer, to guide the chariot where it ought to go. This horse is "white, noble, and easily guided."[21] In Plato's metaphor, if one does not use reason to control one's desires, the person is as misdirected as a chariot run off course by an impulsive, uncontrolled horse. Plato's metaphor related emotionality and its concomitant weakness to both women and people of color.

be explained by biological differences between the sexes" (Koren, "Why Men Thought Women Weren't Made to Vote").
18. Ashley Fetters, "Turn-of-the-Century Thinkers Weren't Sure If Women Could Vote and Be Mothers at the Same Time," *The Atlantic*, June 12, 2019, https://tinyurl.com/wudl8g6.
19. Charles Worcester Clark, "Woman Suffrage, Pro and Con," *The Atlantic* (March 1890), https://tinyurl.com/s6ooc3t.
20. Lloyd, *The Man of Reason*, 20.
21. Lloyd, *The Man of Reason*, 20.

Original 1910s anti-suffrage pin.

Plato assumed that the emotions are, fundamentally, disruptions of reason: that is, of right/rational thinking.[22] Because the passions interfere with deliberate, rational thought and behavior, they are trouble. Plato, then, did not find much positive or valuable in the experiences of the body and urged detachment from them as much as possible. The appetites pull the spirited part of the soul toward mundane concerns, preventing the reasoning part of the soul from engaging more valuable, transcendent truths. The passions/emotions, then, can be dangerous. They must be controlled by constant evaluation since they will almost inevitably lead to suffering and harm if not carefully disciplined. Indeed, if a man was to exercise the exalted form of reason, "he must leave soft emotions and sensuousness behind; woman will keep them intact for him."[23] The bifurcation of reason and passions continued through the work of seventeenth- and eighteenth-century philosophers such as René Descartes and John Locke, who argued that women should be legally and customarily subjected to their husbands and argued that women

22. The etymological root of *passion* (pathe) is added to other words to name a disease or condition. We also get such emotional terms as *pathetic*, *empathy*, and *antipathy*.
23. Lloyd, *The Man of Reason*, 50.

"should be excluded from political rights" because their ability to reason is inferior to that of men.[24]

Corrections: Contemporary Understandings of the Relationship between the Emotions and Reason

A common view of the relationship between emotions and reason, then, is that emotions disrupt and jeopardize the rational process. The assumption was and continues to be that if people behave rationally, they will make optimal choices, and that emotions impede the process of achieving an optimal decision.[25] However, evidence is accumulating that "without emotional involvement, decision-making might not even be possible, or it might be far from optimal."[26] In fact, neuropsychological research suggests that at the level of brain structure and functioning, there are no clear distinctions between cognitive functions and emotional ones.[27]

What Emotions Are and How They Are Related to Reason

An early project of second-wave feminism in the 1970s was to resist the use of classic philosophies and their influence on science to "deform the self or personality of *the woman*."[28] Feminists, people of color, and their allies fought hard to be seen as fully human and for full inclusion in the decisions that shape their lives, including those in the political realm. This includes arguing that women are emotional and also rational and that men are also emotional. As a part of this argument, emotions came to be seen as important

24. Reimer, "The Feminist Challenge to Western Political Thought," 722.
25. Hans-Rudiger Pfister and Gisela Bohm, "The Multiplicity of Emotions: A Framework of Emotional Functions in Decision Making," *Judgment and Decision Making* 3, no. 1 (2008): 8.
26. Hanna Damasio, "Human Neuroanatomy Relevant to Decision-Making," in *Neurobiology of Decision-Making*, ed. Antonio Damasio, Hanna Damasio, and Y. Christen (New York: Springer, 1994), 12.
27. E. A. Phelps, "Emotion and Cognition: Insights from Studies on the Human Amygdala," *Annual Review of Psychology* 57 (2006): 27–53.
28. Catherine Lutz, "Feminist Theories and the Science of Emotion," in *Science and Emotions after 1945: A Transatlantic Perspective*, ed. Frank Biess and Daniel M. Gross (Chicago: University of Chicago Press, 2014), 342.

epistemic tools. For example, feminists have argued for emotions' important role in decision-making, coining the phrase *epistemic resource* for their value in political analysis and engagement.[29] In other words, emotions play important roles in just about every decision people make—especially moral ones.[30] This assertion has been borne out by recent neuropsychological studies.

Rather than taking a classical approach that assumes emotions exist in localized regions of the brain separate from the "reasoning" part of the brain, for example, contemporary psychological construction theories of emotion argue that emotions and reason work together to help persons think and make choices.[31] In this model, emotions are understood as being constructed moment to moment from multiple components that are derived from both intrapsychic and environment-specific elements.[32] One view is that the process is analogous to ingredients that are in recipes, which, when put together in certain amounts, with certain processes, and in certain contexts, create a cake. The cake, in this analogy, is an emotion.[33]

29. Alison Jaggar, "Love and Knowledge: Emotion in Feminist Epistemology," *Inquiry* 32 (1989): 151–76. It has also been argued that the emotional suffering expressed by women should be seen not as hysterical symptoms (as early psychoanalysts such as Sigmund Freud viewed them) but as creative contributions that seek "the resolution of cultural-historical paradoxes suffered by the [oppressed]" (Jeannette Marie Mageo and Bruce M. Knauft, "Introduction: Theorizing Power and the Self," in *Power and the Self*, ed. Jeannette Marie Mageo [New York: Cambridge University Press, 2002], 8). It is worth noting here that the social sciences were developed, for the most part, by a "homogeneous group of white, middle-class, Western men who pursued their search for knowledge by building on shared assumptions and observations." That research, on and by white, educated males, was informed by the assumptions of that demographic, creating a "closed circle within which theories were articulated and evidence for confirmation was sought." Furthermore, men tend to study women as "outsiders," the "other," just as whites imagine people of color (Josefina Figueira-McDonough, "Toward a Gender-Integrated Knowledge in Social Work," in *The Role of Gender in Practice Knowledge: Claiming Half the Human Experience*, ed. Josefina Figueira-McDonough, F. Ellen Netting, and Ann Nichols-Casebolt [New York: Garland, 1998], 5–6).
30. Michel Tuan Pham, "Emotion and Rationality: A Critical Review and Interpretation of Empirical Evidence," *Review of General Psychology* 11, no. 2 (2007): 167–69.
31. Psychological construction theories are currently considered the "gold standard" (Lisa F. Barrett, "Construction as an Integrative Framework for the Science of the Emotion," in *The Psychological Construction of Emotion*, ed. Lisa F. Barrett and James A. Russell [New York: Guilford, 2015], 453–54).
32. It turns out that emotions are the result of components including beliefs, expectations and hopes, values, goals, motivations, and so on (James Russell, "My Psychological Constructionist Perspective, with a Focus on Conscious Affective Experience," in Barrett and Russell, *The Psychological Construction of Emotion*, 194).
33. Lisa F. Barrett, "The Future of Psychology: Connecting Mind to Brain," *Perspectives in Psychological Science* 4 (1990): 326–39. Other researchers argue that the recipe model is too mechanistic: entries in a recipe book are "static entities." For this reason, they argue, the recipe model

Psychological construction models propose that an emotion is created in a particular moment and within a particular context out of a particular past given the components involved in the immediate sensory data processing. The process includes neutral physical changes (such as the dilation of one's pupils or a person's mouth beginning to water), which are interpreted and given meaning based on the person's context (both immediate and past, through memory) and what one values, as well as the cognitions (thoughts) a person is having.[34] Emotions and cognitions (including reasoning processes) are not separate but rather interconnected and inseparable, designed to support survival, social functioning, and effective decision-making.[35]

Emotions' Role in "Rational" Thinking

Influenced by Plato and Aristotle, as noted above, it was often understood in Western literature that reason/cognition and emotion were opposed. However, it has since been argued that "there are no truly separate systems for emotion and cognition because complex cognitive-emotional behavior emerges from the rich, dynamic interactions between brain networks."[36] In the last twenty years it has become increasingly common for brain-mind scientists to foreground the role of emotion in cognition or "reason." As noted above, emotions can be understood as a subjective experience that are the result of many components, including rationality.

Reason is understood as a process in which persons analyze the pros and cons of possible options, calculate the utility of them and the values they hold, and choose an option that leads to maximal profit.[37] Emotions provide information about what one values, wants, and so on and are integral

is not flexible enough. Still, they do not disagree that emotions are composed of multiple components, including cognition or "reason" (Suzanne Oosterwijk, Alexandra Touroutoglou, and Kristen A. Lindquist, "The Neuroscience of Construction: What Neuroimaging Approaches Can Tell Us about How the Brain Creates the Mind," in Barrett and Russell, *The Psychological Construction of Emotion*, 113–14.

34. For a chart depicting the components of emotions, consult James A. Russell, "Core Affect and the Psychological Construction of Emotions," *Psychological Review* 110, no. 1 (2003): 152.
35. Michel Tuan Pham, Joel B. Cohen, John W. Pracejus, and G. David Hughes, "Affect Monitoring and the Primacy of Feelings in Judgment," *Journal of Consumer Research* 28 (2001): 170.
36. Luiz Pessoa, "On the Relationship between Emotion and Cognition," *Nature Reviews Neuroscience* 9 (2008): 148.
37. Jiayi Luo and Rongjun Yu, "Follow the Heart or the Head? The Interactive Influence Model of Emotion and Cognition," *Frontiers in Psychology* 6 (2015): 1.

to that process, guiding behavioral responses. Emotions, then, are integral to proper reasoning and a part of every thinking act.[38] The point is that emotions *always* play a role in decision-making, they *do* affect rational thinking, rational thinking affects emotions, and women *are* emotional. And so are men. Indeed, none of the empirical studies shows any differences between men's and women's abilities to think or to feel.[39] Sometimes emotions play a stronger role; at other times, cognitions do. But both are always present in all individuals: men and women, white persons and people of color.[40]

In fact, emotions or affect have been found to have four distinct functions: first, they play a role as *information*. Emotions/feelings provide important information about what a person values, and values guide choices.[41] Second, emotions act as a *spotlight* that focuses the decision maker's attention on new information, "making certain kinds of knowledge more accessible for further information processing."[42] Third, emotions can operate as *motivators*, influencing approach-avoidance tendencies as well as the willingness to process information.[43] Fourth, emotions serve as a *common currency* in judgments and decisions. Emotions restrict the options; focus the decision maker on certain, relevant aspects of the options; and help the decision maker sift the potential outcomes of any decision.[44]

Theorists have found that decision makers (often subconsciously) weigh anticipated pleasures or benefits that they believe will come from the different options and choose the option they believe will yield the greatest amount

38. Pfister and Bohm, "The Multiplicity of Emotions," 13.
39. The differences that are present among groups should be understood as socialized functions, not biological ones. In fact, there are more differences among individual men and among individual women than there are between a generalized "male" population and a generalized "female" one.
40. Luo and Yu, "Follow the Heart or the Head?" 6–9.
41. Pfister and Bohm, "The Multiplicity of Emotions," 6.
42. Rolf Reber, *Critical Feeling: How to Use Feelings Strategically* (New York: Cambridge University Press, 2016), 57. Emotions "thus become an indicator of the importance of an event or object" (Reber, *Critical Feeling*, 57). Rather than eschewing the importance of emotions, we should use them to focus our attention, evaluate information, and guide our actions according to the values we hold (Reber, *Critical Feeling*, 60).
43. Nico H. Frijda, Peter Kuipers, and Ter Schur, "Relations among Emotions, Appraisal, and Emotional Action Readiness," *Journal of Personality and Social Psychology* 57, no. 2 (1989): 212–28.
44. Marcel Zeelenberg, Rob M. A. Nelissen, Seger M. Breugelmans, and Rik Pieters, "On Emotion Specificity in Decision Making: Why Feeling Is for Doing," *Judgment and Decision Making* 3, no. 1 (2008): 18. Different goals and values will evoke different emotions in different individuals. Thus, emotions have an "idiosyncratic" effect on decision-making (Zeelenberg et al., "On Emotion Specificity in Decision Making," 19).

of potential pleasure or gain.[45] Decision makers, rather than depend on their "reasoned choice," rely on their gut feeling, or intuition, when making decisions—a notably "emotional" resource.[46] Emotions guide persons toward decisions by focusing one's attention on the values and goals a person wants (consciously or not) to achieve.[47] Thus, making decisions while feeling intense emotions is not necessarily a bad thing and even benefits "rational" thinking and decision-making in certain ways.[48] This goes against the idea that emotions impede thinking and that only reason is the surest way to wisdom.[49] However, a (white) male bias serves as a foundation for present standards of science, culture, and political access. White men have developed "sophisticated treatises" concerning the relationship between subjectivity and objectivity, emotion and reason, when there is much evidence to the contrary.[50] Indeed, because the "dichotomous categories of 'cognition' and 'affect'" are themselves Euro-American cultural constructions, the "master symbols that participate in the fundamental organization of our ways of looking at ourselves and others" can and should be deconstructed.[51] Feminist scholars have sought to do this work for at least a century, including in regard to women's suffrage. Using updated psychological theory, sociology, political theory, and so on, scholars have articulated clearly the need to mobilize strong emotions such as the rage and fear among women, people of color, and other marginalized persons "in the service of political action, social change, and consciousness raising."[52]

Indeed, the feminist principle that "the personal is political" is a reaction

45. Magda Arnold, *Emotion and Personality*, vol. 1, *Psychological Aspects* (New York: Columbia University Press, 1960), 182.
46. Zeelenberg et al., 19. Research shows that emotions are integrated into memories, such that emotions inform the memories of past decisions/choices, and because we base immediate decisions on past experience, emotions are inevitably a part of all decisions we make (Wing-Shing Lee and Marcus Selart, "The Impact of Emotions on Trust Decisions," in *Handbook on Psychology of Decision-Making*, ed. Karen O. Moore and Nancy P. Gonzalez [Hauppauge, NY: Nova Science, 2011], 4).
47. Richard P. Bagozzi, Hans Baumgartner, and Rik Pieters, "Goal-Directed Emotions," *Cognition and Emotion* 12 (2000): 1–26.
48. Pham, "Emotion and Rationality," 157–58.
49. Sandra Morgan, "Towards a Politics of 'Feelings': Beyond the Dialectic of Thought and Action," *Women's Studies* 10 (1983): 219.
50. Morgan, "Towards a Politics of 'Feelings,'" 220.
51. Catherine Lutz, "Emotion, Thought, and Estrangement: Emotion as a Cultural Category," *Cultural Anthropology* 1 (1986): 287–309.
52. Cynthia Burack, *The Problem of the Passions: Feminism, Psychoanalysis, and Social Theory* (New York: New York University Press, 1994), 3.

to a system of knowledge and knowledge production that has separated and opposed realms of human experience that are neither separate nor dichotomous. Resisting this, and relying on their own experience, knowledge of themselves, and updated psychology, philosophy, and science, feminists and their allies (as well as womanists and other persons of color) have worked hard to legitimize feelings as a source of knowledge.[53] While it is true that emotions can interfere with everyone's capacities to reason and process information (as in, say, the aftermath of trauma), this is not only true of women or people of color.[54] Given that we are talking about the late nineteenth/early twentieth centuries, when patriarchy, sexism, homophobia, racism, harsh economic times, and so on certainly resulted in melancholy, anxiety, and depression, perhaps no one should have been voting.[55]

The arguments that emotions do not play a role in decision-making, or that they do not affect "rational" thinking, or that men are not emotional, then, are not correct. The point is that emotions *do* play a role in decision-making, they *do* affect rational thinking, and all women and men *are* emotional. None of the empirical studies mentions differences between men and women in these abilities. In fact, some consider emotions a valuable developmental achievement necessary for effective functioning for all persons.[56]

As noted above, contemporary neuropsychology has determined that emotions (that is, what have been typically viewed as "female," "bestial," or "natural"[57] as opposed to transcendent, godly, and "male") are not a threat to

53. Morgan, "Towards a Politics of 'Feelings,'" 220.
54. Many studies have shown that one's mood affects one's capacity to "reason" and make judgments. In other words, when persons do not attend to their moods, it can affect their "thinking" in ways they are not aware of. For example, in a study on stockbrokers' decisions to invest or not over a three-week period, those who were aware of their moods and feelings achieved higher returns than those who ignored or were not aware of theirs (Lee and Selart, "The Impact of Emotions on Trust Decisions," 6). Not all feelings/emotions are always productive, however. Anger can point to injustice in helpful ways, on the one hand, and it can get in the way of care and cooperation, on the other. See McClure, *Emotions*, esp. chapter 7.
55. Women such as Charlotte Perkins Gilman and other marginalized persons such as Frederick Douglass wrote in poignant ways about the personal and societal costs of these systemic realities (Ehrenreich and English, *For Her Own Good*, 2–14).
56. Marc D. Lewis and Lori Douglas, "A Dynamic Systems Approach to Cognition-Emotion Interactions in Development," in *What Develops in Emotional Development?* ed. Michael F. Mascolo and Sharon Griffin (New York: Plenum, 1998), 159–88. Cognition and emotion are subsystems that become more integrated over the course of human development, in unique ways for each person, through "self-organizing processes" (Lewis and Douglas, "A Dynamic Systems Approach," 161).
57. Relating "female" to "nature" has a long history. Susan Moller Okin blamed Locke's "Foundation

rationality but rather that the appropriateness of decisions actually depends on people's capacities to form appropriate emotions.[58] Indeed, emotions are part of every decision-making process. The argument that decisions (such as whom to vote for) must be made by people who could depend only on reason is, in fact, despite its pervasiveness, "empirically untenable."[59] Giving emotions human and epistemological value will be a critical way to reduce the suffering engendered by exclusion and oppression, an important way of making women and people of color more visible and giving them more power.[60]

Implications for Pastoral Theology and Inclusion of the "Other"

Christian theologians adopted (and in many cases, continue to adopt) the negative view of women's capacities, and many resisted granting women the right to vote. For example, in 1903, the theologian and author Lyman Abbott equated womanhood with the duties of family maintenance, arguing that because women knew they did more to shape society by raising children than they ever could by voting, there was no way they could truly want to bother with voting.[61] As noted above, early philosophies, social sciences, and dominant classical Christian theologies were developed for the most part by a homogeneous group of white, Western men who pursued their search for knowledge by building on faulty assumptions and observations and looked

in Nature" for the "legal and customary subjection of women to their husbands" and for excluding women from political rights (*Women in Western Political Thought* [Princeton, NJ: Princeton University Press, 1979], 200). Furthermore, men are seen as the makers of history, and women provide the connection to nature: she is a reminder of the body, sexuality, passion, and human connectedness (Elizabeth Fee, "Is Feminism a Threat to Scientific Objectivity?" *Journal of College Science Teaching* 11, no. 2 [1981], 85). Consult also philosopher Val Plumwood's work on dualisms between emotion and rationality and human and nature, in which she argues that the dualities have contributed to potent forms of domination, including colonialization (*Feminism and the Mastery of Nature* [New York: Routledge, 1993]).

58. Lisa F. Barrett, *How Emotions Are Made: The Secret Life of the Brain* (Boston: Houghton Mifflin Harcourt, 2017), esp. chapter 9.
59. Lee and Selart, "The Impact of Emotions on Trust Decisions," 2.
60. Morgan, "Towards a Politics of 'Feelings,'" 221.
61. Lyman Abbott, "Why Women Do Not Wish the Suffrage," *The Atlantic*, September 1903, https://tinyurl.com/yd9zsxuy.

for evidence to confirm what they thought they already knew.[62] The answer to the inequalities their science and theology rendered was to grant women and other marginalized groups their own "special" and "unique" natures and relegate them to their own particular spheres. However, "allowing" women and people of color their own spaces (e.g., the "domestic" as opposed to the "public") can reinforce the idea that these persons belong to atypical subgroups and that they are not integral to the fundamental substance of societies and thus do not need to be fully integrated into the dynamics of power that create those societies.[63] For this reason and others, feminists and people of color have vehemently resisted the "icons" of Western history—the views about human nature based on white, patriarchal principles misinformed by outmoded understandings of property, power, and human "nature."[64]

Twentieth- and twenty-first-century pastoral theologians (who are especially committed to ameliorating the root causes of suffering for *all* God's people) are tasked with articulating theologically the shared-ness of human life and the *imago Dei* in all people. This means advocating for the full inclusion of all persons in what is life-giving, resisting what is not, and having some say in their own futures. Full inclusion of marginalized persons is required in order for them to thrive, and this can only be accomplished if the oppressions of sexism and racism (as well as homophobia and other forms of marginalization) are understood both historically and systemically, revealing the ways they have been undergirded by centuries of inaccurate science and male/Euro/white-dominated philosophies, psychologies, and theologies. The flourishing of all God's people will require that competent pastoral caregivers "participate in the movements of social justice that can change

62. Figueira-McDonough, "Toward a Gender-Integrated Knowledge in Social Work," 5.
63. Figueira-McDonough, "Toward a Gender-Integrated Knowledge in Social Work," 4.
64. Reimer, "The Feminist Challenge to Western Political Thought," 723. Even psychologists, to whom pastoral theologians are deeply indebted, weighed in. For example, Sigmund Freud wrote that "throughout history people have knocked their heads against the riddle of the nature of femininity.... Nor will you have escaped worrying over this problem—those of you who are men; to those of you who are women this will not apply—you yourselves are the problem" (Sigmund Freud, "Femininity," in *The Complete Introductory Lectures on Psychoanalysis*, trans. and ed. James Strachey [New York: Norton, 1966], 141). Virginia Woolf asked an audience of women, "Have you any notion how many books about you are written by men? Are you aware that you are, perhaps, the most discussed animal in the universe?" (Virginia Woolf, quoted in Ehrenreich and English, *For Her Own Good*, 4).

the circumstances of people's lives."[65] Indeed, because systemic oppression (usually created and maintained by white men but perpetuated by white women as well) organizes all of human experience, understanding the dynamics of power must be included in every ministry of care.[66] Part of this analysis of power will necessarily include the recognition that persons privileged by the systems in which they are embedded are unable to appreciate fully the experiences, values, and goals of those who are disadvantaged by those systems. Privileged persons must become more aware of the ways they "[sometimes] unwittingly reproduce racism and sexism."[67]

Pastoral theologians have argued that those of us with privilege must change the understandings of self and others (and the practices that accompany them) that allow us to avoid our complicity and to adopt proactive strategies available to us. We must take accountability for the ways systemic advantages accrue to those who are white, male, and straight. We must focus on the ways white and male privilege has accrued benefits to members of those groups and disadvantaged people of color, women, and other minoritized persons and groups, instituted and maintained, in part, by legal impediments to full inclusion.

Assumptions that the "other" is inferior, either rationally or for other reasons, are based on patriarchal, racist, and sexist philosophies, faulty science, and incorrect understandings about the "nature" of women and people of color. The dualisms set up by Plato and promulgated for two millennia have created a zero-sum game, denying both women and people of color the possibility of being their full emotional and rational selves. These "isms" are the result of the denial of interdependence that an adequate understanding of the fullness of human beings requires, and of the mutual care and respect that the *imago Dei* urges.[68] Pastoral theologians have a responsibility to articulate theologies that confront these distortions head-on and to

65. James N. Poling, "Women Out of Order and Injustice and the Care of Souls," *Pastoral Psychology* 60 (2011): 765.
66. Sheryl A. Kujawa-Holbrook and Karen B. Montagno, introduction to *Injustice and the Care of Souls: Taking Oppression Seriously in Pastoral Care*, ed. Sheryl A. Kujawa-Holbrook and Karen B. Montagno (Minneapolis: Fortress Press, 2009), 1. Consult also Sheryl A. Kujawa-Holbrook, "Love and Power: Antiracist Pastoral Care," in *Injustice and the Care of Souls*, ed. Kujawa-Holbrook and Montagno (Minneapolis: Fortress Press, 2009), 13–28.
67. Nancy Ramsay, "Navigating Racial Difference as a White Pastoral Theologian," *The Journal of Pastoral Theology* 12, no. 2 (2002): 12.
68. Fumitaka Matsuoka, *The Color of Faith: Building Community in a Multicultural Society* (Cleveland, OH: United Church Press, 1998), esp. chapter 1.

describe a divine hope for the flourishing of all based on love, justice, relationality, and truth.[69]

Such articulations and the practices that must accompany them will be rooted in the particular historical stories of excluded individuals and groups.[70] These stories will provide challenges to Enlightenment understandings of the bifurcation of emotion and reason and highlight the epistemological role emotions play in human flourishing. Pastoral theologians will continue to argue for the importance of emotions for cultivating wholeness in individuals and the communities and institutions of which they are a part. They will argue for the way emotions are related to the personal, the interpersonal, and the cultural, that they should be attended to as expressions of the actual material conditions and the social structures from which they emerge, and that they have an impact that matters. Emotions, as related through the stories of human experience, can be tools used in concert with reason to affect a more just, inclusive, and flourishing world. It is time to claim *all* of *all people's* full emotional and rational selves, a fundamental commitment necessary to integrating *all* citizens into the public and political spheres where they belong.

Bibliography

"15th Amendment." Interactive Constitution. Accessed February 5, 2020. https://tinyurl.com/y4gdosgx.

Abbott, Lyman. "Why Women Do Not Wish the Suffrage." *The Atlantic*. September 1903. https://tinyurl.com/yd9zsxuy.

Arnold, Magda. *Emotion and Personality*. Vol. 1, *Psychological Aspects*. New York: Columbia University Press, 1960.

Ault, Alicia. "How Women Got the Vote Is a Far More Complex Story Than the History Textbooks Reveal." *Smithsonian Magazine*, April 9, 2019. https://tinyurl.com/u3cvfr8.

69. Consult McClure, *Emotions*, chapter 7, for an exploration of a Christian theology of flourishing.
70. Black women are not interested in finding the "mega-theory to create *the* story of *the* Black woman so much as to sustain [them]selves and give voice to [their] many different voices and to articulate [their] many different practices" (Abena P. A. Busia, "After/words: . . . And This Is What We've Decided to Tell You after Everything We've Shared . . . ," in *Theorizing Black Feminisms: A Visionary Pragmatism of Black Women*, ed. Stanlie M. James and Abena P. A. Busia [New York: Routledge, 1993], 291).

Averill, James. "Inner Feelings, Works of the Flesh, the Beast Within, Diseases of the Mind, Driving Force, and Putting on a Show: Six Metaphors of Emotion and Their Theoretical Extensions." In *Metaphors in the History of Psychology*, edited by David E. Leary, 104–32. Cambridge, MA: Cambridge University Press, 1990.

Bagozzi, Richard P., Hans Baumgartner, and Rik Pieters. "Goal-Directed Emotions." *Cognition and Emotion* 12 (2000): 1–26.

Barrett, Lisa F. "Construction as an Integrative Framework for the Science of the Emotion." In *The Psychological Construction of Emotion*. Edited by Lisa F. Barrett and James A. Russell, 448–58. New York: Guilford, 2015.

———. "The Future of Psychology: Connecting Mind to Brain." *Perspectives in Psychological Science* 4 (1990): 326–39.

———. *How Emotions Are Made: The Secret Life of the Brain*. Boston: Houghton Mifflin Harcourt, 2017.

Belliotti, Raymond A. *Happiness Is Overrated*. Lanham, MD: Rowman & Littlefield, 2004.

Burack, Cynthia. *The Problem of the Passions: Feminism, Psychoanalysis, and Social Theory*. New York: New York University Press, 1994.

Busia, Abena P. A. "After/words: . . . And This Is What We've Decided to Tell You after Everything We've Shared . . . " In *Theorizing Black Feminisms: A Visionary Pragmatism of Black Women*, edited by Stanlie M. James and Abena P. A. Busia, 287–96. New York: Routledge, 1993.

Clark, Charles Worcester. "Woman Suffrage, Pro and Con." *The Atlantic* (March 1890), https://tinyurl.com/s6ooc3t.

Damasio, Hanna. "Human Neuroanatomy Relevant to Decision-Making." In *Neurobiology of Decision-Making*, edited by Antonio Damasio, Hanna Damasio, and Y. Christen, 1–12. New York: Springer, 1994.

Ehrenreich, Barbara, and Dierdre English. *For Her Own Good: 150 Years of the Experts' Advice to Women*. New York: Anchor/Doubleday, 1979.

Fee, Elizabeth. "Is Feminism a Threat to Scientific Objectivity?" *Journal of College Science Teaching* 11, no. 2 (1981): 84–92.

Fetters, Ashley. "Turn-of-the-Century Thinkers Weren't Sure If Women Could Vote and Be Mothers at the Same Time." *The Atlantic*. June 12, 2019. https://tinyurl.com/wudl8g6.

Figueira-McDonough, Josefina. "Toward a Gender-Integrated Knowledge in Social Work." In *The Role of Gender in Practice Knowledge: Claiming Half the Human Experience*, edited by Josefina Figueira-McDonough, F. Ellen Netting, and Ann Nichols-Casebolt, 3–26. New York: Garland, 1998.

Freud, Sigmund. "Femininity." In *The Complete Introductory Lectures on Psychoanalysis*, translated and edited by James Strachey, 139–67. New York: Norton, 1966.

Frijda, Nico H., Peter Kuipers, and Ter Schur. "Relations among Emotions, Appraisal, and Emotional Action Readiness." *Journal of Personality and Social Psychology* 57, no. 2 (1989): 212–28.

Jaggar, Alison. "Love and Knowledge: Emotion in Feminist Epistemology." *Inquiry* 32 (1989): 151–76.

Jones, Martha S. "The Politics of Black Womanhood, 1848–2008." In *Votes for Women: A Portrait of Persistence*, edited by Kate Clarke Lemay, 29–48. Princeton, NJ: Princeton University Press, 2019.

Koren, Marina. "The Pioneering Female Doctor Who Argued against Rest." *The Atlantic*. July 6, 2019. https://tinyurl.com/vjrq2z3.

———. "Why Men Thought Women Weren't Made to Vote." *The Atlantic*. July 11, 2019. https://tinyurl.com/rm3enlg.

Kujawa-Holbrook, Sheryl A., and Karen B. Montagno, eds. *Injustice and the Care of Souls: Taking Oppression Seriously in Pastoral Care*. Minneapolis: Fortress Press, 2009.

Lee, Wing-Shing, and Marcus Selart. "The Impact of Emotions on Trust Decisions." In *Handbook on Psychology of Decision-Making*, edited by Karen O. Moore and Nancy P. Gonzalez, 1–16. Hauppauge, NY: Nova Science, 2011.

Lewis, Marc D., and Lori Douglas. "A Dynamic Systems Approach to Cognition-Emotion Interactions in Development." In *What Develops in Emotional Development?* edited by Michael F. Mascolo and Sharon Griffin, 159–88. New York: Plenum, 1998.

Lloyd, Genevieve. *The Man of Reason: "Male" and "Female" in Western Philosophy*. Minneapolis: University of Minnesota Press, 1984.

Lorber, Judith. "Using Gender to Undo Gender: A Feminist Degendering Movement." *Feminist Theory* 1, no. 1 (2000): 79–95.

Luo, Jiayi, and Rongjun Yu. "Follow the Heart or the Head? The Interactive Influence Model of Emotion and Cognition." *Frontiers in Psychology* 6 (2015): 1–14.

Lutz, Catherine. "Emotion, Thought, and Estrangement: Emotion as a Cultural Category." *Cultural Anthropology* 1 (1986): 287–309.

———. "Feminist Theories and the Science of Emotion." In *Science and Emotions after 1945: A Transatlantic Perspective*, edited by Frank Biess and Daniel M. Gross, 342–54. Chicago: University of Chicago Press, 2014.

Mageo, Jeannette Marie, and Bruce M. Knauft. "Introduction: Theorizing

Power and the Self." In *Power and the Self*, edited by Jeannette Marie Mageo, 8–26. New York: Cambridge University Press, 2002.

Matsuoka, Fumitaka. *The Color of Faith: Building Community in a Multicultural Society*. Cleveland, OH: United Church Press, 1998.

McClure, Barbara J. *Emotions: Problems and Promise for Human Flourishing*. Waco, TX: Baylor University Press, 2019.

McConnaughy, Corrine M. *The Woman Suffrage Movement in America: A Reassessment*. Cambridge, MA: Cambridge University Press, 2013.

Morgan, Sandra. "Towards a Politics of 'Feelings': Beyond the Dialectic of Thought and Action." *Women's Studies* 10 (1983): 203–23.

Ogburn, William F., and M. F. Nimkoff. *Technology and the Changing Family*. Boston and New York: Houghton Mifflin, 1955.

Okin, Susan Moller. *Women in Western Political Thought*. Princeton, NJ: Princeton University Press, 1979.

Oosterwijk, Suzanne, Alexandra Touroutoglou, and Kristen A. Lindquist. "The Neuroscience of Construction: What Neuroimaging Approaches Can Tell Us about How the Brain Creates the Mind." In *The Psychological Construction of Emotion*, edited by Lisa F. Barrett and James A. Russell, 111–43. New York: Guilford, 2015.

Pessoa, Luiz. "On the Relationship between Emotion and Cognition." *Nature Reviews Neuroscience* 9 (2008): 148–58.

Pfister, Hans-Rudiger, and Gisela Bohm. "The Multiplicity of Emotions: A Framework of Emotional Functions in Decision Making." *Judgment and Decision Making* 3, no. 1 (2008): 5–17.

Pham, Michel Tuan. "Emotion and Rationality: A Critical Review and Interpretation of Empirical Evidence." *Review of General Psychology* 11, no. 2 (2007): 155–78.

Pham, Michel Tuan, Joel B. Cohen, John W. Pracejus, and G. David Hughes. "Affect Monitoring and the Primacy of Feelings in Judgment." *Journal of Consumer Research* 28 (2001): 167–88.

Phelps, E. A. "Emotion and Cognition: Insights from Studies on the Human Amygdala." *Annual Review of Psychology* 57 (2006): 27–53.

Plumwood, Val. *Feminism and the Mastery of Nature*. New York: Routledge, 1993.

Poling, James N. "Women Out of Order and Injustice and the Care of Souls." *Pastoral Psychology* 60 (2011): 765–68.

Ramsay, Nancy. "Navigating Racial Difference as a White Pastoral Theologian." *The Journal of Pastoral Theology* 12, no. 2 (2002): 11–27.

Reber, Rolf. *Critical Feeling: How to Use Feelings Strategically.* New York: Cambridge University Press, 2016.

Reimer, Ruby. "The Feminist Challenge to Western Political Thought." *Polity* 14, no. 4 (1982): 722–29.

Russell, James A. "Core Affect and the Psychological Construction of Emotion." *Psychological Review* 110, no. 1 (2003): 145–72.

———. "My Psychological Constructionist Perspective, with a Focus on Conscious Affective Experience." In *The Psychological Construction of Emotion*, edited by Lisa F. Barrett and James A. Russell, 183–208. New York: Guilford, 2015.

Tetrault, Lisa. *The Myth of Seneca Falls: Memory and the Women's Suffrage Movement: 1848–1898.* Chapel Hill: University of North Carolina Press, 2014.

Zeelenberg, Marcel, Rob M. A. Nelissen, Seger M. Breugelmans, and Rik Pieters. "On Emotion Specificity in Decision-Making: Why Feeling Is for Doing." *Judgment and Decision Making* 3, no. 1 (2008): 18–27.

4. Claiming Our Inheritance

KIMBERLY L. DETHERAGE

"We hold these truths to be self-evident, that all men are created equal, that they are endowed by their Creator with certain unalienable rights, that among these are Life, Liberty and the pursuit of Happiness."[1] In 1776, the United Colonies of Great Britain wrote these words when declaring their independence and separation from Great Britain. They went on to write, "that whenever any Form of Government becomes destructive . . . it is the Right of the People to alter or to abolish it" and to form a new government that provides security and safety, especially where repeated offenses have been addressed and left unanswered.[2] The United Colonies sought to be free from tyranny and despotism.[3]

1799 Baltimore newspaper *Federal Gazette* and *Baltimore Daily Advertiser* with front page slave ad for "six negro MEN, . . . 4 or 5 negro Women, and some Children." This is followed by a listing of horses, cattle, sheep, hogs, wagons, carts, and ploughs. April 9.

When the men of the United Colonies wrote to secure their freedom, that independence did not include people of African descent, especially black women. Ever since, black women have been fighting for equality and parity in a government that has systematically oppressed and denied life, liberty, and the pursuit of happiness to the black family. It is a right of inheritance that belongs not just to one group of people but to everyone. I imagine black

1. "Declaration of Independence: A Transcription," National Archives and Records Administration, accessed December 1, 2019, https://tinyurl.com/h2zqchv.
2. "Declaration of Independence."
3. "Declaration of Independence."

women understood they were children of the promised land, so God would deliver them also. Since the first slaves arrived on the shores of America in Jamestown, Virginia, in August 1619, black women seeking freedom have been altering the forms of government on the local, state, and federal levels through rebellion, protest marches, public speaking, organizing, forming women's clubs, obtaining and seeking quality education, utilizing their experiences and resources, and exercising their voices and talents through literature, art, law, the sciences, and the power of the vote.

As we commemorate the one-hundredth anniversary of the ratification of the Nineteenth Amendment and the women's right to vote on August 18, 1920, we understand that black people did not fully secure the right to vote until the Civil Rights Act of 1965 and today still face issues of voter suppression as a means of denying them the freedom of choice and equality. The vote does count, and the polls showed that in 2008, 2012, and 2016, African American women voters represented the highest percentage of any group of people.[4] Black women are still on the forefront seeking to alter our government's systemic racism and sexism by addressing issues of affordable housing, education, childcare, healthcare, and poverty, just to name a few, understanding that the issues that affect black women affect everyone. As Adella Hunt Logan wrote in 1912 in the article "Colored Women as Voters," "The colored American believes in equal justice to all, regardless of race, color, creed or sex, and longs for the day when the United States shall indeed have a government of the people, for the people and by the people—even including the colored people."[5] Women of African descent are out to claim their inheritance.

The Daughters of Zelophehad and Maria Stewart

When I think about African American women and their quest for freedom, parity, and equality in these United States, I am reminded of the biblical story of Zelophehad's daughters found in Numbers 27 and 36. The precursor to their story is in Numbers 26. God tells Moses to gather up all the clans of the

4. Kelly Dittmar, and Glynda C. Carr. "Black Women Voters: By the Numbers," HuffPost, December 6, 2017, https://tinyurl.com/smwf4fa; "By the Numbers: Black Women Voters," Higher Heights for America, accessed December 1, 2019, https://tinyurl.com/sawpeuj.
5. Adella Hunt Logan, "Colored Women as Voters," *The Crisis* 4 (September 1912): 243.

tribes of Israel and take a census of the entire Israelite community by families, counting all males twenty years of age or older. These clans/males will inherit a territory of land when they go into the promised land.

In Numbers 27, we learn of Zelophehad, a descendant of the tribe of Manasseh, who has five daughters: Mahlah, Noah, Hoglah, Milcah, and Tirzah. At the time of the taking of the census, Zelophehad is deceased and has no sons. Without any sons, his daughters will get nothing. Since women have no rights, the sisters know that ownership of land is key to their future survival. The land they are about to enter has no promise for them. Without land they will be penniless and will have to rely on the goodness of others. The daughters want to make sure they claim their inheritance; they want what is rightfully theirs. After the census and before entrance into the promised land, we read:

> The daughters . . . came forward and stood before Moses, Eleazar the priest, the leaders and the whole assembly at the entrance to the tent of meeting and said, "Our father died in the wilderness. He was not among Korah's followers, who banded together against the Lord, but he died for his own sin and left no sons. Why should our father's name disappear from his clan because he had no son? Give us property among our father's relatives."
>
> So Moses brought their case before the Lord, and the Lord said to him, "What Zelophehad's daughters are saying is right. You must certainly give them property as an inheritance among their father's relatives and give their father's inheritance to them." (Num 27:1–7 NIV)

Just like the daughters of Zelophehad, Maria Stewart (1803–1879), a free black woman, wanted to claim her inheritance not just for herself but for her entire race. Orphaned at the age of five, she became an indentured servant to a white minister and his family. Having no formal education, her education came from sneaking away to read books in the minister's library and attending Sabbath schools after she left indentured service.[6] Stewart dared to speak out against the injustices that existed and the need for the black race to educate themselves, stand up, and speak out for their rights. In 1832,

6. Maggie MacLean, "Maria Stewart," ehistory, The Ohio State University, accessed December 1, 2019, https://tinyurl.com/wyhokgg; Erin Blakemore, "This Little-Known Abolitionist Dared to Speak in Public against Slavery," *Time*, January 24, 2017, https://tinyurl.com/qktagn2.

at the age of thirty-one, Stewart was the first woman, black or white, to give public lectures to audiences of men and women. This was long before the advent of the women's suffrage movement at the Seneca Falls Convention in 1848 and five years before the Grimké sisters' antislavery speeches.[7] Stewart spoke on issues of slavery, prejudice, women's rights, education, literacy, collective empowerment and unity, myths and stereotypes, the push to send people of color to Liberia, and the need for the race to rise up.

When William Lloyd Garrison, publisher of The Liberator, was looking for black writers, Stewart went to his office with eight writings. In 1831, in her first publication, titled "Religion and the Pure Principles of Morality," Stewart spoke out against slavery and the treatment of people of color in the North and South and the need for people of color to stand up, organize, and unite for collective empowerment and social change. Additionally, she spoke about the need to establish strong educational and economic institutions in black communities. Through her writings, Stewart also advocated for women's empowerment and women's rights. She went against the "cult of domesticity," which maintained that a woman's place is in the home. Stewart believed that women should become involved in all aspects of life in the community. She called out to women of color: "O, ye daughters of Africa, awake! Awake! Arise! No longer sleep nor slumber, but distinguish yourselves. Show forth to the world that ye are endowed with noble and exalted faculties."[8] "How long," she asked, "shall the fair daughters of Africa be compelled to bury their minds and talents beneath a load of iron pots and kettles?"[9]

Stewart gave four public speeches in Boston. Her first was on April 28, 1832, when she spoke before the African American Female Intelligence Society of Boston. In her second speech, which was on September 21, 1832, Stewart lectured to the New England Anti-Slavery Society to an audience of both men and women, black and white, at Franklin Hall. Stewart dared in speaking to the mixed audience to confront the prejudices of the white race and the need for blacks, especially women, the caretakers of the family, to rise up, protest, and seek change. For Stewart, a life of servitude, a lack of education, and the inability to use God-given talents, whether one was a slave

7. Beverly Guy-Sheftall, ed., Words of Fire: An Anthology of African-American Feminist Thought (New York: The New Press, 1995), 3.
8. Maria W. Stewart, "Religion and the Pure Principles of Morality, the Sure Foundation on Which We Must Build," in Guy-Sheftall, Words of Fire, 27.
9. Stewart, "Religion and the Pure Principles of Morality," in Guy-Sheftall, Words of Fire, 29.

or a free black person, represented a life of drudgery akin to death. Stewart challenged stereotypes of blacks being lazy and idle and addressed issues of liberty by announcing that, by listening for a long time to whites proclaiming their need for equal rights and privileges, "our souls have caught the flame" and deserve to "rise above the condition of servants and drudges."[10] Stewart even challenged black people to appeal to the legislature for change, asking, "Have you prayed the Legislature for mercy's sake to grant you all the rights and privileges of free citizens, that your daughters may raise to that degree of respectability which true merit deserves, and your sons above the servile situations which most of them fill?"[11]

Stewart's third speech, delivered at the African Masonic Hall on February 27, 1833, was titled "African Rights and Liberty." The speech was addressed mainly to black men to encourage them to take their rightful place in society and speak up, and not to let fear prevent their voices from being heard. Stewart said, "African rights and liberty is a subject that ought to fire the breast of every free man of color in these United States, and excite in his bosom a lively, deep decided and heart-felt interest."[12]

When Stewart was challenged as a woman for speaking out in public, she declared that her right to speak came from God. Stewart understood that someone had to speak out and advocate for the rights of blacks in America, the free and the slave. Because she was a woman, she faced ridicule and her speeches were received with negativity. She was out there seemingly by herself, not publicly supported by her friends who privately believed she was right. Speaking in public was taboo, but through her public speaking and published writings, she spoke out for the civil rights and conditions of a people who were not seen as equal in the white man's view. Stewart's fourth and final speech was delivered on September 21, 1833, in Boston, where she proclaimed that she was leaving Boston and that she had "'made [herself] contemptible in the eyes of many, that [she] might win some,' which she admitted was 'like a labor in vain.'"[13]

10. Maria W. Stewart, "(1832) Maria W. Stewart, 'Why Sit Ye Here and Die?'" BlackPast, January 24, 2007, https://tinyurl.com/rr5adko.
11. Stewart, "(1832) Maria W. Stewart, 'Why Sit Ye Here and Die?'"
12. Maria Stewart, "Maria Stewart's 'Address Delivered at the African Masonic Hall, Boston,' (February 27, 1833)," History Is a Weapon, accessed December 1, 2019, https://tinyurl.com/y85brael.
13. "Maria Stewart: First African American Woman to Lecture in Public," History of American Women, accessed December 1, 2019, https:// tinyurl.com/vpbn4p7.

"Equal suffrage is the birthright of woman," 1912 postcard; the flag is in colors of lavender and yellow; the escutcheon (shield in the middle of the flag) says: "The Ballot is denied to woman. The Blot on the Escutcheon." Backside of postcard is signed by Blanche to Mrs. Oscar Jacklin, Shelbyville, Indiana.

Although, her public career lasted only a few years and her writings were almost forgotten, Stewart was ahead of her time; her speeches and writings were the foundation and precursors of the coming movements for freedom and women's rights. Stewart wanted to claim her inheritance, and not just hers but the inheritance of all people of color, to have the same opportunities as whites to use their God-given abilities. Stewart was the first African American woman to lecture about women's rights and black women's rights; the first American woman to speak to an integrated audience of men and women, black and white; the first-known American woman to lecture in public on political issues; and the first African American woman to make public antislavery speeches. Believing in her God-given right to be free, she dared to alter the system of government and culture that was present during the times in which she lived.

The Daughters of Zelophehad and Shirley Chisholm

The daughters of Zelophehad also knew that in order to make a difference, in order to make a change, they had to be unified, work together, empower themselves, and not wait for someone to give them permission. The daughters knew that if they waited, no one was going to give them anything or offer them a seat at the table; they had a strategy and knew they needed a plan. They knew they could not just wing it. The daughters were willing to take a risk and knew their plan had to be well thought-out and perfectly timed. They decided they would make their petition directly to Moses, Eleazer the priest, the leaders of Israel, and the entire assembly prior to the division of the land. The daughters decided what they were going to say and how they were going to appeal to the leadership—Moses in particular. They did not ask for secret meetings but went to the top while the other leaders were present to hear.

Shirley Chisholm (1924-2005) also had a strategy for getting a seat at the table and claiming her inheritance. She was the first black woman to be elected to Congress and the first black person to run for president of the United States. Although Chisholm thought her career would be in early childhood development, she found herself, through her political involvement

in the Democratic clubs of Brooklyn, ready to challenge the status quo, speak her mind about issues, and commit herself to changing the white establishment's power. As a result, she was labeled as one who did not follow the rules. In her book *Unbought and Unbossed*, she states:

> The rules of the political game are designed to make it possible for men in power to control the actions of their supporters and stay there. If they can't control someone, they are disturbed. It is a threat to their security. They put the troublemaker's name in a figurative little black book with a note: this is a person we have to hold back. They label him a rebel, a nonconformist, a maverick.[14]

Chisholm was seen as a maverick. In the redistricting of Brooklyn, she saw an opportunity to run for Congress despite challenges from Republican candidate James Farmer, a black man, former national chairperson of the Congress of Racial Equality, and veteran of the 1960s freedom rides in the South.[15] Chisholm believed that, after twenty years of experience, she had a right to run for Congress. Her campaign slogans were "Fighting Shirley Chisholm—Unbought and Unbossed" and "Vote for Chisholm for Congress: Unbought and Unbossed."

She was a woman who listened to the needs of the people. Without a lot of money, Chisholm gathered grassroots support and pounded the pavement for ten months and was determined to do her best and to win. When Chisholm learned she had a tumor and was forced to have an operation, she was back on the campaign trail soon thereafter because she knew she needed to be present out in the community; she knew her absence was political food for the opposition. Chisholm was not afraid to speak to the issue of community needs and did not apologize for being a woman. When challenged on why she was out campaigning instead of being at home taking care of her family, she did not back down or give up. Chisholm won the seat for Congress 2.5:1 over James Farmer. She stated that one of her inspirations for staying in the tough race was that one day a woman had come to her door,

14. Shirley Chisholm, *Unbought and Unbossed* (Boston: Houghton Mifflin, 1970), 59.
15. Jone Johnson Lewis, "Biography of Shirley Chisholm, First Black Woman in Congress," ThoughtCo.com, last updated May 15, 2019, https:// tinyurl.com/r7knvhy.

given her $9.69, and informed her that this was just the first donation—she learned that the money had come from people on welfare at a bingo party.[16]

While in Congress, Chisholm bucked the system, first by challenging her assignment to the House Committee on Agriculture. She was told by Wilbur Mills, chairperson of the House Committee on Ways and Means, to be a good soldier and accept the assignment; she continued to protest and was assigned to the House Committee on Education and Labor. Chisholm was the first newcomer congressperson to challenge an appointment. She believed that being assigned to the agriculture committee would not be the best way to represent her constituents in the urban Twelfth District of Brooklyn.

Just four years after being elected as the first black woman in Congress, in 1972, Shirley Chisholm had a plan—to run for president of the United States of America. She ran during the Vietnam War, the emergence of black power and the Black Panther Party, and the women's rights movement. On January 25, 1972, Chisholm announced her candidacy for president of the United States at Concord Baptist Church in Brooklyn, where she resided and served her constituency as congresswoman. As the first woman and black person to run for the highest office in the land, Chisholm understood that her presence signified a new era in American history. Altering the status quo in government, she challenged the white male establishment and ran a grassroots campaign on issues such as violence and the Vietnam War, poverty and discrimination, medical care, employment, and decent housing.

Chisholm understood that people of color "must regain control of our destiny." She believed in the power of the vote to make change and the need for people to exercise that vote. When Chisholm spoke at Mills College in California, Barbara Lee, a student and president of the Black Student Union, said, "After hearing her speak, I went up to her and asked what could I do to help?" Shirley Chisholm responded, "First . . . go register to vote."[17] Chisholm knew that the vote held power.

The ability to vote empowers and liberates; when people wondered why she was running, she said it was because she could, as a citizen of the United States who fit the criteria to run for president (a natural-born citizen and over thirty-five years of age). Although she knew she might not win, her

16. Chisholm, *Unbought and Unbossed*, 73.
17. Shola Lynch, dir., *Chisholm '72: Unbought & Unbossed* (Beverly Hills, CA: Twentieth Century Fox Home Entertainment, 2004), DVD.

bid for the presidency was a serious one. Her campaign paved the way for people of color to get in the game, to dream of what could be. Chisholm campaigned seeking the delegates' votes because she knew that the more delegates she had heading into the Democratic National Convention, the more leverage she would have in championing the issues of healthcare, education, the end of the Vietnam War, and Head Start.[18] During the Florida primary, when Mayor John Lindsay asked her to step aside, Chisholm told him no, because she had a right to be there.[19]

Although Chisholm lost the Democratic nomination for president, she paved the way for others, such as Rev. Jesse Jackson, Dr. Ron Daniels, and President Barack Obama, to even consider that they, too, had a right to run and be president of the United States. Without Chisholm, there may have never been, in 2008, a President Barack Obama. Shirley Chisholm once said, "If they don't give you a seat at the table, bring a folding chair."[20] In looking back over her career, she stated, "I want history to remember me . . . as a black woman who lived in the 20th century and dared to be herself. I want to be remembered as a catalyst for change in America."[21]

The Daughters of Zelophehad and Coalitions for Change

As Stewart and Chisholm were catalysts for change, so were the five daughters of Zelophehad. Mahlah, Noah, Hoglah, Milkah, and Tirzah empower themselves through their knowledge of the law and of God and God's love for them. What I like about the sisters is that they do not wait or let someone else speak on their behalf. They go to Moses, Eleazar the priest, and the entire community before the land is divided. They do not wait until the deed is done and talk about how they got left out. They do not grumble among themselves about how unfairly women are treated; they do not resign themselves to their fate. They go out of their tents to the tent of meeting, where

18. Shirley Chishlom, *The Good Fight* (New York: Harper and Row, 1973), 24.
19. Lynch, *Chisholm '72: Unbought & Unbossed*.
20. Glynda G. Carr, "Unbought and Unbossed, Shirley Chisholm Stands as a Timely Lesson on Claiming a Seat at the Table," *Huffpost*, November 30, 2017, https://tinyurl.com/vfa4pub.
21. Donna Brazile, foreword to *Unbought and Unbossed*, by Shirley Chisholm, 40th anniversary ed. (Washington, DC: Take Root Media, 2010), xiii.

"the Tablets from Sinai rest in the Ark, to the place of holiness and authority."[22] They go where only the men can go, walking through thousands of people. They face the crowd, and they go to Moses, who has a direct relationship with God. They face obstacles, ridicule, and the potential of being ostracized and even abandoned once they get to the promised land for speaking out, for daring to change God's law. They seek to claim their inheritance.

Despite their personalities and differences, the sisters work together. They do not say, "My plan will work better than your plan." They do not say, "You are too young" or "You are too old." They do not say, "You do it your way, and I will do it my way." They understand that they might not always agree, but when the plan is decided, they work the plan together. They form a sisterhood and know how important it is to work together toward a common goal. They understand that as sisters, as women, they cannot go their separate ways and do their separate things to accomplish the same goal. The sisters also understand that their survival and the welfare of their family and future generations depend on them standing together.

Throughout history black women have formed coalitions to bring about change in their homes, families, communities, and churches; this has occurred on the national, state, and local level. Black women went to rallies, joined the suffrage movement, and faced racism in the white suffrage organizations, but they did not give up. Women came together during the black women's club movement to fight for social and political reform, the enfranchisement of women, and educational improvement.[23] Such clubs were the National Association of Colored Women (NACW), founded in 1896, which advocated for civil rights and women's suffrage with their motto of "lifting as we climb," and the Alpha Suffrage Club of Chicago, founded by Ida B. Wells, which was one of the first black women's clubs whose sole focus was gaining the right to vote.[24]

In 2011, Higher Heights for America was created by black women for black women, and its purpose is to invest in, organize, support, train, and encour-

22. Silvina Chemen, "Contemporary Reflection," in *The Torah: A Women's Commentary*, ed. Tamara Cohn Eskenazi and Andrea L. Weiss (New York: URJ Press and Women of Reform Judaism, 2008), 985.
23. Rosalyn Terborg-Penn, *African American Women in the Struggle for the Vote, 1850–1920* (Bloomington: Indiana University Press, 1998).
24. "Between Two Worlds: Black Women and the Fight for Voting Rights," National Park Service, accessed October 5, 2019, https://tinyurl.com/yckyjk2n.

age black women's participation and leadership at all levels of government through voter participation, running for elected office, and supporting progressive policies. The organization is intergenerational, voices the concerns of black women, and offers salons to afford sister-to-sister conversation and Sunday brunch, which provides national conversation on trending political issues and concerns affecting the community.[25]

The #MeToo movement, although co-opted by white women, was organized in 2006 by Tarana Burke to address issues of sexual violence among young black girls from "low wealth communities."[26] The organization provides support for survivors of sexual violence and is propelled by survivors to end sexual violence in the community. The 'me too.' Movement, partnering with the National Women's Law Center, National Domestic Workers Alliance, Justice for Migrant Women, and sixty-seven other organizations, joined together to write a letter to the 2020 presidential candidates, debate moderators, media organizations, and political commentators, demanding they address the substantive issues with real solutions for "sexual and gender-based violence, sexual harassment, and survivors' rights," which affect women, who compose 51 percent of this nation's population and 53 percent of its voters.[27]

It was the *Make It Work* campaign of women of color, their long hours of work, and their grassroots efforts to register voters and encourage people to get out the vote that helped propel Doug Jones to be elected senator for Alabama in 2017.[28]

In 2000, sororities like Delta Sigma Theta, founded in 1913, went from the social and political to the ecclesiastical arena to help Rev. Vashti Murphy McKenzie become the first woman bishop in the African Methodist Episcopal Church since its organization in 1816. It was with the Alpha Kappa Alpha sorority that Kamala Harris announced her candidacy for president of the United States of America, having their support and backing. Black women

25. "Who We Are," Higher Heights for America, accessed January 23, 2020, https://tinyurl.com/s783952.
26. "History & Vision," The 'me too.' Movement, accessed December 2, 2019, https://tinyurl.com/yapyphc7.
27. The 'me too.' Movement et al., "Open Letter," accessed January 23, 2020, https://tinyurl.com/rst32qb.
28. Tracy Sturdivant, "The Political Power of Black Women Signals Need for 'Whole Person Politics' in 2018," *Essence*, January 2, 2018, https://tiny url.com/tba8ksk.

have always understood that the sisterhood has power and used that power to build coalitions to facilitate change.

The Daughters of Zelophehad, Stacey Abrams, and Many Others

The daughters of Zelophehad know the law, which means that they know God's words. As women of the second generation after the exodus, they have heard the stories of Passover and of God delivering their people out of Egypt. They know that despite their position in the community, God speaks to women as well as to men. The daughters know that when God made male and female, God looked at all that God had made and said that it was good (Gen 1:31). They know how God's promise was not just to their ancestor Abraham but to Sarah too, and they know from their history that it was a woman, Hagar, who first named God *El Roi*, "God who sees me" (Gen 16:13). They know that it was Rahab who hid Joshua and Caleb from their enemies, and that God protected Rahab and her family because of that (Josh 2; 6). They know that it was Hebrew midwives, Shiphrah and Puah, who defied the Egyptian king, and, in saving the Hebrew baby boys, saved a nation, and God rewarded them (Exod 1). The daughters know the faith of their mother, although she is not mentioned in the text, and also know that God uses women and works through women.

On August 25, 2017, Stacey Abrams—a black woman born in Madison, Wisconsin, and raised in Gulfport, Mississippi, and Atlanta, Georgia; a daughter of Methodist ministers; and a graduate of Spelman College, the University of Texas, and Yale Law School—resigned her position as House Minority Leader in the Georgia General Assembly (the first woman and African American to hold the position) to run for governor of the State of Georgia.[29] Abrams had a wealth of experience in government: at the age of seventeen she worked as a typist for a congressional campaign and was soon hired as a speech writer; she worked as a tax attorney for a major law firm in Atlanta right after graduation from law school; at the age of twenty-nine, she became the Deputy City Attorney for the City of Atlanta; she served more than ten

29. Ashley C. Ford, "State Representative Stacey Abrams Is the Bright Future of American Politics," *Lenny Letter*, September 28, 2016, https://tiny url.com/wmvcb5d.

years in the Georgia House of Representatives.[30] Abrams's campaign created a lot of hope, excitement, and negativity. The excitement and hope were that a black person, a woman, could hold the office of governor in the bastion of the South, with its strong Republican base. The negativity was that she was a black woman who dared to go against the status quo. Having grown up in a household where her parents believed in social justice and service to humanity, Abrams has fought for the welfare of all people, especially the oppressed.

On May 22, 2018, Abrams won the Democratic gubernatorial nomination for the State of Georgia, which made her the first woman and African American to be a major-party candidate. Having her party's endorsement, she still faced an uphill battle. Abrams ran against a politically conservative white male, Republican Brian Kemp, a strong supporter of President Donald Trump who was currently serving as Secretary of State for Georgia and whose office oversaw the electoral process. With the help of the Democratic Party, grassroots organizations, churches, ordinary people, and funding from inside and outside the state, Abrams raised over $40 million and ran an aggressive field campaign to get out the vote and to counter the attacks made against her by her opponent and even by men and women of her own race because she was a woman. Not only was she a woman, but also she did not fit "societal" standards of beauty.

Abrams went to the rural areas with unlikely voters to press the issue of Medicaid expansion to reach "low-propensity voters" "whose voices have been largely ignored because they haven't been engaged before" and to press their need to vote.[31] One of her strategies was to gain thousands of new voters and not rely on the traditional voters and the ninety thousand identified Republicans who were potentially "persuadable" to vote for her based on her policies and record.[32] On September 6, 2018, thousands of persons began casting their absentee ballots, and on November 6, 2018, millions of Georgians came out to cast their votes. Abrams's loss was a huge disappointment and an indictment of the state of civil rights not just in Georgia but in America.

30. Michelle Darrisaw, "12 Things to Know about Stacey Abrams, Who Announced She's Not Running for Senate in 2020," *The Oprah Magazine*, April 30, 2019, https://tinyurl.com/tep6ytm.
31. Bill Barrow, "Inside Stacey Abrams' Strategy to Mobilize Georgia Voters," AP News, October 12, 2018, https://tinyurl.com/uas68hr.
32. Barrow, "Inside Stacey Abrams' Strategy."

Abrams lost the election for governor of the State of Georgia with a total of 49.78 percent of the votes, losing by only fifty thousand votes. On November 16, 2018, after many days of the race being too close to call, Abrams gave a concession/non-concession speech. There were major issues of voter suppression in that particular election, as in prior elections in Georgia. The names of more than a million residents of Georgia had been stricken from the rolls, "including a 92-year-old civil rights activist who had cast her ballot in the same neighborhood since 1968."[33] More than fifty-three thousand voter registrations were pending a month before the election. Thousands of registrations were rejected. Polling sites were closed or inadequate and machines were not working, in some cases because there was no outlet to plug them into. People had to wait in long lines for hours to vote; some had to get off the line to go to work for fear of losing their jobs.[34] People were refused ballots because the poll workers believed that there would not be enough paper to go around. Lawsuits were filed. In her concession/non-concession speech, Abrams stated, "So, to be clear, this is not a speech of concession. Concession means to acknowledge an action is right, true or proper. As a woman of conscience and faith, I cannot concede."[35]

In her speech she addressed the persons who believed that she should not use her speech to set forth the wrongdoing and imperfections of the gubernatorial race or the remedy that was needed going forward, but instead that she "should be stoic in [her] outrage and silent in [her] rebuke." She stated, "But stoicism is a luxury and silence is a weapon for those who would quiet the voices of the people, and I will not concede because the erosion of our democracy is not right."[36]

Abrams sought to claim not just her inheritance but the inheritance of all people to be able to cast their votes without hindrance for the candidate of their choice. Through her non-concession speech, Abrams announced her new organization, Fair Fight Georgia, which seeks to monitor and hold accountable the electoral process, bring about election reform in Georgia, and advocate on behalf of the voices of all people to ensure fair elections.[37]

33. Heather Timmons, "Stacey Abrams' Concession Speech Is a Powerful Critique of US Civil Rights," Quartz, November 19, 2018, https://tiny url.com/tc8o6c3.
34. Timmons, "Stacey Abrams' Concession Speech."
35. Timmons, "Stacey Abrams' Concession Speech."
36. Timmons, "Stacey Abrams' Concession Speech."
37. Timmons, "Stacey Abrams' Concession Speech."

Black women stand on the foundation of our mothers, grandmothers, and aunties. We stand with an understanding of the intersectionality of being black and women in these United States. We stand because we remember the sacrifices of the women who have come before us. We remember the Sojourner Truths and the Harriet Tubmans, who championed the cause for liberation and women's right to vote, along with women such as Mary Ann Shadd Cary, Frances Ellen Watkins Harper, Charlotte Vandine Forten Sr., Harriet Forten Purvis Jr., Margaretta Forten, Angelina Weld Grimké, Charlotte Forten Grimké, Sarah Remond, Josephine St. Pierre Ruffin, and Mary Church Terrell. Out of black women's organizing emerged clubs such as the National Federation of Afro-American Women and the National League of Colored Women, which merged in 1896 to become the National Association of Colored Women.[38] We remember Angela Davis, Judith Smith, JoAnne Chesimard, and countless women during the late sixties and seventies who fought for liberation and black power.

In the church, we remember women like Jarena Lee, who in 1819 became the first woman licensed to preach in the African Methodist Episcopal (AME) Church and who preached despite not being ordained because women did not have the right to be ordained. Symbolically, it was important for the Women in Ministry of the AME Church to fight for her to be ordained after her death as a conscious acknowledgment of the injustice of denying her call and what should have happened over 197 years ago. It was not until the 2016 General Conference of the AME Church that Lee was posthumously ordained. The organized body of AME Women in Ministry had fought for years to make her ordination happen, especially during its two-hundredth anniversary.

Likewise, we remember Rev. Carey Hooper of Harlem, New York, who in 1964 was the first woman to run for bishop in the AME Church after the General Conference in 1960 voted for the full ordination of women. Rev. Hooper ran for bishop at six consecutive General Conferences, which meet every four years, meaning that she ran for twenty-four years. Rev. Hooper was mocked, ridiculed, and laughed at, but with her Bible in her hand, she kept running, stating that although "I may not win, I'm paving the way for the future for other women to run for bishop" in an all-black male arena.[39] Once

38. Terborg-Penn, *African American Women in the Struggle for the Vote*, 88.
39. Rev. D. Albert Turk in discussion with the author, April 2004.

Rev. Hooper opened the door, women began to run for the highest office in the AME Church.

The Daughters of Zelophehad and Those Who Continue to Fight

Alas, in Numbers 36:1-12, we find that the daughters of Zelophehad do not win their land outright. There is a stipulation. When the men of the tribe of Manasseh hear that the women will have unlimited rights and freedom to own the land outright without any male control, they devise a plan to get control of the land. The heads of the ancestral houses of the descendants of Manasseh go to Moses and the leaders with the argument that if women are given the land outright with no restrictions, they can marry someone outside the clan and their inheritance will go to another tribe, thereby diminishing the inheritance that is meant for their clan. Moses agrees. The stipulation is made that the daughters have to marry men in their father's clan so that the ancestral land will not go outside the tribe of Manasseh. In fact, no woman who inherited land outright could marry outside her father's ancestral clan. The daughters of Zelophehad do as the Lord had commanded Moses and marry sons of their father's brother.[40]

The daughters, even when they do not get all that they want, do not stop. They take what gains they are given, use them to their benefit, and continue the fight. Black women today are still fighting for equality, affordable housing, healthcare reform, the safety and security of citizens, gun control, prison reform, quality education for all people, and the right to participate in the electoral process, and fighting against police brutality and sex trafficking. The list goes on. They understand, as Dr. Anna Julia Hayward Cooper—suffragist, activist, former slave, and scholar—said in 1892, that "only the BLACK WOMAN can say 'when and where I enter, in the quiet, undisputed dignity of my womanhood, without violence and without suing or special patronage, then and there the whole *Negro race enters with me.*'"[41]

Stewart, Chisholm, Abrams, and countless women of color, named and unnamed, were "committed to survival and wholeness of entire people, male

40. Walter J. Harrelson, *The New Interpreter's Study Bible: New Revised Standard Version with the Apocrypha* (Nashville: Abingdon, 2003), 239-40.
41. Anna Julia Cooper, *A Voice from the South* (Xenia, OH: Aldine Printing House, 1892), 30-31.

and female," while exhibiting "outrageous, audacious, courageous or *willful* behavior" in order to take their rightful place in the society that refuses to give them a seat at the table.[42] Today, black women continue to seek to alter the state of our racist, sexist, and classist government through advocacy, legislative change, and the collective power of their vote to claim their inheritance for all people. The struggle is not over. Unlike the original colonies, we will never separate from America. This is our country.

> We hold these truths to be self-evident, that all men and women are created equal, that they are endowed by their Creator with certain unalienable rights, that among these are Life, Liberty and the pursuit of Happiness.[43]

Bibliography

Barrow, Bill. "Inside Stacey Abrams' Strategy to Mobilize Georgia Voters." AP News. October 12, 2018. https://tinyurl.com/uas68hr.

"Between Two Worlds: Black Women and the Fight for Voting Rights." National Park Service. Accessed October 5, 2019. https://tinyurl.com/yckyjk2n.

Blakemore, Erin. "This Little-Known Abolitionist Dared to Speak in Public against Slavery." *Time*. January 24, 2017. https:// tinyurl.com/qktagn2.

Brazile, Donna. Foreword to *Unbought and Unbossed*, 40th anniversary ed., by Shirley Chisholm, xiii-xvii. Washington, DC: Take Root Media, 2010.

"By the Numbers: Black Women Voters." Higher Heights for America. Accessed December 1, 2019. https://tinyurl.com/sawpeuj.

Carr, Glynda G. "Unbought and Unbossed, Shirley Chisholm Stands as a Timely Lesson on Claiming a Seat at the Table." *Huffpost*. November 30, 2017. https://tinyurl.com/vfa4pub.

Chemen, Silvina. "Contemporary Reflection." In *The Torah: A Women's Commentary*, edited by Tamara Cohn Eskenazi and Andrea L. Weiss, 985-86. New York: URJ Press and Women of Reform Judaism, 2008.

Chisholm, Shirley. *The Good Fight*. New York: Harper and Row, 1973.

———. *Unbought and Unbossed*. Boston: Houghton Mifflin, 1970.

42. Alice Walker, *In Search of Our Mothers' Gardens: Womanist Prose* (Orlando: Harcourt, 1983), xi.
43. "Declaration of Independence," alt.

Cooper, Anna Julia. *A Voice from the South.* Xenia, OH: Aldine Printing House, 1892.

Darrisaw, Michelle. "12 Things to Know about Stacey Abrams, Who Announced She's Not Running for Senate in 2020." *The Oprah Magazine.* April 30, 2019. https://tinyurl.com/tep6ytm.

"Declaration of Independence: A Transcription." National Archives and Records Administration. Accessed December 1, 2019, https://tinyurl.com/h2zqchv.

Dittmar, Kelly, and Glynda C. Carr. "Black Women Voters: By the Numbers." HuffPost. March 7, 2016; updated December 6, 2017. Accessed April 3, 2020. https://tinyurl.com/smwf4fa.

"First African American Woman to Lecture in Public." History of American Women. Accessed December 1, 2019. https://tiny url.com/vpbn4p7.

Ford, Ashley C. "State Representative Stacey Abrams Is the Bright Future of American Politics." *Lenny Letter.* September 28, 2016. https://tinyurl.com/wmvcb5d.

Guy-Sheftall, Beverly, ed., *Words of Fire: An Anthology of African-American Feminist Thought.* New York: The New Press, 1995.

Harrelson, Walter J. *The New Interpreter's Study Bible: New Revised Standard Version with the Apocrypha.* Nashville: Abingdon, 2003.

"History & Vision." The 'me too.' Movement. Accessed December 2, 2019. https://tinyurl.com/yapyphc7.

Lewis, Jone Johnson. "Biography of Shirley Chisholm, First Black Woman in Congress." ThoughtCo.com. Last updated May 15, 2019. https://tinyurl.com/r7knvhy.

Logan, Adella Hunt. "Colored Women as Voters." *The Crisis* 4 (September 1912): 242–43.

Lynch, Shola, dir. *Chisholm '72: Unbought & Unbossed* (DVD). Beverly Hills, CA: Twentieth Century Fox Home Entertainment, 2004.

MacLean, Maggie. "Maria Stewart." ehistory. The Ohio State University. Accessed December 1, 2019. https://tinyurl.com/wyhokgg.

The 'me too.' Movement et al., "Open Letter." Accessed January 23, 2020. https://tinyurl.com/rst32qb.

Stewart, Maria. "(1832) Maria W. Stewart, 'Why Sit Ye Here and Die?'" BlackPast. January 24, 2007. https://tinyurl.com/rr5adko.

———. "Maria Stewart's 'Address Delivered at the African Masonic Hall, Boston,' (February 27, 1833)." History Is a Weapon. Accessed December 1, 2019. https://tinyurl.com/o59d89t.

———. "Religion and the Pure Principles of Morality, the Sure Foundation on Which We Must Build." In *Words of Fire: An Anthology of African-American Feminist Thought*, edited by Beverly Guy-Sheftall, 26–29. New York: The New Press, 1995.

Sturdivant, Tracy. "The Political Power of Black Women Signals Need for 'Whole Person Politics' in 2018." *Essence*. January 2, 2018. https://tinyurl.com/tba8ksk.

Terborg-Penn, Rosalyn. *African American Women in the Struggle for the Vote, 1850–1920*. Bloomington: Indiana University Press, 1998.

Timmons, Heather. "Stacey Abrams' Concession Speech Is a Powerful Critique of US Civil Rights." *Quartz*. November 19, 2018. https://tinyurl.com/tc806c3.

Walker, Alice. *In Search of Our Mothers' Gardens: Womanist Prose*. Orlando: Harcourt, 1983.

"Who We Are." Higher Heights for America. Accessed January 23, 2020. https://tinyurl.com/s783952.

PART II
PRESENT: CLEARLY SEEING WHERE WE ARE

In part 2, contributors give a clear assessment of where we are in the present. In chapter 5, Michelle Oberwise Lacock and Carol Lakota Eastin explain how the history of indigenous people on the North American continent reveals the gynocratic tribes (governments ruled by women) and becomes an embodied vision of a more equal society. The authors remind us of the crucial role the American Indian women played in the feminist movement. Through her cousin, Gerrit Smith, Elizabeth Cady Stanton met and dined with members of the Haudenosaunee (Iroquois) tribe. Lucretia Mott spent time living among the Seneca. Matilda Joselyn Gage was a member of the Wolf Clan. These and other early feminists were introduced to the concept of the Great Spirit (neither male nor female), matrilineal tribes, the right of Native American women to vote, and the harmony of the sexes.

In chapter 6, Sophia Park focuses on the paradox of women's right to vote but their powerlessness to keep or even protect their own children. Starting with the kidnapping of children by the Tennessee Home Society Orphanage in 1939 and ending with the present day, Park, as a mother and a new US citizen, explores the tragic fact that women now have the power to vote but have no power to protect their children and families.

Sex trafficking and sexual exploitation of children and women around the world are the focus of the present work of Francesca Debora Nuzzolese, author of chapter 7. Her interviews with extraordinary women in the trenches of antitrafficking efforts, combined with her own advocacy for and counseling of those who have been dehumanized, beckons those of us, privileged now with the power of the vote, to join in the long road to the emancipation of others.

This photo contains a list of the planks to be presented by the League of Women Voters to the Democratic Party. The six planks are in the following order: Child Welfare; Education; Home and High Prices; Women in Gainful Occupations; Public Health and Morals; Independent Citizenship for Married Women.

80 | Women with 2020 Vision

On February 3, 1922, a preliminary planning committee for the Pan-American Conference of Women Voters met for a social tea. The conference was scheduled to be held the following April in connection with the third annual conference of the National League of Women Voters. Seated in the front row, left to right: Mrs. Maud Wood Park from Washington, DC; Mrs. Frederic Van Lennep, born and brought up in Chile and whose father was a noted philanthropist known as "The Luther of South America"; Mrs. Carrie Chapman Catt, noted suffrage leader; Mrs. Minor Cooper Keith from Costa Rica. Standing left to right: Miss Bassett Moore; Mrs. Bassett Moore, wife of the former A.D.C. Commissioner; Mrs. S. S. Inglehart, Chile; Mrs. De Hebard, Panama; and Mrs. Carson de Pinillos, Peru.

Chapter 8, by Angelique Walker-Smith, affirms the leadership of Pan-African women of faith to address present-day hunger and poverty, highlights the important role Pan-African women of faith have in lifting their voices in advocacy and elections, and reveals collective efforts to influence decision makers. Walker-Smith reminds us that 2020 is a critical year for making sure that hunger and poverty are on the platforms of candidates aspiring to public office. In this way, we follow not only women like Zipporah and Hagar but wise rulers like the Queen of Sheba and Queen Candace of Ethiopia.

5. Seeing through American Indian Eyes: A Vision of Balance and Equity

MICHELLE OBERWISE LACOCK AND CAROL LAKOTA EASTIN

> Nowhere is the Haudenosaunee appreciation for women better reflected than in their music and dance. When the women dance, they form a circle around the drum; they move with the Earth, counterclockwise, their feet caressing the Earth as they shuffle to one of the hundreds of verses sung in their honor. To be part of that circle is a great source of strength for me.
>
> —Joanne Shenandoah[1]

In the 1830s, Elizabeth Cady Stanton was often invited to dinner at the home of her cousin Gerrit Smith, whose older brother, Peter Skenandoah Smith, was named after an Oneida friend of the family, Chief Skenandoah.[2] Gerrit Smith was a radical social activist, abolitionist, and suffragist.[3] Stanton was excited to visit him and his guests, with one of his guests being Oren Tyler, who had been adopted by the Onondaga.[4]

During one fine evening of conversation and lovely food, Stanton had an engaging conversation with members from the Haudenosaunee tribe. She was grateful that her cousin spoke fluent Iroquois, which made the conversation so much easier. Stanton was excited to talk with the Native American[5] women as they shared about how they had equal power with the men and participated in all major decisions of the tribe. Imagine: women had the

1. Quoted in Wilma Mankiller, *Every Day Is a Good Day: Reflections by Contemporary Indigenous Women* (Golden, CO: Fulcrum, 2004), xxvii.
2. Sally Roesch Wagner, *Sisters in Spirit: Haudenosaunee (Iroquois) Influence on Early American Feminists* (Summertown, TN: Native Voices, 2001), 32.
3. Henry B. Stanton, *Random Recollections* (New York: Macgowan and Slipper, 1886), 94.
4. Wagner, *Sisters in Spirit*, 32.
5. We use the terms *Native American* and *American Indian* interchangeably. Some use the terms *Amerindians* and *First Nation Peoples*. In general, and when possible, it is better to refer to people by tribal name.

power to select and remove the chiefs and to veto any act of war. Stanton was astonished and filled with hope that maybe someday that would happen for all women. She left dinner that night clearly affected, stating in 1891 in the *National Bulletin*, a suffrage movement newspaper, that "in the councils of the Iroquois every adult male or female had a voice upon all questions brought before it."[6] Additionally, "she marveled [that clan mothers] could depose a chief and 'send him back to the ranks of the warriors.'"[7] According to Sally Roesch Wagner, a historian and women's studies scholar, this political reality had a profound impact on early feminists like Stanton, Lucretia Mott, and Matilda Gage, all three of whom had Native American women as friends.[8] Mott spent significant time living among the Seneca, and Gage was made a member of the Wolf Clan of the Mohawk Nation of the Iroquois.[9]

A New World Brings a New Vision

When Europeans arrived in the New World, they found a land teeming with resources beyond their imagination. Animals and plant life were so plentiful that some described it as akin to a "land flowing with milk and honey," as described in the Old Testament (Deut 31:20 NRSV). In addition to natural resources, they found nations of people who had established systems of agriculture, trade, and government. Recent estimates as to the number of American Indians on this continent at the time of Europeans' arrival are as high as one hundred million. There were over five hundred nations, each with its own unique culture, spiritual beliefs, and language; these people had a worldview very different from that of their European visitors. Gender roles were often clearly defined; however, one gender was not understood to be superior to the other. Women were understood to hold significant power because of their ability to carry life and to give birth, and that power held sway over many affairs of the people. The reality of the New World was that here women had voice and great influence.

In contrast, inherent in the European worldview transported to the Amer-

6. Elizabeth Cady Stanton, "The Matriarchate, or Mother Age," in *The Women's Suffrage Movement*, ed. Sally Roesch Wagner (New York: Penguin, 2019), 23.
7. Jessica Nordell, "Millions of Women Voted This Election. They Have the Iroquois to Thank," *Washington Post*, November 24, 2016, https://tiny url.com/vjhrp8v.
8. Wagner, *Women's Suffrage Movement*, xxiii.
9. Wagner, *Sisters in Spirit*, 41.

ican continent and demonstrated in its exclusive governance was the idea that some human beings are superior to others. In the US Constitution, the "founding fathers" did not set parameters for who had the right to vote, leaving it to the states to decide, and the states did just that. There was no clarity about voting as a citizen's right. However, it was clear that white men held the most power. Among many other things, a Judeo-Christian philosophy often brought teachings that men were superior to women. This idea was challenged by Lucretia Mott, who was a Quaker. In one of her sermons at Unitarian Church in Washington, DC, which she gave on January 15, 1843, she said, "Woman has long been excluded from the privilege of speaking to the people, and the Bible has been applied to for a sanction of this exclusion of her right to speak, even to the men of the cities."[10]

The very understanding of the Godhead as Father, Son, and Holy Spirit was interpreted by most to mean that God is masculine. And that masculine God in whose image "men were made" was used as the proof of male superiority. For the indigenous people of the Americas, the concept of a masculine god and of male superiority were foreign. Native societies had developed over centuries on the North American continent with a different understanding of gender. For them, the roles of men and women complemented each other, and in many of the tribes, the experience of "God" included a reciprocal duality of male and female (e.g., Mother Earth and Father Sky).[11] Spiritual practices and ceremonies sought connection and balance.

References to the Great Spirit were not necessarily attached to a masculine or feminine pronoun, and some of the key spiritual stories include a significant female character (e.g., Spider Woman, Sky Woman, White Buffalo Calf Woman, and Corn Mother). Because of this theological perspective, the structures of the family, the society, and its governance were not male dominated. In fact, the structure of many tribes was matrilineal, with women choosing which men were to be leaders and holding the power to determine whether they would continue in their roles or not. In her book *Sacred Hoop*, Paula Gunn Allen seeks to recover the feminine in the account of American Indian history: "Traditional tribal lifestyles are more often gynocratic than

10. Christopher Densmore, Carol Faulkner, Nancy Hewitt, and Beverly Wilson Palmer, eds., *Lucretia Mott Speaks: The Essential Speeches and Sermons* (Urbana: University of Illinois Press, 2017), 21.
11. Clara Sue Kidwell, Homer Noley, and George E. Tinker, *A Native American Theology* (Maryknoll, NY: Orbis, 2001), 17.

not, and they are never patriarchal. These features make understanding tribal cultures essential to all responsible activists who seek life-affirming social change."[12]

As colonizers and early US citizens shared space with the indigenous people on this continent, there was a notable difference in how women and men related to one another and how indigenous governments included women in powerful roles. This was noticed by female ethnographers, anthropologists, and others who came into contact with American Indian women. In fact, "the earliest white women on this continent . . . were neighbors to a number of tribes and often shared food, information, child care, and health care."[13] This encounter between women from "two worlds" had a significant impact on the empowerment of American women, American family life, and ultimately American governance. The increased power of American women naturally led to more balanced marital relationships, legal rights of women, better treatment of children, women's voice in politics—including the right to vote—and the elevation of women into every professional and political role in this nation.

If this thesis seems a bit far-fetched, consider the question asked by Sally Roesch Wagner, who for twenty years studied the writings of early US women's rights activists. She writes, "I could not fathom how they dared to dream their revolutionary dream. Whatever made them think . . . equal rights for women were achievable? Then it dawned on me. They believed women's liberation was possible because they knew liberated women, women who possessed rights beyond their wildest imagination: Haudenosaunee women."[14] If the reader continues to be surprised, she is not alone. Paula Gunn Allen, a contemporary Laguna/Pueblo/Sioux Indian literary critic, commented on how far removed this version of American feminism must seem to most people steeped in "mainstream or radical versions of feminism's history."[15] She writes, "I am intensely conscious of popular notions of Indian women as beasts of burden, squaws,[16] traitors, or, at best, vanished

12. Paula Gunn Allen, *The Sacred Hoop: Recovering the Feminine in American Indian Traditions* (Boston: Beacon, 1986), 2–3.
13. Allen, *The Sacred Hoop*, 216.
14. Wagner, *Sisters in Spirit*, 41.
15. Allen, *The Sacred Hoop*, 213–14.
16. *Squaw* is a word used to refer to Indian women that is highly offensive to native people. Unbeknown to many, the word has a sexual connotation that is derogatory. As it is now considered a

denizens of a long-lost wilderness. How odd, then, must my contention seem that the gynocratic[17] tribes of the American continent provided the basis for all the dreams of liberation that characterize the modern world."[18] She encourages feminists to be aware of their history on the North American continent and to realize that the forces that devastated gynarchies in Europe, Africa, and Latin America have also sought to wipe them out in North America. Wars were fought to take land and resources and to control the minds and hearts of the native people.[19] The fact that so many have forgotten the history of indigenous people on this continent would suggest those battles were largely successful.

Yet amid the efforts to repress the universal truth that women are equal to men, the truth breaks through like a persistent dandelion breaking through a concrete sidewalk to be seen and to spread its leaves. Over the generations it has been demonstrated that one cannot completely contain the human spirit despite measures to silence the cause of women. Stanton, Mott, and Gage were wonderful women who had an encounter with women in the Native American community who had voice, equality, and power in all aspects of life. Once they had experienced that vision, they would not be silenced.

White Women Who Knew Indian Women

Lucretia Coffin Mott, a Philadelphian who lived from 1793 to 1880, was known for her outspokenness and power as a speaker. Mott was a central figure in the suffragist movement who fought for racial and sexual equality. She was a Quaker, a mother, and a wife who had her own authority and who often riled other Quakers, community members, ministers, journalists, and various politicians.

For our purposes it is notable that Lucretia Mott grew up in Nantucket surrounded by the Wampanoag nation, where her great-great-great-great-grandfather had been a missionary, and that she spent a month with the Seneca Indian people just prior to attending the Women's Rights Conference

racial slur, many states have passed legislation that place names that include this word are to be changed.
17. *Gynocratic* means a government ruled by women.
18. Allen, *The Sacred Hoop*, 214.
19. Allen, *The Sacred Hoop*, 214.

in Seneca Falls on July 19–20, 1848.[20] She had been attending a strawberry fest, at which she gathered strawberries as well as her personal power.[21] The official report of that two-day event reads, "Lucretia Mott of Philadelphia was the moving spirit of the occasion."[22] There she proclaimed along with the others: "We hold these truths to be self-evident: that all men and women are created equal."[23] It was affirmed that men and women shall pursue their own happiness and that any laws that prevent a woman from occupying such a station in society as her conscience shall dictate are contrary to the great precept of nature.[24] Lucretia Mott took the Declaration of Independence to a new level by presuming women would be included in the phrase *all men are created equal*. We cannot overestimate the influence of her significant time among the Seneca people.

Joseph Keppler, *Savagery to "Civilization,"* Puck 75 (May 16, 1914): 4. *Image courtesy of the Library of Congress.*

20. Carol Faulkner, *Lucretia Mott's Heresy: Abolition and Women's Rights in Nineteenth-Century America* (Philadelphia: University of Pennsylvania Press, 2011), 12.
21. Faulkner, *Lucretia Mott's Heresy*, 136.
22. Faulkner, *Lucretia Mott's Heresy*, 140.
23. "Report of the Woman's Rights Convention" (Rochester, NY: North Star Printing Office, 1848), on National Park Service, accessed January 21, 2020, https://tinyurl.com/ydahhbgr.
24. "Report of the Woman's Rights Convention."

An example of the powerful influence of American Indian women on the equality that Mott was seeking to achieve is the illustration by Joseph Keppler, *Savagery to "Civilization,"* where Iroquois women are looking on at other women who are marching and carrying a banner that says "Woman Suffrage."[25] The text on the right side of the illustration reads as follows:

> WE, THE WOMEN OF THE IROQUOIS:
> Own land, the lodge, the children.
> Ours is the right of adoption, of life or death;
> Ours the right to raise up and depose chiefs;
> Ours the right of representation at all councils;
> Ours the right to make and abrogate treaties;
> Ours the supervision over domestic and foreign policies;
> Ours the trusteeship of the tribal property;
> Our lives are valued again as high as man's.

The text underneath the title of the image states the following: "THE INDIAN WOMEN: We whom you pity as drudges reached centuries ago the goal that you are now nearing." The fact that a political image such as this was published demonstrates that at the time of the suffragist movement, the influence of American Indian women had become well known.

Eva Emery Dye, an Oregon suffragist who lived from 1855 to 1947, selected Sacajawea as an important woman who could represent the women's movement. Although Lewis and Clark mentioned her briefly in their journals, the story of the Shoshoni teenager who led their expedition while carrying her infant son became a symbol of American womanhood. Across America, statues have been erected to remember Sacajawea.[26] Those statues stand to remind us of the words of Dr. Anna Howard Shaw, who spoke of her at the National American Woman's Suffrage Association in 1905:

> Forerunner of civilization, great leader of men, patient and motherly woman, we bow our hearts to do you honor! . . . May we the daughters of an alien race . . . learn the lessons of calm endurance, of patient persistence and unfaltering courage exemplified in your life,

25. Joseph Keppler, *Savagery to "Civilization,"* Puck 75 (May 16, 1914): 4.
26. "Sacagawea Statues," National Park Service, accessed January 21, 2020, https://tinyurl.com/qqnatmm.

in our efforts to lead men through the Pass of justice, which goes over the mountains of prejudice and conservatism to the broad land of the perfect freedom of a true republic; one in which men and women together shall in perfect equality solve the problems of a nation that knows no caste, no race, no sex in opportunity, in responsibility or in justice! May the "eternal womanly" ever lead us on![27]

Gloria Steinem says, "As for Native women, suffragists regularly cited their status as evidence that women and men could and should have balanced roles. Indeed, there was no other visible source of hope in this New World where expansion rested on the unpaid labor and uncontrolled reproduction of all women."[28]

In 1888, ethnologist and suffragist Alice Fletcher lived among the northeastern tribes and reported to the International Council of Women that among the Iroquois "a wife is as independent as the most independent man in our midst."[29] She observed these women making independent financial decisions about property. On one occasion she asked her Seneca friend if her husband would approve of her giving away her horse, and the Seneca women who were present laughed at her question with some indignation.[30]

Matilda Gage (1826–1898) and Elizabeth Cady Stanton (1815–1902) were two of the key leaders in the suffragist movement, and they found their vision for a future in upstate New York through their relationships with Haudenosaunee women. Both Gage and Stanton raised questions about how "Indians" were named by Columbus and how at ease he was at deciding he had the right to name another group of people without asking what a particular person or group wanted to be called.

In 1893 Gage, who was an important scholar of the suffrage movement, wrote the following:

> When America first became known to white men as the New World, within the limits of what is now called New York state existed one of the oldest known republics in the world, a confederacy of Five

27. Ella Clark and Margo Edmans, *Sacajawea of the Lewis and Clark Expedition* (Berkley: University of California Press, 1979), 93–98.
28. Gloria Steinem, introduction to *Every Day Is a Good Day*, xviii.
29. Wagner, *Women's Suffrage Movement*, 37.
30. Wagner, *Women's Suffrage Movement*, 37.

Nations when it was first formed, which added tribes to its numbers as its successor, the American republic, adds states to its Union.[31]

Gage realized that whether one described America as the Old or New World depended on one's perspective, pointing out that it was the white men who called it the "New World."[32] Gage also wrote a series of articles on the Haudenosaunee in which she explained the form of government, the meaning of sovereignty, and the role of women in the society. These articles were a source of education and inspiration for American women during this time. Having seen and experienced a society built on equality, Gage was able to name the oppression of the society in which she lived. By doing so, she and others like her were able to inspire other women to challenge the status quo of the day and demand equality for women. Due to her friendship with Native American women, Gage was given an adoptive Native American name: "Ka-ron-ien-ha-wi or Sky Carrier or She who holds the sky," which "is a clan name of the wolves" in the language of the Mohawk Nation of the Iroquois.[33]

Stanton worked diligently throughout her life for women to have the right to vote. She also realized that the vote was not the only concern that needed to be addressed. She saw firsthand how Native American women and men treated each other as equals in all aspects of life and how in her culture women were still considered subordinates. Women were treated in many cases like property and certainly not as persons who had rights or voice. In her speech at the first National Women's Suffrage Convention, held in Washington, DC, on January 22, 1869, she stated, "This fundamental principle of our government—the equality of all citizens of the republic—should be incorporated in the Federal Constitution, there to remain forever. . . . All artificial distinctions, whether of family, blood, wealth, color, or sex, are equally oppressive to the subject classes and equally destructive to national life and prosperity."[34] For her, equality became in many ways the overall focus; voting rights would be the first step in making a fuller equality happen.

31. Matilda Joslyn Gage, "The Remnant of the Five Nations," *Evening Post* (New York, [N.Y.]), September 24, 1875, New York Historical Newspapers, accessed January 22, 2020, https://tinyurl.com/vd2r3g2.
32. Wagner, *Sisters in Spirit*, 23.
33. Wagner, *Sisters in Spirit*, 32.
34. Wagner, *The Women's Suffrage Movement*, 189–90.

Who Are the Haudenosaunee?

Where did this vision of equality come from? A key influence was from the relationships these women had with the people many have called the Iroquois, who were known to themselves as the Haudenosaunee ("People of the Longhouse") or the Ongwe Honwe ("The Real People").[35] These people comprised a powerful confederacy of tribes: the Onondagas, the Cayugas, the Senecas, the Mohawks, the Oneidas, and the Tuscaroras, and are also known as "The Six Nations." In these tribes, the clan matron played a critical role in the political and ceremonial life of the people, having all the "real authority vested in" her.[36]

The Jesuits were a group of missionaries who, over many years, studied the culture and language of the Haudenosaunee. Over time they came to respect them; however, they compared them to the French and thought they lacked government, law, letters, and religion. What they did not understand, because they came from a patriarchal society, was "the matrilineal kinship system of the Iroquois society and the related power of women."[37] Dr. Peter MacLeod, a Canadian historian, expands on this in his writings about the Canadian Iroquois and the French during the Seven Years' War:

> Most critically, the importance of clan mothers, who possessed considerable economic and political power within Canadian Iroquois communities, was blithely overlooked by patriarchal European scribes. Those references that do exist show clan mothers meeting in council with their male counterparts to make decisions regarding war and peace and joining in delegations to confront the *Onontio* [the Iroquois term for the French governor-general] and the French leadership in Montreal, but only hint at the real influence wielded by these women.[38]

35. Alexandra Harris and Tim Johnson, eds., *The Haudenosaunee Guide for Educators* (Washington, DC: National Museum of the American Indian Education Office, 2009), 2.
36. Rebecca Kugel and Lucy Eldersveld Murphy, eds. *Native Women's History in Eastern North America before 1900: A Guide to Research and Writing* (Lincoln: University of Nebraska Press, 2007), 94.
37. Bruce Trigger, *Natives and Newcomers: Canada's "Heroic Age" Reconsidered* (Montreal: McGill-Queen's University Press, 1985), 661.
38. D. Peter MacLeod, *The Canadian Iroquois and the Seven Years' War* (Toronto: Dundurn, 2012), xiv.

Minnie Myrtle Miller, who was born Theresa Dyer, observed in 1855 that no Iroquois treaty was binding unless it was ratified by three-fourths of the male voters and three-fourths of the mothers of the nation.[39] This required, in fact, a double super majority.

Elizabeth Stanton described how the clan women held great power and were the ones to nominate the chief. The women also did not hesitate when necessary to "knock off the horns" from the head of a chief, which would send him back to the ranks of warriors. The phrase literally referred to breaking the deer horns from his helmet, which symbolized his status.[40] The elder women of the clans took the lead in decision-making and had the power to overturn or veto all the acts not only of their own clan's councils but also of the tribal and national councils.[41] Women of these tribes continue to lead today.

A contemporary Onondaga clan mother and a respected traditional indigenous leader of today, Audrey Shenandoah, describes the role of women as complex and important. Men and women have different responsibilities, and both are important. Women are able to pursue whatever they desire with the basic understanding that women have the dynamic "role of being a very special person by being able to carry life, give life, and nurture it from the beginning."[42] The fact that men and women have different roles does not imply one is superior to the other. Shenandoah states the following:

> Balance is important in everything we do. When the Women's Rights movement began, they asked women from our communities to speak because they thought we were more powerful than the men, that we made all the decisions for our people. Some of them are still trying to make themselves not only equal but superior to men, without any recognition that there should be balance.[43]

This attribute of Haudenosaunee women had been noted by the French nun Marie Guyart in 1654: "These female chieftains are women of standing amongst the savages and they have a deciding vote in the councils. They

39. Sally Roesch Wagner, *The Untold Story of the Iroquois Influence on Early Feminists* (Aberdeen, SD: Sky Carrier, 1996), 34.
40. Wagner, *Untold Story of the Iroquois Influence*, 33.
41. Wagner, *Untold Story of the Iroquois Influence*, 8–9.
42. Mankiller, *Every Day Is a Good Day*, 104.
43. Mankiller, *Every Day Is a Good Day*, 104.

make decisions there like the men, and it is they who even delegated the first ambassadors to discuss peace."[44] Unfortunately, the word *savages* was used widely in the seventeenth through nineteenth centuries by the European immigrants to America when they referred to indigenous people. It implied "a lower degree of civilization."[45] This attitude even carried forth in the Declaration of Independence, where natives are referred to as "merciless Indian Savages."[46]

The Twentieth Century: Passage of the Nineteenth Amendment and Beyond

As influential as native women were upon the suffragists, we have been unable to find the names of those early native women with whom Stanton, Mott, and Gage were in relationship, even though friendships among white women and native women were common and seen as normal interactions. The names have not been recorded in history and thereby have been easily forgotten. In the twentieth century, particularly after the passage of the Nineteenth Amendment, we begin to find record of notable native women who were activists and professionals in their own right. It is evident that in the early 1900s, women in New York were familiar with their neighbors in the Iroquois Confederacy. The daily newspapers would have reports on affairs in those tribal nations, including sports and politics, with some articles written by Native Americans. American Indian women of many tribes found their way to the big city to pursue education or careers in music and other arts, including film. Native women were authors, poets, singers, and composers.

Zitkala-Sa: Artist, Woman of Letters, Activist

One of these women was Gertrude Simmons Bonnin, who was also known as Zitkala-Ša, or "Red Bird," in the Sioux language. She was born on the Yankton Indian Reservation in South Dakota in 1867. Her story is an extraordinary one.

44. Marie Bruneau, *Women Mystics Confront the Modern World* (New York: State University of New York Press, 1998), 106.
45. Wagner, *Sisters in Spirit*, 24.
46. "Declaration of Independence: A Transcription," National Archives and Records Administration, accessed December 1, 2019, https://tiny url.com/h2zqchv.

As a native woman who attended boarding school, was college educated, and became a successful professional during this time period, her story needs to be remembered.

When she was eight, she was removed by missionaries to the White's Manual Labor Institute in Wabash, Indiana. She was an avid learner despite the conditions, and eventually she achieved the impossible, earning a degree from Earlham College. Her desire was to be a teacher and a writer. In 1921 she published a widely read collection of writings, *American Indian Stories*, describing her early traditional childhood. Her harmonious childhood was described in sharp distinction to the brutal and cruel life of forced assimilation imposed on her in boarding school.

Zitkala-Ša was also an accomplished violinist and pianist, and she played with the New England Conservatory of Music from 1897 to 1899. She composed songs for an opera called *The Sun Dance*, which was performed by a troupe from the Ute Reservation. Her writings were published in *Harper's Magazine* and *Atlantic Monthly* and then in the *American Indian Magazine*, where she was editor-in-chief from 1918 to 1920.[47] A political activist, she founded the National Council for American Indians, a civil rights organization, in 1926.[48] Due to her work, the "Indian Reorganization Act of 1934 was passed which gave the management of Indian lands back to Native Americans."[49]

Not the End

Just as much as it would be an error to forget the significant role American Indian women played in the feminist movement, and in fact in the progress of most human affairs on the American continent, it would equally be in error to ignore or be blind to the continuing influence of strong American Indian women today in every area of human endeavor. It has been suggested that the Indianization of America has happened, though most people are unaware of the powerful influence of indigenous lifeways and spiritual teachings.[50] In

47. Tadeusz Lewandowski, *Red Bird, Red Power: The Life and Legacy of Zitkala-Ša* (Norman: University of Oklahoma Press, 2016), 324.
48. Patrick Deval, *American Indian Women* (New York: Abbeville, 2014), 176–78.
49. Gina Capaldi, *Red Bird Sings: The Story of Zitkala-Ša, Native American Author, Musician, and Activist* (Minneapolis: Millbrook, 2011), 30.
50. *Indianization* is the historical spread of the characteristics and culture of American Indians.

the seventeenth and eighteenth centuries, Europeans arriving on this continent encountered a gentle people who honored women, gay persons, and children as equals in their communities, did not physically abuse their own family members, and avoided war when possible. They had no words for "art" or "religion" because making things beautiful and recognizing the spiritual were not separate from life—they were seen as integral parts of it. These were a people who had established systems of government, agriculture, medicine, athletics, and trade and who lived balanced lifestyles that included leisure time, daily bathing (something unheard of among European immigrants), and a respect for creation. Today much of American life includes indigenous foods and lifestyles. Indianization has not ended but continues to occur, and American Indian women stand at the cutting edge of change as they lead us in the areas of spirituality, the environment, family life, education, the arts, and politics.

Rosalie Little Thunder, Sicangu Lakota, an award-winning bead artist, Lakota language teacher, and grassroots activist, has devoted much of her life to advocating for the survival of the buffalo and has encouraged the United Nations Permanent Forum on Indigenous Issues to participate in a global campaign to protect the sacred species of indigenous peoples. She gives unique insight into the role of women in native communities by stating the following:

> We are the creators of "home," caretakers of the spiritual and physical needs of the *tiwahe* or household, and our *tiospaye*, or extended family. We are teachers, healers, storytellers, peacemakers, problem solvers, and visionaries. The roles and responsibilities in indigenous cultures are different and dynamic. Unless humanity evolves to a point where we are all asexual, I don't think we will get true equity, whatever that is. I am not sure we should wish for that. Feminism is a Euro-American response to a misogynist problem created by Euro-Americans.[51]

The indigenous worldview understands everything in creation as having a vital role in the web of life, in which all things are related and connected. It would not be a goal of creation for human beings to all be the same, but

51. Mankiller, *Every Day Is a Good Day*, 117.

rather for beauty to be seen in the diversity of races, genders, and cultures. Rather than viewing people or animals in a hierarchy, they are seen in a circle. In one Lakota tradition, a ball is tossed among the people standing in a circle. If the ball is dropped by anyone in the circle, everyone is affected. The point of this teaching activity is to see the value of every person's contribution.

Current justice issues that concern Native American women include water rights, domestic violence, and healthcare. There are women called Water Walkers who walk and pray all around the Great Lakes for the lakes' purification. There is a Red Dress Movement to increase awareness of missing and murdered indigenous women and girls. There is an expanding women's movement that connects indigenous women globally and seeks decolonization across the planet, which means combatting and dismantling colonial policies that have impacted indigenous communities. There needs to be a remembering of history to tell a more complete story that includes indigenous viewpoints and educates persons of all races about such issues as the ongoing effects of historical trauma and the Doctrine of Discovery, which was the legal fiction that the pope had the right to divide the land in the Americas. At that time it was believed the land "belonged" to the European nations that "discovered" it.[52] Just as the feminist movement has called for remembering her-story, it needs to call for remembering the indigenous story.

In 1985 Wilma Mankiller became the first female chief of the Cherokee Nation. She was an avid activist about whom, upon her death, President Obama stated, "She worked to transform the nation-to-nation relationship between the Cherokee Nation and the federal government and served as an inspiration to women in Indian Country and across America."[53] She was a recipient of the Presidential Medal of Freedom and "recognized for her vision and commitment to a brighter future for all Americans. Her legacy will continue to encourage and motivate all who carry on her work."[54]

52. Judith Nies, *Native American History: A Chronology of the Vast Achievements of a Culture and Their Links to World Events* (New York: Ballantine, 1996), 79.
53. Ken Raymond, "Wilma Mankiller: A Legend 'In Her Own Time,'" *The Oklahoman*, April 7, 2010, https://tinyurl.com/rvg6mea.
54. Ken Raymond, "Wilma Mankiller."

Wilma Mankiller addresses London conference, October 23, 1992; pictured with her husband, Charlie Soap. Press photo.

Chief Mankiller reminded us of the following: "As native women work for the benefit of future generations, they are embraced by the memory of their ancestors. In the strength of that embrace, the line between the past, the present, and the future is not as distinct as it is in the larger society.... Outsiders are always admonishing native women to forget about history and the past, but history is woven into the very fabric of their daily lives."[55]

Another prominent native woman who is a seeker of justice and a teller of stories is Joy Harjo. In 2019, this Muscogee Creek woman was made the twenty-third poet laureate of the United States. In her poetry, she remembers US history from a Native American woman's perspective and points us to a brighter future, one she might call "American Sunrise."[56] It is our hope that in this significant moment in American history, all will remember those women who went before us, both immigrants and the indigenous women of this continent, who shaped the freedoms we have come to enjoy and whose legacy encourages us to keep going—until all persons experience liberty, freedom, equality, and justice.

Bibliography

Allen, Paula Gunn. *The Sacred Hoop: Recovering the Feminine in American Indian Traditions*. Boston: Beacon, 1986.

Bruneau, Marie. *Women Mystics Confront the Modern World*. New York: State University of New York Press, 1998.

Capaldi, Gina. *Red Bird Sings: The Story of Zitkala-Ša, Native American Author, Musician, and Activist*. Minneapolis: Millbrook, 2011.

Clark, Ella, and Margo Edmans. *Sacajawea of the Lewis and Clark Expedition*. Berkeley: University of California Press, 1979.

"Declaration of Independence: A Transcription." National Archives and Records Administration. Accessed December 1, 2019. https://tinyurl.com/h2zqchv.

Densmore, Christopher, Carol Faulkner, Nancy Hewitt, and Beverly Wilson Palmer, eds. *Lucretia Mott Speaks: The Essential Speeches and Sermons*. Urbana: University of Illinois Press, 2017.

Deval, Patrick. *American Indian Women*. New York: Abbeville, 2014.

55. Mankiller, *Every Day Is a Good Day*, 5–6.
56. Joy Harjo, *An American Sunrise: Poems* (New York: Norton, 2019), title page.

Faulkner, Carol. *Lucretia Mott's Heresy: Abolition and Women's Rights in Nineteenth-Century America*. Philadelphia: University of Pennsylvania Press, 2011.

Gage, Matilda Joslyn. "The Remnant of the Five Nations: Woman's Rights among the Indians." *Evening Post* (New York, [N.Y.]). September 24, 1875. New York Historical Newspapers. Accessed January 22, 2020. https://tinyurl.com/vd2r3g2.

Harjo, Joy. *An American Sunrise: Poems*. New York: Norton, 2019.

Harris, Alexandra, and Tim Johnson, eds. *The Haudenosaunee Guide for Educators*. Washington DC: National Museum of the American Indian Education Office, 2009.

Keppler, Joseph. *Savagery to "Civilization."* Puck 75 (May 16, 1914).

Kidwell, Clara Sue, Homer Noley, and George E. Tinker. *A Native American Theology*. Maryknoll, NY: Orbis, 2001.

Kugel, Rebecca, and Lucy Eldersveld Murphy, eds. *Native Women's History in Eastern North America before 1900: A Guide to Research and Writing*. Lincoln: University of Nebraska Press, 2007.

Lewandowski, Tadeusz. *Red Bird, Red Power: The Life and Legacy of Zitkala-Ša*. Norman: University of Oklahoma Press, 2016.

MacLeod, D. Peter. *The Canadian Iroquois and the Seven Years' War*. Toronto: Dundurn, 2012.

Mankiller, Wilma. *Every Day Is a Good Day: Reflections by Contemporary Indigenous Women*. Golden, CO: Fulcrum, 2004.

Nies, Judith. *Native American History: A Chronology of the Vast Achievements of a Culture and Their Links to World Events*. New York: Ballantine, 1996.

Nordell, Jessica. "Millions of Women Voted This Election. They Have the Iroquois to Thank." *Washington Post*. November 24, 2016. https://tinyurl.com/vjhrp8v.

Raymond, Ken. "Wilma Mankiller: A Legend 'In Her Own Time.'" *The Oklahoman*. April 7, 2010. https://tinyurl.com/rvg6mea.

"Report of the Woman's Rights Convention." Rochester, NY: North Star Printing Office, 1848. On National Park Service. Accessed January 21, 2020. https://tinyurl.com/ydahhbgr.

"Sacagawea Statues." National Park Service. Accessed January 21, 2020. https://tinyurl.com/qqnatmm.

Stanton, Elizabeth Cady. "The Matriarchate, or Mother Age." In *The Women's Suffrage Movement*, edited by Sally Roesch Wagner. New York: Penguin, 2019.

Stanton, Henry B. *Random Recollections*. New York: Macgowan and Slipper, 1886.

Steinem, Gloria. Introduction to *Every Day Is a Good Day*, by Wilma Mankiller.

Trigger, Bruce. *Natives and Newcomers: Canada's "Heroic Age" Reconsidered*. Montreal: McGill-Queen's University Press, 1985.

Wagner, Sally Roesch. *Sisters in Spirit: Haudenosaunee (Iroquois) Influence on Early American Feminists*. Summertown, TN: Native Voices, 2001.

———. *The Untold Story of the Iroquois Influence of Early Feminists*. Aberdeen, SD: Sky Carrier, 1996.

———, ed. *The Women's Suffrage Movement*. New York: Penguin, 2019.

6. Power to Vote, No Power to Protect

SOPHIA PARK

Lisa Wingate, in her historical fiction book *Before We Were Yours*,[1] tells the haunting story of the forced separation of a family living in a squalor boat on the southern end of the Mississippi River. Wingate bases the story on a real-life scandal that occurred in Memphis through the agency of the Tennessee Children's Home Society Orphanage in 1939. According to a 1950 state investigation, thousands of poor children had been abducted by Georgia Tann, the director of the orphanage, and sold to wealthy families all over the country in collusion with legal, medical, and police support. In Wingate's book, Rill, a twelve-year-old and the oldest of five siblings, is put in charge of looking after the younger ones on a stormy night as her parents, Queenie and Briny, rush to the hospital due to complications in labor with a pair of twins. Shortly after the parents leave, a group of police officers climb aboard their shanty boat and forcefully take Rill and her younger siblings. They are able to do this because Briny, the husband and father, unwittingly has signed away the children, thinking he is paying for the hospital bill. During this forced separation, Wingate vividly records the wrenching account of Rill and her siblings being ripped away from all they know and love, and Rill's determination, albeit unsuccessful, to keep her sisters and brother together.

 Though Wingate's writing is emotionally compelling, I was left wondering about Queenie, the mother, whose children are forcefully and permanently taken away from her. Because the account of Queenie is largely absent in the story, as a woman and a mother, I was left to wonder what a mother's experience of forced separation from her children would have been like. What would be going through Queenie's mind the moment she finds out her children were kidnapped? How would she feel and how can any mother go on living without knowing the whereabouts and the safety of her children? These questions lingered in my mind. I imagined desperation, determination

1. Lisa Wingate, *Before We Were Yours* (New York: Ballantine, 2017).

to find them, and the devastation that sets in when she realizes she will never know.

Queenie's heartbreaking story of forced separation from her children, unfortunately, is neither unique nor a thing of the past. Many different examples exist, such as when a newborn with a physical imperfection was declared dead to the mother but secretly sent away to an adoption agency, coordinated by the family and hospital authorities, or the collective abuse of government and agency powers, as in Wingate's historical novel. For centuries and even now, many "Queenies" abound in different countries, clothed in different stories. And at a time when the progress for women's greater political power is being celebrated, it is important to note the paradox of vast numbers of mothers rendered powerless to even keep and protect their own children. In other words, while numerous women, many of whom are also mothers, have been proudly using their power to cast votes and are celebrating this historic moment of the one-hundredth year of women's voting rights in the United States, some others, even within the same neighborhoods, are suffering the traumatic effects of losing their own living child or children, unable to exercise any power to prevent it. While this has been a sad reality on the southern border of the United States, this paper's focus is not on the legal or the illegal status of the mothers who have experienced forced separation or whether these acts to separate are justified or not. I am a mother and a new citizen with the power and the responsibility to vote in the United States. Seeing the recent forced separation of mothers and children, and learning of similar stories throughout generations and across borders, has prompted me to reflect on the role, the meaning, and the implications of my vote.

Women's rights have come a long way through the tireless work of activists and advocacy groups giving speeches, signing petitions, marching in parades, and seeking to empower and give voting rights to the future generations of women. While we celebrate the hundredth year of women's suffrage by paying homage to our foremothers and forefathers who have worked so hard, it is a good time to pause and look around to see who has been left behind. At this point in history, after one hundred years of women exercising the right to vote in the United States, what are we now celebrating? Who is throwing the celebration party and which group of women has the privilege of inviting "others" into the celebration? Having recently become the beneficiary of the work of women activists by acquiring the right to vote and join in the celebration, I wonder about how much women's suffrage has made a

difference for minority women and for socioeconomically vulnerable women who still feel powerless and even oppressed. How can we include *all* women, especially those who have felt powerless to protect their children, in the celebration? More importantly, how can we empower these women to gain a sense of power in and feel joyful about the meaning of women's suffrage?

Washington, DC: "Mr. President, what will you do for woman suffrage?" 1917.

It is inconceivable to think that exercising one's maternal love and mother's instinct to protect the children one bore should even need to be considered a "right." To have the right to vote is to exercise one's own civic power. However, when one cannot keep and protect one's children, what is the significance of suffrage in one's life? What does the right to exercise one's power mean for these mothers when they do not have the right to protect their children? What is the moral and ethical obligation of those of us who are celebrating women's suffrage to these mothers and to the next generation of women who will honor the work of the activists for women's suffrage? Voting means having a right to exercise civic power. Even though the word *voting* is mainly used in the realm of political decision-making, I want to propose an expansion of the implication of the word to include having the right to exercise decision-making power in regard to the well-being of oneself and one's child. As in the true account of Queenie and her children, women should have legal entitlement and power to protect their children and to pre-

vent forced separation. In support of granting and restoring decision-making power for all women, for the well-being of oneself and one's children, we, as women, can work together to create for every powerless woman "spaces of appearance"—a term coined by Hannah Arendt meaning social conditions where women on the fringes of society are moved to the center to gain social and political recognition, where her dignity is valued, her agency respected, and her decisions accepted.

Traumatic Effects of Forced Separation on Mothers

Mothers conceive and physically carry children to term in their wombs.[2] In addition to the physical connection of mother and child, a symbiotic bond is formed in the womb, where fetuses have been found to develop preferential responses to maternal scents and sounds that persist after birth.[3] The tendency to imprint led John Bowlby to conclude that both children and mothers (maternal instinct) are biologically programmed to seek and remain close to attachment figures in order to survive and perpetuate the species. Sticking close to a caregiver ensures that the child's needs are met and that they are protected from dangers in the environment. Bowlby emphasizes the "strong, causal relationship between an individual's experiences with his parents and his later capacity to make affectional bonds."[4] Acquiring a "secure base" is important for the healthy development of self-esteem and eagerness to learn and trust, and thus, it is crucial for an individual's psychological, cognitive, neurobiological, and social development.[5] Bowlby's Attachment Theory also highlights the importance of nurturing a strong attachment between caregiver and child.

Research continuously supports findings that withdrawing maternal support early in a child's life can have a number of physiological and behavioral

2. I also acknowledge that one can become a mother by different means: e.g., adoption, fostering, and guardianship.
3. "How Mother-Child Separation Causes Neurobiological Vulnerability into Adulthood," Association for Psychological Science, June 20, 2018, https://tinyurl.com/vgpf7wx.
4. John Bowlby, "The Making and Breaking of Affectional Bonds: Aetiology and Psychopathology in the Light of Attachment Theory," British Journal of Psychiatry 130 (1977): 206.
5. Mary D. Ainsworth, Mary C. Blehar, Everett Waters, and Sally Wall, Patterns of Attachment: A Psychological Study of the Strange Situation (Hillsdale, NJ: Erlbaum, 1978), 80.

consequences that may contribute to a complex, changing pattern of vulnerability over the lifespan. Bowlby adds that "chronic anxiety, intermittent depression, attempted or successful suicide are some of the more common sorts of troubles related to such experiences" and that "prolonged or repeated disruptions of the mother-child bond during the first five years of life are known to be especially frequent in patients later diagnosed as psychopathic or sociopathic personalities."[6] In a report on behalf of the World Health Organization, Bowlby concludes that the greater the degree and length of the separation/disruption, the more there is potential for irreversible damage.[7]

While most research has focused on the effects of forced separation on children, mothers/caregivers suffer greatly as well. Responding to the recent forced separation of parents and children at the southern border of the United States due to policy change, Stanford's psychiatry department put forth the "Statement on the Impact of Parent-Child Separation on Parents' Ability to Effectively Participate in Asylum Proceedings" to address "the impact that trauma has on child development and family functioning."[8] The statement addresses the research findings that ruptures in parent-child attachment due to experiences such as trauma, loss, and separation are associated with significant parental/caregiver distress and impairment in functioning.[9] The statement also includes the effects of "inherent uncertainty," where the parents may experience "ambiguous loss," as there is no certainty that their child will return the way she or he used to be, or in some

6. Bowlby, "The Making and Breaking of Affectional Bonds," 127.
7. John Bowlby, *Maternal Care and Mental Health: A Report Prepared on Behalf of the World Health Organization as a Contribution to the United Nations Programme for the Welfare of Homeless Children*, 2nd ed. (Geneva: World Health Organization, 1952), 52.
8. Victor Carrion et al., "Statement on the Impact of Parent-Child Separation on Parents' Ability to Effectively Participate in Asylum Proceedings," Stanford Medicine, accessed November 19, 2019, https://tinyurl.com/usep22p.
9. John Bowlby, "The Influence of Early Environment in the Development of Neurosis and Neurotic Character," *International Journal of Psycho-Analysis* 2 (1940): 1–25; Godfrey F. Glasgow and Janice Gouse-Sheese, "Theme of Rejection and Abandonment in Group Work with Caribbean Adolescents," *Social Work Groups* 17, no. 4 (1995): 3–27; Maite P. Mena et al., "Extended Parent-Child Separations: Impact on Adolescent Functioning," *Journal for Specialists in Pediatric Nursing* 13, no. 1 (2008): 50–52; Carola Suárez-Orozco, Hee Jin Bang, and Ha Yeon Kim, "I Felt Like My Heart Was Staying Behind: Psychological Implications of Family Separations and Reunifications for Immigrant Youth," *Journal of Adolescent Research* 26, no. 2 (2008): 222–57.

cases, such as for Queenie, that children will return at all.[10] In such cases, "since the loss cannot be reconciled with the uncertainty, the grief process is frozen."[11] One can imagine the heartache for Queenie and the impossibility of grieving when the whereabouts or the safety of her children are unknown. This leads to experiencing significant loss of control and helplessness, which exacerbates trauma-related distress and negative psychological outcomes.[12] These trauma-related psychological symptoms include unwanted memories, avoidance of trauma reminders, difficulty concentrating, hypervigilance, and negative mood instability, including depression, anxiety, and disassociation. Experiencing one or more of such symptoms "may result in failing to provide important and relevant details to support their cases, negatively impacting their ability to provide comprehensive and compelling information in asylum proceedings."[13] Even for mothers/caregivers who do not go through asylum proceedings, their capacity to cope and make decisions is significantly impaired.

Traumatic stress, such as forced separation from one's children, extends to experiencing significant repercussions for neurobiological and physiological functioning. According to Ulrich-Lai and Herman, when people experience a stressor, all resources, physiological and emotional, are diverted to responding to the stressor.[14] The human brain, adjusting to survival mode, goes into lockdown while the body focuses on maintaining safety. When this happens, executive functioning, or the ability to solve problems, evaluate consequences, and make decisions, is particularly vulnerable to the effects of stress.[15] Navigating the whereabouts of her children while taking care of her newborn twins and dealing with the effects of trauma stress most likely would have prevented Queenie from being a mother who could meet the attachment needs of her remaining children. As research shows, the trauma of being in forced separation brings on devastating and long-lasting

10. Pauline Boss, *Family Stress Management: A Contextual Approach*, 2nd ed. (Thousand Oaks, CA: Sage, 2002), 71.
11. Carrion et al., "Statement," 2.
12. Julian D. Ford et al., *Posttraumatic Stress Disorder: Scientific and Professional Dimensions*, 2nd ed. (San Diego: Academic Press, 2015), 81-132.
13. Carrion et al., "Statement," 4.
14. Yvonne M. Ulrich-Lai and James P. Herman, "Neural Regulation of Endocrine and Autonomic Stress Responses," *Nature Reviews Neuroscience* 10 (2009): 397-409.
15. Amy F. T. Arnsten, "Stress Signaling Pathways That Impair Prefrontal Cortex Structure and Function," *Nature Reviews Neuroscience* 10 (2009): 410-22.

effects to mothers/caregivers that diminish their functioning and prevent their flourishing. Furthermore, Queenie's trauma would not only diminish her own flourishing but could also have compounding effects that diminish the health and flourishing of the future generations.

As a woman, a mother, and a fellow human being, I am troubled by the reality of forced separation and the resulting detrimental effects that reverberate. While it is easiest to feel helpless and offer sympathy and prayer, more can be done. Just as the trauma experienced by one mother can negatively impact those around her, including those whom she cares for and on down through the generations, one woman's health and flourishing can reverberate and affect another—even multitudes—such that the collective health of society can uphold and support the flourishing of all women. Although individually I cannot heal all women, through my own health and flourishing I can have a positive impact on the women within my reach. In the same way, as members of society, we can collectively foster environments, structures, and systems in which no mothers need experience forced separation from their children, and wherein all are held and supported to flourish, to have their dignity respected and their agency restored.

Collective Empowerment and "Spaces of Appearance"

While change can happen through individual actions, women's suffrage has provided a larger platform on which to garner collective power to initiate change. María-José Rosado-Nunes, a renowned researcher on women and religion, writes on the efforts of women activists who have "set out to affirm rights and individual liberties by proclaiming that women, as social subjects, are citizens, with the right to interfere in the political sphere of society; and that they, as individuals, have the right to control their own sexuality and reproductive capability."[16] However, I believe this doesn't go far enough. I would argue for the addition of the right to keep and protect the child that has been born to her. This effort can be better accomplished through collective action.

16. María-José Rosado-Nunes, "Catholicism and Women's Rights as Human Rights," in *The Rights of Women*, ed. the Concilium Foundation (London: SCM, 2011), 54.

Collective action as women protest: "No self respecting women should wish or work for the success of a party that ignores her sex." –Susan B. Anthony, 1872.

Pastoral theologian Ryan LaMothe, who writes on the topic of political theology in his book *Care of Souls, Care of Polis*, expands the focus of pastoral theology from a micro perspective of care for individuals to the macro, or the larger political framework, and locates it within the framework of care and justice. He advocates for the need to address the "systemic political-economic and social forces and structures that are implicated in individu-

als' particular sufferings" but are often overlooked.[17] While emphasizing the political nature of pastoral theology, LaMothe puts the focus of political action on the benefit and flourishing of humans and emphasizes the primordial—that is, Macmurray's idea that the "'state is merely a mechanism'" with "'no value in itself'" but "is assessed in terms of whether it facilitates the sharing of human experience, acting together, and the flourishing of its citizens—the common good."[18] Informed by the Christian tradition, human sciences, and his own commitment to social justice and advocacy, LaMothe expands on the notions of care and justice for political action "aimed at the survival, flourishing, and liberation of individuals, communities, society and the earth."[19]

Hannah Arendt, a German-American political theorist from the early twentieth century, writes about the polis not as the political institution of the Greek city-states, as was commonly understood, but rather as the "organization of the people as it arises out of acting and speaking together, and its true space lies between people living together for this purpose, no matter where they happen to be."[20] She expounds on developing political power by tapping into the power that can be amassed by the polis. In doing so, she develops the concept of polis into "space of appearance." This is a potential political space where a person is not only a number but gains power as part of a significant number of people. She explains spaces of appearance as spaces "where I appear to others as others appear to me, where men [sic] exist not merely like other living or inanimate things but make their appearance explicitly."[21] For her, such public spaces of appearance are constantly recreated wherever individuals gather together politically—that is, "wherever men [sic] are together in the manner of speech and action."[22] The nature of the space of appearance is fragile and temporary as it can only become actu-

17. Ryan LaMothe, *Care of Souls, Care of Polis: Toward a Political Pastoral Theology* (Eugene, OR: Cascade, 2017), 2.
18. LaMothe, *Care of Souls*, 7, quoting from John Macmurray, "The Conception of Society," in *John Macmurray: Selected Philosophical Writings*, ed. Esther McIntosh (Exeter: Imprint Academic, 2004), 106.
19. LaMothe, *Care of Souls*, 29.
20. Hannah Arendt, *The Human Condition*, 2nd ed. (Chicago: University of Chicago Press, 1958), 198.
21. Arendt, *The Human Condition*, 198–99.
22. Arendt, *The Human Condition*, 199.

alized through words and actions when people are gathered. "Its peculiarity," as Arendt says,

> is that . . . it does not survive the actuality of the movement which brought it into being, but disappears not only with the dispersal of men [sic]—as in the case of great catastrophes when the body politic of a people is destroyed—but with the disappearance or arrest of the activities themselves. Wherever people gather together, it is potentially there, but only potentially, not necessarily and not forever.[23]

For Arendt, this capacity to act together for a public-political cause is what she names "power." For her, power is the property not of an individual but of a plurality of actors joining together for some political purpose with the outcome of collective engagement and based on consent.[24] Arendt states that "power springs up whenever people get together and act in concert."[25] Thus, power is consolidated whenever the space of appearance is created. Indeed, for Arendt, power is "what keeps the public realm, the potential space of appearance between acting and speaking men [sic], in existence" and is always "a potential and not an unchangeable, measurable and reliable entity like force or strength. . . . it springs up between men [sic] when they act together and vanishes the moment they disperse."[26] As a space of appearance gathers greater power through collective action of numbers of people, it speaks to the importance of active involvement to utilize the potential power from within the polis.

In the Greek city-state, women and children were recognized as belonging to the polis but not as citizens who could engage in the public-political space. Barbarians and slaves likewise were recognized but not as citizens. Thus, women and slaves were deemed to be on the fringe, having no political power. In the United States one hundred years ago, even though women were recognized as citizens and as belonging to the polis, they were not given political power to be in the center of public-political space but were on the fringes of society. By obtaining the right to vote, women have moved into the public-political space. However, not all women can go to the center.

23. Arendt, *The Human Condition*, 199.
24. Hannah Arendt, *Crises of Republic* (Orlando: Harcourt Brace & Co, 1972), 143–55.
25. Arendt, *Crises of Republic*, 151.
26. Arendt, *The Human Condition*, 200.

There remain some women, even some with citizenship, who are on the fringes, lacking power even to prevent being forcefully separated from their children. With enough voices and the power of women in the center of public-political space, political power through the space of appearance can be created to foster environments and societal structures and systems that respect women's agency, restore their dignity, and support the flourishing of mothers and their children.

Power can be found in action, but greater power can be found with greater numbers. Power, then, lies at the basis of every political community and is the expression of a potential that is always available to people.[27] Collective gathering and action on the part of women can turn potential power into actual power and create a space of appearance. Collective action, whether through voting, protests, or other social advocacy means, will continue to propel the space of appearance into existence. As with a fire that grows and wanes, collective actions fan the flame needed to keep the space of appearance alive. Collective power is needed to bring change.

The space of appearance, according to Arendt, is the collective power created through political voices and actions to effect change. However, I want to expand the term beyond the appearance of collective power through numbers of people in action to include the power garnered for every woman to "appear" to herself and others, to be seen, to belong, and to have a voice, regardless of citizenship. In other words, I am enlarging the meaning of *space of appearance* to include conditions that can enable vulnerable mothers to come into full presence to self and others, with full dignity and full agency. It is the work of collective power to create conditions in which every mother on the fringes can "appear" in ways as basic, but important, as having her presence seen and acknowledged, her dignity respected, and her decisions accepted. Small gestures that create empowering conditions where she can exercise her right to decide on her own welfare and that of her child will cause ripple effects, enabling the "appearance" of future generations and their flourishing. A mother's "salvation"—the movement from darkness to light, from invisibility to presence, and from voicelessness to agency—is passed through generations, bringing "salvation" to many others.

27. Maurizio Passerin d'Entreves, "Hannah Arendt," *The Stanford Encyclopedia of Philosophy*, ed. Edward N. Zalta, Fall 2019, http://tinyurl.com/vxc2ho8.

Mary, Mother of God, and Space to Appear

An example can be found in the story of Mary, the mother of Jesus. Through Mary, in the birth of her son Jesus, salvation is given to many others because she is first given the power to decide whether to carry a child out of wedlock. She exercises this power. Looking closely at the infancy narrative in the Gospel of Luke as interpreted by Hak C. Kim, we will see how God, through the angel Gabriel's visit with Mary, creates the conditions for the space of appearance where Mary's dignity is respected, her agency is valued, and she is free to exercise the power to choose.[28]

Mary is an ordinary young woman living in a patriarchal culture in the region of Palestine and engaged to be married to a man named Joseph. She is neither wealthy nor powerful. Rather, she describes herself as among the lowest of God's maidservants (Luke 1:48 NRSV). She is from Nazareth in Galilee, a remote and insignificant city far from privilege and power. Mary is one of two persons in Luke's Gospel visited by Gabriel, an angel of the Lord. He first visits Zechariah, a priest in the order of Aaron, to announce that his wife, Elizabeth, will bear a son in her advanced age. An undisclosed amount of time later, Gabriel visits Mary and proceeds to tell of "God's universal plan of salvation at Luke 1:30-33."[29] Mary is confused by this statement. The angel, maybe sensing her fear, says, "Do not be afraid, Mary, for you have found favor with God" (1:30). Kim explains that as Gabriel continues to relay God's message, a dialogue takes place between him and Mary.[30] Mary is puzzled and asks, "How can this be, since I am a virgin?" (1:34). Gabriel explains how God will fulfill God's plan (1:35) and adds, "For nothing will be impossible with God" (1:37).

Kim compares Gabriel's approach to Zechariah and to Mary.[31] While the angel announces the birth of John to Zechariah—not Elizabeth—Mary's full presence is acknowledged by Gabriel's visit to her directly. Gabriel respects Mary's dignity and awaits her response. Mary uses her own agency and accepts God's proposition by replying, "Here am I, the servant of the Lord; let it be with me according to your word" (1:38). In other words, conditions

28. Hak C. Kim, "Luke's Soteriology: A Dynamic Event in Motion" (PhD dissertation, University of Durham, 2008).
29. Kim, "Luke's Soteriology," 31.
30. Kim, "Luke's Soteriology," 31–32.
31. Kim, "Luke's Soteriology," 31–32.

were created to give Mary, a vulnerable woman and a lowly maidservant of God, space to "appear," to come into her full presence with full dignity, and empowering her to use her full agency to choose. Kim contrasts this with Gabriel's approach to Zechariah: Not only does Mary have her own voice, but God does not force her to do anything or simply inform her of what will happen. Rather, God invites her to participate in the decision-making process regarding the coming of Jesus.[32] In implementing God's plan to save God's people, God respects Mary's dignity and her right to choose what will happen to her body. Then, when Mary has given her acceptance, the angel leaves her (1:38). Not only is Mary's dignity valued and her agency recognized in this encounter, but through her decision, she and her future generations are moved from darkness, to light; from invisibility, to presence; from enslavement to sin, to becoming sons and daughters of God.

In Mary's story we see that through the angel Gabriel's—indeed through God's—creation of a space of appearance for a lowly and vulnerable woman, she came to fully "appear" when empowering conditions were created. The encounter that respected her dignity and valued her agency empowered her to make a choice that changed the course of her life and that of future generations.

Unfortunately, the space of appearance was not created for Queenie. Instead, the social, political, legal, and medical network involved with the Memphis-based adoption organization that kidnapped and sold poor children to wealthy families all over the country took advantage of her situation and exploited her and her children for financial gain. Their reduction of the space of appearance meant that Queenie's and her children's inviolability and uniqueness were disregarded, resulting in failures in both care and justice.[33] The care and justice that can flow through the space of appearance failed to materialize, thus resulting in forced separation and deep suffering.

Queenie's story is not unique but is one of many that continue to flood our eyes and ears, stories to which we have unfortunately become quite immune. However, every voice and action on behalf of justice will contribute to collectively keeping the flame of the space of appearance alive to create empowering conditions in which every woman can appear and participate fully in her life and in the lives of her children. Obtaining the right to vote has trans-

32. Kim, "Luke's Soteriology," 31.
33. LaMothe, *Care of Souls*, 76.

ported women into the center of the public-political stage. Through collective power, a space of appearance can be created for every mother on the fringes to be seen, her plight heard, and her decisions about her child's welfare respected. Let us pass the power on to the fringes, letting it flow to move each woman and her children from invisibility to empowerment, from powerlessness to agency, from suffering to hope. We can truly celebrate when all women, including mothers holding their children, can flourish *and* stand on the public-political stage.

Bibliography

Ainsworth, Mary D., Mary C. Blehar, Everett Waters, and Sally Wall. *Patterns of Attachment: A Psychological Study of the Strange Situation*. Hillsdale, NJ: Erlbaum, 1978.

Arendt, Hannah. *Crises of Republic*. Orlando: Harcourt Brace & Co, 1972.

———. *The Human Condition*. 2nd edition. Chicago: University of Chicago Press, 1958.

Arnsten, Amy F. T. "Stress Signaling Pathways That Impair Prefrontal Cortex Structure and Function." *Nature Reviews Neuroscience* 10 (2009): 410–22.

Boss, Pauline. *Family Stress Management: A Contextual Approach*. 2nd edition. Thousand Oaks, CA: Sage, 2002.

Bowlby, John. "The Influence of Early Environment in the Development of Neurosis and Neurotic Character." *International Journal of Psycho-Analysis* 2 (1940): 1–25.

———. "The Making and Breaking of Affectional Bonds: Aetiology and Psychopathology in the Light of Attachment Theory." *British Journal of Psychiatry* 130 (1977): 201–10.

———. *Maternal Care and Mental Health: A Report Prepared on Behalf of the World Health Organization as a Contribution to the United Nations Programme for the Welfare of Homeless Children*. 2nd edition. Geneva: World Health Organization, 1952.

Carrion, Victor, Hilit Kletter, Ryan Matlow, Daryn Reicherter, Helen Wilson, Michael Hamilton, and Alex Lugo. "Statement on the Impact of Parent-Child Separation on Parents' Ability to Effectively Participate in Asylum Proceedings." Stanford Medicine. Accessed November 19, 2019. https://tinyurl.com/usep22p.

d'Entreves, Maurizio Passerin. "Hannah Arendt." *The Stanford Encyclopedia of Philosophy*. Edited by Edward N. Zalta. Fall 2019. https://tinyurl.com/vxc2ho8.

Ford, Julian D., Damion J. Grasso, Jon D. Elhai, and Christine A. Courtois. *Posttraumatic Stress Disorder: Scientific and Professional Dimensions*. 2nd edition. San Diego: Academic Press, 2015.

Glasgow, Godfrey F., and Janice Gouse-Sheese. "Theme of Rejection and Abandonment in Group Work with Caribbean Adolescents." *Social Work Groups* 17, no. 4 (1995): 3–27.

"How Mother-Child Separation Causes Neurobiological Vulnerability into Adulthood." Association for Psychological Science. June 20, 2018. https://tinyurl.com/vgpf7wx.

Kim, Hak C. "Luke's Soteriology: A Dynamic Event in Motion." PhD dissertation, University of Durham, 2008.

LaMothe, Ryan. *Care of Souls, Care of Polis: Toward a Political Pastoral Theology*. Eugene, OR: Cascade, 2017.

Macmurray, John. "The Conception of Society." In *John Macmurray: Selected Philosophical Writings*, edited by Esther McIntosh, 95–108. Exeter: Imprint Academic, 2004.

Mena, Maite P., Victoria B. Mitrani, Carol A. Mason, Jonathan A. Muir, and Daniel A. Santisteban. "Extended Parent-Child Separations: Impact on Adolescent Functioning and Possible Gender Differences." *Journal for Specialists in Pediatric Nursing* 13, no. 1 (2008): 50–52.

Rosado-Nunes, María-José. "Catholicism and Women's Rights as Human Rights." In *The Rights of Women*, edited by the Concilium Foundation, 50–63. London: SCM, 2011.

Suárez-Orozco, Carola, Hee Jin Bang, and Ha Yeon Kim. "I Felt Like My Heart Was Staying Behind: Psychological Implications of Family Separations and Reunifications for Immigrant Youth." *Journal of Adolescent Research* 26, no. 2 (2008): 222–57.

Ulrich-Lai, Yvonne M., and James P. Herman. "Neural Regulation of Endocrine and Autonomic Stress Responses." *Nature Reviews Neuroscience* 10 (2009): 397–409.

Wingate, Lisa. *Before We Were Yours*. New York: Ballantine, 2017.

7. Caring for Victims of Human Trafficking: A Contemporary Example of Emancipation

FRANCESCA DEBORA NUZZOLESE

One hundred years ago some women in some parts of the world accessed their right to vote. Others, in many other parts of the world, continued to struggle for their rights not only to vote but also to fulfill their basic human potential. Envisioning what is next for women in the twenty-first century involves paying attention to those women, in particular, who are still caught in systems of injustice and inequality and becoming companions on their journey so that together one day we might claim emancipation for all.

For the past fifteen years I have been involved in the antitrafficking movement in the roles of psychotherapist, educator, and researcher. Therapeutic work with victims of sexual trauma and scholarly attention to issues of gender, violence, and socioeconomic vulnerability have pulled me particularly in the direction of sex trafficking and sexual exploitation of women and children around the world. My commitment to understanding the complexity of this phenomenon and to contributing to its eradication has led me on many professional paths, both metaphorically and literally, where I have encountered remarkable human beings. Many of them have become respected friends and colleagues who stand out as contemporary heroes and heroines in the battle against dehumanizing and exploitative practices. While their contribution and names don't make the headline news—for the safety and protection of all involved—they tend to do cutting-edge, transformative work on behalf of some of the most vulnerable individuals and communities in our world. With very little funding and support, and in the most unlikely places, these contemporary visionaries manage to accomplish miracles because of their commitment to walk the difficult paths of human change, transforming vulnerability into resilience, oppression into resistance, woundedness into wholeness.

AN UP-TO-DATE SUFFRAGETTE.

A caricature that sexualizes, degrades, and ridicules the position of suffragettes. British postcard. Original.

1828 JOSEPHINE BUTLER 1928
1828–1906

Elizabeth Fry 1780–1845 — Florence Nightingale 1820–1910

A NATIONAL CENTENARY MEMORIAL TO A GREAT PIONEER

An Appeal to Thinking Men and Women

JOSEPHINE BUTLER was one of the world's great women. A fearless pioneer, she gave tirelessly of her life to grappling with a world problem which few cared either to understand or to investigate.

TO-DAY men and women have come to reverence her name and the work which dominates her memory. She fought for the hopeless, the helpless, the homeless, the outcast, the despised.

JOSEPHINE BUTLER had the clearest conception of the nature of moral and civil liberty.

OF ALL the illustrious women whom the Victorian age in England produced, she probably touched, and in retrospect still touches, the national life at the greatest number of points.

JOSEPHINE BUTLER suffered that justice might be done even to the least and the worst. She kindled a light which is now beginning to shine throughout the world. Fifty-six Governments associated with the League of Nations have this year attached their seals to a document which is a lasting monument to the courage and faith which inspired her magnificent crusade. Yet the Regulation system still continues in varying forms in many parts of the world.

THIS YEAR, therefore, the centenary of her birth, it is fitting to do honour to her memory. Public opinion has still to be educated to the point that there can be but one moral standard—and that this must voluntarily be kept—for the physical as well as the moral well-being of the community.

THE MEMORIAL FUND will establish on a sound basis the Josephine Butler Memorial House, and the Association for Moral and Social Hygiene, which are continuing the task she so nobly inaugurated.

MAY WE beg all who honour Josephine Butler's memory, and who recognise the vital necessity for her work to be carried forward, to respond generously to this Memorial Appeal?

DONATIONS, and offers to help and to speak, should be sent to Lady Ravensdale, Chairman, Josephine Butler Appeal, 6A, Blomfield Road, London, W.9.

The JOSEPHINE BUTLER £40,000 APPEAL

President: THE RT. HON. THE VISCOUNT ASTOR. *Chairman*: THE BARONESS RAVENSDALE
Treasurer: SIR WILLIAM McCLINTOCK, K.B.E., G.V.O. *Organising Secretary*: Miss Adeline Bourne.

The first postcard was printed in Britain, but it is representative of the way the move to empowerment by women is often sexualized, degraded, and dismissed. You see a jeering passenger grab the leg and pantaloon of an "up-to-date" suffragette as he looks up at a caricature of a suffragette.

Building on the legacy of some of the visionary women of the past, such as Josephine Butler, who promoted social reform for women and advocated for education and equality, this chapter introduces the contribution of a few contemporary women who work closely with victims and survivors of human trafficking to accompany them on their long journeys toward healing and wholeness. Relying on direct interviews and firsthand knowledge of their organizations and projects, I present the values and theologies that sustain these women's work and showcase their pursuits as legitimate expressions of *contemporary emancipatory practices.*

Contextualizing Antitrafficking Work

The trafficking of human beings for sexual and labor exploitation is one of the most lucrative businesses in our time and age, second only to the smuggling of drugs and weapons.[1] Its international and domestic reach in the most public and private spheres of our life and its reliance on globalized economies and human greed render it one of the most disturbing and complex phenomena of our time, a humbling challenge to the most sophisticated humanitarian efforts, secular and Christian alike. The destructive and regressive potential of this industry on the entire human ecosystem is overwhelming and disempowering, therefore eliciting some predictable human responses: denial of its occurrence and magnitude, minimization of its insidiousness, and dismissal of its treacherous impact. Thankfully, not everyone succumbs to these responses. Despite the complexity and apparent intractability of this phenomenon, a spirit of solidarity and radical compas-

1. Given the criminal nature of these industries and operations, it is impossible to accurately quantify the economic toll in terms of underpayment of wages and recruiting fees. It is harder still to measure the actual cost on the *humanity* of exploited individuals and communities. For some reliable statistics, see: "National Human & Sex Trafficking Statistics," Geoffrey G. Nathan Law Offices, accessed November 28, 2019, https://tinyurl.com/y4ar4fpx; "Myths, Facts, and Statistics," Polaris, accessed February 15, 2020, https://tinyurl.com/y7jrk5wp; "Hotline Statistics," National Human Trafficking Hotline, accessed November 28, 2019, https://tinyurl.com/znaoqw2. Particularly helpful is the statistical data provided by the International Labour Organization, which can be found at ILOSTAT, accessed February 3, 2020, https://ilostat.ilo.org/.

sion sprouts within the human community through the commitment of some human beings who choose to walk with those who are caught in this particular predicament. They work relentlessly to move people out of its grip. The work is complicated and challenging, and the results are not always readily recognizable. And yet, antitrafficking practitioners, activists, and advocates engage the work on a daily basis with inspiring determination.

In my professional life, I have had the privilege of encountering many of these special human beings, particularly women, who have taken on the formidable task of tackling the psychospiritual toll that human trafficking has on its victims and survivors. Presenting with rather ordinary and unassuming profiles (at least on the surface), they soon reveal a fierce character and an unquestionable commitment to focus intentionally on this particularly hard-to-care-for group of human beings through nonconventional ministries. Inspired and challenged by such unlikely personalities and uncommon vocational choices, I have often wondered about them. Who are they, truly—these front-liners of the antitrafficking work? What kind of theology propels them? Who and what sustains them? What is the ultimate aim of their ministerial efforts? How does this work impact their daily lives and relationships, their faith, and their theologies? How does their work contribute to the larger agenda of human emancipation and rehumanization?

Bringing these questions to a selected group of six women who lead grassroots organizations around the world has yielded very insightful information about their visionary, risk-taking, and in some ways subversive character; it has also revealed the powerful, healing, and rehumanizing potential of their ministerial efforts. Gathered for the 2019 leadership team meeting of ICAP Global in Chamonix, France, and representing some key regions of the world, such as Europe, North America, Latin America, and Central Asia, these extraordinary women present great diversity in terms of their age, civil status, cultural background, denominational affiliation, professional expertise, and ministerial focus. What they hold in common, however, is an unequivocal sense of calling and clarity of purpose: to engage the predicament of women and girls who are caught in the webs of labor and sex trafficking and to accompany them on the long roads to healing and wholeness.

Ordinary Women with Extraordinary Callings

Developing particular ministerial projects usually takes time, discernment, and collaborative and strategic planning; yet, the impetus to move toward this particular population (i.e., women who are trying to overcome the impact of severe exploitation) does not appear as calculated and rationally pondered. Each of the interviewees' stories refers to a moment in time when "summoning" takes place. Most of them experienced it as a mystical occurrence, activated at the encounter of a keen, empathic soul with a form of oppressive, unjust, and abusive/unnecessary suffering. It is as if witnessing other women's suffering compels the seer to meaningful action. The interviewees attribute this impulse to act on behalf of the suffering other to a distinctive *sense of calling* from the Divine, "to shine the light of Christ in the darkest places of human existence and to embody the gospel mandate to share the good news of Jesus's redeeming love and God's liberating power."[2] Such convictions are at the heart of a particular expression of the Christian faith, known as the Evangelical tradition, out of which countless antitrafficking organizations, projects, and operations are carried out successfully and worldwide.[3]

This distinctive Christian imperative, *the calling* to antitrafficking work, is the most consistent theme emerging from and linking the narratives of these women and providing the impetus for them to move forward against all odds in the direction of radical care. For some of them, this meant standing up against their own denominational and institutional supporters, because at times churches, donors, and denominations prefer to keep issues of faith and spirituality separate from issues of social, political, and economic justice.

2. Courtney Dow in discussion with the author, June 7, 2019. At the time of the interview, Courtney was the director of Out of Darkness, the antitrafficking ministry of Atlanta Dream Center. No longer serving in that capacity, Courtney is currently doing doctoral work at Auburn University.
3. All women interviewed for this paper belong to this particular tradition. It is beyond the scope of this paper to present the controversial and highly criticized involvement of Evangelical Christians in the antitrafficking movement and their particular focus on sexual exploitation (while labor exploitation is more widespread and problematic) on moral rather than justice grounds. For a cursory understanding of this debate, consult the following helpful article: Ruth Graham, "How Sex Trafficking Became a Christian Cause Célèbre," *Slate*, March 5, 2015, https://tinyurl.com/vcnhayx. For a deeper historical contextualization of this issue, consult Yvonne Zimmerman, *Other Dreams of Freedom: Religion, Sex and Human Trafficking* (Oxford: Oxford University Press, 2013).

More than that, there is a propensity to ignore the responsibility we human beings (Christians included!) share in the perpetration of exploitative, greedy, and unjust practices.[4]

"You don't choose to care for victims of human trafficking. You are called to it," affirms Courtney Dow, former director of outreach for Out of Darkness, as she reflects on her own original involvement in antitrafficking work about a decade ago. After spending some time in Thailand and learning about the cost of sexual exploitation, she returned home to the United States to fully immerse herself in the lives and predicaments of women caught in sexual exploitation. Compelled by a personal and theological craving for justice, she discerned that working with this particular group of women would be the best match for her calling because, in her view, "women in the sex trade represent the most obvious victims of a complex, interrelated system of injustices, all piling up particularly on the back of poor, disadvantaged, and deeply vulnerable women."[5]

This sentiment is shared by other leaders in the antitrafficking movement, even though they might have had different ministerial intentions when they stumbled into the intricate webs of human exploitation.

> I started as an activist in university under Marco's leadership, to oppose political injustice, wondering about the role of the church in such political climate. Social issues were pressing, and I didn't know how to reflect on that. Women were being shipped to Japan to work as sexual entertainment for soldiers and coming home in a casket (mysterious death) or with severe emotional and physical problems. I asked God: What can I do here? And the answer came: Reach out to the women in the streets of Manila. They are poor and at risk. I was never fond of the evangelical model of distributing Bible tracts. What I wished to do was befriend them, understand their stories, build relationships, and connect in a very personal way. I could not

4. Elizabeth Gerhardt, in her book *The Cross and Gendercide* (Downers Grove, IL: InterVarsity, 2014), provides a correlation between a theology of the cross and the violent predicament of women around the world, which can help us see more clearly what kind of theology can sustain such sacrificial and courageous responses to the plight of victims of trafficking and abuse.
5. Dow in discussion with the author.

tolerate to see them treated like that . . . to live lives of complete and utter abuse.[6]

Thus Thelma Nambu, one of the founders of Samaritana Transformation Ministries, describes the beginning of her work in the Philippines twenty-seven years ago. With rather little organization or planning but the help of a handful of women from her Bible study, she took on caring for the poorest women in the slums of Manila, raising support for each one of them, compelled to make a difference in their lives, case by case, one woman at a time. The calling to make a difference in these women's lives led her to get a formal theological education, and as a result, she was able to give a theological frame to her work: a ministry of incarnational presence, where the core agenda is to walk alongside women on their way to more constructive choices for life and work.

Thelma's initial nudge became a life-altering experience with profound personal impact as well. She shared, "I personally went on a gradual journey of spiritual transformation, which led me to see the needs of poor women as the most urgent imperative for my life and work, and for the church in the Philippines." Together with her husband, Jonathan, she runs the Samaritana Project, which recently celebrated twenty-five years of successful operations, providing education and professional opportunities for women at risk of exploitation.

Thelma's framing of her sense of calling is echoed by the words of Lauran Bethell, a human trafficking expert and global consultant for International Ministries, the mission agency for American Baptist Churches. Originally assigned to teach English at a Christian boarding school in Thailand, she was "mystically" lured into antitrafficking work, and for years she directed one of the most successful educational centers in Southeast Asia. It all began with seeing and hearing the narratives of dislocation and sexual exploitation of the Thai women she encountered on her way to language school in Bangkok. Lauran says,

> I didn't really choose this. God chose me for this work. The stories I heard were hard to ignore and to make sense of. "I am in prostitution to support my family," the girls would say. "I would do anything else,

6. Thelma Nambu in discussion with the author, June 5, 2019. Thelma is the program director of Samaritana Transformation Ministries in the Philippines.

but I have to sacrifice myself for the sake of my family." The call was irresistible. I had to get involved in this project, the New Life Center, which was being started in the northern part of Thailand. I needed to intervene in the lives of these young girls and help them see their full value in God's sight. It all came together quickly and in some kind of mystical way.[7]

After thirty-five years of ministry in the trenches of antitrafficking work, Lauran's sense of call and clarity of purpose still shine through as she continues to equip, inspire, and consult with antitrafficking practitioners all over the world. "This work is a marathon, not a sprint," Lauran shares. "My new call, for the past twenty years, has been to keep the runners (practitioners) in the race, committed, equipped, nourished, and encouraged."

Extraordinary Callings to Extraordinary Tasks

For each of these women, fulfilling the imperative to enter the complexity of trafficked, dehumanized existence inevitably implies developing a vision for rehumanized life for the women coming out of exploitation as well as for the communities to which they belong. While each geopolitical region presents its own contextual particularities in terms of socioeconomic, cultural, and religious values, some themes emerge congruously in the narratives of these different leaders. Steeped mostly in their theological anthropology, the ministerial objectives they all consider essential to their visions are *healing*, *restoration*, and *empowerment*.[8]

7. Lauran Bethell in discussion with the author, November 4, 2019. Lauran is a global consultant for human trafficking for International Ministries and coordinator and leadership team chair for ICAP Global.
8. Some resources articulating a Christian perspective on antitrafficking work can be found in the works of Glenn Miles and Christa Foster Crawford, who edited both *Stopping the Traffick: A Christian Response to Sexual Exploitation and Trafficking* (Oxford: Regnum Books International, 2014) and *Finding Our Way through the Traffick: Navigating the Complexities of a Christian Response to Sexual Exploitation and Trafficking* (Oxford: Regnum Books International, 2017). These volumes contain the perspectives of many practitioners in the antitrafficking community, who share commitments and visions for wholeness similar to those of the women interviewed for this project.

Healing as Wholeness

Enduring any form of abusive behavior leaves women deeply traumatized, with scars evident on the many levels of their being. These include the psychological, the physical, the relational, and the spiritual realms of existence. The presence of Post-Traumatic Stress Disorder (PTSD) and other life-threatening ailments demands that primary attention be given to the well-being of the person in her or his entirety.[9] No ministry can ignore that, first and foremost, trafficked women deserve and need to be well in their bodies as well as in their surroundings so that they can move toward relational and spiritual wholeness. While this fact might sound like common sense to many, some of the leaders interviewed for this project have had to fight hard to access resources that provide for the physical and psychological needs of the women in their care.

> When they heard that the money was for clinical care of women in prostitution, some of the pastors in my community refused to support the ministry. This was one of the most upsetting moments of my ministry, very discouraging for my soul. Regardless, I had to push through. Our women were poor. They needed care; their children needed food and clean homes to live in.[10]

Thus Mariliana Morales describes her experience when she began reaching out to women in prostitution in the poorest areas of her home country, Chile. Her heart was particularly disturbed by the beyond-desperate conditions in which women were living in many parts of the Latin South, in city centers and rural areas as well as across borders, which they tried to cross in desperation. At the heart of her organization, Fundación Rahab, which she founded and now directs, there is a commitment to provide nutrition, psycholog-

9. The physical and mental health issues faced by trafficked women are severe, and the impact on these women's functioning lasts for life. The issues are usually very hard to address simultaneously, which is one of the reasons any work of intervention and rehabilitation implies multiple organizations working in alliance with each other to provide the holistic care needed. For a detailed list of such issues, refer to "Human Trafficking–Medical Effects on Victims," accessed November 28, 2019, https://tinyurl.com/hezkbv6. For a more comprehensive, clinically sound understanding of the phenomenon, consult Melissa Farley, *Prostitution, Trafficking and Traumatic Stress* (New York: Routledge, 2003).
10. Mariliana Morales in discussion with the author, June 6, 2019. Mariliana is the director of Fundación Rahab in Costa Rica.

ical care, and personal homes as the key elements of a holistic approach to recovery and new life for women in Costa Rica. "Providing women with their own homes is an important step for their healing, but at the same time they need a loving community, where they can relearn what it means to be loved, accepted, and wanted, as beloved daughters of God," Mariliana remarks. "How can they know what healing feels like, if they don't experience basic human and Christian love?"

Everyone involved in antitrafficking work knows firsthand that healing for victims of trafficking, especially sex trafficking, moves on a very circuitous path with myriad twists and turns and many setbacks. An interesting way to conceive of it is as a mysterious wandering in a dark tunnel, with a pinpoint of light somewhere, at times closer, at times in the farthest distance, and sometimes not perceptible at all. Providing spaces for shared experience as well as ongoing, individual therapeutic care is a key ingredient on the road to recovery, along with an environment that is professionally informed and educated about the needs of women suffering from PTSD. The work of therapists, practitioners, friends, family, and the community at large is absolutely foundational to the process of healing. Women leading antitrafficking projects know this better than anyone else. While they might hold important leadership, administrative, and managerial roles, these women never stop being a lifeline of love, compassion, and care to the whole ministerial enterprise, which always includes the women in recovery, their families and communities, and the entire staff who work with them.

Ultimately, attention to the web of relationships around persons who are trafficked shows why healing and wholeness are never an individual and private matter but a collective, communal, interdependent activity, which tends to bring all humans onto the same level. This attentiveness to connection ultimately reminds us that, as we all participate in the predicament of being human, we all stand in need of ongoing grace. Indeed, involvement and immersion in the lives of those who are more obviously wounded and in need of healing tends to be a prime opportunity for each person involved to acknowledge our own particular brokenness and vulnerabilities. Courtney seems to have learned this in depth from her decade of work in outreach, which is the form of ministry she loves the most: "Some of the women I work with are in utter vulnerability, but when I am with them I feel like I can see myself better. They understand grace better than I do. They heal me from my own self-righteousness. With them, I get to learn how to love better, and in these relationships, I discover what salvation is all about." Her remarks

express beautifully the impact of this kind of ministry on the whole human ecosystem, as it exposes any illusion of separation between "victims" and "rescuers," bringing us all into a common, shared experience of vulnerability and responsibility toward the suffering of the world.

Restoration

Prolonged abuse and oppression have the capacity to profoundly distort our self-image, including the increasing inability for us to see ourselves as reflecting the image of God. Central to most Christian ministries is attention to soul and spiritual care, with a clear focus on helping those who have been consistently dehumanized by violent and abusive practices to gain a restored sense of selfhood and personhood. Reclaiming the original imprint of divine love on the human person, the unconditional and utter belovedness for which we were created, is of paramount importance to any process of rehumanization. It is the hallmark of Christian intervention in the broken affairs of the world. In other words, what essentially motivates and drives most of these specific ministerial efforts is the commitment to speak worth and value into the lives of those who have been disfigured by suffering and oppression—in order to restore their *imago Dei* as the essential point of departure for a new life.

Sarah Austin, of NightLight International, speaks with great passion about the restoration of the *imago Dei*:

> At the core of my work is building transformational relationships, relationships that restore the goodness, the beauty, the gifts I see in each woman I work with. I have had a pretty good life, and I struggle with the longing to be *seen*. Imagine women who are never seen for what they are really worth but only for the body part they can sell. I do lots of things at my job . . . but what I personally value the most is the opportunity to see women as God sees them and let them know that this counts more than all their past.[11]

11. Sarah Austin in discussion with the author, June 7, 2019. Sarah is the outreach coordinator of NightLight International.

Sarah is well aware that her job description could distract her from this very important task. As the outreach coordinator, she is responsible for the supervision and education of volunteers and the case management of survivors, who can be very demanding and hard to please with all their endless practical needs. But in both dimensions of her role, she strives to keep a clear vision of what ultimately matters: that women coming out of abuse may know themselves in a different light and that the restoration of their soul and spirit might spearhead their desire for better life choices and opportunities. Sarah says, "Without true restoration, the road backwards is way too easy. That is why my relationships with them are the most important part of my work. If they don't trust that I love and accept them, as Jesus does, my work will amount to little. In the end, they will keep believing the lies inside their heads."[12]

What Sarah seems to be affirming is that in the context of nurturing and loving relationships, people can learn to see themselves differently and experience themselves as capable of those relational tasks necessary for human thriving. Empathy, compassion, trust, mutuality, and generosity can be modeled and practiced in the delicate dance of restoration; that which experiences of trauma, abuse, and violence have taken away, the presence of a committed, caring, and compassionate other can certainly bring back. "Emancipation for women," Sarah concludes, "occurs when they get free from the bondage of the internal lies. It takes a lot of truth, spoken in love, to remove the lies. And I am called to do just that."

Empowerment

Every trajectory of healing contains a strong emphasis on empowerment as "the process of becoming stronger and more confident, especially in con-

12. Sarah's awareness of the intrapsychic impact of exposure to sexual exploitation is confirmed by the narratives of countless survivors who struggle to regain a sense of worth. Particularly insightful in this regard are the works of Holly Austin Smith, *Walking Prey: How America's Youth Are Vulnerable to Sex Slavery* (New York: Palgrave Macmillan, 2014); and Rachel Lloyd, *Girls Like Us: Fighting for a World Where Girls Are Not for Sale* (New York: HarperCollins, 2011). Both authors recount their personal experiences in very powerful ways and place them within a broader psychosocial context, helping readers comprehend the complex and multifaceted journeys of recovery.

trolling one's life and claiming one's rights."[13] General education and vocational/professional training are strongholds of antitrafficking work and one of the more reliable routes for women to break through cycles of economic dependency and bondage. Within the more successful holistic approaches, attention to vocational interests, natural aptitudes, and marketability of certain skills is prioritized in order to move women toward financial independence and long-term sustainability. While access to vocational choices and dignified work is a universal value, in some cultures it is imperative that women as young as ten be able to provide for and support not only their own and the extended family but also the community at large, hence these communities' tolerance of prostitution. Creating opportunities for other kinds of work in these contexts becomes the only viable way for girls to regain their sense of full personhood and dignity and restore their sense of belonging. It is hoped that in time this might create a cultural change altogether, as girls from these communities grow into successful adults and begin to change the sociocultural values and expectations placed on girls' bodies for the generations to come.

Located in Northern Thailand, the New Life Center, where Lauran began, offers measures to prevent sex trafficking by doing just this: providing education and vocational training for young tribal girls on the borderlands so they can fulfill the filial and societal expectation to support their families with work they choose, rather than the exploitative sexual labor the traffickers choose for them. Lauran explains, "Without proper education and something concrete to do, these girls would end up in the brothels. Many we were able to keep out of brothels with targeted programs, to ensure they could sustain themselves and their families. They are the ones who now own their own businesses and employ and empower others. The next generation is on their way. This is my best reward."

Like psychological healing and spiritual restoration, empowerment through access to wider and more appealing choices for one's life, relationships, and work contributes to the larger agenda of seeing humanity restored to its full potential. Without proper and authentic choices, we are deprived of a basic human right—the right to agency, out of which we develop as fully independent, individuated, and mature social beings. Prolonged captivity

13. Lexico Dictionary, s.v. "empowerment," accessed November 29, 2019, https://tinyurl.com/tt976lp.

and bondage, such as slavery in past and contemporary times, can hurt this very essential human function, distorting the whole notion of what healthy and self-loving choices might be. It is an insidious lie that infiltrates the psychospiritual apparatus of victims of sexual trauma in particular, utterly convincing them that their only viable choice for survival is to tolerate and accept violence and abuse on their own bodies and psyche. Given our essential interrelatedness, this festering lie propagates a sense of brokenness or illness in the whole human community; when one is dehumanized, we all are.

Founder and director of Arise in Central Asia, Ann Marie Isenring educates and mobilizes women in the most rural and forgotten areas of Central Asia and the Middle East, persuaded that change in this part of the world will come from these potentially powerful, although currently vulnerable and oppressed, women. Afflicted by intergenerational transmission of violence and trauma, entire generations of women and girls disappear from these geographic areas to feed the brothels, manufacturing industries, and elderly-care business of Western European countries, leaving a profound void in family, society, and the possibility of future contributions.[14] The lack of social, political, and economic infrastructures and the absence of proper professional education leaves very little choice for anyone interested in surviving, let alone thriving. So they migrate to some other land and end up contributing to some other society. But this cannot be the only way forward, Ann Marie argues. Education can be brought to them, leadership and empowerment courses can be introduced, and new vocational resources and skills can begin to bring hope for a different future to deeply depressed and hopeless communities. Educated girls can lead the way to societal, cultural, and economic change. Despite the difficulties and cultural obstacles, this is at the heart of Ann Marie's work.

Learning to substitute the self-destructive messages in our brain pathways with self-loving and constructive ones is not an easy task. Although neuroscientists assure us it is possible because of neurological plasticity, those who work with deeply traumatized women know what a painstaking process

14. Among many forms of highly exploitative migrant work is the phenomenon of *badanti*, or female caregivers, engaged in the full-time care of the elderly, especially in Italian homes. For more information, refer to Silvana Rugolotto, Alice Larotonda, and Sjaak van der Geest, "How Migrants Keep Italian Families Italian: *Badanti* and the Private Care of Older People," *International Journal of Migration, Health and Social Care* 13 (2017): 185–97, accessed December 15, 2019, doi: 10.1108/IJMHSC-08-2015-0027.

it is. Relapse into old patterns of thinking, behaving, and choosing is always lurking in the background, a return to what is familiar albeit potentially destructive and regressive. Ann Marie explains:

> Change is so difficult, and it is so slow. Women in these communities are constantly brought back to submission through violence in the streets, in their homes, and even through bad theology preached in the church. But when I see them, I don't see their wounded spirits and sullen hearts. I see potential for leadership, for power, for moving their communities out of violence and poverty. I want to see them rebuild Central Asia. I believe in them. I count on them to do it.[15]

That is how the work of ordinary women, with distinctively fierce commitments and clarity of purpose, moves them into the arena of contemporary heroines, championing and modeling emancipatory practices. They do not relent in their advocacy for women's and girls' access to ongoing care and education—creating ever-new spaces, places, and communities for practicing free choices, healthy self-agency, and generous contribution to the construction of a better world for their own communities and for all.

Sustainability for the Journey

Antitrafficking work is draining and exhausting in all its forms and expressions. For every single girl or woman who finds herself on the long and tortuous way to healing and wholeness, there are hundreds of children born at risk of being trafficked, exploited, oppressed, or dehumanized in one way or another. Needless to say, this work is not for the faint of heart.

The professional hazards of secondary trauma, compassion fatigue, and spiritual despair constantly lurk in the background of everyone who chooses—or *is called* to—this particular context of care, our heroines included.[16] When asked about sustainability for their pursuits and efforts

15. Ann Marie Isenring in discussion with the author, June 6, 2019. Ann Marie is founder and director of Arise in Central Asia.
16. Much research has been conducted on the vulnerability of helping professionals to burnout and secondary trauma, and this certainly includes antitrafficking practitioners, especially Christians, whose theologies are often unhelpful in terms of encouraging self-care and sustainability of their efforts. One of the latest resources available on the topic of self-care can be found in Lisa D. Hinz, *Beyond Self-Care for Helping Professionals: The Expressive Therapy Con-*

over many years of operation and involvement, along with the predictable setbacks and relapses, the scarcity of funds and resources, and the increasing sophistication of exploitative strategies, the unanimous response is *faith*. The support of loving families, spouses, friends, and communities is indispensable for any of this work to continue and for the protagonists of our story to thrive in their visionary and emancipatory pursuits. However, ultimately, what motivates and sustains these women in particular flows from the same source, which is the Spirit of God.

Each one of them expresses this conviction in their own spiritual or theological language, emphasizing a particular dimension of faith that is more authentically personal. "An unwavering faith in the healing power of God" is the answer Ann Marie gives to the question of sustainability of her work over the years. She seems to hold this truth in the core of her being, as she continues to rally hundreds of women for the amazingly transformative and empowering conferences she hosts annually for women of Central Asia. Mariliana also grounds herself in a deep trust in God's guidance in order to face the hardships and challenges of her ministry. "I put myself aside and let God guide me," she says. "No matter how hard it gets, I trust God to show me the next step forward. And I move on, in faith." Honoring the contemplative tradition she has embraced and introduced to her coworkers, Thelma attributes her persistence through the years to the power of prayer, without which she would have faltered many times. The pressures and complexities of her ministry seem to demand a posture of humility and utter trust in the guiding power of the Spirit, who works among and alongside her and her team. "Prayer: humble, honest, relentless. Prayer is what keeps me going" is Thelma's answer, which she offers with a reassuring and persuasive smile. Unwavering faith, prayer, and a humble openness to God's trustworthy guidance are some of what sustains the work of antitrafficking practitioners and emancipatory leaders of our time. By these simple means, ordinary women become (and remain) extraordinary leaders, championing the cause of justice and emancipation on behalf of other women and girls who still lack some basic human rights in the twenty-first century. This is how and why they choose, daily, to respond to the deeper call, to work toward the rehumaniza-

tinuum and the *Life Enrichment Model* (New York: Routledge, 2019). The gift of this model is in its suggestion that self-care begins with enriching one's life, shifting the environment to add more creative and life-enhancing outlets, which in turn can enliven one's work and ministerial outlook while one cares for others.

tion of the human race—one girl, one woman, one conversation, one house, one job, one healing journey at a time.

Conclusion

Statistical accounts might not always be accurate, but the reality of girls' and women's vulnerability to a complex mix of systemic injustices in the twenty-first century cannot be denied. While we proudly celebrate the legacy of visionary, determined, and fearless leaders in the suffragette movement of one hundred years ago, in the year 2020 we also humbly acknowledge that millions of women and girls around the world are still deprived, on account of their gender, of some other very basic rights. My commitment to see all kinds of rights granted to all human beings in all parts of the world has connected me to the powerful witness of the women I introduced in this chapter. Thanks to the lives, work, and contributions of Sarah Austin, Lauran Bethell, Courtney Dow, Ann Marie Isenring, Mariliana Morales, and Thelma Nambu, I have been re-inspired and reenergized for the hard work ahead. It is my sincere hope that sharing the gift of their witness might encourage others to join in the long road to liberation, restoration, and emancipation deserved by all created beings.

Bibliography

"Empowerment." Lexico Dictionary. Accessed November 29, 2019. https://tinyurl.com/tt976lp.

Farley, Melissa. *Prostitution, Trafficking and Traumatic Stress*. New York: Routledge, 2003.

Gerhardt, Elizabeth. *The Cross and Gendercide*. Downers Grove, IL: InterVarsity, 2014.

Graham, Ruth. "How Sex Trafficking Became a Christian Cause Célèbre." *Slate*. March 5, 2015. https://tinyurl.com/vcnhayx.

Hinz, Lisa D. *Beyond Self-Care for Helping Professionals: The Expressive Therapy Continuum and the Life Enrichment Model*. New York: Routledge, 2019.

"Hotline Statistics." National Human Trafficking Hotline. Accessed November 28, 2019. https://tinyurl.com/znaoqw2.

"Human Trafficking—Medical Effects on Victims." Accessed November 28, 2019. https://tinyurl.com/hezkbv6.

ILOSTAT. International Labour Organization. Accessed February 3, 2020. https://ilostat.ilo.org/.

Lloyd, Rachel. *Girls Like Us: Fighting for a World Where Girls Are Not for Sale.* New York: HarperCollins, 2011.

Miles, Glenn, and Christa Foster Crawford, eds. *Stopping the Traffick: A Christian Response to Sexual Exploitation and Trafficking.* Oxford: Regnum Books International, 2014.

———, eds. *Finding Our Way through the Traffick: Navigating the Complexities of a Christian Response to Sexual Exploitation and Trafficking.* Oxford: Regnum Books International. 2017.

"Myths, Facts, and Statistics." Polaris. Accessed February 15, 2020 https://tinyurl.com/y7jrk5wp.

"National Human & Sex Trafficking Statistics." Geoffrey G. Nathan Law Offices. Accessed November 28, 2019. https://tinyurl.com/y4ar4fpx.

Rugolotto, Silvana, Alice Larotonda, and Sjaak van der Geest. "How Migrants Keep Italian Families Italian: *Badanti* and the Private Care of Older People." *International Journal of Migration, Health and Social Care* 13 (2017): 185–97. Accessed December 15, 2019. doi: 10.1108/IJMHSC-08-2015-0027.

Smith, Holly Austin. *Walking Prey: How America's Youth Are Vulnerable to Sex Slavery.* New York: Palgrave Macmillan, 2014.

Zimmerman, Yvonne. *Other Dreams of Freedom: Religion, Sex and Human Trafficking.* Oxford: Oxford University Press, 2013.

8. Pan-African Women of Faith: Lifting Our Voices and Votes to End Hunger and Poverty

ANGELIQUE WALKER-SMITH

The year 2020 is a critical one for making sure that hunger and poverty are on the platforms of candidates aspiring to public office. Pan-African women are disproportionately affected by hunger and poverty. The unique season of general elections in the United States as well as elections in countries like Burkina Faso, Benin, Burundi, Central African Republic, Comoros, Egypt, Ethiopia, Ghana, Morocco, Sudan, Tanzania, Dominican Republic, Suriname, Trinidad and Tobago, and Venezuela are opportunities to make changes that address hunger and poverty with a vision of ending gender inequities and nurturing the empowerment of women and girls. This chapter offers up past illustrations of how Pan-African women of faith have influenced and can influence the platforms of their electoral candidates in partnership with them, and identifies the Pan African Women of Faith network, which began in 2015, as a resource for this kind of advocacy and electoral work—now and in the future.

To this end, we affirm the leadership provided by Pan African Women of Faith to address hunger and poverty and highlight the important role of Pan-African women of faith historically and in recent years. We hope that these illustrations will inspire and direct Pan-African women and girls to lift their voices in the upcoming elections and will inform their collective efforts to ensure that specific issues facing Pan-African women and girls are clarified so as to influence potential and new decision makers to end hunger and poverty.

The joint declaration of Pan African Women of Faith and the Pan African Women's Ecumenical and Empowerment Network (PAWEEN) in their recent call to action in partnership with Bread for the World, the African Union, and the World Council of Churches at conferences in 2016, 2018, and 2019 has led to a reframing of how Pan African Women of Faith approach their faith together despite the historic colonial powers that have separated their fam-

ilies and identities in Africa and throughout the African diaspora for hundreds of years. Women are rediscovering how to lift their voices together in light of their shared and separate histories. An example of this was in Liberia in 2003–2005, where diverse Pan-African women of faith from various ethnic groups and American descendants of the African diaspora transformed their nation with their advocacy and voice. In this case, this advocacy led to the first African nation with a female president. An illustration from the United States is the 2017 campaign led by Pan-African women of faith, primarily women of the formally enslaved African diaspora, to elect Senator Doug Jones in Alabama during the US midterm elections. As described in the next section, biblical illustrations of the Queen of Sheba and Queen Candace are ancient examples of Pan-African women of faith leading government. I end the chapter with the call to action and advocacy by Pan African Women of Faith from its 2018 and 2019 conferences on electoral engagement in 2020.

Biblical Background

Pan-African women of faith are in the Bible but often overlooked. While Hagar, the mother of Abraham's son Ishmael, and Zipporah, Moses's wife, may come to mind, there are others, named and often unnamed, in the Bible. The "certain women" mentioned at the tomb of Jesus (Luke 24:22 NKJV) come to mind as a reference of how the Bible refers to unnamed women, for example. There were African queens as well. There are two African queens in the Bible who ruled during critical periods. One was the queen of Sheba (1 Kgs 10; 2 Chron 9:1–12) and the other was Queen Candace of Ethiopia, who sent a eunuch on a mission as her emissary (Acts 8:26–40). He was Christianized during his diplomatic journey. These are important roles to point out because Pan-African women of faith like Hagar and Zipporah are not viewed as leaders in the public space although both are remembered as mothers who nurtured the next generation of leaders. And both of these queens ruled in Ethiopia, which is the only African country not colonized by a European power.

It is also in Ethiopia that the first and oldest hominid was found, the ark of the covenant is said to have once been placed, and the queen of Sheba

may be entombed.[1] Given its ancient history, Ethiopia is not only a biblical and secular treasure but a proud location of all peoples and especially African peoples. This is because, in part, self-governance and the acceptance of Christianity were codified and practiced before the disruption of colonialism and colonial missionizing to other African peoples. Today the Ethiopian Orthodox Tewahedo Church is a manifestation of this.[2]

The Queen of Sheba

The fullest and most significant version of the story of the queen of Sheba[3] appears in the *Kebra Nagast* (*The Glory of the Kings*), the Ethiopian national saga, translated from Arabic into Ge'ez in 1322. According to this composition, Menelik I is the child of Solomon and Makeda (the queen of Sheba), from whom the Ethiopian dynasty claims descent to the present day. Based on the Gospels of Matthew (12:42) and Luke (11:31), the "queen of the South" is claimed to be the queen of Ethiopia in those times when King Solomon sought merchants from all over the world, in order to buy materials for the building of the temple.

There are several references to the queen of Sheba's leadership throughout the Bible, including in 1 Kings 10:1–13.

Queen Candace

Acts 8:26–40 says that Philip, while traveling, encountered "an Ethiopian eunuch, a court official of the Candace, queen of the Ethiopians" (8:27 NRSV). This man was "in charge of her entire treasury" and was returning home from worshipping in Jerusalem.

Ross S. Kraemer notes that:

1. "Ethiopia and Its Religions: From the Queen of Sheba to Christianity," *New York Times* Journeys, accessed February 4, 2020, https://tiny url.com/uedenjd.
2. Stéphane Ancel, "The Ethiopian Orthodox Täwahedo Church in Jerusalem and Its Archives," (presentation, Workshop of Opening Jerusalem Archives Project, Centre de Recherche Français à Jérusalem, April 8, 2014), accessed February 4, 2020, https://tinyurl.com/s3abwph.
3. Walter Arthur McCray, *The Black Presence in the Bible*, vol. 1, *Discovering the Black and African Identity of Biblical Persons and Nations* (Chicago: Black Light Fellowship, 1995).

> older English translations, most notably the KJV, treated the Greek *kandakē* as the name of the Ethiopian queen, calling her Candace. Newer translations, including the NRSV, recognize that Kandake is an Ethiopian title meaning either "queen" or "queen mother," and known to have been used for the queen of Meroe. It is impossible to identify the Kandake here [in Acts 8] with any particular Ethiopian queen. In any case, the queen herself is significant only for demonstrating the high status of the eunuch converted by Philip in this passage.[4]

The Ethiopian Orthodox Tewahedo Church opposes this minimalist view as well as similar views of other scholars. The Ethiopian Orthodox Tewahedo Church traces its beginning to her and her relationship to the conversion of the Ethiopian eunuch, who was her treasurer, in Acts 8:26-40.[5]

In sum, this queen, like the queen of Sheba, is significant to the formation of faith of the Ethiopian eunuch and the Ethiopian Orthodox Tewahedo Church. In a paper on Nubian queens, Carolyn Fluehr-Lobban writes, "Three of the Ethiopian queens were central to significant turning points in dynastic history," and the two discussed above are included in her paper.[6]

The Background of Pan-African Women and Politics

The contextual background of Pan-African women biblically and currently is important to furthering the understanding of the argument and observations in this chapter. Aili Marie Tripp helps us with the following observation relative to African women affected by the history of colonialism (unlike Ethiopia, although they, too, have been affected by globalization):

> While women were never fully equal to men in the political sphere, women in precolonial Africa governed kingdoms, established cities,

4. Ross S. Kraemer, "Acts 8:27: The Candace, Queen of the Ethiopians," in *Women in Scripture: A Dictionary of Named and Unnamed Women in the Hebrew Bible, the Apocryphal/Deuterocanonical Books, and the New Testament*, ed. Carol Meyers, Toni Craven, and Ross S. Kraemer (Grand Rapids: Eerdmans, 2000), 461.
5. "Ethiopian Orthodox Tewahedo Church," World Council of Churches, accessed February 11, 2020, https://tinyurl.com/vrfnb7c.
6. Carolyn Fluehr-Lobban, "Nubian Queens in the Nile Valley and Afro-Asiatic Cultural History" (presentation, Ninth International Conference for Nubian Studies, Boston, MA, August 20–28, 1998), accessed December 16, 2019, https://tinyurl.com/uk8srsh.

launched military conquests, and founded states. Some governed as sole rulers often as queens, while others governed together with a king, as a mother or sister of the king. A third arrangement involved a tripartite sharing of power among the king, mother, and sister, and a fourth arrangement involved societies in which an age set or group of elders governed the society and in which women exerted either direct or indirect power.[7]

However, Tripp cites the challenges of the spread of Islam and Christianity and later colonization, which often caused women to lose much of their political voice. Very importantly she reminds the reader that after independence from colonial powers, women were further sidelined from political life. It wasn't until the 1990s that women reemerged as political leaders. Today, outside and internal pressures for these kinds of reforms continue.[8]

Sustainable Communities Require Full Electoral Participation of Women

In order for any nation-state to advance its vision of a sustainable society, women must not only survive but thrive. The invitation for women to fully participate in the electoral process historically, today, and in the future is an important indicator for moving toward a sustainable society that advances gender equity and provides adequate resources to support this now and for future generations. To this end, the electoral process must include an electoral platform that proposes specific policies and practices that alleviate and address the systemic and urgent issues of hunger and poverty that disproportionately affect women and girls. The 2015 *Hunger Report* of Bread for the World states the following: "Women and girls are disproportionately affected by hunger and poverty because of discrimination."[9] Without consideration of these issues, the vision of a sustainable society is hindered from reaching fruition. The Sustainable Development Goals (SDGs) support this

7. Aili Marie Tripp, "Women and Politics in Africa," in *Oxford Research Encyclopedia of African History*, ed. Thomas Spear (Oxford: Oxford University Press, 2017), 233–55, doi: 10.1093/acrefore/9780190277734 .013.192.
8. Tripp, summary of "Women and Politics in Africa."
9. *2015 Hunger Report: When Women Flourish . . . We Can End Hunger* (Washington, DC: Bread for the World Institute, 2014), 13, accessed February 4, 2020, https://tinyurl.com/v3uetpq.

premise.[10] SDGs include, for example, the goals of gender equality (SDG #5) and peace, justice, and strong institutions (SDG #16), especially with a gender lens; women and girls are critical for implementing a vision of sustainable societies.

These goals were supported in the 2015 *Hunger Report* of Bread for the World; the following were a few of the key messages of the report:

- The path to end hunger requires support of "the post-2015 sustainable development goals, including goals to end hunger, extreme poverty, and gender inequality.
- "Women and girls are disproportionately affected by hunger and poverty because of discrimination.
- "The public at large and the faith community in particular can play an important role in changing laws, policies, norms and behaviors that are harmful to women and girls."[11]

The following are some of the recommendations of the report that directly speak to the voices and public participation of women:

- "Make it easier for women to run for public office at all levels of government.
- "Increase the proportion of women peace negotiators.
- "Create more space for women-led civil society groups to participate in public policy debates.
- "Build a generation of women leaders in government and civil society, especially young women."[12]

2020 Elections in African Countries and Diaspora Countries with Majority African Populations

While much attention has been given to eight primary issues of consideration for voters and the fact that voting by Pan-African women in the United

10. 2015 *Hunger Report*, 178.
11. "Executive Summary," in 2015 *Hunger Report*, 3, accessed December 16, 2019, https://tinyurl.com/kf5tfb7.
12. "Executive Summary," 9.

States matters, the specific alignment of such issues and more targeted issues of these women in the United States and globally have not been systematically addressed.[13] This is despite the consistent pivotal participation of these women in general elections.

This pivotal participation included a Pan-African woman as a 2020 US presidential hopeful. During the early Democratic campaign races, the presidential hopefuls included Senator Kamala Harris, an African American woman from California. Although she did not gain majority support and dropped out of the race, her presence and voice were important in a crowd of mostly white candidates for the Democratic nomination. Sadly, all candidates who were not white eventually left the presidential race.

Additionally, there are African and majority African populated countries in the diaspora holding general elections as well in 2020. Although the foreign policies of the United States do affect these countries, it is helpful to remember that the elections that will be held in Burkina Faso, Benin, Burundi, Central African Republic, Comoros, Egypt, Ethiopia, Ghana, Morocco, Sudan, and Tanzania also matter. The same is true of the Dominican Republic, Suriname, Trinidad and Tobago, and Venezuela, where the African diaspora is well represented or dominant. In other words, 2020 is an opportunity to remember that while the United States is still the wealthiest nation and a superpower in the world and influences both domestic priorities and global space, the agency of women to vote in other national elections matters, too.

All of these nations are affected by the aforementioned issues identified in the 2015 *Hunger Report* and the Sustainable Development Goals. More specifically, Pan-African women are affected in the following ways:

> Today, pan-African women are disproportionately affected by hunger and poverty. In some pan-African countries, women and girls can spend up to six hours every day just fetching water. In addition, 13.5 percent of the population in some of these countries experience hunger. We have witnessed extraordinarily higher rates of hunger and poverty among pan-African communities in Africa, Latin America and the Caribbean, Central America, and the United States:

13. Jonathan Capehart, "What Do Black Women Voters Want?" *Washington Post*, September 10, 2019, https://tinyurl.com/sr4e4f2. For the eight primary issues of consideration for voters, consult "America 2020," *U.S. News and World Report*, accessed February 4, 2020, https://tinyurl.com/rt2eb56.

- *Hunger and poverty in Africa.* For example, almost one in two people in Burkina Faso is living below the national poverty line....
- *Hunger and poverty in Latin America and the Caribbean.* For example, over 75 percent of people living in rural areas of Haiti are living below the poverty line and experiencing extreme food insecurity....
- *Hunger and poverty in Central America.* For example, ... Afro-Honduran women and single mothers ... face higher levels of hunger than the general population.
- *Hunger and poverty in the United States.* One in three single African American mothers are food insecure, compared to one in five mothers in the general population....
- *In sub-Saharan Africa* ... girls still face barriers to entering both primary and secondary school.
- *Women in northern Africa* hold less than one in five paid jobs in the nonagricultural sector....[14]

Therefore, it is fair to say that these issues should be a primary part of the electoral platform in these regions where Pan-African women are affected. Below I present the election in Liberia and the election of Senator Doug Jones in Alabama (influenced by Pan African Women of Faith) as examples of how electoral issues can engage and transform the electoral landscape.

Liberia

Liberia, like Ethiopia, is often referred to as an African country that remained independent during the European period of colonization and neocolonialism, but this is not an accurate description of the country. Rather, it is a place where the United States played a unique role in the creation of and history of politics in the country.

This history is tied to Liberia's unique link to Africans enslaved in the United States and those Africans enslaved while traveling from differing

14. Angelique Walker-Smith, "The Legacy, Leadership, and Hope of Pan-African Women of Faith in Building Sustainable Just Communities as a Missional Focus," *International Review of Mission* 105 (November 2016): 232.

points in Africa to the United States. The country was founded by African Americans in the 1820s.

Angela Thompsell, in her article about the history of Liberia, states the following about this: "These Americo-Liberians governed the country until 1989, when they were overthrown in a coup. Liberia was governed by a military dictatorship until the 1990s, and then suffered two lengthy civil wars. In 2003, the women of Liberia helped bring an end to the second civil war, and in 2005, Ellen Johnson Sirleaf was elected president of Liberia."[15]

The Pan African Women of Faith Case Study in Liberia

In 2003, Pan African women of faith prayerfully led their people to the end of the Liberian civil war and the election of the first woman president, Ellen Johnson Sirleaf, on the continent of Africa by organizing Liberian women of faith from various traditions. This important story of the transformation of this country was captured in the movie *Pray the Devil Back to Hell*, which showcased a movement called Women of Liberia Mass Action for Peace, which was led primarily by the Nobel Peace Laureate Leymah Gbowee. The work of this group led to governmental structural reforms and a reduction of hunger and poverty, which had been dramatically present during the civil war.[16]

Liberia Today

Despite the importance of the aforementioned transformative work of Pan African Women of Faith, stable presidential leadership from the first woman president, and the influx of development initiatives, both the civic landscape and conditions of hunger and poverty in Liberia remain challenging. This was confirmed in the "Report on Women's Empowerment in Liberia," produced by the Visionary Young Women in Leadership (VYWL) in July 2018. The executive summary of the report states that:

15. Angela Thompsell, "A Brief History of the African Country of Liberia," ThoughtCo., last updated February 13, 2018, https://tinyurl.com/y4cksf7b.
16. Walker-Smith, "Legacy, Leadership, and Hope," 234.

although Liberia's 2005 democratic transition saw the election of Africa's first woman head of state, Liberian women continue to face considerable challenges to their participation in political processes. While women are slowly closing the gap, they are still underrepresented as party and civil society leaders, elected representatives and government officials.[17]

Further, the Borgen Project reports that poverty in Liberia is still high and often leads to hunger. Moreover, food is a large cost for Liberian families, and Liberia is ranked 177 of 188 countries in the 2015 Human Development Index, which measures things like a country's food deficit. Liberia was affected by the Ebola outbreak in 2014, and some long-term consequences of the fourteen-year civil war, which "destroyed social services and infrastructure critical to combating poverty and hunger in Liberia," persist.[18]

One of the lessons learned here is that transformation to relative peace is a slow process. Electoral gains are important steps, but sustained advocacy alongside partnerships and projects like the Gbawanken Rural Women Community Grain Reserve, a Liberian project, can help us move to more sustainable communities. This project is a partnership with the UN Women–led Joint Programme on Rural Women's Economic Empowerment (JPRWEE) and is funded by the governments of Norway and Sweden.[19] Elections do matter, but accountability of leadership and the election of women are key components for sustainability.

Hunger and Poverty in Alabama

History of Disenfranchisement and Voting Inequities for Women in Alabama

17. "Report on Women's Empowerment in Liberia: Diamond Leadership Role Model Project," Visionary Young Women in Leadership, 6, accessed December 16, 2019, https://tinyurl.com/sp64byj.
18. Alexi Worley, "10 Facts about Hunger in Liberia," April 25, 2017, Borgen Project, https://tinyurl.com/qsmunm7.
19. "Rural Women Lead the Way in Addressing Food Insecurity in Liberia," Africa Renewal, accessed December 16, 2019, https://tinyurl.com/qv68uru.

Women in Alabama only received the right to vote after the passage of the Nineteenth Amendment, which Alabama did not ratify until 1953.[20] This came after the already difficult history of disenfranchisement of any group that was not white, male, and wealthy. Sarah A. Warren notes the following that pertained to formerly enslaved men and then women:

> The Republican-controlled U.S. Congress abolished slavery under the 13th Amendment, granted citizenship to former slaves under the 14th Amendment, and guaranteed them the right to vote with the 15th Amendment. Congress forced the ex-Confederate states to pass constitutions that further articulated these rights to former slaves. When Alabama's Democratic Party regained control of the state government in the election of 1874, one of its first actions was to overturn Alabama's Reconstruction Constitution of 1868, which had expanded voting rights among African Americans and poor whites.[21]

Hunger and Poverty in Alabama

According to Bread for the World's fact sheet about hunger and poverty in Alabama, Alabama is the fifth hungriest state in the United States, where:

- 1 in 6 households struggles to put food on the table.
- 1,316,665 people live in counties with poverty rates of 20 percent or more.
- 24,866 veterans live below the poverty line.
- If Medicaid is block granted, an additional 324,600 people could be uninsured, compared to 448,926 people currently uninsured.[22]

In addition, "1 in 4 children and 1 in 6 women live in poverty," "an individual must earn $14.94 per hour in Alabama to provide for a family, yet, the state

20. "Alabama and the 19th Amendment," National Park Service, last updated January 14, 2020, https://tinyurl.com/u2kxcq4.
21. Sarah A. Warren, "Constitutional Convention of 1901," Encyclopedia of Alabama, last updated May 23, 2018, https://tinyurl.com/y2l7wpmo.
22. "Ending Hunger in Alabama," Bread for the World, accessed December 16, 2019, https://tinyurl.com/tvod55j.

minimum wage is $7.25," and "people of color in Alabama are 3 times more likely than whites to live with hunger and poverty."[23]

Bread for the World recommends that, in order to address these disparities, elected officials should "support adequate federal funding" for low-income communities, which includes antihunger programs, good jobs, a livable minimum wage, quality education, affordable housing and healthcare, a fair and equitable tax policy, a comprehensive immigration policy, and a fair and equitable criminal justice system.[24]

The Timely Vote of Pan African Women of Faith in Alabama

Poet and politician Andrea Jenkins, a black woman recently elected to city council in Minneapolis, said the following:

> From Sojourner Truth and Harriet Tubman, to Shirley Chisholm and Maxine Waters, Black women have taken in their own hands to make America the great nation that it strives to be. Yesterday, in Alabama, we witnessed yet again—Black (people) standing up for equality and justice. When we center the most marginalized people in our community and make life better for them, we make life better for everyone. Let Black women lead![25]

Paul Brandeis Raushenbush, in an article about the election of Senator Doug Jones in Alabama, wrote the following statement:

> The religious voters spoke in Alabama and it wasn't the ones that people were expecting to hear. Roy Moore counted on being the "religious" candidate, and, indeed, he was supported by over 80% of White Evangelicals who voted. Yet, what is being widely noted in the aftermath of the election was that the voters who spoke loudest in

23. "Ending Hunger in Alabama."
24. "Ending Hunger in Alabama."
25. Andrea Jenkins, quoted in Paul Brandeis Raushenbush, "Black Women and the 'Values Vote' in Alabama," Auburn Seminary, accessed December 16, 2019, https://tinyurl.com/vzhxsfh.

the Senate race were Black voters, and especially Black women. And many of them go to church.[26]

The following excerpt of the statement created and adopted by Pan African Women of Faith and the Pan African Women's Ecumenical and Empowerment Network (PAWEEN) in partnership with Bread for the World, the World Council of Churches, and the African Union's Pan African Women's Diaspora Association is a helpful way forward in addressing the electoral platform of priorities of Pan-African women of faith.[27] In 2019 a conference was held to follow up on the recommendations from this 2018 statement, and the movement has continued from there.

The Pan African Women of Faith Call to Action, November 8–9, 2018, at the African Union–USA Mission

We, women of faith who are African and of African Descent, are called to action at a *Sankofa* (a season of looking back and forward) moment of *Ubuntu* (humanity). This moment calls for boldness of faith, joy, peace, love and persistent courage that our foremothers and forefathers brought to bear and empowers us for this moment and for our children. We are troubled by the experiences of the past and present that have dared to marginalize and reject our presence and voices. Therefore, we are called to action to deepen our historic resolve to change this narrative. We re-claim a narrative of healing, hope and justice called by our ancestors. We are determined to foster a Pan African Women of Faith advocacy and unity movement of faith that uplifts and builds up Africans and African Descended People in a sustainable world of love, justice and peace.[28]

This opening statement from the Pan African Women of Faith Global Strategy Consultation and the following summary key messages help direct a

26. Raushenbush, "Black Women and the 'Values Vote' in Alabama."
27. "Documentation," *The Ecumenical Review* 71 (October 2019): 566–74, https://doi.org/10.1111/erev.12460.
28. "Documentation," 572.

way forward for the issues in this chapter. The four key messages in the call to action are as follows: a robust change in the negative perception of Africans and those of African origin; the inclusion of all those displaced in Africa's diaspora; the attainment of full gender parity; and the cessation of inequitable policies and the advocacy for justice at home and abroad.

This chapter affirms the leadership provided by Pan African Women of Faith and their call to action. May we lift our voices in unity amid our diversities, in advocacy for justice, in solidarity with women impacted by hunger and poverty, and in support of "alternative economies."[29] To do this, we shall cultivate the gift of listening to God's voice in our midst, embrace the leadership of the younger generation, and "challenge and agitate oppressive institutional structures."[30] The call ends with this final paragraph:

> Join this *movement* and mobilize our people around this shared vision; organize and connect local struggles under this partnership. This movement is committed to engagement among ourselves, faith communities and government leaders. We affirm our identities as women who celebrate our African identity and invite our governments, leaders, other stakeholders and institutions to join us in solidarity with our voices and votes being heard and addressed.[31]

The season leading up to the 2020 elections and the years following are critical for making sure that hunger and poverty are on the platforms of candidates aspiring to public office not only in the USA but globally as we move toward the 2030 Sustainable Development Goals. As one of the priorities of the 2016 Consultation of Pan African Women of Faith states, "We must vote for people who are serious about our issues and hold our candidates for political office and elected officials accountable."[32] In this way, we follow not only women like Hagar and Zipporah but wise rulers like the Queen of Sheba and Queen Candace of Ethiopia.

29. "Documentation," 573.
30. "Documentation," 573.
31. "Documentation," 574.
32. "Documentation," 573.

Bibliography

2015 Hunger Report: When Women Flourish . . . We Can End Hunger. Washington, DC: Bread for the World Institute, 2014. Accessed February 4, 2020. https://tinyurl.com/v3uetpq.

"Alabama and the 19th Amendment." National Park Service. Last updated January 14, 2020. https://tinyurl.com/u2kxcq4.

"America 2020." *U.S. News and World Report.* Accessed February 4, 2020. https://tinyurl.com/rt2eb56.

Ancel, Stéphane. "The Ethiopian Orthodox Täwahedo Church in Jerusalem and Its Archives." Paper presented at Workshop of Opening Jerusalem Archives Project, Centre de Recherche Français à Jérusalem, April 8, 2014. Accessed February 4, 2020. https://tinyurl.com/s3abwph.

Capehart, Jonathan. "What Do Black Women Voters Want?" *Washington Post.* September 10, 2019. https://tinyurl.com/sr4e4f2.

"Documentation." *The Ecumenical Review* 71 (October 2019): 566–74. https://doi.org/10.1111/erev.12460.

"Ending Hunger in Alabama." Bread for the World. Accessed December 16, 2019. https://tinyurl.com/tvod55j.

"Ethiopian Orthodox Tewahedo Church." World Council of Churches. Accessed February 11, 2020. https://tinyurl.com/vrfnb7c.

"Executive Summary." In *2015 Hunger Report.* Accessed December 16, 2019. https://tinyurl.com/kf5tfb7.

Fluehr-Lobban, Carolyn. "Nubian Queens in the Nile Valley and Afro-Asiatic Cultural History." Paper presented at Ninth International Conference for Nubian Studies, Boston, MA, August 20–28, 1998. Accessed December 16, 2019. https://tinyurl.com/uk8srsh.

Kraemer, Ross S. "Acts 8:27: The Candace, Queen of the Ethiopians." In *Women in Scripture: A Dictionary of Named and Unnamed Women in the Hebrew Bible, the Apocryphal/Deuterocanonical Books, and the New Testament,* edited by Carol Meyers, Toni Craven, and Ross S. Kraemer, 461. Grand Rapids: Eerdmans, 2001.

"The Many Cultures of Ethiopia." *New York Times* Journeys, *New York Times.* Accessed February 4, 2020. https://tinyurl.com/uedenjd.

McCray, Walter Arthur. *The Black Presence in the Bible.* Vol. 1, *Discovering the Black and African Identity of Biblical Persons and Nations.* Chicago: Black Light Fellowship, 1995.

Raushenbush, Paul Brandeis. "Black Women and the 'Values Vote' in Alabama." Auburn Seminary. Accessed December 16, 2019. https://tinyurl.com/vzhxsfh.

"Report on Women's Empowerment in Liberia: Diamond Leadership Role Model Project." Visionary Young Women in Leadership. Accessed December 16, 2019. https://tinyurl.com/sp64byj.

"Rural Women Lead the Way in Addressing Food Insecurity in Liberia." Africa Renewal. Accessed December 16, 2019. https://tinyurl.com/qv68uru.

Thompsell, Angela. "A Brief History of the African Country of Liberia." ThoughtCo. Last updated February 13, 2018. https://tinyurl.com/y4cksf7b.

Tripp, Aili Marie. "Women and Politics in Africa." In *Oxford Research Encyclopedia of African History*, ed. Thomas Spear. Oxford: Oxford University Press, 2017. doi: 10.1093/acrefore/9780190277734.013.192.

Walker-Smith, Angelique. "The Legacy, Leadership, and Hope of Pan-African Women of Faith in Building Sustainable Just Communities as a Missional Focus." *International Review of Mission* 105 (November 2016): 226–42.

Warren, Sarah A. "Constitutional Convention of 1901." *Encyclopedia of Alabama*. Last updated May 23, 2018. https://tinyurl.com/y2l7wpmo.

Worley, Alexi. "10 Facts about Hunger in Liberia." Borgen Project. April 25, 2017. https://tinyurl.com/qsmunm7.

PART III
FUTURE: ENVISIONING WHAT'S NEXT

In the third section, we offer a vision for the future. In chapter 9, Insook Lee presents Confucianism's concepts of the Middle Way and harmony and their transformative power to offer a new way of "seeing." This concept of harmony is an effective instrument for Korean feminists to use in disrupting the patriarchal status quo while liberating women from social and political oppression. Lee integrates the Western liberal feminist concern for rights and freedom and the Confucian concern for moral agency and self-cultivation as a powerful means to ameliorate suffering and injustice.

In chapter 10, Mary Elizabeth Toler invokes the words of abolitionist Theodore Parker by referring to the arc of the moral universe, an arc that bends toward justice. In the midst of their work for abolition, women began to "see" a fissure or gap in the structure of the universe: they were second-class, disrespected residents of the universe. Now, as we women have made gains through suffrage and the women's movement, where do we see ruptures in equality and dignity in a world fragmented by race, class, nativity, gender, age? With movements birthed by societal rupture, where is the arc of the moral universe bending toward justice now? Toler begins with violence toward black men.

In chapter 11, while standing on the cusp of the fiftieth anniversary of the ordination of women in the Evangelical Lutheran Church in America (ELCA), Judith Roberts and Mary J. Streufert expose challenges and opportunities for women's voices in the public arena and the church through the lens of the ELCA. This volume began with an honest assessment of the use and misuse of Christianity and the Bible in support of slavery and women's subordination. Now, the volume closes with a reforming vision of justice. In 1988, the ELCA confessed racism as sin and, recently, confessed sexism and patriarchy as sins as well. In 2009, the ELCA removed the obstacles to gay, bisexual, and lesbian persons in same-sex, publicly accountable, monogamous relationships. As Streufert and Roberts admit, this justice work is not without challenges to the organization. Nevertheless, this closing chapter gives us a greater field of vision toward what justice for all might look like.

The epilogue offers words for the journey that began before our birth and sheds some light on our pursuit of our birthright.

August 26, 1920 - August 26, 2020
Countdown to 100 Years
Women's Equality Day

The Nineteenth Amendment was ratified on August 18, 1920, after a package of documents arrived at 4 a.m. from Tennessee, the 36th state to ratify the amendment. However, the constitutional amendment was certified and made official on August 26, 1920, when the US Secretary of State, Bainbridge Colby, signed and certified the document of ratification. Representative Bella Abzug in 1971 promoted the bill in the US Congress to identify August 26th as Women's Equality Day.

9. The Art of Feminism in the Framework of Confucian Harmony

INSOOK LEE

The work for women's equality is not limited to the United States. Women under the power of patriarchal Confucianism in South Korea have long sought gender justice and equality, especially under the influence of modernization. Today, gender equality still is not promising. In 2018, South Korea ranked 115th out of 149 countries in the Global Gender Gap Report presented by the World Economic Forum.[1] This rank is in sharp contrast to South Korea's twenty-eighth-place ranking as the world's most competitive economy.[2] One reason for this sluggish progress in gender equality appears to be rooted in the country's deeply embedded traditional Confucian culture. Aware of this cultural inhibition, Korean women have imported Western liberal feminist strategies into their fight for gender justice, which prioritize individual rights, freedom, equality, and autonomy. Since then, the viability of individual rights and the freedom of Western liberal feminism have been continuously tested against the Confucian ideal of social harmony. In Confucian culture, people "define themselves in terms of kinship and community rather than as rights-bearers."[3] Korea is just one of the many countries that attempt to add Western liberal forms of gender equality to their community-oriented cultural contexts, including many countries in Africa, the Middle East, and Latin America. In fact, "three-quarters of the world's peoples have defined and continue to define themselves in terms of kinship and commu-

1. World Economic Forum, *The Global Gender Gap Report 2018* (Cologny/Geneva: World Economic Forum, 2018), https://tinyurl.com/y29gg499. The Global Gender Gap Report benchmarks 149 countries on their progress toward gender parity across four thematic dimensions: economic participation and opportunity, educational attainment, health and survival, and political empowerment.
2. "Singapore Topples United States as World's Most Competitive Economy," IMD, May 28, 2019, https://tinyurl.com/y34gmcnp.
3. Henry Rosemont Jr., "Human Rights: A Bill of Worries," in *Confucianism and Human Rights*, ed. Wm. Theodore de Bary and Tu Weiming (New York: Columbia University Press, 1998), 64.

nity rather than as rights-bearers."[4] The idea of social harmony, rather than individual rights and freedom, is still the primary concern in these parts of the world.

Although Western liberal feminism has made a significant contribution to Korean women's movements by promoting their political, economic, and legal rights, these so-called "modernized" or "Westernized" women have been severely criticized for disrupting the harmony of family, community, and society. Those two values—Confucian tradition and Western liberal feminist tenets—have clashed with each other, creating a new dilemma for many Korean women. They become trapped between the two distinct ideologies. On the one hand, by rejecting Confucian tradition, they may run the risk of "los[ing] touch with their cultural heritage and remain[ing] an outsider to the whole community."[5] On the other hand, by refusing Western liberal feminist values, they end up quietly submitting to, and complying with, patriarchal oppression.[6] This dilemma puts Korean women in a precarious, ambivalent position toward both Confucian traditions and Western liberal feminist values. Significant internal conflicts, caused by this unresolved split sense of self and loyalty, may arise.

As a way to overcome this dilemma, this chapter explores how to promote Korean women's claims to rights and gender justice within the framework of Confucian traditions. In particular, I look into the Confucian ideal of harmony as a potential source for gender equality. The critical component in overcoming the resultant dilemma brought on by these supposedly dueling ideologies of rights is that the concept of Confucian harmony has been historically distorted and used to suppress gender equity. Through the recovery of the original meaning of Confucian harmony, Korean women can transform it into a "subversive" tool for gender justice. By "subversive," I mean in an effort to dissolve the Confucian patriarchal system from within.

Western Liberal Justice for Korean Women

The feminist concern for gender justice in the United States is predom-

4. Rosemont, "Human Rights," 64.
5. Ranjoo Herr, "Is Cultural Diversity Compatible with Feminism? Confucianism and Women's Cause," *Journal of American Studies* 27 (2009): 154.
6. Herr, "Is Cultural Diversity Compatible with Feminism?" 154.

inantly influenced by Western liberalism, which prioritizes human rights, freedom, equality, and autonomy. These liberal ideas are well expressed in the US Bill of Rights, which was ratified in 1791. A major purpose of these amendments is to protect the individual and minority against the majority. The underlying assumption is that there is a danger of the abuse of community operating by the majority against the minority. Thus, Western liberal approaches to social justice refer to protection of the individual against the majority, community, or state. This Western liberal approach originated from the Kantian concept of the "transcendent subject," who is a free moral agent with "pure practical reason."[7] This Kantian style of a liberal subject is a moral agent who focuses on character, virtue, and duty and asks, "What ought I (or we) do?"[8]

This Kantian moral agent, however, has historically undergone dramatic changes. John Rawls (1921–2002), an American moral and political philosopher in the liberal tradition, tried to keep Kant's notion of the free, autonomous subject who claims individual rights. However, Rawls wanted to remove the "obscurity of the transcendental subject," while saving the priority of individual rights. As a result, Rawls changed the Kantian "transcendental subject" to an "unencumbered self," which he thought was "more congenial to the Anglo-American temper."[9] Thereafter, the unencumbered self became a foundation of Western liberalism: for the unencumbered self, our capacity to choose—not what we choose—is "most essential to our personhood."[10] The individual self is prior to its ends, so the right is prior to the good. As a result, the unencumbered self is free from the sanctions of social roles and is installed as sovereign. This is the liberal version that prevails over the contemporary Western discourse of justice. Political philosopher Michael Sandel criticizes this version of social justice and claims that the unencumbered self is problematic.[11] For Sandel, the unencumbered self is denied the possibility of membership in any community bound by moral ties antecedent to choice. Individuals with this unencumbered self are more

7. Michael J. Sandel, "The Procedural Republic and the Unencumbered Self," in *Political Theory Reader*, ed. Paul Schumaker (Hoboken, NJ: John Wiley & Sons, 2010), 145. The "transcendent subject" is in contrast to an "empirical being."
8. Onora O'Neil, "Liberal Justice: Kant, Rawls, and Human Rights," *Kantian Review* 23 (2018): 643.
9. Sandel, "The Procedural Republic and the Unencumbered Self," 145.
10. Sandel, "The Procedural Republic and the Unencumbered Self," 145.
11. Sandel, "The Procedural Republic and the Unencumbered Self," 146.

interested in individual entitlements and ask, "What am I (or we) entitled to claim?" This conceptual framework of liberalism changed the Kantian moral subject's question from "What ought I do?" to "What can I claim?" In short, Rawls's justice claim is considered a concern for fairness, but without ethics.[12]

A Confucian Concept of Justice

Confucianism appears to stand in opposition to Western liberalism when it seeks social justice. However, Confucianism should be considered "different from" rather than "in opposition to" Western liberalism. Confucianism does not have a closely matching concept of "justice" under Western liberalism's terms of individual freedom and rights. Confucianism's concept of justice is centered on righteousness, or *yi*, which is often translated as "justice" in English. Rather than a political or legal concept as in the West, however, Confucian *yi* is a moral virtue, which can be acquired by self-cultivation.[13] Confucius (551–479 BCE), founder of Confucianism, says, "The *junzi* [a cultivated man] is conversant with rightness (*yi*) whereas the petty person is conversant with profit" (*Analects* 4.16).[14] A major difference between the *junzi* and a petty person is whether they seek justice or personal gain.

The Confucian sense of justice refers to the self that acts against inborn dispositions of "liking what is beneficial and desiring gain" (Xunzi 23.114.16).[15] People must follow *yi*, not their personal interests, to "resist the lure of gain."[16] The quest for profit and self-interest is against the Confucian moral sense of justice. Mencius (372–289 BCE), another founder of Confucianism, threatened the political leaders with the risks of revolt if they were more

12. O'Neil, "Liberal Justice," 644.
13. Self-cultivation is a process of developing our original inclinations toward goodness. According to Mengzi, all humans are born with four observable active moral senses or "sprouts" that are already in their initial stages of development. If properly nourished and protected from harm, those sprouts eventually grow into humaneness (ren 仁), rightness (yi 義), propriety (li 禮), and wisdom (zhi 智). See Mengzi 2A6 and 6A6, in Erin M. Cline, "Two Senses of Justice: Confucianism, Rawls and Comparative Political Philosophy," *Dao* 6 (2007): 374.
14. Adapted from Cline, "Two Senses of Justice," 369.
15. Eric L. Hutton, trans., "Xunzi," in *Readings in Classical Chinese Philosophy*, 2nd ed., ed. Philip J. Ivanhoe and Bryan W. Van Norden (Indianapolis, IN: Hackett, 2005), 301.
16. Christopher Duvert, "How Is Justice Understood in Classic Confucianism?" *Asian Philosophy* 28 (2018): 302.

concerned with their own personal interests than with those of the people, thus violating this sense of justice.[17] Justice must be the rule of action and be above any personal interest or material advantage. Confucius, on another occasion, also advised that "he who seeks his own utility [his own interest or advantage] hurts justice."[18] The *junzi* must overcome capricious personal desires through adherence to rightness and avoid selfish gain for the sake of the common good. Thus, a Confucian sense of justice aims to protect the communities from individuals' personal interests, which can lead to capricious selfishness and, thus, become an obstacle to other people's well-being. In short, the Confucian and the Western liberal approaches to justice have different primary foci. The former emphasizes the protection of the communities against individuals' personal interest, while the latter aims to protect individuals from potential communal abuse.

Confronted by these two different approaches, Korean women may ask, "Which approach to gender justice, Western liberal or Confucian, is more workable for us (me)?" I contend that this either-or approach is likely to fail. A Western liberal approach to gender justice alone, at this extreme, would be marred with the perception of excessive individualism, a potentially selfish project that would no longer appeal to either women or men in a Confucian context. In Korean as well as other Asian societies, such feminism is seen as a societal anomaly: wholly self-interested persons who disturb the overall harmony in family and society. Disturbingly, the blowback to Korean women who choose individual rights "has given rise to another group—men who feel threatened by these women and are lashing out in online forums and in the city's streets."[19] The leader of such a new activist group addressed a small group of "angry young men" who claim "true gender equality."[20] Twenty-nine-year-old Moon Sung Ho, leader of the group *Dang Dang We* (translated as "We are not shameful for being men"), started the group in 2018 and held a panel discussion at the National Assembly, South Korea's top legislature, to expose what he perceived to be the alleged harms of the feminist movement. He contended that "feminism is no longer about gender equality. It is gender

17. Duvert, "How Is Justice Understood in Classic Confucianism?" 303.
18. Duvert, "How Is Justice Understood in Classic Confucianism?" 302.
19. Daniel Darmawan, "Is This the Face of South Korea's New Anti-Feminist Movement?" *Vice*, December 6, 2018, https://tinyurl.com/vbwyxc7.
20. Jake Kwon, "South Korea's Young Men Are Fighting against Feminism," CNN, September 23, 2019, https://tinyurl.com/y62bv7ft.

discrimination and its manner is violent and hateful."[21] The fear of social disruption and the threat of being a target of accusation from such men have further silenced many women and like-minded, pro-feminist men. The goals of social, gender, political, and economic justice appear to be slipping away unless a clear resolution to this dilemma is found.

I propose that the original concept of Confucian harmony, in accordance with the Middle Way, can be a powerful means to achieve the goal of integrating the two different approaches—the Western liberal feminist concern for rights and freedom and the Confucian concern for moral agency based on self-cultivation. What complicates this integration is the fact that Confucian harmony has long been socially and politically (ab)used, which has effectively limited Korean women's opportunities for autonomous moral agency. It is no wonder that Korean women often feel trapped, confused, or ambivalent toward the seemingly incompatible positions in terms of gender justice. Therefore, it is essential for Korean feminists to reveal the historical changes and distortions of the roots of Confucian harmony.

Historical Distortions of Confucian Harmony

Confucian harmony has been popularly misinterpreted as conformity and submission.[22] In the face of any injustice they may experience, I have heard many Korean, and Asian, women say, "For the sake of the harmony of our family (or of our church or community), I say nothing. I will remain silent." Their tone is often sarcastic in the sense that they clearly see the injustice but must remain in their culturally prescribed place. In other words, they do not want to disrupt Confucian harmony. However, what is misunderstood here is that this type of acquiescence to the status quo actually contradicts the original Confucian teaching of harmony. This popular (mis)understanding of Confucian harmony more properly reflects disharmony and an anti-Confucian way of living and relating. In other words, to preserve what they think is harmony, they actually betray the very harmony that original Confucian traditions teach. This popular concept of Confucian harmony has long been misused and abused as a tool to suppress women's agency. The con-

21. Kwon, "South Korea's Young Men Are Fighting against Feminism."
22. Chenyang Li, *Confucian Philosophy of Harmony* (New York: Routledge, 2014), 10.

sequence is "the patriarchal hegemony of harmony," which cannot tolerate gender equality.[23]

This misuse of Confucian harmony goes back to Dong Zhongsu (179–104 BCE), who for the first time incorporates the concepts of *yin* and *yang* into formal Confucian teachings.[24] A distinction has to be made between earlier yin-yang theory and Dong's version of the theory. Before Dong, many thinkers characterized the relationship between yin and yang as a dynamic of creative tension (화, "harmony"). It was Dong who proposed that a desirable resolution of this tension is the imposition of the proper order.[25] In this proper order, he believed, everything should have a "unity."[26] As a result, the theory of yin-yang harmony has turned into a theory of a hierarchical order that keeps things in orderly unity. Since then, Confucian scholars, mostly male, have adopted Dong's idea for the purpose of maintaining a stable social order.

Before Dong, yin-yang energies had been explained only in relation to the material world in nature, such as in the four seasons (yin as winter and yang as summer). It was Dong who first argued that yin-yang energies also exist within the human mind and relationships. Using this hierarchical concept of yin-yang, he justified the imposition of order within human relationships. He developed the three famous bonded relationships, which have been a core teaching of Confucianism ever since. He associated ruler, father, husband, and elder with yang, and subject, son, wife, and youngster with yin. For Dong, yin is fated to always follow and be subordinate to yang. This shift in emphasis tends to create a static and fixed order of social relationships rather than a dynamic process of original, harmonious yin and yang.[27] Dong replaced the "harmony" of yin and yang with a "unity" (합) of yin and yang.[28] Dong's unity is considered more associated with imposed unity—the bringing together of two different elements in conformity to a predetermined order of hierarchy. It is not surprising that Dong used the cosmic inferiority of the

23. M. C. Chiu, "Harmonizing the Resistance, Resisting the Harmony: A Critical Discourse on the Reconstruction of Indigenous Theory of Gender Justice in Hong Kong," *Asian Journal of Social Science* 36 (2008): 98, doi: 10.1163/156853108X267576.
24. Robin R. Wang, "Dong-Zhongshu's Transformation of Ying-Yang Theory and Contesting of Gender Identity," *Philosophy East & West* 55 (2005): 209.
25. Wang, "Dong-Zhongshu's Transformation of Ying-Yang Theory," 214.
26. Wang, "Dong-Zhongshu's Transformation of Ying-Yang Theory," 214.
27. Wang, "Dong-Zhongshu's Transformation of Ying-Yang Theory," 214.
28. Wang, "Dong-Zhongshu's Transformation of Ying-Yang Theory," 216.

yin to the yang in order to justify the social inferiority of woman to man. He bluntly said, "Even if the husband is bad, he is still *yang*, even if the wife is great, yet she is still *yin*."[29] This prescription later came to characterize gender inequality in Confucian societies. Therefore, a distinction has to be made between earlier Confucianism, mostly developed by Confucius and Mencius, and Dong's new version of Confucianism. Confucianism "took a twist" with Dong's interpretation, and this new configuration led to a rigid gender hierarchy that still resonates today.[30]

Since the institution of Confucianism as a national religion in 1392, Korean women have been familiarized only with Dong's historically popular version. Even today, this influence prevails in the daily normative practices of Koreans, both women and men. Many Korean women have little choice but to silently suffer under gender inequality in the name of social harmony. This ideological oppression must be addressed by recovering the original meaning of Confucian harmony. The problem is not the concepts of yin and yang per se but the twisted connotations variously attached to these terms. The restoration of the classical meaning of harmony is necessary to (re)empower Korean women in their claim to rights and justice. In the rest of this chapter, I explore the original interpretation of Confucian harmony as well presented in the classical text *The Middle Way*, or *Doctrine of the Mean*, as a way to promote gender justice for Korean women.

Confucian Harmony in *The Middle Way*

Harmony is the highest value in Confucian society. It is also the core concept of *The Middle Way*, one of the Four Books of Confucianism. A key to Confucian harmony is endless, creative, and reciprocal adjustment between various component parts.[31] These dynamic forces can be best described with the concepts of *qi*, the vital energies in the universe.[32] Qi is composed of two opposing forces, yin and yang, which I already discussed above. *Yin* (−) *energy* is associated with the shadow side of the force, such as shrunken, waning, and dying. *Yang* (+) *energy* is identified with the light side of the force, such

29. Wang, "Dong-Zhongshu's Transformation of Ying-Yang Theory," 218.
30. Wang, "Dong-Zhongshu's Transformation of Ying-Yang Theory," 223.
31. Li, *Confucian Philosophy of Harmony*, 90.
32. Duvert, "How Is Justice Understood in Classic Confucianism?"

as brightness, passion, expansion, and growth. They each have their rightful place, but they are never so powerful as to take entire control.[33] There is always a small amount of light in the dark and dark in the light. These forces wax and wane in a cyclical nature. What matters here is balance and harmony. When yin grows to its limit or peak, the yang inside it will expand within yin and dominate the process, and vice versa. Thus, the search for harmony is a quest for the balance between two or more extremes and tensions. Many duos of complementary opposites structure Confucian thought without being disjunctively dualistic. For example, a person's health depends on the smooth flow of *qi*, within the body and beyond. When *qi* is obstructed or when the balance between the forces of the yin *qi* and yang *qi* is upset, the person falls into illness.[34] Thus, to preserve a good life is to maintain a good harmony of *qi*. The same can be said about relationships. Confucian harmony is a continuous process of adjusting to differences and reconciling conflicts. It creates optimal conditions for the healthy existence of all parties.[35] Harmony cannot be retained by simply keeping the status quo, which will become stale and lifeless. The continuation of harmony itself demands new energy and new initiatives. A harmonious state always changes, evolves, and fluctuates. Whatever level of harmony has been achieved, it can always be enhanced, expanded, and transformed.[36] In this sense, Confucian harmony has no fixed formula other than a basic structure and is not sequentially or linearly structured.[37] It is closer to contemporary jazz in the sense that it is spontaneous, extemporaneous, and not conformed to any fixed order or entity.

Confucian harmony and the Middle Way are two sides of the same coin. *The Middle Way* teaches the following:

> When joy, anger, sorrow and pleasure have not yet arisen [in mind], it is called the Mean [Middle Way] (中 centeredness, equilibrium). When they arise to their appropriate levels [in response to actual situations], it is called "harmony" 和. The Mean is the great root of all-under-heaven. "Harmony" is the penetration of the Way through

33. Wang, "Dong-Zhongshu's Transformation of Ying-Yang Theory," 211.
34. Li, *Confucian Philosophy of Harmony*, 90.
35. Li, *Confucian Philosophy of Harmony*, 10.
36. Li, *Confucian Philosophy of Harmony*, 9.
37. Li, *Confucian Philosophy of Harmony*, 92.

all-under-heaven. When the Mean and Harmony are actualized, Heaven and Earth are in their proper positions, and the myriad things are nourished. (*The Doctrine of the Mean*, A.1)[38]

According to *The Middle Way* (중용), prior to the arousal of feelings and thoughts, we should stay centered (중) in our deep True Nature. When feelings and thoughts are aroused as a reaction to a concrete situation in the world, we should respond (용) to the situation in harmony with our True Nature. This is the creative dynamic between the original self and the empirical self in Confucianism. The former represents the transcendent, spiritual side of self, and the latter refers to all the practical functions of the empirical ego in trying to manage the reality outward. These two sides of self are inseparable, and both are required to create a harmonious balance at every moment and situation. If an individual or a group slants toward one side of this dynamic, balance is broken, and undesirable effects or consequences will develop.

Western liberal feminism tends to slant toward the project of the empirical self, predominantly focusing on the ego's interest, often alienated from the inner work of a spiritual, transcendental ground. In this state, the ego's work can get easily self-centered on personal interests and gains, losing a balance between the concern for self and the concern for others. However, the other extreme also potentially brings a different danger. When we only focus on the individual's moral responsibility for the common good, the demand of self-sacrifice of individual needs and freedom can lead to self-demolition. Both approaches lose their balance in a reality where constantly shifting extremes often take place. Confucians would say that the balance between yin (-) and yang (+) is broken and, as a consequence, disharmony results. I argue that to maintain a harmonious balance between two extremes is *the art of feminism*, whose mission is to destabilize the present patriarchal system. The concept of Confucian harmony, especially as it is outlined in *The Middle Way*, can serve to develop a creative balance in the shifting tensions of modern personhood.

38. A. Charles Muller, trans., "The Doctrine of the Mean," last updated June 8, 2018, https://tinyurl.com/w8mnnc6.

The Art of Feminism in Confucian Harmony

Harmony and Uniformity

Confucian texts clearly differentiate between harmony (*hwa*) and sameness (*tong*). Confucius said that "the *junzi* [cultivated person] harmonizes but does not seek sameness, whereas the petty person seeks sameness but does not harmonize" (*Analects* 13.23).[39] Sameness refers to conformity with a preestablished, fixed existing status quo, which is a sign of disharmony.[40] For Confucians, conformity to sameness, or uniformity, means *disharmonizing*. For example, a sage king seeks harmony by choosing ministers who can "harmonize" by remonstrating with the king when the king has done wrong. True friends "harmonize" by challenging their friends' wrongdoings rather than being complacent when harm is done to others or themselves. It is a friend's duty to speak up and challenge negative actions. The Confucian ideal of harmony is "harmony without mindlessly following others."[41] Harmony is a method used to restore balance by correcting wrongdoings.

In my practice of pastoral counseling in a church setting, I have heard many Korean women who are ministers express frustration. It is the case that many of these women find themselves only assigned to roles that are traditionally labeled "women's work"—for example, teaching preschool children—but that do not suit their particular gifts. For one of them, the rationale of her male superior is that teaching preschool children is *the* most important ministry for God. In this case, if the woman minister speaks out, she fears being labeled as selfish or out of sync with the greater good of the church community. In contrast, her quiet frustration, along with subsequent depression and loss of vitality for her calling, is personally harmful and may also be felt among the entire congregation and have problematic "de-harmonizing" effects.

39. Adapted from Chenyang Li, "The Philosophy of Harmony in Classical Confucianism," *Philosophy Compass* 3 (2008): 426.
40. Li, *Confucian Philosophy of Harmony*, 11.
41. Chenyang Li, "Confucian Harmony: A Philosophical Analysis," in *Dao Companion to Classical Confucian Philosophy*, ed. V. Shen (New York: Springer, 2013), 384.

This 1910 postcard features a suffragette Madonna in a caricature of disharmony.

In this particular situation, how does the Korean woman harmonize to restore balance? Contextual and situational awareness is a key element. If the male pastor's intention is to manipulate and control the woman's active role and agency as minister, his demand must be challenged and *harmonized*. It is her duty and right to speak out, for example, in a committee meeting and challenge the command. This way, she restores Confucian harmony to herself and her congregation. In doing so, she relies upon a Western liberal feminist tactic that focuses on her sense of justice and the rights to which she is entitled. She may face criticism from the Confucian community for being selfish and arrogant. However, her action can be a well-calculated one, with good intention, and thus function as a tactic that disrupts the status quo. Her *harmonizing* action is firmly rooted in the foundation of the Middle Way, not in her selfish gain. In this case, the notion of Confucian harmony can be a radically effective tool for Korean women to fight against the imbalance of gender equality.

Timing in Confucian Harmony

The Confucian concept of "timing" (시중) is crucial in the harmonizing process. The Confucian text says, "The cultivated person practices zhongyong [the Middle Way]; the petty person is contrary to zhongyong. . . . The cultivated person . . . exercises appropriately timed centrality (shi-zhong); . . . the petty person . . . does not have the requisite caution and concern" (*The Middle Way* 2.1–2).[42] For example, an individual expresses his or her anger, but the same angry behavior can be the sign of harmonizing or of de-harmonizing depending upon the context and timing of the event. The Korean woman in the above example must decide whether she should speak up immediately in public to obtain the most optimal effect or wait until her position will be understood more clearly in a stronger future context.

42. Quoted in Li, *Confucian Philosophy of Harmony*, 79.

Harmony among Various Virtues

Confucian harmony is about harmony among various virtues. For Confucians, it is not just the practice of the virtues themselves but the practice of the virtues in harmony that results in the highest virtue.[43] In *Analects* 4.25, Confucius says, "Virtue is never solitary: it always has neighbors."[44] The five cardinal virtues in Confucianism are benevolence, righteousness, propriety, wisdom, and integrity. The harmony among these virtues is more important than each individual virtue. Benevolence, for example, when practiced against righteousness or wisdom, is no virtue at all.[45] If the Korean woman in the above example expresses her anger and frustration without harmony's virtues of compassion and wisdom, her act will end up being disharmonious. As a consequence, such an action may cause more problems, disrupting the overall harmony of the community. Confucian harmony should be an orchestrated harmony among various virtues.

Not Too Much, Not Too Little

This principle of harmony is similar to the understanding that "too much of a good thing is bad" and "too little of a good thing is bad." A harmonious person knows when to stop and when to go further. A certain virtuous action itself can be thought of as good, but any good action without abstinence (self-restraint) will eventually turn into disharmony and, therefore, no longer be a virtue at all. For example, good parents know when and how they should discipline according to their love. This well-balanced parental wisdom is associated with Confucian harmony. The woman mentioned above must be centered in the Middle Way so that she embraces the wisdom to know what the optimal level of challenge is and when it should be enacted. Too much or too little challenge will not disturb the status quo enough, and such confrontation is off balance and can easily turn into an action infused with self-

43. Chenyang Li, "The Ideal of Harmony in Ancient Chinese and Greek Philosophy," *Dao* 7 (2008): 95.
44. Quoted in Edward Slingerland, *Confucius: Analects with Selections from Traditional Commentaries* (Indianapolis, IN: Hackett, 2003), 37.
45. Y. O. Kim, *The Middle Way: The Taste of Humanity* (Seoul, Korea: Tongnamoo, 2011), 160.

ish motives. As discussed above, actions based on personal gain or advantage are unjust for Confucian subjects.

Conclusion

Confucian harmony is dynamic, contextual, and situational. It is not conformity to a pre-given order. It is, rather, embodied by strong agency in accordance with each particular situation: how, what, where, and when do matter. This concept of harmony can be used as an effective tool for Korean feminists to disrupt the status quo of a patriarchal system. We are all unique individuals, independent from any ends and purposes that we will accomplish. At the same time, we are the members of a certain family, community, and society. Western liberal ideas prioritize the protection of individual rights from the abuse of the majority, primarily through political and legal means. Confucianism understands the issues of justice from an ethical perspective, giving more emphasis to the inner work of self-cultivation. These two different approaches can work in tandem by mirroring each other. Confucian harmony is a path to the *art of feminism*. It will enable and empower women to ask both questions simultaneously: "What am I entitled to (as a free individual)?" and "What ought I do (as a moral agent tied to a community)?" It is these two inseparable, compelling questions in constant, creative tension and searching for an optimal balance that create Confucian harmony.

Bibliography

Chiu, M. C. "Harmonizing the Resistance, Resisting the Harmony: A Critical Discourse on the Reconstruction of Indigenous Theory of Gender Justice in Hong Kong." *Asian Journal of Social Science* 36 (2008): 79–103. doi: 10.1163/156853108X267576.

Cline, Erin M. "Two Senses of Justice: Confucianism, Rawls and Comparative Political Philosophy." *Dao* 6 (2007): 361–81.

Darmawan, Daniel. "Is This the Face of South Korea's New Anti-Feminist Movement?" *Vice*. December 6, 2018. https://tinyurl.com/vbwyxc7.

Duvert, Christopher. "How Is Justice Understood in Classic Confucianism?" *Asian Philosophy* 28 (2018): 295–315.

Herr, Ranjoo. "Is Cultural Diversity Compatible with Feminism? Confucianism and Women's Cause." *Journal of American Studies* 27 (2009): 153–70.

Hutton, Eric L., trans. "Xunzi." In *Readings in Classical Chinese Philosophy*, 2nd ed., edited by Philip J. Ivanhoe and Bryan W. Van Norden, 255–309. Indianapolis, IN: Hackett, 2005.

Kim, Y. O. *The Middle Way: The Taste of Humanity*. Seoul, Korea: Tongnamoo, 2011.

Kwon, Jake. "South Korea's Young Men Are Fighting against Feminism." CNN. September 23, 2019. https://tinyurl.com/y62bv7ft.

Li, Chenyang. "Confucian Harmony: A Philosophical Analysis." In *Dao Companion to Classical Confucian Philosophy*, edited by V. Shen, 379–94. New York: Springer, 2013.

———. *Confucian Philosophy of Harmony*. New York: Routledge, 2014.

———. "The Ideal of Harmony in Ancient Chinese and Greek Philosophy." *Dao* 7 (2008): 81–98.

———. "The Philosophy of Harmony in Classical Confucianism," *Philosophy Compass* 3 (2008): 423–35.

Muller, A. Charles, trans. "The Doctrine of the Mean." Last updated June 8, 2018. https://tinyurl.com/w8mnnc6.

O'Neil, Onora. "Liberal Justice: Kant, Rawls, and Human Rights." *Kantian Review* 23 (2018): 641–59.

Rosemont, Henry Jr. "Human Rights: A Bill of Worries." In *Confucianism and Human Rights*, edited by Wm. Theodore de Bary and Tu Weiming, 54–66. New York: Columbia University Press, 1998.

Sandel, Michael J. "The Procedural Republic and the Unencumbered Self." In *Political Theory Reader*, edited by Paul Schumaker, 144–46. Hoboken, NJ: John Wiley & Sons, 2010.

"Singapore Topples United States as World's Most Competitive Economy," IMD, May 28, 2019, https://tinyurl.com/y34gmcnp.

Slingerland, Edward. *Confucius: Analects with Selections from Traditional Commentaries*. Indianapolis, IN: Hackett, 2003.

Wang, Robin R. "Dong-Zhongshu's Transformation of Ying-Yang Theory and Contesting of Gender Identity." *Philosophy East & West* 55 (2005): 209–31.

World Economic Forum. *The Global Gender Gap Report 2018*. Cologny/Geneva: World Economic Forum, 2018. https:// tinyurl.com/y29gg499.

10. Between the Ballot and the Bullet: Women's Suffrage, Liminality, and the Arc of the Moral Universe

MARY ELIZABETH "BETH" TOLER

In August 1967, Rev. Dr. Martin Luther King Jr. addressed the Eleventh Annual Southern Christian Leadership Conference in Atlanta, Georgia. In this famous speech, King invoked the words of nineteenth-century minister and abolitionist Theodore Parker and proclaimed, "Let us realize that the arc of the moral universe is long but it bends towards justice."[1] King's claim expresses a specific kind of informed optimism, an eyes-wide-open faith in humanity. Obviously, there is evil and trial and tragedy and hatred all around us, and yet moments of good periodically surface and invite us to consider the possibility that there is an imperceptible trajectory of history whose mostly hidden contours are moving toward liberty and justice for all.

Whether or not you ascribe to the positivist, progressivist philosophy that underlies the arc of the moral universe, three things are clear: the arc of the moral universe sometimes sharply bends in the direction of injustice, nothing bends toward justice without someone or something bending it in that direction, and the arc is in continual flux. In other words, if there is an arc of the moral universe, any movement toward justice is usually born out of an intense struggle for justice, and any movement toward justice is simply that: a movement toward justice. Struggle for justice in one area becomes a

1. Martin Luther King Jr., "Where Do We Go from Here? (1967)," in *A Testament of Hope: The Essential Writings and Speeches of Martin Luther King, Jr.*, ed. James M. Washington (San Francisco: Harper and Row, 1986), 252. According to Taylor Branch, King's quote came from Theodore Parker (*Parting the Waters: America in the King Years 1954–63* [New York: Simon and Schuster, 1988], 197). Parker's original words were: "I do not pretend to understand the moral universe, the arc is a long one, my eye reaches but little ways. I cannot calculate the curve and complete the figure by the experience of sight; I can divine it by conscience. But from what I see I am sure it bends towards justice" (Theodore Parker, "Of Justice and the Conscience," in *Ten Sermons of Religion* [London: Chapman, 1853], 78).

building block for sniffing out and addressing other injustices. The arc has not found its final resting point.

The women's suffrage movement in America that culminated in granting women the right to vote with the Nineteenth Amendment to the Constitution is a prime example of the ongoing process and work of the arc of the moral universe. In the midst of the struggle to abolish slavery, women became inspired to claim their own rights as full persons in the eyes of the American republic. Now, a century later, the women's suffrage movement reminds us that there are still groups of people who cannot enjoy equal status, and calls us to the ongoing work of the arc of the moral universe.

What follows is an outline of the women's suffrage movement and how it fits in the rhythm of the ongoing work of justice in the United States and the overall arc of the moral universe. By locating and tracing its roots through the narrative of slavery, the women's suffrage movement can be viewed as a nodal moment of justice in the arc of the moral universe whose official starting point begins with the abolition movement and whose arrow points to future justice work. Just as the work of justice to end slavery awakened and inspired women to claim their political rights as full and equal citizens, so, too, does the women's suffrage movement awaken and inspire others to claim their humanity as full and equal citizens. In other words, the women's suffrage movement, through its genesis and process, demonstrates that nodal moments of justice in the arc of the moral universe are actually fertile spaces that usher us to the threshold of the next battle for justice, even as we continue fighting in other places without resolution.

The Arc of Women's Suffrage in the United States

When Thomas Jefferson penned the iconic claims in the Declaration of Independence that "all men are created equal, that they are endowed by their Creator with certain unalienable Rights, that among these are Life, Liberty and the pursuit of Happiness," a foundation was immediately created for addressing issues of human rights and justice.[2] In fact, over the next fifteen

2. "Declaration of Independence: A Transcription," National Archives and Records Administration, accessed December 1, 2019, https://tiny url.com/h2zqchv.

years, the founders of the republic spent considerable energy parsing out the meaning of the unalienable rights of "men" and addressing the substantial deficiencies on matters of individual liberties. These debates ultimately resulted in the Constitution of the United States and the Bill of Rights.

The contradiction between the self-evident truths proclaimed by Jefferson and the reality of slavery was palpably evident in every moment of the debates that produced the Declaration, Constitution, and Bill of Rights. All of the participants in the Second Continental Congress who signed the Declaration of Independence knew that slavery was an issue that concerned the nation. In fact, Jefferson's first draft of the Declaration *did* recognize the issue of slavery. In it, he stated that King George had "waged cruel war against human nature itself, violating it's [sic] most sacred rights of life & liberty in the persons of a distant people who never offended him, captivating & carrying them into slavery in another hemisphere, or to incur miserable death in their transportation thither."[3]

In the end, those who drafted the Declaration believed that it was better to remove the section dealing with slavery than risk a long debate. They needed the support for independence from the southern states. The clause itself was stricken out at the request of delegates from South Carolina and Georgia but with the agreement of New England states. The delegates recognized that the Declaration was going to result in war with England and that if the colonies were not united, they would not prevail. It was too big an issue for thirteen separate and independent colonies to tackle before they had even formed a country or won independence from England.[4]

Fast-forward to the Constitutional Convention of 1787, where the issue of slavery was also hotly debated. The Constitution that the delegates proposed included several provisions that explicitly recognized and protected slavery. Without these provisions, southern delegates would not support the new Constitution—and without the southern states on board, the Constitution had no chance of being ratified. The final version of the Constitution allowed southern states to count slaves as three-fifths persons for purposes of apportionment in Congress, denied Congress the power to pro-

3. Thomas Jefferson, "Jefferson's 'Original Rough Draught' of the Declaration of Independence," reconstructed by Julian Boyd, The Library of Congress, accessed October 30, 2019, https://tinyurl.com/oo3dxgb.
4. "Slavery, The Horrifying Institution," USHistory.org, accessed October 30, 2019, https://tinyurl.com/ttfbmmu.

hibit importing new slaves until 1808, and prevented free states from enacting laws protecting fugitive slaves.[5]

While the first generation of the republic was sorting out the principles of justice, liberty, and rights through debates emanating from the Declaration and codified in the Constitution and the Bill of Rights, there was a groundswell of protests against the institution of slavery. A growing abolition movement was strengthening in Europe and the Americas. There was a steady stream of nations banning the slave trade and then abolishing slavery as an economic option.

Many abolitionists, especially in England and in the United States, were women. As they invested themselves in the work to end slavery, they became increasingly keen to note that they, too, were second-class residents. In an address to the American Anti-Slavery Society on May 8, 1860, Elizabeth Cady Stanton captured this reality when she declared, "This is the only organization on God's footstool where the humanity of woman is recognized, and these are the only men who have ever echoed back her cries for justice and equality. . . . All time will not be long enough to pay the debt of gratitude we owe these noble men . . . who roused us to a sense of our own rights, to the dignity of our high calling."[6] This stark awakening, along with the existing principles forged in the founding documents of the republic—equality and unalienable rights—created the moral impetus for women's rights and universal suffrage.

Indeed, twelve years earlier, on July 19, 1848, in upstate New York, the Seneca Falls Convention opened and the women's suffrage movement in the United States was officially launched. It was possibly the first convocation in the republic called and led by women. The conveners were Lucretia Mott and Elizabeth Cady Stanton, strong women who had learned the skills of prophetic resistance in the company of other international abolitionist leaders. On the second day of the convention, Frederick Douglass and a few other men addressed the assembly, a sign of connection and solidarity

5. "The Constitution and Slavery," Digital History, accessed October 30, 2019, https://tinyurl.com/p9lcuop.
6. Elizabeth Cady Stanton, "Address by ECS to the American Anti-Slavery Society," in *The Selected Papers of Elizabeth Cady Stanton and Susan B. Anthony: In the School of Anti-Slavery 1840–1866*, ed. Ann D. Gordon (New Brunswick, NJ: Rutgers University Press, 1997), 411.

between the work toward abolition and the rights of women.[7] This historic meeting, and others like it, generated the moral and spiritual force behind the women's suffrage movement that finally culminated in the Nineteenth Amendment.

The culminating event of the Seneca Falls Convention was the presentation of the Declaration of Sentiments. Primarily authored by Elizabeth Cady Stanton, the Declaration of Sentiments was modeled after the Declaration of Independence and directly challenged the established laws of coverture that excluded women from the rights of full citizenship. It boldly (re)claimed that "all Men and Women are created equal" and called for extending to women the right to vote, control property, sign legal documents, serve on juries, and enjoy equal access to education and the professions.[8] According to the nineteenth-century antislavery newspaper published by Frederick Douglass, *The North Star*, the presentation and passing of the Declaration of Sentiments was a "grand movement for attaining the civil, social, political, and religious rights of women."[9]

The arc of the women's suffrage movement that grew out of the abolitionist movement and was solidified at Seneca Falls would continue to stretch for decades as women worked tirelessly to both end slavery and win the right to vote. The abolition of slavery in 1865, securing the voting rights of African American men in 1870, and disagreements over strategy threatened to disrupt the arc multiple times. However, on August 18, 1920, the Nineteenth Amendment to the Constitution was ratified, affording all women in the United States the rights and responsibilities of citizenship. In the process, women discovered their voice and staked their claim on equality and their own unalienable rights.

7. "Antislavery Connection," Women's Rights National Historical Park, accessed October 30, 2019, https://tinyurl.com/uxyzem9.
8. "Declaration of Sentiments," in *First Convention Ever Called to Discuss the Civil and Political Rights of Women, Seneca Falls, New York, July 19, 20, 1848*, accessed January 14, 2020, https://tinyurl.com/ud5etzh.
9. Frederick Douglass, "The Rights of Women," *North Star* (Rochester, NY), July 28, 1848, Elizabeth Cady Stanton Papers, Manuscript Division, Library of Congress (008.00.00), accessed January 14, 2020, https://tinyurl.com/vkd5zqd.

Between the Ballot and the Bullet: The Liminality of Women's Suffrage

The institution of slavery produced an undeniable breach in the grand narrative of unalienable rights found in the Declaration of Independence. This rupture invited men and women of all classes, races, and creeds into the abolitionist movement because the state of the republic and its constructs of identity and social order were dissonant with the country's founding values of human rights and liberty and with the faith-based values of human dignity and justice. However, for women, the abolitionist movement was more than a space to fight for the human rights of African slaves and their descendants. For many women, the abolitionist movement became a liminal, or transformational, space that roused them from their own status as second-class citizens and called them to activate genuine personal, social, and political reformation.

According to Victor Turner (1920–1983), a British cultural anthropologist, liminality occurs when there is a rupture in the predefined orientations and grand narratives that undergird society. Individuals or groups who experience this rupture are ushered into a space of transition and become *liminars* who are neither this nor that and simultaneously both and neither. Turner goes on to define *liminars* as individuals who are "neither here nor there; they are betwixt and between the positions assigned and arrayed by law, custom, convention, and ceremony."[10] While in the liminal state, individuals are stripped of anything that might differentiate them from others. In other words, they have temporarily fallen through the cracks of the established social structures that have upheld their individual and collective identities. Yet ironically, it is in these cracks that individuals become most aware of themselves and their need for transformation. Liminality, therefore, should be understood as a temporary space, a creative midpoint between two states of defined existence, that optimally resolves with a redefined incorporation into the social structure.[11]

From a spiritual perspective, liminality is an important part of the spiritual

10. Victor W. Turner, *The Ritual Process* (New York: Penguin, 1969), 95.
11. Harmony Siganporia and Frank G. Karioris, "Introduction: Rupture and Exile: Permanent Liminality in Spaces for Movement and Abandonment," *Culture Unbound: Journal of Current Cultural Research* 8, no. 1 (2016): 20–25.

journey. Richard Rohr describes liminality as a sacred space "where we are betwixt and between the familiar and the completely unknown ... where the old world is able to fall apart and a bigger world is revealed."[12] He goes on to suggest that liminality is the space where genuine transformation occurs, and that we have to allow ourselves to be drawn out of normalcy, out of a stance of "business as usual." Liminality includes a process of deconstructing false towers of existence and some reshaping of a person's identity in preparation to inhabit a new dwelling place on the spiritual journey.

The liminality of the abolitionist movement that gave birth to women's suffrage can best be framed as the space *between the ballot and the bullet*, a space claimed by Susan B. Anthony in an 1863 speech when she declared, "Women can neither take the Ballot nor the Bullet ... therefore to us, the right to petition is the one sacred right which we ought not to neglect."[13] On a literal level, when Anthony stakes claim to the territory between the ballot and the bullet, she is pointing to the First Amendment of the Constitution and the article that guarantees the right "to petition the Government for a redress of grievances."[14] By pointing to the right to petition, she is highlighting both the political ideal and the codified constitutional doctrine that government officials must hear and respond to complaints by citizens, even disenfranchised ones. She is proclaiming that though women may not be able to enjoy the full rights of citizenship, which include total political access and the ability to serve in the military, they do have an avenue for action.

On another literal level, Anthony's words serve as an important counternarrative to a prominent storyline that depicts women in the abolitionist movement as merely helpful and inspirational wives, mothers, and daughters rather than activists in their own right. By calling out the space between the ballot and the bullet, Anthony is reminding her audience that women are the backbone of the abolitionist movement and vital to its success. Without women and the local societies they formed around abolition, public sentiment would not be nearly as engaged. There would be less money to pub-

12. Richard Rohr, *Everything Belongs: The Gift of Contemplative Prayer* (New York: Crossroad, 1999), 155–56.
13. Susan B. Anthony, "Address to the American Anti-Slavery Society," Women's Rights National Historical Park, accessed October 30, 2019, https://tinyurl.com/uxyzem9.
14. "The U.S. Constitution," Interactive Constitution, accessed October 30, 2019, https://tinyurl.com/vogfsbp.

lish abolitionist tracts, fewer halls and platforms packed with people, and no petitions to present to the government.[15]

This 1914 caricature of suffragettes was sent by a German to a friend in New York City. It reads: "After the English army is beaten, the suffragettes will mobilize."

Yet on a figurative level, when Anthony stakes claim to the territory between the ballot and the bullet, she is identifying a chink in the armor of the republic and highlighting the ways in which women already were shedding the confines of normalcy through their abolitionist activities. She is recognizing a liminal space, a midpoint of existence where nineteenth-century women were exploiting the cracks of societal norms, deconstructing the false towers of their identities as defined for them by the state, and creatively transforming the very nature of their status and existence as citizens.

The abolitionist movement thrust women from the strict confines of domestic duties into the public sphere in unprecedented ways, ways that defied and transformed the prescribed social roles of women. Women gained experience as leaders, organizers, newspaper publishers, fundraisers, and lecturers. Furthermore, in the 1850s, as women's rights began to figure more prominently in the abolitionist movement, and as the women's rights move-

15. Claire Midgely, *Women against Slavery: The British Campaigns, 1780–1870* (London: Routledge, 1995).

ment became more organized, the issue of suffrage was not the only one on the table. For example, Lucy Stone became well known in reformer circles when she and her husband altered the traditional marriage ceremony. At their wedding, they read aloud a statement saying that they disagreed with the laws of coverture that gave husbands control over their wives and children. Stone also decided not to take her husband's last name to signify that she maintained a separate identity.[16]

The discussion of women's rights also included other key social issues like property rights, dress reform, and religion.[17] In terms of dress reform, Elizabeth Cady Stanton and others believed that freeing women from traditional heavy skirts and tight corsets would allow them to be more productive members of society. In a letter to Stanton, Gerrit Smith, a leading social reformer, politician, and abolitionist, sums up the sentiment well:

> I admit that the dress is not the primal cause of her helplessness and degradation. That cause is to be found in the false doctrines and sentiments of which the dress is the outgrowth and symbol. . . . Were women to throw off the dress, which in the eye of chivalry and gallantry is so adapted to womanly gracefulness and womanly helplessness, and to put on a dress that would leave her free to work her own way through the world, that chivalry and gallantry would nearly or quite die out. No longer would she present herself to man in the bewitching character of a plaything, a doll, an idol, or the degraded character of his servant.[18]

Though an initial driving force in both the abolitionist movement and women's suffrage, particularly because of those movements' roots in Quakerism and Christian piety, religion also eventually came under the scrutiny of women's rights. In particular, Christianity and the church became sharply criticized for the role they played in perpetuating women's status as second-class citizens. No one codified this more than Elizabeth Cady Stanton. In addition to *The Woman's Bible* (1895), where she critiqued Christian scripture

16. Allison Lange, "Early Organizing Efforts," National Women's History Museum, accessed October 30, 2019, https://tinyurl.com/qrnxwvj.
17. Lange, "Early Organizing Efforts."
18. Gerrit Smith, "Letter from Gerrit Smith to Elizabeth Cady Stanton, 1855," University of Rochester, River Campus Libraries, accessed October 30, 2019, https://tinyurl.com/wt4foyl.

from a feminist perspective, Stanton also wrote numerous articles on the subject of women and religion and vociferously urged women to "recognize how religious orthodoxy and masculine theology obstructed their chances to achieve self-sovereignty."[19] Furthermore, Stanton firmly believed that women's emancipation could only be achieved through "religious liberty, which is freedom from old theological superstitions."[20] In other words, for Stanton, "to change the position of woman in dogmatic theology, where she is represented as the central figure in Paradise Lost," says Stanton in one of her essays, "is to revolutionize the system."[21]

Through these examples, it is clear that in the liminal space designated by Anthony as between the ballot and the bullet, women not only found an avenue to actively engage the work of abolition and women's suffrage; they also crossed the threshold of a new world order. However, it would be naive to think that the liminal space of the women's suffrage movement was an uncomplicated, pure space. There were major discrepancies between the way black women and white women accessed and experienced women's suffrage. Though black and white citizens worked side by side in both the abolitionist and women's suffrage movements, education, social class, and race were huge factors in granting greater or lesser access to the public sphere of these movements. These socioeconomic factors also protected white women from any significant violent or punitive retribution when they wielded their pens, petitions, and protests.

Sojourner Truth, a freed slave who became active in both the abolitionist movement and the women's suffrage movement, depicts this reality well. In a letter, she recalls two incidents while in the company of prominent reformers and abolitionists Josephine Griffing and Laura Haviland:

> A few weeks ago I was in company with my friend Josephine S. Griffing, when the Conductor of a street car refused to stop his car for me, although [I was] closely following Josephine and holding on to the iron rail. They dragged me a number of yards before she suc-

19. Kathi Kern, "'Free Woman Is a Divine Being, the Savior of Mankind': Stanton's Exploration of Religion and Gender," in *Elizabeth Cady Stanton, Feminist as Thinker: A Reader in Documents and Essays*, ed. Ellen Carol DuBois and Richard Cándida Smith (New York: New York University Press, 2007), 94.
20. Kern, "'Free Woman Is a Divine Being, the Savior of Mankind,'" 94.
21. Elizabeth Cady Stanton, "The Duty of the Church to Woman at This Hour," *Free Thought Magazine* 20 (1902): 191, accessed January 14, 2020, https://tinyurl.com/yx7lvf7c.

ceeded in stopping them. She reported the conductor to the president of the City Railway, who dismissed him at once, and told me to take the number of the car whenever I was mistreated by a conductor or driver. On the 13th inst [sic] I had occasion to go for blackberry wine, and other necessities for the patients in the Freedmen's Hospital where I have been *doing* and advising for a number of months. I thought now I would get a ride without trouble as I was in company with another Friend Laura S. Haviland of Michigan. As I ascended the platform of the car, the conductor pushed me, saying "go back–get off here." I told him I was not going off, then "I'll put you off" said he furiously, clenching my right arm with both hands, using such violence that he seemed about to succeed, when Mrs. Haviland told him, he was not going to put me off. "Does she belong to you?" said he in a hurried angry tone. She replied "She does not belong to me, but she belongs to Humanity." The number of the car was noted, and conductor dismissed at once upon the report to the president who advised his arrest for assault and battery as my shoulder was sprained by his effort to put me off. Accordingly I had him arrested and the case tried before Justice Thompson. My shoulder was very lame and swolen [sic], but is better. It is hard for the old slaveholding spirit to die. But die it *must*.[22]

In addition to the discrepancy in the liminal experience, the battle for universal suffrage waged by a more radical wing of the abolitionist movement often got couched in racialized language and concepts of social and racial hierarchies. For example, in the midst of Elizabeth Cady Stanton's passionate commitment to the ideal of equal rights for all American citizens, she sometimes lapsed into polarizing and degrading language.[23] She was so convinced that women's suffrage and male black suffrage were intricately intertwined and dependent on each other that she vociferously campaigned against the ratification of the Fifteenth Amendment and its narrow offering of suffrage to "freedmen." Though her commitment to universal suffrage is admirably unwavering, her language of opposition is abhorrent. According to Stanton,

22. Sojourner Truth, quoted in We Are Your Sisters: Black Women in the Nineteenth Century, ed. Dorothy Sterling (New York: Norton, 1997), 254.
23. Ann D. Gordon, "Stanton on the Right to Vote: On Account of Race or Sex," in DuBois and Smith, Elizabeth Cady Stanton, Feminist as Thinker, 113.

the amendment threatened to "degrade mothers, wives, and daughters, in their political status, below unwashed and unlettered ditch-diggers, bootblacks, hostlers, butchers and barbers."[24] Stanton further declared that if in the passing of the Fifteenth Amendment, the demand is not made to represent women in government, then "the lower orders of Chinese, Africans, Germans, and Irish, with their ideas" will be "left to make laws for you and your daughters."[25]

As repugnant as this language is, Stanton did not always employ this kind of social and racial rhetoric. During the same campaign against the Fifteenth Amendment, she also wrote, "When we contrast the condition of the most fortunate women at the North, with the living death colored men endure everywhere, there seems to be a selfishness in our present position. But remember we speak not for ourselves alone but for all womankind . . . for the women of this oppressed race too, who, in slavery, have known a depth of misery and degradation that no man can ever appreciate."[26]

In conclusion, the transformational space that gave birth to women's suffrage was not a morally pure, peaceful place. It was a space often rife with conflict over the meaning of equality. It was a space often fragmented into competitive notions of gender, race, nativity, and class. It was a space often contaminated by racial constructions, imperial presumptions, and evolutionary elitism. Nonetheless, in spite of these stark realities, the liminal space of the women's suffrage movement afforded all women a chance to explore and expand the confines of their prescribed social and political horizons. Women donned new identities and challenged elemental conceptions of womanhood. In short, in the space between the ballot and the bullet that Susan B. Anthony first named and highlighted in her 1863 address to the American Anti-Slavery Society, women became a moral force. The role of the "emancipated" woman in the transformation of society became solidified, and the arc of the moral universe moved forward in its bend toward justice.

24. Gordon, "Stanton on the Right to Vote," 117.
25. Gordon, "Stanton on the Right to Vote," 117.
26. Gordon, "Stanton on the Right to Vote," 117.

Between the Ballot and the Bullet: New Liminal Spaces in the Arc of the Moral Universe

The arc of the moral universe is in perpetual motion, and its line is peppered with nodal moments in its bend toward justice. Much like the birth of a new solar system, each nodal moment in the movement toward justice is birthed by a societal rupture where the predefined orientations and grand narratives that undergird society collapse. This rupture ushers in a spirit of liminality that rouses individuals and groups from the slumber of the status quo and calls them to activate genuine personal, social, and political change.

As we consider the nodal moment of the abolitionist movement and women's suffrage in the arc of the moral universe and the societal rupture that gave birth to those movements, we are invited to turn an eye toward the present day and survey the landscape of our modern American society. Where are the ruptures and fissures? What conditions exist that challenge and betray the grand narrative of equality and justice laid out by our founding fathers? Where is the equilibrium of equality and equity disrupted, resisted, or repressed? What conditions exist that perpetuate physical, mental, and spiritual bondage? Where should we plot a point in the arc of the moral universe and work to bend it toward justice? And what liminal spaces exist that inspire individuals and groups to challenge the norms of oppression and political disenfranchisement and invite them to redefine the realms of their existence?

There are several ruptures in the current American landscape that betray the grand narrative of equality and justice laid out by our founding fathers, and there are liminal spaces that exist in each of them that are igniting creative shifts and changes in individual and societal identities. However, in the contemplative light of the women's suffrage movement, what clearly stands out is the gap between the political declaration of full and equal rights in the Thirteenth, Fifteenth, and Nineteenth Amendments and the continued political, civic, and social disenfranchisement of African Americans. Moreover, what is equally and ironically clear is how the liminal space between the ballot and the bullet that Susan B. Anthony staked claim to over one hundred years ago carries over and continues to serve as a way to frame the space for change and transformation. Though the contemporary meaning of this phrase is obviously different than Anthony's, the parallel holds. What follows

is a brief outline of how the African American community may be currently situated in this liminal space. By naming and outlining the new spatial iteration between the ballot and the bullet, the hope is to invite the reader to participate in an imaginative process and consider the possibilities of where and how the work of the arc of the moral universe may continue.

The African American community stands between the ballot and the bullet in devastating ways. In particular, the African American community exists in the space between active voter suppression (ballot) and the deadly effects of police brutality and racial profiling (bullet). According to the American Civil Liberties Union, although levels of voter participation have increased exponentially since 2008, voter suppression is also on the rise. Voter suppression is measured through four primary factors: voter registration laws, voter purges, ID laws, and early voting laws. These voter suppression measures are often couched in terms of reducing the possibility of voter fraud, but in reality, they make the voting process more difficult for minority groups.[27]

Since 2008, thirteen states have introduced voter registration bills that would either end Election Day and same-day voter registration, limit voter registration drives, or reduce opportunities for voters to register. For example, "census data shows that . . . African-American voters are about twice as likely to register to vote through voter registration drives as white voters."[28] In the lead-up to the 2012 elections, nearly 250,000 North Carolinians—41 percent of whom were African American—registered to vote through the state's same-day registration system. This system was repealed in 2013.[29]

Between 2014 and 2016, there was a 12.8 percent increase, about 1.9 million people, in the number of voters purged from state voter rolls, an increase that had a higher impact on African American voters than white voters.[30] For example, Ohio removed an estimated 846,000 people from its voter rolls for failing to vote in previous elections. Between 2012 and 2016, more than 10 percent of registered voters were purged in "heavily African-American"

27. "The Facts about Voter Suppression," American Civil Liberties Union, accessed November 14, 2019, https://tinyurl.com/wc6a8tt.
28. "The Facts about Voter Suppression."
29. Danielle Root and Liz Kennedy, "Increasing Voter Participation in America: Policies to Drive Participation and Make Voting More Convenient," Center for American Progress, July 11, 2018, https://tinyurl.com/y92yzamt.
30. "The Election Administration and Voting Survey: 2016 Comprehensive Report," U.S. Election Assistance Commission, 47, https://tinyurl.com/uvyr5ze; Root and Kennedy, "Increasing Voter Participation in America."

neighborhoods near downtown Cincinnati, compared with only 4 percent of those living in the surrounding suburb of Indian Hill.[31]

In 2011, ten states introduced bills that would reduce early or absentee ballot voting periods; such bills passed in Florida, Georgia, Ohio, Tennessee, and West Virginia. The impact of these measures on the African American community can be seen by the fact that in Florida, 54 percent of African Americans utilized early voting, and in Georgia, 35 percent of African Americans utilized early voting.[32]

In 2011, eight states passed stricter voter ID laws. These laws disproportionately impact African Americans. A widely cited study by the Brennan Center found that 25 percent of black voting-age citizens did not have a government-issued photo ID, compared with 8 percent of white voting-age citizens. And a study for the Black Youth Project, which analyzed 2012 voting data for people ages eighteen to twenty-nine, found 72.9 percent of young black voters and 60.8 percent of young Hispanic voters were asked for IDs to vote, compared with 50.8 percent of young white voters.[33]

As the voices of African Americans are silenced at the polls because of unjust laws, African Americans are also being silenced at alarming rates through the bullets of police brutality. On August 9, 2014, Michael Brown, an unarmed teenager from Ferguson, Missouri, was shot and killed by police officer Darren Wilson. Out of that moment, and in the wake of Wilson's acquittal, the Black Lives Matter protest began, a light was shed on the reality of police violence in the African American community, and a movement was born to increase accountability of public safety officials. According to a study published in August 2019, African American men "face a one in 1,000 risk of being killed during an encounter with police, a rate much higher than that of white men." The risk is greatest between the ages of twenty and thirty-five.[34] Another recent study found that out of the 1,147 people killed by police in 2017, African Americans represented 25 percent, despite making up

31. Ari Berman, "As the GOP Convention Begins, Ohio Is Purging Tens of Thousands of Democratic Voters," *The Nation*, July 18, 2016, https:// tinyurl.com/tgwpfnz.
32. "The Facts about Voter Suppression."
33. Root and Kennedy, "Increasing Voter Participation in America."
34. Laura Santhanam, "After Ferguson, Black Men Still Face the Highest Risk of Being Killed by Police," PBS NewsHour, August 9, 2019, https://www.pbs.org/newshour/health/after-ferguson-black-men-and-boys-still-face-the-highest-risk-of-being-killed-by-police.

only 13 percent of the US population.[35] So far, in 2019, out of the 753 civilians who have been shot and killed by police, 150 (20 percent) are African Americans.[36] It is also significant that another study found that between 2013 and 2018, 21 percent of African Americans killed by police were unarmed, compared to 14 percent of white victims.[37]

The impact of the police killings of unarmed African American men reaches far beyond the actual death. A June 2018 report from the British journal *The Lancet* focused on the mental well-being of African Americans who are not directly involved in acts of police killings and violence. Using self-reported responses from a national mental health survey and data from a police shooting database, the study compared the mental health of African American adults who lived in the vicinity of a police killing of an unarmed African American before and after the killing. What they found was a "substantial" impact of police killings on the mental well-being of African Americans in the states where the police violence happened.[38] This research adds to a growing body of literature on the impact of police violence within the African American community, including research that examines the ways that police violence kills black women slowly through trauma, pain, and loss.[39]

To be black and male at the same time in the United States is a difficult and dangerous reality; it is an existence precariously situated between the ballot and the bullet. Where is the liminal space between the ballot and the bullet that spawns new identities, challenges confining structures of existence, and transforms the very nature of our existence? Where is the arc of the moral universe longing to point its arrow? Where and how will the members of the African American community be fully embraced in the political structures of our society? Where and how, in the words of poet Danez Smith, will there be

35. "Police Violence Map," Mapping Police Violence, accessed November 17, 2019, https://mappingpoliceviolence.org/.
36. "Number of People Shot to Death by the Police in the United States from 2017 to 2019, by Race," Statista, accessed November 17, 2019, https://tinyurl.com/yavrbsn5.
37. "Police Violence Map."
38. Joshua Barajas, "New Study Gives Broader Look into How Police Killings Affect Black Americans' Health," PBS NewsHour, June 21, 2018, https:// tinyurl.com/y9nxyuyj.
39. Christen A. Smith, "The Fallout of Police Violence Is Killing Black Women Like Erica Garner," PBS NewsHour, January 5, 2018, https://tinyurl.com/rbzmuvj.

a space created where there are "no bullet holes in the heroes. & no one kills the black boy. & no one kills the black boy. & no kills the black boy."[40]

Bibliography

Anthony, Susan B. "Address to the American Anti-Slavery Society." Women's Rights National Historical Park. Accessed October 30, 2019. https://tinyurl.com/uxyzem9.

"Antislavery Connection." Women's Rights National Historical Park. Accessed October 30, 2019. https://tinyurl.com/uxyzem9.

Barajas, Joshua. "New Study Gives Broader Look into How Police Killings Affect Black Americans' Health." PBS NewsHour. June 21, 2018. https://tinyurl.com/y9nxyuyj.

Berman, Ari. "As the GOP Convention Begins, Ohio Is Purging Tens of Thousands of Democratic Voters." *The Nation*, July 18, 2016. https://tinyurl.com/tgwpfnz.

Branch, Taylor. *Parting the Waters: America in the King Years 1954–63.* New York: Simon and Schuster, 1988.

"The Constitution and Slavery." Digital History. Accessed October 30, 2019. https://tinyurl.com/p9lcuop.

"Declaration of Independence: A Transcription." National Archives and Records Administration. Accessed December 1, 2019. https://tinyurl.com/h2zqchv.

"Declaration of Sentiments." In *First Convention Ever Called to Discuss the Civil and Political Rights of Women, Seneca Falls, New York, July 19, 20, 1848.* Accessed January 14, 2020. https://tinyurl.com/ud5etzh.

Douglass, Frederick. "The Rights of Women." *North Star* (Rochester, NY), July 28, 1848. Elizabeth Cady Stanton Papers. Manuscript Division. Library of Congress (008.00.00). Accessed January 14, 2020. https://tinyurl.com/vkd5zqd.

"The Election Administration and Voting Survey: 2016 Comprehensive Report." U.S. Election Assistance Commission. https://tinyurl.com/uvyr5ze.

40. Danez Smith, "dinosaurs in the hood," in *Don't Call Us Dead: Poems* (Minneapolis: Graywolf, 2017), 27.

"The Facts about Voter Suppression." American Civil Liberties Union. Accessed November 14, 2019. https://tinyurl.com/wc6a8tt.

Gordon, Ann D. "Stanton on the Right to Vote: On Account of Race or Sex." In *Elizabeth Cady Stanton, Feminist as Thinker: A Reader in Documents and Essays*, edited by Ellen Carol DuBois and Richard Cándida Smith, 111–27. New York: New York University Press, 2007.

Jefferson, Thomas. "Jefferson's 'Original Rough Draught' of the Declaration of Independence." Reconstructed by Julian Boyd. The Library of Congress. Accessed October 30, 2019. https:// tinyurl.com/oo3dxgb.

Kern, Kathi. "'Free Woman Is a Divine Being, the Savior of Mankind': Stanton's Exploration of Religion and Gender." In *Elizabeth Cady Stanton, Feminist as Thinker: A Reader in Documents and Essays*, edited by Ellen Carol DuBois and Richard Cándida Smith, 93–110. New York: New York University Press, 2007.

King, Martin Luther, Jr. "Where Do We Go from Here? (1967)." In *A Testament of Hope: The Essential Writings and Speeches of Martin Luther King, Jr.*, edited by James M. Washington, 245–52. San Francisco: Harper and Row, 1986.

Lange, Allison. "Early Organizing Efforts." National Women's History Museum. Accessed October 30, 2019. https://tinyurl.com/qrnxwvj.

Midgely, Claire. *Women against Slavery: The British Campaigns, 1780–1870*. London: Routledge, 1995.

"Number of People Shot to Death by the Police in the United States from 2017 to 2019, by Race." Statista. Accessed November 17, 2019. https://tinyurl.com/yavrbsn5.

Parker, Theodore. "Of Justice and the Conscience." In *Ten Sermons of Religion*, 66–101. London: Chapman, 1853.

"Police Violence Map." Mapping Police Violence. Accessed November 17, 2019. https://mappingpoliceviolence.org/.

Rohr, Richard. *Everything Belongs: The Gift of Contemplative Prayer*. New York: Crossroad, 1999.

Root, Danielle, and Liz Kennedy. "Increasing Voter Participation in America: Policies to Drive Participation and Make Voting More Convenient." Center for American Progress. July 11, 2018. https://tinyurl.com/y92yzamt.

Santhanam, Laura. "After Ferguson, Black Men Still Face the Highest Risk of Being Killed by Police." PBS NewsHour. August 9, 2019. https://www.pbs.org/newshour/health/after-ferguson-black-men-and-boys-still-face-the-highest-risk-of-being-killed-by-police.

Siganporia, Harmony, and Frank G. Karioris. "Introduction: Rupture and Exile: Permanent Liminality in Spaces for Movement and Abandonment." *Culture Unbound: Journal of Current Cultural Research* 8, no. 1 (2016): 20–25.

"Slavery, The Horrifying Institution." USHistory.org. Accessed October 30, 2019. https://tinyurl.com/ttfbmmu.

Smith, Christen A. "The Fallout of Police Violence Is Killing Black Women Like Erica Garner." PBS NewsHour. January 5, 2018. https://tinyurl.com/rbzmuvj.

Smith, Danez. "dinosaurs in the hood." In *Don't Call Us Dead: Poems*. Minneapolis: Graywolf, 2017.

Smith, Gerrit. "Letter from Gerrit Smith to Elizabeth Cady Stanton, 1855." University of Rochester, River Campus Libraries. Accessed October 30, 2019. https://tinyurl.com/wt4foyl.

Stanton, Elizabeth Cady. "Address by ECS to the American Anti-Slavery Society." In *The Selected Papers of Elizabeth Cady Stanton and Susan B. Anthony: In the School of Anti-Slavery 1840–1866*, edited by Ann D. Gordon, 409–17. New Brunswick, NJ: Rutgers University Press, 1997.

———. "The Duty of the Church to Woman at This Hour." *Free Thought Magazine* 20 (1902): 189–94. Accessed January 14, 2020. https://tinyurl.com/yx7lvf7c.

Sterling, Dorothy, ed. *We Are Your Sisters: Black Women in the Nineteenth Century*. New York: Norton, 1997.

Turner, Victor W. *The Ritual Process*. New York: Penguin, 1969.

"The U.S. Constitution." Interactive Constitution. Accessed October 30, 2019, https://tinyurl.com/vogfsbp.

11. Lutheran Visionaries: The Public Square and the Church

JUDITH ROBERTS AND MARY J. STREUFERT

Reformation takes a long time.[1] When it comes to the acceptance of women of color speaking in and influencing the public square and the church, it takes even longer. But this particular reformation is beginning to flourish in one very white mainline denomination—the Evangelical Lutheran Church in America (ELCA). ELCA women of color are speaking out and creating change within a church that wrestles with its own racism and sexism—twin legacies that pervade life in the United States.

The global Lutheran movement is over 500 years old, emerging from Martin Luther's witness, which transformed the Christian church in the sixteenth century. The global Lutheran movement is racially and ethnically diverse, yet it remains predominantly white in the United States. As of 2014, the ELCA ranked as the whitest mainline denomination in the United States, with only 4 percent of its members being people of color. Compared with other mainline Protestant denominations in the United States, the ELCA is overwhelmingly white.[2]

Soon after it was formed in 1988, the ELCA confessed racism as sin that fractures both church and society.[3] As the ELCA lives with the tension of complicity in the sin of racism, it also recently confessed sexism and patriarchy as sins that hurt both church and society.[4] Because racism and sexism exist institutionally within the ELCA, this church commits to addressing the

1. The authors are grateful to Denise Rector, doctoral candidate and assistant to Justice for Women, for her editorial assistance.
2. Refer to Michael Lipka, "The Most and Least Racially Diverse U.S. Religious Groups," Pew Research, accessed October 16, 2019, https://tinyurl.com/s65wbvd.
3. Evangelical Lutheran Church in America, *Freed in Christ: Race, Ethnicity, and Culture* (Chicago: Evangelical Lutheran Church in America, 1993), 4, accessed January 19, 2020, https://tinyurl.com/un3te9z.
4. Evangelical Lutheran Church in America, *Faith, Sexism, and Justice: A Call to Action* (Chicago: Evangelical Lutheran Church in America, 2019), accessed January 19, 2020, https://tinyurl.com/su9wxde.

harm caused by its theology, policies, practices, attitudes, and actions. Part of that commitment involves taking account of history.

In much of history, women who speak in public have been contested for thousands of years. With only a few exceptions, ancient Greek and Roman stories about women speaking emphasize the necessity of women's silence and the outrageousness of their attempts to speak with authority.[5] The stories do not simply oppose women's public speech, according to classics scholar Mary Beard; they imply that public speech is an attribute of maleness. If a woman spoke in public, she was not a woman.[6] In fact, these ancient stories show how terrible it is when women take power and that women must be prevented from having power and influence.[7] This ancient view cast a far-reaching spell on many cultures. It is mirrored not only in such notable texts as the New Testament epistles, but also in the United States.

The ideas that women who speak in public are not really women and that they should be kept silent stopped people from supporting women's suffrage for decades before it was ratified. Journalists close to President Wilson reported that he described pro-suffrage women as "masculinized women" who were of the "aggressive, masculine-like, harsh-voiced type."[8]

Simultaneously, white supremacy gripped custom and law, enabling slavery and its outcomes (postbellum lynching, segregation, and so on) to prevail to such an extent that Ida B. Wells was famously moved to proclaim, "The Afro-American is not a bestial race."[9] The result is that, for decades, women and men of color experienced a lack of full rights as citizens in the United States, largely because none of them was considered by law and by ideology to be the fully human equal of white males. This ideology continues to wreak havoc; the concept of intersectionality describes the specific overlapping discriminations of racism and sexism experienced by women of color.[10]

The idea that women in particular should keep silent is also a strong reli-

5. Exceptions involve defense of life, witness before martyrdom, and defense of home, children, husband, and other women. Consult Mary Beard, *Women & Power: A Manifesto* (New York: Liveright, 2017), 13, 16.
6. Beard, *Women & Power*, 3–19.
7. Beard, *Women & Power*, 58–59.
8. James Kerney and David Lawrence, as quoted in Brooke Kroeger, *The Suffragents: How Women Used Men to Get the Vote* (Albany: State University of New York Press, 2017), 96.
9. Consult Ida B. Wells, "Southern Horrors: Lynch Law in All Its Phases (1892)," Digital History, accessed January 9, 2020, https://tinyurl.com/vzv3mab.
10. Kimberlé Crenshaw coined the term *intersectionality* in the late 1980s. Consult her *Critical Race Theory: The Key Writings That Formed the Movement* (New York: The New Press, 1996).

gious belief that in many ways is intertwined with cultural ideas. The injunctions in the New Testament that women should be submissive and silent in church and should not teach men kept women from speaking for centuries as pastors in the Christian tradition.

In the 1960s, Lutherans in the United States studied the question of ordaining women as ministers of word and sacrament by carefully evaluating their own theology and biblical interpretation. The scholarly and pastoral consensus of several Lutheran denominations was that there are no sound reasons against the ordination of women. In 1970 the American Lutheran Church and the Lutheran Church in America voted to reform their churches, affirm the voice of women, and ordain women as pastors.

Even this radical change in theology, biblical interpretation, and pastoral ministry remained fraught with complexity; race and ethnicity and sexuality intersected in Lutheran churches in ways that continued to challenge women's voices. The first Lutheran women ordained in the United States were white; it took nine years before a woman of color was ordained (1979). It took another thirty years (until 2009) to remove the obstacles to ordination for gay, lesbian, and bisexual persons in same-sex, publicly accountable, monogamous relationships. Lutherans in the United States have continued to reform their views on the voice of women, and the future is mixed with opportunities and challenges.

Women of color regularly experience the paradox of joy and oppression in their ministries. Within the ELCA, women of color continue to be woefully underrepresented in religious leadership and to suffer institutional inequities.[11] At the same time, as reflected in *God's Faithfulness on the Journey*, people continue to challenge their voices in public ministry, often through microaggressions.[12]

Women of color in the ELCA experience race- and gender-based inequities and discrimination related to compensation and benefits. For example, white male leaders receive their first call sooner and receive higher compensation than women of color. Women-of-color clergy have higher rates of seminary-education debt, and they take less vacation time than their white female

11. Evangelical Lutheran Church in America, *Faith, Sexism, and Justice*, 20.
12. Rosetta E. Ross, ed., *God's Faithfulness on the Journey: Reflections by Rostered Women of Color* (Chicago: Evangelical Lutheran Church in America, 2018), accessed January 12, 2019, https://tinyurl.com/v33dqvj.

counterparts.[13] The ELCA continuously calls itself to renew efforts to support equitable benefits and pay as one way to address these intersecting forms of discrimination.

Addressing the effects of racism and sexism extends into the ELCA's public witness and means tackling difficult social, political, and economic problems. The pursuit of justice as a form of love in society prioritizes complex questions and commitments. How do we build a society where diversity is truly valued? How do race and ethnicity figure into political decisions on immigration, crime, and environmental pollution? How do economic forces work against people of color in housing, medical care, education, and employment?[14] These questions help the ELCA value the voice of women as public advocates. Indeed, this church learns to follow women in loving and serving the neighbor.

What Does the Lutheran Faith Teach about Justice? Interview with Rev. Amy Reumann

The Rev. Amy Reumann[15] serves as ELCA Director for Advocacy, through which she leads domestic and international work and guides corporate social responsibility in Washington, DC, New York, and fourteen state capital offices.

Pastoral experience gives Reumann a clear sense of justice rooted in faith. The proclamation of the gospel is the good news of God's salvation given in the life, death, and resurrection of Jesus, and it distinguishes the church from all other communities. For Reumann, justice is rooted in our relationship with God. According to ELCA social teaching, the God who justifies calls us to do justice.[16] Reumann says, "Yes, we are justified but it doesn't stop there. Because we are restored to relationship, we are forgiven. We are set

13. Kenneth W. Inskeep and John Hessian, "45th Anniversary of the Ordination of Women: Executive Summary–Clergy Questionnaire Report 2015," June 2016, accessed January 18, 2020, https://tinyurl.com/tj2sf8p; "ELCA Council Commends Report on Multicultural Strategies," ELCA News, April 18, 2007, https://tinyurl.com/rlnfvsd.
14. Evangelical Lutheran Church in America, *Freed in Christ*, 6.
15. Unless otherwise noted, quotations in this section are from Amy Reumann in discussion with Judith Roberts, September 27, 2019.
16. Evangelical Lutheran Church in America, *The Church in Society: A Lutheran Perspective* (Chicago: Evangelical Lutheran Church in America, 1991), accessed January 19, 2020, https://tinyurl.com/tklsgko.

free. We are called into relationship through God with our neighbor. [Martin] Luther was direct about that responsibility. Loving our neighbor means loving their well-being, loving their condition."

Lutherans see the role of Christians in government actions very clearly: "With Martin Luther, this church understands that 'to rebuke' those in authority 'through God's Word spoken publicly, boldly and honestly' is 'not seditious' but 'a praiseworthy, noble, and . . . particularly great service to God.'"[17] We are to speak the word of God boldly, and that means being public with our faith. Reumann states, "'Publicly' means caring about all of society in the ways we as humans care for one another, advocating that all people are adequately cared for in their spiritual, emotional, physical, and material needs."

Lutherans understand that public action should be done with humility. Reumann further explains that "works righteousness is all about winning and losing, but we are called to exercise a more temperate position. We are not always right. We need to listen to all voices. There are many different solutions, many different perspectives, and when we are wrong, we cannot be afraid to admit."

The ELCA espouses to be the priesthood of all believers. As one ELCA pastor writes, "In leveling the hierarchy of clergy and laity, Martin Luther affirmed that all baptized Christians have equal access to God through prayer because all of them come to God through the mediatorial work of Christ (1 Tim 2:5)."[18] Reumann picks up on this idea: "Advocacy is the work of the people. We are not doing it for the ELCA, but we are calling churches to be involved in this work. . . . We are a church in society, and we engage issues that are of concern. We must be engaged with elected officials, speaking out on key issues, registering to vote, and showing up at all levels."

The priesthood of all believers influences ELCA advocacy through the model of accompaniment, which is informed by the community. Reumann says, "We are not the voice for the voiceless—that means that people can't speak for themselves. But we can provide platforms for people to lift their own voices. We can be the support for that." Reumann encourages individual Lutherans to put their passions about issues to work by joining with others.

17. Evangelical Lutheran Church in America, *The Church in Society*, 4.
18. William Flippin, Jr., "Ubuntu and the Priesthood of All Believers," *Living Lutheran*, February 12, 2019, https://tinyurl.com/vruyn59.

Women within the ELCA are willing to use their voices and take action. According to Reumann, 38,000 people receive ELCA advocacy alerts; 60 percent of them identify as women.

The ELCA advocates as a denomination through its social teaching and policy, which itself is formed through communal discernment. Reumann notes, "As a church, we can't do things or take actions on a whim. It must be based on our social teachings" and faithful interpretation and implementation of them. Reumann says, "Each new [social] statement or implementing resolution provides new avenues to address issues." In effect, ELCA advocacy flows from the church's theological views.

The Power of the Ancestors: Interview with Rev. Kwame Pitts

The Rev. Kwame Pitts[19] serves in Amherst/Buffalo, New York, as pastor at Crossroads Lutheran Church and with Lutheran Campus Ministries. For Pitts, ancestry and identity bring responsibility. She identifies as a person of the African Diaspora (because the diaspora is a significantly large community), a daughter of Africa, a pastor, and a practical womanist theologian who is claimed by the Creator. Her mother named her after Ghana's first president, Kwame Nkrumah, a revolutionary who organized the fifth Pan-African Congress—a movement for political, economic, and social cooperation for all people of African descent.[20] Pitts feels a responsibility to honor that legacy.

August 2019 marked the quadricentennial of the arrival of the first enslaved Africans to the British colony of Old Fort Comfort in Virginia. That same month, the ELCA issued a Declaration of the ELCA to People of African Descent for its historical complicity in slavery and the enduring legacy of racism in the United States and globally.[21] According to the United Nations Educational Scientific and Cultural Organization (UNESCO), an estimated seventeen million African people were stolen during the transatlantic

19. Unless otherwise noted, quotations in this section are from Kwame Pitts in discussion with Judith Roberts, August 7, 2019.
20. Refer to Daniel Yergin and Joseph Stanislaw, *Commanding Heights* (New York: Simon & Schuster, 1988), 83–88.
21. Evangelical Lutheran Church in America, "Declaration of the ELCA to People of African Descent," in Joyce Caldwell, "Explanation of the Declaration of the ELCA to People of African Descent," https://tinyurl.com/y6dayuq3.

slave trade.[22] Four hundred years of oppression for black people in the United States is painful, Pitts points out. With the clarity of embodied ethics described by womanist Traci West, Pitts influences the ELCA to address racism institutionally.[23]

One remedy for Pitts is honoring ancestors of the transatlantic slave trade through rituals, including veneration and ancestral altars. West African Elder Malidoma Patrice Somé asserts the importance of acknowledging ancestors in traditional African spirituality. Drawing on West African cosmology, Somé teaches that we are to emulate divine harmony among Creator, creation, and our ancestors.[24] For Pitts, rituals ground and heal the community through remembrance and divine connection.

Responsibility to the community extends from the gospel. Through preaching, Pitts challenges parishioners to move beyond a "feel-good" gospel to a more active and alive gospel. For Pitts, "the gospel is a verb and not just a noun." When congregants complain about social justice issues, she reminds them "that this [social justice] was all that Jesus did, and Jesus was countercultural. It didn't end with his ascension. We are supposed to make disciples, and fight for social justice, fight against racism." At times, the fight for justice comes with a price: "The religious leaders didn't like Jesus."

For Pitts, being a womanist theologian is not just about claiming the identity of a black woman but is about the work that comes along with the identity. She became more conscious of her intersecting identities through the ugliness of the church. She experienced marginalization when she came into seminary. People made judgments about her light-skin complexion, seemingly thinking she was a "nice, quiet young African American woman," but Pitts wasn't willing to play the game of light-skin privilege. Pitts says, "I can't turn off my blackness and won't turn it off." Talking about her racial identity is a way of starting the conversation about racial justice.

Pitts says, "We are called to ensure that our black communities are lifted up, whether that is theological or vocational. It is about the sustainability of our black communities." For her, #BlackLivesMatter was a major organiz-

22. "Transatlantic Slave Trade," UNESCO, accessed October 25, 2019, https://tinyurl.com/yc7txr6u.
23. Consult Traci C. West, *Disruptive Ethics: When Racism and Women's Lives Matter* (Louisville, KY: Westminster John Knox, 2006).
24. Consult Malidoma Patrice Somé, *Of Water and the Spirit: Ritual, Magic, and Initiation in the Life of an African Shaman* (New York: Penguin, 1995).

ing catalyst. Pitts wasn't trained in formal community organizing; she says it comes naturally to people who are oppressed: "It is just what is lived out, and we have to fight for our own survival. Who else is going to care about my people?" Pitts sees the womanist perspective of communal care as necessary for the ELCA because of the ten-year gap between the ordination of white women and the ordination of women of color. Womanist theology is a central theology and not a subset, she argues, and if the ELCA wants to work toward a world of inclusion, the church must embrace womanist theology as God's Word spoken through black women. Pitts emphasizes, "We don't worship theology; we worship God. Our voices are just as important as the cisgender, white, hetero, male theologians [who] are always uplifted."

Communal care takes form not only in preaching but also in direct action. Because people can quickly connect on social media, Pitts uses it as a form of activism. She informs, gathers, organizes, and collaborates online. When she isn't on social media, she lives her faith by her presence in her own community. Pitts attends city council meetings and speaks up about unjust policies.

Pitts also serves in campus ministry. College settings provide "the fluidity to . . . be active," Pitts observes. "Students and young adults are hungry [for] justice issues," and campus ministry empowers them to speak out. College students often live at the intersection of issues, so she serves from this intersection. For example, as a cisgender woman, she is an ally for LGBTQIA inclusion. She advocates equally for non-cisgender and non-binary siblings because they, too, are harmed "by unjust laws, policies, and actions in church and society."

Pitts analyzes situations—*Who is affected? How is the church connected directly or indirectly? What is our response as a church?*—and encourages love through Christ. Pitts believes that predominantly white, middle- to upper-middle-class congregations can work toward racial justice even if the people affected aren't in their backyard: "We are called to love our neighbor, and when we are not being in relationship with Christ—then we are being anti-Christ."

Faith and Family: Interview with Jennifer DeLeon

Jennifer DeLeon[25] serves as director for justice within Women of the ELCA (WELCA). Her experiences show how faith is advocacy. A self-described unapologetic Christian Lutheran and daughter of Guatemalan immigrants, DeLeon reflects on her embodied identity: "When I walk into a room, they see I'm brown, and they see I'm big." For DeLeon, being a daughter of immigrants is important. As a young person, she never felt like she belonged in either Guatemala or the United States. At school she found herself acting more American, while at home she acted more Guatemalan. Paraphrasing a quote from the movie *Selena*, DeLeon says, "You've got to be more Latino than Latinos and more American than Americans. It's exhausting!"

Because she was born in the United States and speaks English, DeLeon feels she carries a privilege that others from her community do not have. Many times, she finds herself in a position to help people. DeLeon says she uses her cultural and linguistic knowledge to help people with issues of housing or employment, which she understands largely stem from laws and legislation. She watched her parents do the same. "This was called advocacy," she points out, "and you don't separate this from your faith."

DeLeon worked with students in Illinois on the Student Adjustment Act of 2001, securing in-state tuition for undocumented students. The students who were involved became members of Zion Cristo Rey Lutheran Church in Chicago's Logan Square. "Through advocacy the students saw the church responding to their needs, and they decided to join [the church]. Advocacy became an arm of outreach. That wasn't necessarily the intention, but it became part of the culture of the congregation," says DeLeon. "Policy change is one piece of advocacy. There is also hands-on, direct service." For DeLeon, moving all people toward justice work–advocacy–is her calling.

When it comes to the current political climate, DeLeon believes that "now more than ever, we must be courageous and speak out for the oppressed." When she asks women to live out their faith, she reminds them of the book of Esther. DeLeon encourages women to "Esther up!" by reminding them

25. Unless otherwise noted, quotations in this section are from Jennifer DeLeon in discussion with Judith Roberts, September 12, 2019.

that they've been prepared "for such a time as this." She evangelizes through advocacy: "No matter who you are and where you are from, it is important to get involved at any level."

DeLeon learned advocacy by watching her parents. She says, "They were raised in a Catholic church, and Pre-Cana classes weren't taught in Spanish. You couldn't get married without taking the classes." Her parents began teaching those courses in Spanish. "They were working within the institution to change [it] and to create access," says DeLeon. Another example involved her father's community leadership. When neighborhood kids got involved in gang activities, her father responded by creating a youth group and a culturally reflective after-school program.

DeLeon grew up seeing and caring for her neighbor. She taught English as a second language and organized to protect communities from funding cuts. Eventually, she became involved in community and faith-based organizing because creating change is exhausting, but "your faith gives you the energy to continue the struggle." She is rooted in prayer and theologies that connect with Latin American, black liberation, *mujerista*, and womanist views. Her theology "comes from the bottom up, Jesus's preferential position of looking at the condition of the poor. This is where our faith calls us to be," says DeLeon.

Communities of Population in Resistance, Guatemalan activists for civil and cultural rights, trained her in faith-based organizing. A team from Guatemala came to her church. She learned traditional organizing models, such as from Saul Alinsky, and also Paulo Freire's approach of empowering people to create change. In her current practice, DeLeon uses a combination of these methods. For DeLeon, the Alinsky model moves her out of anger and serves as a catalyst. She says, "It was too hard to live [my] life being angry. Faith-based organizing moves from a position of love—following teachings of Jesus."

When she worked in the public policy office in Illinois, she did advocacy training with people using mental health and assisted living services. They became the spokespersons about their own issues, speaking about why they needed housing. DeLeon says, "Advocacy is the act of taking a stand. It is creating space for people impacted about an issue to speak for themselves. People that have been marginalized need space to be made so they/we can speak for our issues."

Advocacy, in fact, evangelized DeLeon. She became Lutheran because there was a faith leader in a community organization who showed up con-

sistently, "a white leader pastoring a working-class, Latino, immigrant community. She came to all the community meetings. She showed up to protest meetings and always invited people to church," including DeLeon. DeLeon says, "She believed in me."

As part of DeLeon's work, Women of the ELCA has lifted up four advocacy issues: antitrafficking, domestic violence, immigration, and racial-justice education. DeLeon provides support and resources to over 7,000 ELCA congregations and campuses for service, Bible study, advocacy, community, and more. According to DeLeon, women get involved in this work at multiple levels: from making hygiene kits for women living in shelters or on the streets to sponsoring billboards that create awareness of human trafficking and advocating for the passage of laws for victims. In other words, she continues to evangelize.

Becoming the Beloved ELCA Community: Interview with Rev. Priscilla Austin

The Rev. Priscilla Austin[26] serves Emmanuel Lutheran in Seattle, Washington. She defines herself as a black and brown woman of Caribbean heritage with roots in Nevis, St. Kitts. Her ancestry is an amalgamation of Spanish, Puerto Rican, Taino, and African cultures; Austin describes herself as a descendant of "the indigenous peoples of the Caribbean, as well as those who were brought to the Caribbean."

Women of color like Austin are leading the way in improving the institutional culture of the ELCA as related to diversity and inclusion. At its constituting convention in 1988, the ELCA adopted the goal "that within 10 years of its establishment its membership shall include at least 10 percent people of color or primary language other than English."[27] In 2013 "the church was still far from achieving its original goal."[28] Former ELCA secretary W. Chris Boerger stated, "We just need to say we failed at our first goal of being a

26. Unless otherwise noted, quotations in this section are from Priscilla Austin in discussion with Judith Roberts, October 23, 2019.
27. 1993 Churchwide Assembly, "Reports and Records, Volume 2: Assembly Minutes" (Chicago: Evangelical Lutheran Church in America, 1995), 846, accessed January 19, 2020, https://tinyurl.com/wehds6g.
28. John Potter, "From Vision to Reality: How Has the ELCA Made Progress on Diversity Since Its 2016 Commitments?" *Living Lutheran*, June 18, 2019, https://tinyurl.com/u79nk7u.

church of 10 percent.... Let's start calling it a failure, let's not call that a work in progress."[29]

The 2016 ELCA Churchwide Assembly made an unprecedented move to adopt a resolution to create a task force composed entirely of persons of color from across the country: the Resolution for a Strategy toward Authentic Diversity, authored by Austin. Austin, a voting member at the assembly, recalls, "We're on the floor, we have the power, we have the voice, we have the vote. We need to create a resolution that actually institutes the change we're trying to do." Although Austin was named as author, she lifts up the collaboration behind the effort: "Because I perceive myself as a womanist theologian who sees the intersections of issues and the world and theology, I was not willing to write that resolution by myself. I recognize that I am the face that came forward. It is a thing that happened in collaboration ... Indian, brown, clergy, cisgender, gay, Latinx people, white folk, lay, deacon, from Midwest towns and urban areas. It was an amazing collection of fifteen leaders who sat down with us and just kind of spitballed ideas." To ensure that it wasn't just younger voices speaking, the group relied on the wisdom of "elders and the folks who had been in this battle before," says Austin.

According to Austin, "The resolution was about strategic authentic diversity. It seemed really important to behave strategically, even in forming the resolution." Austin says this is her way of working. When people look at her as a leader, Austin says, they say things like, "'Oh, Priscilla, we will follow you anywhere.' And I'm like, I don't want to lead you anywhere, but I will go with you. We will go hand-in-hand, we will go arm-in-arm, but I don't need to be out front." Austin is aware that she leads nothing by herself. She says, "Truthfully, none of this would have worked if it was just me screaming into the void. It was our whole system saying, 'Y'all need to change.'" In 2019, the ELCA Churchwide Assembly approved the Strategy for Authentic Diversity created by that 2016 task force.[30]

As a woman of color serving in the ELCA, Austin knows what needs to change. She has had many negative experiences: being overlooked and dismissed, accepting a congregational call that was below compensation guide-

29. Potter, "From Vision to Reality."
30. Evangelical Lutheran Church in America, "How Strategic and Authentic Is Our Diversity: A Call for Confession, Reflection and Healing Action" (Chicago: Evangelical Lutheran Church in American, 2019), accessed January 19, 2020, https://tinyurl.com/ubwa7oc.

lines, and taking out an excessive amount of seminary loans because her job during seminary was ridiculously underpaid.

When Austin arrived in the Northwest Washington Synod, she was the only black Puerto Rican ELCA minister in the state. Austin thinks people gravitated to her because of her ethnicity. She shares that people felt like, "'Oh, we finally have a black woman who can save us; let us have these conversations with her and follow her lead!'" From a womanist perspective, Austin says, she wasn't willing to be a "sacrificial lamb. I will walk *with* you, and if you're genuinely in conversation to walk with me, we can do some stuff."

For Austin, womanist theology is about recognizing contextual identities along with pedagogical theology and translating them into ways of understanding God and God's calling. "In truth, it's highly Lutheran. It's highly contextual. It's very priesthood of all believers, all believers, like, *all* the believers, not just the cisgender, white, hetero male believers. Not just the ones who look German and like Martin Luther or not just the Scandinavian ones who came and built the church where I'm at. It's an incorporation of all of our stories, and it begins with my story that acknowledges your story, that finds the way into what our story is," says Austin.

A Lutheran theology and way of being has shaped her whole life. She believes God "continues to speak in context. Out of that context, God reveals God's self and God's intention and desire for the world." Austin says she is "very big on priesthood of all believers because it is only in valuing the gifts of all people that we get the fullness of who it is we as a community can be." According to Austin, "We then begin to open ourselves up to the necessity to respond to injustice, to respond to what is happening in the world that hurts a part of the body. If one part of the body is experiencing injustice and oppression, the whole body is oppressed and ensnared in the web of sin and bondage to evil. And until we break ourselves free from all of it, for everyone, we're not living the liberated, loving life that God wants us to have."

For Austin, the work for authentic diversity is about moving the needle. "Now we've got some of these mechanisms in place, my hope is that we utilize them, that we don't just sort of create them from a tokenized standpoint and [then] don't give them the power to do the thing that we want them to do," says Austin. She believes "we are holding ourselves accountable to something bigger than cheap grace.... This [new strategy] really sets the table for us to share mutually in a space of grace what works and what doesn't work so that we can continue as an institution to authentically lead the world in a way that is genuine, that is sincere. And that says, we're going to make mistakes.

We are sinners and saints." It is her hope that in recognizing and beginning to recognize our own authentic ethnic diversity, "we will stop being afraid to talk about the racial aspect, particularly how that impacts justice in this country and how that impacts how we fight for justice in this country."

The reformation in the ELCA thus picks up speed because of women of color, because of their voices in the public square and in the church. This church will still live with challenges and opportunities, yet it continues to learn to do so as the priesthood of *all* believers.

Rare and original political postcard dated 1911, titled "Votes for Women" by BM Boye.

Bibliography

1993 Churchwide Assembly. "Reports and Records, Volume 2: Assembly Minutes." Chicago: Evangelical Lutheran Church in America, 1995. Accessed January 19, 2020. https://tinyurl.com/wehds6g.

Beard, Mary. *Women & Power: A Manifesto*. New York: Liveright, 2017.

Crenshaw, Kimberlé. *Critical Race Theory: The Key Writings That Formed the Movement*. New York: The New Press, 1996.

"ELCA Council Commends Report on Multicultural Strategies." ELCA News. April 18, 2007, https://tinyurl.com/rlnfvsd.

Evangelical Lutheran Church in America. *The Church in Society: A Lutheran Perspective*. Chicago: Evangelical Lutheran Church in America, 1991. Accessed January 19, 2020. https://tinyurl.com/tklsgko.

———. "Declaration of the ELCA to People of African Descent." In Joyce Caldwell, "Explanation of the Declaration of the ELCA to People of African Descent." https://tinyurl.com/y6dayuq3.

———. *Faith, Sexism, and Justice: A Call to Action*. Chicago: Evangelical Lutheran Church in America, 2019. Accessed January 19, 2020. https://tinyurl.com/su9wxde.

———. *Freed in Christ: Race, Ethnicity, and Culture*. Chicago: Evangelical Lutheran Church in America, 1993. Accessed January 19, 2020. https://tinyurl.com/un3te9z.

———. "How Strategic and Authentic Is Our Diversity: A Call for Confession, Reflection and Healing Action." Chicago: Evangelical Lutheran Church in American, 2019. Accessed January 19, 2020. https://tinyurl.com/ubwa7oc.

Flippin, William, Jr. "Ubuntu and the Priesthood of All Believers." *Living Lutheran*. February 12, 2019. https://tinyurl.com/vruyn59.

Inskeep, Kenneth W., and John Hessian. "45th Anniversary of the Ordination of Women: Executive Summary–Clergy Questionnaire Report 2015." June 2016. Accessed January 18, 2020. https://tinyurl.com/tj2sf8p.

Kroeger, Brooke. *The Suffragents: How Women Used Men to Get the Vote*. Albany: State University of New York Press, 2017.

Lipka, Michael. "The Most and Least Racially Diverse U.S. Religious Groups." Pew Research. Accessed October 16, 2019. https://tinyurl.com/s65wbvd.

Potter, John. "From Vision to Reality: How Has the ELCA Made Progress on Diversity Since Its 2016 Commitments?" *Living Lutheran*. June 18, 2019. https://tinyurl.com/u79nk7u.

Ross, Rosetta E., ed. *God's Faithfulness on the Journey: Reflections by Rostered Women of Color*. Chicago: Evangelical Lutheran Church in America, 2018. Accessed January 12, 2019. https://tinyurl.com/v33dqvj.

Somé, Malidoma Patrice. *Of Water and the Spirit: Ritual, Magic, and Initiation in the Life of an African Shaman*. New York: Penguin, 1995.

"Transatlantic Slave Trade." UNESCO. Accessed October 25, 2019. https://tinyurl.com/yc7txr6u.

Wells, Ida B. "Southern Horrors: Lynch Law in All Its Phases (1892)." Digital History. Accessed January 9, 2020. https://tinyurl.com/vzv3mab.

West, Traci C. *Disruptive Ethics: When Racism and Women's Lives Matter*. Louisville, KY: Westminster John Knox, 2006.

Yergin, Daniel, and Joseph Stanislaw. *Commanding Heights*. New York: Simon & Schuster, 1988.

Epilogue: Women with 2020 Vision: A Summary of New "Sightings"

JEANNE STEVENSON-MOESSNER

There is a stirring in the soul that creates a movement. There are also moments when we first become aware of our predecessors in such a movement. I experienced such a "stirring" while walking across the university campus after receiving official news of my promotion to full professor. I wanted to walk alone in the enormity of the moment—that is, until I realized I had not been alone in this arduous journey. From a very deep and soulful place came the words, "We did it."

In the classic American film *The Grapes of Wrath*, which debuted exactly eighty years ago, protagonist Tom Joad takes leave of his mother while describing his hunger for justice: "I'll be all around in the dark. I'll be everywhere you can look. Wherever there's a fight, so hungry people can eat, I'll be there. Wherever there's a cop beatin' up a guy, I'll be there. I'll be in the way guys yell when they're mad. I'll be in the way kids laugh when they're hungry and they know supper's ready. And when the people are eatin' the stuff they raise and livin' in the houses they build—I'll be there, too." A migrant in the Great Depression, Ma Joad, with her indominable spirit, says to Pa with a phrase reverberating from the Preamble to the US Constitution: "We're the people that live. They can't wipe us out, they can't lick us. We'll go on forever, Pa, 'cause we're the people."[1]

The suffrage movement in the United States was the ceaseless effort for women to exercise their birthright to vote in a government by the people, a government where the word *people* was assumed to include women as

1. *The Grapes of Wrath*, directed by John Ford (1940; Beverly Hills, CA: Twentieth Century Fox, 1998), VHS. The film, whose screenplay was written by Nunnally Johnson and which was produced by Darryl Zanuck, is based on the novel of the same name by John Steinbeck, which was published in 1939. The phrase *the grapes of wrath* was taken from the "Battle Hymn of the Republic" (1861), written by Julia Ward Howe, abolitionist, social activist, and suffragette. She died in 1910 and so did not live to vote in a federal election.

well as men. The suffrage movement grew out of and followed the Great Revivals of the 1830s, the temperance movement, and abolitionism. The suffrage movement operated on a belief in the equal rights and dignity of women—whether casting a ballot or casting for a role in the stage of life. For better and for worse, Christianity was a force in this movement, both in the abuse of Scripture (as in the support of slavery) and in the promulgation of the belief that in Christ there is neither male nor female, neither slave nor free, thus supporting the right to vote for formerly enslaved persons and for women. In other words, there should be no unjust distinction.

The early temperance movement (1784–1861) in the United States was an attempt to limit the availability and consumption of alcohol, particularly whiskey. Temperance became a political, social, and religious force. Preachers like Lyman Beecher, father of Harriet Beecher Stowe, argued from the pulpit for total abstinence (1825).[2] Temperance was connected to domestic abuse and neglect, to the misuse of family resources and funds, and to the perpetuation of unemployment for men in the grips of addiction. The use of alcohol was seen as a social evil or sin. It became connected to the cause of the suffragettes because it was linked to domestic violence against women and children, poverty in households, and impairment of the male head of the household. Frances Willard (1839–1898), educator, temperance reformer, and suffragette, took up this cause and became the president of the Women's Christian Temperance Union (WCTU) in 1879. Willard was also the first dean of women at Northwestern University and the first president of the National Council of Women. She organized Mother Love, with its objective of home protection from the evils of alcoholic drink. Their badge was a white ribbon, symbolizing purity.

There were numerous efforts alongside the women's movement to promote the welfare of children. Some of these efforts were started by suffragettes like Juliette Gordon Low, who founded the Girl Guides, which later became the Girl Scouts of the United States of America, after the model of scouting in the United Kingdom. Low's purpose was to help young women become self-sufficient. She herself was deaf after an accident and amplified the fight to include girls who are specially abled. The Girl Scouts USA even-

2. Lyman Beecher, *Six Sermons on the Nature, Occasions, Signs, Evils, and Remedy of Intemperance* (Boston: T.R. Marvin for Crocker & Brewster and J. Leavitt, 1827). Lyman Beecher was also a cofounder of the American Temperance Society.

tually grew to be inclusive of African Americans and of those who are gay and lesbian. It will be the work of another volume to follow the many tributaries of the river of freedom and equality, a river dredged of impediments of resistance and made to flow by the women's movement in the United States.

The postcard, entitled "The White Ribbon," held out the hope for purity from addiction to alcohol.

Postcard reads: The Saloon or the Boys and Girls, 1913.

Epilogue | 211

The Young Women's Christian Association (YWCA) was founded in London in 1855 to advocate for women. The branch in the United States opened in New York City and Boston in 1858 primarily to build residences for working women. In 1860, a boarding house was completed in New York City for working women from the farms, teachers, factory workers, and students—all women who needed a safe place to sleep and locate themselves. Appendix B to this volume contains a letter (1913) from the national board of the YWCA based in New York City thanking a donor for equipping a large lecture room in the training school, which also served as a dormitory for young women. The YWCA was interracial from 1912 onward.

As epitomized by the YWCA, the women's movement is also an international campaign to promote equal voice, vote, and opportunities for women. As this book on suffrage in the United States has developed, women in other parts of the world and organizations like Church Women United have offered their support. As a recent example, Inger Solveig Borgen of Lillestrøm, Norway, found a poem and letter written by her grandmother, Inga Ravndal, in 1895. Both the original copy in Norwegian and the translation in English were sent to me. The full text of the letter is in Appendix C. The letter opens with her grandmother's poem:

> Tell me, does a woman have any rights?
> Yes, to pray, give thanks, praise,
> Make others' burden light, keep watch while others sleep.
> The right to wipe away tears of sorrow,
> Calm every bitter pain,
> Help mildly with advice and deed,
> Whisper comfort to an anguished heart.

Then, Inga Ravndal goes on to illustrate the angelic, virtuous, and graceful portrayal of woman. Yet, she notices that a shift is occurring:

> Now the time has come when she [woman] will no longer stand as the one being sung about. She has now lifted the curtain which for so long has hidden her and concealed her from view. She has now had her eyes opened, and now she sees her tasks in life, now sees her own worth.
>
> She now knows that she has been created for more than the attic, kitchen and cellar. She sees now how for centuries, she has been buried like any other carrion in the desert sands.

Centuries of sand and dust have layered themselves over her. Men have done all they could to keep her down in ignorance.

But then came a violent hurricane that shook all the foundations, and the woman is shaken up, and gradually the dust falls off of her in layers, until she at last stands clean, purified and tested. . . .

Then she is no longer standing there as a forget-me-not hidden behind a tuft of grass. No, she stands as herself in stormy or calm weather.

She will no longer be like a plaything, a doll to satisfy a man's whims and random thoughts. . . .

Why shouldn't we women feel love for our Fatherland and wish to be included in doing something for our country and people, whom we love just as much as men do? And when we once fully get the right to vote, then this will be what we have been aspiring to; only then do we have what is our right. (Inga Gjørgine Ravndal, 1895, Norway)

This book, *Women with 2020 Vision*, is a story of a hard-fought victory for the acknowledgment of women's birthright to vote and "to be the people." As we contributors write this volume, we are aware that a vast number of women and men around the world live without equal vote and voice in their societies. Even in a country like the United States, where officially all have the vote, not all have access to exercise that right. In recent correspondence with me, Ellen Brady talks of "new sightings" of hope and concrete actions to remedy this:

> Another Kenyan friend will visit in January. We have connected him to a group working to provide "Google addresses" to homes in the Navajo Nation, where a lack of street addresses impedes everything from voter registration to emergency services. The Maasai Mara has similar issues, and we hope that he can take the effort back there.[3]

The #MeToo movement, organized in 2006 by Tarana Burke, continues in 2020 on a continuum with all the heroic efforts to recognize that we women are the people too. There is an unsettling comparison between the way women in the nineteenth century were treated as men's property and the way modern-day actresses have been handled as stage property. The

3. Ellen Brady (MD) in discussion with the author, January 13, 2020.

women's movement operates with the belief in the dignity of women. In an interview with Katherine Kendall, the actress who spoke up to support actresses Rose McGowan and Ashley Judd, who accused Harvey Weinstein of rape, sexual abuse, and sexual misconduct, Katherine commented on Harvey Weinstein's attempt to seduce her and her escape.[4] The following is an excerpt from that interview:

> Katherine Kendall: It is so hard. You are telling your story, all you can do is say what happened . . . and even though nothing happened to me physically, it really affected me physically anyway. . . . Even though he didn't touch me, my body was altered by that fearful encounter. It was really threatening; I felt like he wanted to get my reaction. . . . Not only did he want to get with me, he was challenging me with coming out of the [bath]room naked. It had a threatening energy about it. It was something really hard to put behind me. . . .
>
> Jeanne Stevenson-Moessner: Especially not knowing how far the threat would go or the possibility of other scenarios.
>
> Katherine: He had the power to make any phone calls at any moment about anything I was going to be doing in my career . . . he was the one. If anyone had that power, he [did]. Everyone wants that power in this business; it is definitely kind of a grab for power. Everyone would like to be the one to say: "I can green-light anything." . . . "I can shut down anything." He had that [power].
>
> Jeanne: It is like playing god for a moment, theologically speaking.
>
> Katherine: It is a lot like him having that godlike thing; he could feel that godlike power. Very few people spoke up to him, although some people did, some men. A few did. He was bullish, brutal, and mean—violent in other ways. It was the way he operated in the world.
>
> Jeanne: And the system allowed it.

I asked Katherine Kendall for some words of wisdom to the younger generation. She offered the following: "Listen to that voice inside that knows right and wrong. Have faith that you will find an ally someday—to help you on your

4. Katherine Kendall has been interviewed on a number of stations, including CNN, PBS NewsHour, Court TV, Grabien, and Popcorn Talk, and for a number of magazines, such as the *Guardian*, the *Observer*, and the *Washington Post*. She was one of "The Silence Breakers" in claims of Harvey Weinstein's sexual harassment of young actresses.

journey. In my day, [sexual harassment and abuse] wouldn't have made news. I knew in my heart it was really wrong; don't doubt that voice within. Hold on to your worth. The balance [of power] is shifting."

In closing, she volunteered: "It is an honor to feel like I am helping anyone. There will be one person out there who needs to hear this."[5]

Some of the leaders of the National Women's Conference march in Houston, Texas, November 16, 1977 (Associated Press original photo by Greg Smith). The torch was carried by relay runners from New York. Left to right: Billie Jean King; former US Representative Bella Abzug (under the hat); Betty Friedan. Maya Angelou read the Declaration of American Women 1977. Coretta Scott King and Margaret Mead were among the 20,000 who attended.

The women's movement continues to take many forms in many religions and countries. As we continue to find our commonalities in the midst of differences, may the relationship of abolitionists and suffragettes like Sojourner Truth, Elizabeth Cady Stanton, and Harriet Beecher Stowe come to mind. As Katherine Kendall has done, may we step up to support our sisters and coworkers. May we strengthen the movement, for there is work ahead. How can privileged white women, for example, come alongside the fight against

5. Katherine Kendall in taped interview with the author, February 3, 2020.

voter suppression and regression in judicial decisions that impact the less privileged?

We are becoming increasingly educated on further indignities that are death-like. Although several contributors to this volume are actively working in international arenas for more rights for all the world's women, it is a small candle of hope to offer in dim corners of oppression. Nevertheless, we pledge "to hold out the hope" as our predecessors in the United States did for us. This flame of justice will never die as we continue to work, write, collaborate, organize, and serve in the vision of becoming all that God created us to be. In closing, I offer you the mantra I have used many times:

We will not be defeated! Then someday we will say, "We did it."

Bibliography

Beecher, Lyman. *Six Sermons on the Nature, Occasions, Signs, Evils, and Remedy of Intemperance.* Boston: T.R. Marvin for Crocker & Brewster and J. Leavitt, 1827.

Ford, John, dir. *The Grapes of Wrath*, 1940; Beverly Hills, CA: Twentieth Century Fox, 1998. VHS.

Appendix A

The following is a speech, "Toast to the Suffragette," given by Pearl P. in Columbia, South Carolina, in 1913. The original is in the author's possession.

Here's to the Suffragette! Here's to the woman who thinks! Here's to the woman who is brave enough to fight for what she thinks!

For 8000 years woman has surrounded herself with a collossal vanity; she has seen herself thru a golden haze, as a beautiful and beloved creature, as a queen enthroned in the hearts of men, as the still quiet voice whose influence governs the world. Clothed in this mountain of conseit wearing a supposed crown, woman has sat and smiled thru the ages - smiled at the adulation of man; being assured by the poets and an occasional mere man that she is only a little lower than the angels while her dear beautiful influence is the power that moves the destinies of man and nations..

For the last twenty five years perhaps a million omen have been forced to enter the commercial wolrd to support themselves and chuldren; woman was astounded to find that man's chivalry extended to the drawing room chiefly; she who had considered herself a queen, who had been assured by man for ages that she is a beloved and venerated object was dumfounded to find that he would not give her justice in the business wolrd; she foynd that he was not willing to pay her more than half the salary paid a man for the same work. It was a frightful stroke to her vanity. Lovely woman recovered but she sat up and began to take notice. Someway the insipient film began lifting from her eye she looked about woth a clearer vision while facts began focusing with astonishing rapidity. It was a wretshed experience not to think of the wound to lovely woman's vanity. Had not man assired her thru the ages that her dear gentle influence was the force that moved man and destinies! She looked forth - what did she see ? A great pageant of sin, whiskey and immorality stalk nakedly by unhampered by the hands that cast the vote ; she found that the laws would not give her a right to her own child. She began to ponder about the value and not value of her wonderful influence and how if it was so wonderful such atrocities were possible. She grew thoughtful as never in the past eight thousand years then the truth dawned and lovely woman grew furious for man has lied to her to keep her quiet and pleased while he appropriated all the vices for himself and was happy in Only inthe last few years has this truth dawned upon woman- she is seeing her true position and her value to the world if she has bravery enough to fight for it. She has cast off that overwhelming vanity, is discarding a crown that was never golden and is not too pure to probe into the moral sores that may soon infect her son unless she protects

him

Last year 1912- most of us lived very quietly and sanely some even unselfishly while the ~~men of the U.S.A. or~~ Husbands, fathers and sons of other women drank up 2 billion dollars worth of whiskey - 2 billion dollars worth of whiskey in one year in the United States of America!

The women of Columbia are trying to build a Woman's Building- a home to protect our working girls; other women are attemtting to raise $2500. to erect a hospital at our home for fallen girls; still anothe $10,000 is needed for a decent house for oue rescue orphans. $52000 in all- and yet it is almost impossible to raise it.

Still last month, the month of March- it was Lent — most of us lived very quietly, some in devitionall happy in the thought that we were queens of ~~our~~ our home while the hand that rocks the cradle is the power that rules the world. The men of Richland County, (which is Columbia) drank up $130,000 worth of whiskey. $130,000 worth of whiskey in one month! isnt it stupendous- isnt it staggering? I get this information from the published accounts of the Dispensary sales for March and an estimate of the whiskey consignments handled by the Express Co. for the same length of time.

The men of South Caroline drank up nearly half a nillion dollars worth of liquor during the month of March. Nearly half a million worth of whiskey in this state in thirty days! And yet good women can not raise $52,000 for three of the noblest causes on erath. O wom an where is your much mooted influense! What influence pray tell me have you had in meeting the great moral issues that confront us to day! What influence have you had upon either the character or the vote of the men fo this state that half a million dollars should be poured out in liqour in thirty days. Isnt it enough to make the best womna question her influence!

X Taxes have been used as a great issue in the woman's canmpaign- but you know as well as I that the average woman cares not a rap for taxes- what she does care for, is that little son who is coming on and who must soon cope with a civilixation that refuses to bridle ~~se~~ vice in any manner that yearly elects mayors, councilmen and police on the beat who wink at immorality, who view unflinchingly the great yearly pageant of young men and boys that fall into the snares. Perhaps next year it may be your boy - it may be mine.

A woman who will not fight for the soul of her boy is not worthy of the name of mother, even the savage lioness will fight until death for her offspring. 8000 years of woman's dear beautiful influence, of her gentle saintlike piety has not saved the sons of the past generations- it is not saving the sons of today. So here's to the woman who is brave enough to fight! Here's to the woman

who has sense enough to cast off a ridiculous vanity- here's to the woman who has sense enough to take from her head the pasteboard crown, she has worn thru the ages- ~~here's to the woman~~- she may rest assured that she is not queen in any one's life save her own vain imagination. Here's to the woman whose love for her boy is greater then false conventions and who is brave enough to fight for the privilege of strengthening and purifying our civilization.

In thibking of the tenacity of the Suggeragette I am reminded of the old negro who came to his master complaining- he said -" I declar boss I nearly run ravin crazy over my ole coman pesterin me attter me ney. Fo Gawd I dont git in dee house an its money- money- money. I cont git ter eat in no peace its money money money. I dont git ter sleep in no peace its money money money all dee time tel I clar ter Gawd I nearly run ravin crazy over dat oomna pesterin me bout money."

" Well john maybe you dont give her enough," said his master, " How much money do you allow her ?"

" Now boss you jest natually hit dee nail on dee head- us been married 20 years an I aint gin her none yit. But I clar ter Gawd ef dat ooman keep it up I gine gib her some fur peace sake."

So fill the bumpers all around - lets drink to woman - not a vain puppet.

Sent to
The Suffragette –
given by Pearl P. Pope
at a Banquet in
 Columbia.

Appendix B

The following is a letter (January 8, 1913) from the national board of the YWCA based in New York City thanking a donor for equipping a large lecture room in the training school, which also served as a dormitory for young women. The letter was from Elizabeth Weiser to Mrs. H.J. Carr. The original is in the author's possession.

> FOURTH BIENNIAL CONVENTION, RICHMOND, VA., APRIL 3-10, 1913
>
> **NATIONAL BOARD**
> of The
> **Young Womens Christian Associations**
> of the United States of America
> 600 Lexington Avenue
> NEW YORK CITY
>
> Telephone Plaza 6000-1-2
> Cable Address Outpost New York
>
> Miss Mabel Cratty *General Secretary*
>
> SECRETARIAL DEPARTMENT
> SECRETARIES
> Miss Elizabeth Wilson *Executive Secretary*
> Miss Caroline B Dow *Dean of Training System*
> Miss Edith N Stanton *Office Executive*
> *Director Bureau of Reference*
>
> Miss Grace H Dodge *President*
> Mrs James S Cushman *First Vice President*
> Mrs R C Jenkinson *Second Vice President*
> Mrs William W Rossiter *Secretary*
> Mrs Samuel J Broadwell *Treasurer*
>
> Miss Grace H Dodge
> *Chairman Secretarial Dept*
>
> January 8, 1913.
>
> Mrs. H. J. Carr
>
> Dear Friend:
>
> As you probably know, the Young Women's Christian Association National Headquarters were solemnly dedicated Wednesday, December 4, with a service of responsive Scripture and prayers and most appropriate hymns. On the day following about fifteen hundred people accepted the invitation to inspect the offices and Training School.
>
> At that time the sixth and seventh floors of the school stood unfurnished and the eighth floor of the offices was unoccupied. Since then the Student Volunteer Movement has moved into this office floor, and bedroom furniture has been ordered for the remaining Training School rooms.
>
> The construction, coloring and equipment of the building have been universally admired.
>
> Your gift went to the furnishing of the large lecture room of the School on the southeast corner of the third floor - a room large enough to seat one hundred persons, though its capacity has not yet been taxed. It is the center of the academic life of the School and proves an inspiring place to both lecturers and students. It is also commented on most favorably by the scores of visitors who are taken around almost daily.
>
> Thanking you for your co-operation and assuring you that we shall be happy to have you visit the building whenever you are in the city.
>
> Most sincerely,
>
> Elizabeth Wilson

Appendix C

The following is a letter written by suffragette Inga Ravndal in 1895 and translated by her granddaughter, Inger Solveig Borgen of Lillestrøm, Norway. Used with permission.

<u>A WOMAN'S RIGHTS</u>
by Inga Ravndal (1895)
A poem says it so beautifully:

> "Tell me, does a woman have any rights?
> Yes, to pray, give thanks, praise,
> Make others' burden light, keep watch while others sleep.
> The right to wipe away tears of sorrow,
> Calm every bitter pain,
> Help mildly with advice and deed,
> Whisper comfort to an anguished heart."

Yes, it sounds so nice, rather moving, isn't it? Isn't it a huge right a woman has, imagine: No matter her circumstances, she must still be content, and give thanks – praise, no matter if her own burden is heavy – she should still help to carry others', and then even be permitted to keep watch when others sleep. Isn't it grand, this is what others would give a woman the right to do!

So they write one book after another – one poem more beautiful than the next, in which they praise and sing about virtues and graces – lifting her to the clouds as if she were an angel.

Now the time has come when she will no longer stand as the one being sung about. She has now lifted the curtain which for so long has hidden her and concealed her from view. She has now had her eyes opened, and now sees her tasks in life, now sees her own worth.

She now knows that she has been created for more than the attic, kitchen and cellar. She sees now how for centuries, she has been buried like any other carrion in the desert sands.

Centuries of sand and dust have layered themselves over her. Men have done all they could to keep her down in ignorance.

But then came a violent hurricane that shook all the foundations, and the woman is shaken up, and gradually the dust falls off of her in layers, until she at last stands clean, purified and tested. Of course she is a little weak and feeble to begin with, but soon she becomes firm and strong enough to take ahold of life. Then she is no longer standing there as a forget-me-not hidden behind a tuft of grass. No, she stands as herself in stormy or calm weather.

She will no longer be like a plaything, a doll to satisfy a man's whims and random thoughts.

She will stand as his faithful helper and dear friend to whom he can tell everything, seek advice and counsel, with whom he can share interests, in civic life concerning governing and country, and in daily life as well!

Why shouldn't we women feel love for our Fatherland and wish to be included in doing something for our country and people, whom we love just as much as men do? And when we once fully get the right to vote, then this will be what we have been aspiring to; only then do we have what is our right.

Some men think that women desire to have power alone, that they would be the ones to dominate and rule if they got the right to vote.

Well, it wouldn't be so strange, as they then would revenge all the injustice which they have suffered over time; but that is not the case. They would, as Ibsen puts it:

> When two people together make an effort to build society, she and he together will clear new country.

Yes, women have great power, as was written in the last issue of «The Plow» (a subscription magazine). She is indeed the one who runs institutions from the ground up, and she will still be included in working to establish everything that is good, if only she is allowed to.

You men do not have to be so very afraid of giving women more rights — no, she will only become more fit as a good and faithful wife — as a mother who can raise sons and daughters who will be an honor to themselves and their country.

Inga Gjørgine Ravndal (1866 – 1938)
Inga and Samuel married in 1900/1901.
Traveled to the USA in 1907, and back to Norway in 1920.
Women in Norway got voting rights in 1913.

The Norwegian Kopi

KVINDENS RET, skrevet av Inga Ravndal 1895.

Der staar saa skjønt i et digt :
" Sig har kvinden nogen ret ?
 Ja at bede, takke, love,
 gjøre andres byrde let, vaage medens andre sove.
 Ret at tørre sorgens graad,
 stille hver en bitter smerte,
 hjelpe mildt med raad og daad,
 hviske trøst til kvalfuldt hjerte."

 Ja, det heres saa pent ud, ganske rørende ud, ikke sandt ?
Er det ikke en stor ret kvinden har, tenk hvordan hun enn har det,
hun må dog være fornøiet, takke, love om hendes byrde er aldrig
saa tung - hun skal dog hjelpe at bære andres og tenk hun skal hun
faa lov at vaage nwar andre sove, ja, er det ikke storartet,
slik vil de andre hende give kvinden ret til !

 Ja saa skriver de den ene bog efter den annen - det ene digt
sjønnere enn det andre hvor de lovpriser og besjunger dyder og
yndigheder - hæver hende til skyerne som var hun en engel.-

 Nu er tiden kommen, at hun ikke længer vil staa som den
besungne. Hun har nu løftet det tæppet som saa længe har skjult
hende og gjemt hende bort - hun har nu faaet sine øine op og ser
nu sine opgaver i livet, ser nu sit eget værd.
Hun ved nu, at hun er skabt til mere end loft, kjøkken og kjælder.
Hun ser hvordan hun i aarhundreder har været begravet lige som et
annet aadsel i erkenens vand.
Det ene aarhundredes sand og støv har lagt sig lagvis over hende.
Mændene har gjort alt hvad de har kunnet for at holde hende nede i
uvidenheder.
 Men så kommer en voldsom orkan der ryster i alle grundvolder,
og kvinden rystes op og lagvis falder støvet af hende til hun
endelig staar ren, lutret og prøvet, - hun er jo noget svag og vek
i førstningen, men snart bliver hun fast og stærk til at tage tag
med i livet.
 Saa staar hun ikke længer som en forglemmeiei gjemt bag tuen.
Nei, hun staar som egen i storm og stille,-
Hun vil ei længer være som et legetøi, en dukke til behag for
mandens luner og indfald.
Hun vil staa som hans trofaste medhjælp og kjære veninde med hvem
han kun meddele sig i alt, søge raad og veiledning, med hvem han
kan dele interesser i det borgerlige for stat og land og for det
mer dagligdagse !
 Hvorfor skulle ikke vi kvinder have fædrelandskjærlighet og
ønske at være med og gjøre noget for land og folk som vi elsker
ligesaa vel som manden. Og naar vi engang faar fuld stemmeret, saa
først har vi naaet det vi tragter efter, da først faar vi vaar
ret.
 Somme mænd tror at kvinden alene vil have magten, at de vil
være de raadende og herskende hvis de fik stemmeret.
Ja det var jo ikke saa rart for da vil de hævne all den uret som
de har lidt op igjennom tidene, men det er ikke tilfælde. De vil
som Ibsen siger et sted :

forts. *et mellemstad*

" naar to i lag tar livets tag da samfundet bygges,
hun og han tilsammen skal rydde det nye land ".

Ja kvindens magt er stor som der stod i "Plogen" noget om sidst. Hun er jo den som giver grundstøtet for bolagenes omstyrtning og hun vil fremdeles være med at arbeide op alt som godt er naar hun bare faar lov.
I mænd behøver ikke at være saa frygtaktige og rædde for at give kvinder mere ret - nei, hun vil kun blive mere skikket som en god og trofast hustru - som en mor der kan opdrage sønner og døtre til ære for sig og sit land. *sønner*

Inga og Samuel giftet seg ca. 1900 - 1901
Kvinnene i Norge fikk stemmerett 1913.

Inga Ravndal f. 1866 - d. 1938.

Inga Gjørgine Ravndal

This is my grandmother. Inga -

Bestemor

- Born 1866
- Died 1938
- Married 1900 (01²)
- U.S.a. 1907
- Back to Norway 1920

—

Women got the right to vote in 1913.

In Memoriam

The following is the death notice of a young girl from a newspaper. The original is in the author's possession. This newspaper, *The Revolution*, was published from 1868 to 1872 and was edited by Elizabeth Cady Stanton and Parker Pillsbury.

> ## A SAD STORY.
>
> Miss Carrie Jones, who has been a pupil at a boarding-school in New Jersey for five years past, attempted to commit suicide at Oak Hill Seminary a few days since, by taking corrosive sublimate; at last accounts she was sinking rapidly and no hopes were entertained of her recovery. The cause of this rash act was a notification from her father, instigated thereto by her step-mother, that he would no longer be responsible for her board, and that he did not wish her to return home, but she must hereafter depend on her own exertions for support. Miss

"Miss Carrie Jones, who has been a pupil at a boarding-school in New Jersey for five years past, attempted to commit suicide at Oak Hill Seminary a few days since, by taking corrosive sublimate; at last accounts she was sinking rapidly and no hopes were entertained of her recovery. The cause of this rash action was notification from her father, instigated thereto by her step-mother, that he would no longer be responsible for her board, and that he did not wish her to return home, but she must hereafter depend on her own exertions for support."

The writer points out on the following page that young girls are not prepared for this independence by their education. They are taught to be dependent. "Will not the time soon come, when stronger training, and better views of woman's rights and duties, shall make such tragedies like this impossible?"
June 22, 1870.

Jones is described as a young girl of about twenty years of age, amiable, intelligent, and well educated.

This sad story gives serious argument in favor of the reforms which your paper advocates. Had this unfortunate young person belonged to the other sex, neither herself nor others would have felt it to be very cruel for the Father to have said, after educating his child to twenty years of age, "Now you must take care of yourself. It is time that I should be relieved of the necessity of supporting you, and in the natural order of things, you should be able, and willing, to provide for yourself." The son, in most cases in this country, would have received such an intimation without feeling that he had any right to complain of it,—but alas! we educate our daughters with such dependent natures;—we unfit them so sedulously for that battle of life, which Nature and Heaven design for all souls, that such a message to the daughter is like the doom of Fate. This unhappy one succumbed, and rushed to another existence, to escape the evil of this. Will not the time soon come, when stronger training, and better views of woman's rights and duties, shall make tragedies like this impossible?

<div style="text-align:right">H. C. I.</div>

Washington, June 12, 1870.

Name Index

Abbott, Lyman, 51, 54
Abrams, Stacey, 259
Abzug, Bella, 215
Ailes, Roger Eugene, 259
Alinsky, Saul, 259
Allen, Paula Gunn, 85, 86, 259
Angelou, Maya, 215
Anthony, Susan B., 189, 219, 259
 History of Women's Suffrage, 14, 17, 21, 39
Ardinburgh, Charles, 7
Arendt, Hannah, 106, 111, 112
Aristotle, 40, 46
Austin, Priscilla (Reverend), 203
Austin, Sarah, 130, 136

Barrett, Lisa, 54
 "The Future of Psychology: Connecting Mind to Brain," 46, 54
 Psychological Construction of Emotion, The, 45, 46, 54, 56, 57
Baumfree, Isabella (Sojourner Truth), 1–4, 7–8, 15–17, 20–21, 24–25, 34, 150, 182–183, 215
Beard, Mary, 194
Beecher, Catharine, 8
Beecher, Henry Ward, 8
Beecher, Lyman (Reverend), 8, 210
Belliotti, Raymond A., 40
 Happiness Is Overrated, 40, 54
Bethell, Lauran, 126, 127, 136
Birney, J.G., 8

Bonnin, Gertrude Simmons. *See* Zitkala-Ša
Borgen, Inger Solveig, 212, 223
Bowlby, John, 106, 107
Bowser, Muriel, 32
Bradley, Jennette, 32
Brady, Ellen (MD), x, xxvii, 213
Brown, Michael, 187
Burke, Tarana, 18, 70, 213
Busia, Abena P. A., 53, 54
 "After/words," 53, 54

Carroll, Jennifer, 32
Cary, Mary Ann Shadd, 74
Chesimard, JoAnne, 74
Child, Lydia Maria, xxii
Chisholm, Shirley, 1, 33, 65–68, 76–77, 150
 Unbought and Unbossed, 66–68, 76–77
Clark, Charles Worcester, 42
 "Women's Suffrage: Pros and Cons," 42
Cline, Erin, 160, 171
 "Two Senses of Justice," 160, 171
Cooper, Anna Julia Hayward, 75
Cosby, Bill, 19
Crawford, Christa Foster, 127, 137
Crenshaw, Kimberlé Williams, 19, 194, 207

Daniels, Ron (Dr.), 68
Davis, Angela, 74

Davis, Paulina Wright, 40
Dayton, Donald, 12
DeLeon, Jennifer, 201
Descartes, René, 44
Detherage, Kimberly, xiii, 1, 59
Douglass, Frederick, 37, 49, 176, 177
Douglass, Grace, xxii
Dow, Courtney, 124-125, 136
DuBois, W.E.B., 25
Dunlop, Marion Wallace, xxviii
Dye, Eva Emery, 89
Dyer, Theresa. *See* Miller, Minnie Myrtle

Eastin, Carol Anuklik Lakota, xiv, 79, 83
Ehrenreich, Barbara, 41, 49, 51, 55
 For Her Own Good, 41, 49, 51, 55
Estby, Clara, xxvi
Estby, Helga, xxvi

Farley, Melissa, 128,136
 Prostitution, Trafficking and Traumatic Stress, 128, 136
Farmer, James, 66
Fawcett, Millicent, xxviii
Figueira-McDonough, Josefina, 45, 51, 55
 "Toward a Gender-Integrated Knowledge in Social Work," 45, 51, 55
Finney, Charles G., 11, 12, 14
Fletcher, Alice, 90
Fluehr-Lobban, Carolyn, 142, 153
 "Nubian Queens in the Nile Valley and Afro-Asiatic Cultural History," 142, 153
Ford, John, 209, 216
 Grapes of Wrath, The, 209, 216

Forten, Charlotte Vandine, Sr., 74
Forten, Margaretta, 74
Forten, Sarah Louisa, xxii
 "An Appeal to Women," xxii
Freire, Paulo, 202
Freud, Sigmund, 45, 51
 "Femininity," 51, 55
Friedan, Betty, 215

Gage, Matilda, 14, 17, 21, 79, 84, 87, 90-91, 94, 100
Garrison, William Lloyd, 62, xxii
Gbowee, Leymah, 147
Gerhardt, Elizabeth, 125, 136
 Cross and Gendercide, The, 125, 136
Gilbert, Oliver, 7, 15, 20
 Narrative of Sojourner Truth, 7, 15-16, 20
Gilman, Charlotte Perkins, 49
Gothard, Bill, 3
Graham, Ruth, 124, 136
 "How Sex Trafficking Became a Christian Cause Célèbre," 124, 136
Griffing, Josephine, 182
Grimké, Angelina Weld, 74
Grimké, Charlotte Forten, 74
Guyart, Marie, 93

Hagar, 71, 81, 140, 152
Hamer, Fannie Lou, xxvi, 30-31, 34, 36
Hampton, Jenean, 32
Hansen, Debra Gold, xxi, xxiv, xxix
Harjo, Joy, 99, 100
Harper, Frances Ellen Watkins, 74
Harris, Kamala (Senator), 33, 70, 145
Haviland, Laura, 182, 183
Herman, James P., 108, 117

Hinz, Lisa D., 134, 136
 Beyond Self-Care for Helping Professionals, 134, 136
Ho, Moon Sung, 161
Hooper, Carey (Reverend), 74
Howe, Julia Ward, 209
Howland, Emily, 25
Hunt, Helen LaKelly, x, xxiii, xxix
 And the Spirit Moved Them: The Lost Radical History of America's First Feminists, xxix, xxiii
Hurston, Zora Neale, 23, 24, 36
Isenring, Ann Marie, 133, 134, 136
Jackson, Jesse (Reverend), 68
Jaggar, Alison, 45, 55
 "Love and Knowledge: Emotion in Feminist Epistemology," 45, 55
Jefferson, Thomas, 174, 175, 190
Jefferson-Snorton, Teresa (Bishop), xiv, xxii, 1, 23, 35
Jenkins, Andrea, 150
Johnson, Nunnally, 209
Jones, Doug (Senator), 70, 140, 146, 150
Jones, Laura, xxvi
Jordan, Barbara, 33
Judd, Ashley, 18, 214

Kelly, Abbey, xxii
Kemp, Brian (Governor), 72
Kendall, Katherine. 18, 214, 215
Keppler, Joseph, 88, 89, 100
Kim, Hak C., 114, 115, 117
 "Luke's Soteriology," 114, 115, 117
King, Billie Jean, 215
King, Martin Luther, Jr. (Reverend Doctor), 190
Koren, Marina, 41, 42, 55

"Why Men Thought Women Weren't Made to Vote," 41, 42, 55
Kraemer, Ross S., 141, 142, 153
 "Acts 8:27: The Candace, Queen of the Ethiopians," 81, 140–142, 152, 153

Lacock, Michelle "Morning Star Spirit" Oberwise, xv, 79, 83
Lakota, Sicangu, 96
LaMothe, Ryan, 110, 111, 115, 117
Larson, Kate Clifford, 25, 36
Lee, Barbara, 67
Lee, Insook, xv, 155, 157
Lee, Jarena, 74
Lee, Sheila Jackson, 33
Lewis, Marc D., 50, 56
 "A Dynamic Systems Approach to Cognition-Emotion Interactions in Development," 50, 56
Lincoln, Abraham (President), 10, 19, 21
Lindsay, John (Mayor), 68
Locke, John, 44
Logan, Adella Hunt, 60, 77
Lloyd, Rachel, 131, 137
 Girls Like Us: Fighting for a World Where Girls Are Not for Sale, 131, 137
Low, Juliette Gordon, 210
Luther, Martin, 197, 205
Lutz, Catherine, 45, 49, 56
 "Feminist Theories and the Science of Emotion," 45
 "Emotion, Thought, and Estrangement," 49, 56
Lytton, Lady Constance, xxviii

MacLeod, Peter, 92, 100
Mageo, Jeannette Marie, 45, 56
 "Introduction: Theorizing Power and the Self," 45, 56
Mankiller, Wilma, 83, 93, 96–101
Mary (Mother of Jesus), 114
McConnaughy, Corrine M., 41, 56
 "Advice to a Bride," 41
 Lady's Book, The, 41
 Woman Suffrage Movement in America, The, 41, 56
McClure, Barbara J., xv, 1, 37, 49, 53, 56
 Emotions: Problems and Promise for Human Flourishing, xv, 56
McGowan, Rose. 18, 214
McKenzie, Vashti Murphy (Reverend), 70
McKinney, Cynthia, 33
Mencius, 160, 164
Miles, Glenn, 127, 137
 Finding Our Way through the Traffick, 127, 137
 Stopping the Traffick: A Christian Response to Sexual Exploitation and Trafficking, 127, 137
Mill, John Stuart, xxv, xxvi, xxix
Miller, Minnie Myrtle (born Theresa Dyer), 93
Mills, Wilbur, 67
Moore, Roy, 150
Morales, Mariliana, 128, 136
Moseley-Braun, Carol (Senator), 33
Moses, 60–61, 65, 68–69, 75
Mott, Lucretia Coffin, xxii, 14, 15, 17, 26, 79, 84, 85, 87, 88, 99, 176

Nambu, Thelma, 126, 136
Norton, Eleanor Holmes, 33

Nunes, María-José, 109, 117
Nuzzolese, Francesca Debora, xvi, 79, 119

O'Reilly, Bill, 18
Obama, Barack (President), 68, 97
Okin, Susan Moller, 50, 56
 Women in Western Political Thought, 50, 56
Oliver, Sheila, 32

P., Pearl, xxiv, xxviii, 217
Pankhurst, Emmeline, xxviii
Park, Sophia So-hee, xvi, 79, 103
Parker, Theodore, 155, 173, 190
 "Of Justice and the Conscience," 173, 190
Parks, Rosa, 29, 34
Pitts, Kwame (Reverend), 198
Plato, 40, 42, 43, 46, 53
 Timaeus, 40
Plumwood, Val, 57
Purvis, Jr., Harriet Forten, 74

Queen Candace, 81, 140–141, 152
Queen of Sheba, 81, 140–142, 152, 153

Ramsay, Nancy, x, 19, 20, 52, 57
Raushenbush, Paul Brandeis, 150, 153
Ravndal, Inga, 212. 213, 223, 225
Rawls, John, 159, 160, 171, 172
Reber, Rolf, 47, 57
 Critical Feeling, 47, 57
Reimer, Ruby 40, 44, 51, 57
 "Feminist Challenge to Western Political Thought, The," 40, 44, 51, 57
Remond, Sarah, 74

Reumann, Amy (Reverend), 196–198
Richman, Isabelle Kinnard, 4, 15, 20
 Sojourner Truth: Prophet of Social Justice, 4, 15, 20
Roberts, Cokie, xxv, xxvi, xxx
Roberts, Judith, xvii, 155, 193, 196, 198, 201, 203
Roesch, Sally. *See also* Wagner, Sally Roesch
Rohr, Richard, 179, 190
Rossi, Alice, 11, 14, 15, 21
Ruffin, Josephine St. Pierre, 74
Rugolotto, Silvana, 133, 137
 "How Migrants Keep Italian Families Italian," 133, 137

Sacajawea, 89–90, 99
Sandel, Michael, 159, 172
Segwick, William T., 41
Shaw, Ann Howard, ix, 20, 21, 89
Shenandoah, Audrey, 93
Shenandoah, Joanne, 83
Sirleaf, Ellen Johnson (President), 147
Skenandoah, Chief, 83
Smith, Judith, 74
Smith, Holly Austin, 131, 137
 Walking Prey, 131, 137
Smith, Peter Skenandoah, 83
Snorton, Mama Katherine, 34, 35
Somé, Malidoma Patrice, 199, 208
Squire, Bell, 25
Stanton, Elizabeth Cady, 1, 3, 10–17, 20–21, 26, 37, 40, 79, 83–84, 90, 176–177, 181–183, 189–191, 215, 227
 Slave's Appeal, The, 10, 21
 History of Women's Suffrage, 14, 17, 21, 39
Stanton, Henry, 12, 14

Steinem, Gloria, 90
Sterling, Dorothy, xxiii, xxx, 183, 191
 Turning the World Upside Down, xxiii, xxx
Stevenson-Moessner, Jeanne, xvii, xxii, 1, 3, 12, 15, 20, 21, 209, 214
 "Elizabeth Cady Stanton, Reformer to Revolutionary: A Theological Trajectory," JAAR 62, no.3 (Fall 1994): 673–697.
Stewart, Maria, 1, 60–61, 63, 77
 "African Rights and Liberty," 63
Stone, Lucy, 181
Stowe, Charles Edward, 8
 Life of Harriet Beecher Stowe: Compiled from Her Letters and Journals, 8
Stowe, Harriet Beecher, 1, 3, 8–10, 15–18, 21, 210, 215
 Uncle Tom's Cabin, 9–10, 21
Stratton, Juliana, 32
Streufert, Mary, xviii, 155, 193

Tann, Georgia, 103
Terborg-Penn, Rosalyn, xxi, xxiv, xxx, 69, 74, 78
 African American Women in the Struggle for the Vote, 1850–1920, xxi, xxiv, xxx, 69, 74, 78
Terrell, Mary Church, 26, 28, 34, 36, 74
Thompsell, Angela, 147, 154
 "A Brief History of the African Country of Liberia," 147, 154
Thunder, Rosalie Little, 96
Timmons, Heather, 73, 78
 "Stacey Abrams' Concession

Speech Is a Powerful Critique of US Civil Rights," 73, 78
Toler, Mary Elizabeth "Beth," xviii, 155, 173
Tripp, Aili Mari, 142–143, 154
 "Women and Politics in Africa," 143, 154
Trump, Donald (President), 72
Truth, Sojourner, 1, 3–4, 7–8, 15–17, 20–21, 24–25, 34, 150, 182–183, 215
 "Ain't I a Woman," 24–25, 36
 Book of Life, 7, 15, 17, 20
Tubman, Harriet (Ross, Araminta), 24–25, 34, 36, 150
Turner, Victor, 178, 191
Tyler, Oren, 83

Ulrich-Lai, Yvonne M., 108, 117
 "Neural Regulation of Endocrine and Autonomic Stress Responses," 108, 117

Wagner, Sally Roesch, 83–84, 86, 93, 100–101
Walker-Smith, Angelique, xix, 81, 139, 146, 147, 154
Ware, Susan, xxi, xxx
Warren, Sarah A., 149, 154
 "Constitutional Convention of 1901," 149, 154
Waters, Maxine, 33, 150
Weinstein, Harvey, 18–19, 214
Weld, Theodore, 8
Wells, Ida B., 24–28, 34, 36, 69, 194
West, Traci C., 199
Wilson, Darren, 187
Wingate, Lisa, 103
 Before We Were Yours, 103
Woolf, Virginia, 51

Zanuck, Darryl, 209
Zeelenberg, Marcel, 48, 57
 "On Emotion Specificity in Decision Making," 48, 57
Zhongsu, Dong, 163
Zimmerman, Yvonne, 124, 137
 Other Dreams of Freedom: Religion, Sex and Human Trafficking, 124, 137
Zipporah, 81, 140, 152
Zitkala-Ša, 94–95, 99.

Subject Index

#BlackLivesMatter, 199. *See also* Black Lives Matter
#MeToo movement, 18–19, 70, 213

abolition, ix, xxi, xxiii, xxiv, 8, 11, 12, 14, 88, 100, 155, 174, 176, 177, 179, 182
abolitionism, 12, 14, 210
abolitionist, xxiii, 8, 12, 24, 25, 38, 61, 76, 83, 155, 173, 176–183, 185, 209
abolitionist movement, 24, 25, 177–183, 185
anti-abolitionists, 9
abuse, sexual, 18, 214
activism, xxix, 15, 20, 25, 38, 200
 social justice, xvi, 4, 15, 18, 20, 52, 72, 111, 159, 160, 199
 women's rights, xxix, 14, 16, 23–25, 30, 38, 39, 62, 64, 67, 86–88, 93, 100, 104, 109, 117, 176, 177, 179–181, 189
"Acts 8:27: The Candace, Queen of the Ethiopians" (Kraemer), 142, 153
"Advice to a Bride" (McConnaughy), 41
advocacy, xvii, 24–25, 30, 76, 79, 81, 104, 111, 113, 134, 139–140, 148, 151–152, 196–198, 201–203
African America Female Intelligence Society, 62
African American Women in the Struggle for the Vote, 1850–1920 (Terborg-Penn), xxi, xxiv, xxx, 69, 74, 78

African Methodist Episcopal Church (AME), xii
"African Rights and Liberty" (Stewart), 63
African Union, 139, 151
"After/words" (Busia), 53–54
"Ain't I a Woman?" (Sojourner Truth), 24–25, 36
Alabama, xiv, xxvi, 8, 29, 33, 70, 140, 146, 148–150, 152–154
Alpha Suffrage Club, 25, 69
American Anti-Slavery Society, 176, 179, 184, 189, 191
American Baptist Churches, 126
American Civil Liberties Union, 186, 190
American Equal Rights Association, 16, 39
American Indian(s). *See also* Native American(s)
American Woman Suffrage Association, 25–26
antilynching movement, 25
Anti-Slavery Convention of American Women (1837), xxii, xxiii, xxx
antislavery movement, xxi. *See also* abolition
anti-suffragist, 42
antitrafficking movement, 119, 124, 125
"Appeal to Women, An" (Forten), xxii, xxix
Asian Americans, xxiii
autonomy, 157, 159

Before We Were Yours (Wingate), 103, 117
Belgium, xxviii
Beyond Self-Care for Helping Professionals: The Expressive Therapies Continuum and the Life Enrichment Model (Hinz), 134, 136
birthright, xxii, 64, 156, 209, 213
bishop, xiv, xxii, 35, 70, 74
Black Panther Party, 67
black power, 67, 74
Black Student Union, 67
Black Lives Matter, 187. *See also* #BlackLivesMatter
Book of Life (Sojourner Truth), 7, 15, 17, 20
Boston, xiii, xxi, xxii, xxix, 25, 62, 63, 77, 142, 212
Bread for the World, 143, 144, 149–151, 153
"Brief History of the African Country of Liberia, A" (Thompsell), 147, 154

California, 33–34, 67, 90, 99, 145
Canada, 25
Cherokee Nation, 97
Chicago, 25, 69
Children's Home Society Orphanage, 103
Chile, 81, 128
Christ, Jesus, xiv, 3, 9, 124, 193, 196–197, 200, 207, 210
Christian, xiv, xv, xix, xxii, xxiii, 1, 3, 9, 11, 14, 30, 40, 51, 53, 85, 111, 122, 124, 126–127, 129–130, 136–137, 173, 181, 193, 195, 201, 210, 212
Christianity, 141, 143, 153, 155, 181, 210
churches
 American, 9
 Catholic, 202
 Lutheran, xvii, xviii, 155, 193, 195, 196–198, 201, 203–204, 207
 African Methodist Episcopal Church (AME), 74
 Evangelical Lutheran Church in America (ELCA), xvii, xviii, 155, 193, 196–201, 203–207
civil rights, 1, 18–19, 23, 29, 31, 60, 63, 69, 72–73, 78, 95
Civil Rights Act of 1964, 60
civil rights movement, 19, 23, 29, 31
Civil War, 10, 147–148
cognition, 44, 46–48, 50, 54, 56–57
Colored Ladies' Literary Society of New York, xxiii
Colored Women's League of Washington
Confucianism, 157–158, 160–161, 163–164, 166–167, 170–172
Confucian culture, 157
Confucian harmony, 157–159, 162–164, 166–167, 170–172
Congress of Racial Equality, 66
Congress. *See also* United States Congress
Constitution, 29, 32, 39, 54, 85, 91, 149, 174–177, 179, 189, 191, 209
Constitutional Convention of 1787, 175
"Constitutional Convention of 1901" (Warren), 149
Costa Rica, 81, 128,129
Critical Feeling (Reber), 47, 57
Cross and Gendercide, The (Gerhardt), 125, 136

236 | Women with 2020 Vision

daughters of Zelophehad, 60–61, 65, 68, 71, 75
Declaration of Independence, 59, 76–77, 88, 94, 99, 174–175, 177–178, 189–190
Declaration of Sentiments, 37, 177, 189
Democratic National Convention, 68, 80
Democratic Party, 72, 149
dignity of women, 210, 214
disenfranchisement, 26, 148–149, 185
"Dynamic Systems Approach to Cognition-Emotion Interactions in Development, A" (Lewis and Douglas), 50–56
education, xiv–xvi, 8, 20, 26, 34, 40, 60–62, 67–68, 75, 80, 91–92, 94, 96, 100, 122, 126, 131–134
 theological, xiv–xviii, 8, 10–14, 20–21, 85, 125–127, 135, 198–199
eighteenth century, 40
elections, xxviii, 33, 40, 73, 81, 139–140, 144–145, 148, 152, 186
Eleventh Annual Southern Christian Leadership Conference, 173
emancipation, 14, 17, 19, 23, 25, 79, 119, 123, 131, 135–136, 182
Emancipation Proclamation, 19
"Emotion, Thought, and Estrangement: Emotion as a Cultural Category" (Lutz), 49, 56
Emotions: Problems and Promise for Human Flourishing (McClure), xv, 56
empowerment, xiv, xxii, 17, 19, 62, 109, 116, 122, 127, 131–132
enfranchisement, 4, 24, 31–32, 34, 69
enslaved persons, 210

Equal Rights Amendment, 34
equality, xxi, xxv, xxix, 1, 26, 29–30, 32, 59–60, 66, 75, 87, 89–92, 99, 122, 144, 150, 155, 157–159, 161, 163, 169, 176, 184–185, 211
 racial, xvii, 25, 29, 42, 52, 57, 66, 87, 183–184, 186, 199–200, 203, 206
 sexual, xiii, 14, 18, 42, 70, 79, 86–87, 119, 122, 124–127, 131–133, 137, 214–215
evangelical tradition, 124
Evangelicalism, 12

Fair Fight Georgia, 73
Female Anti-Slavery Societies of Philadelphia, xxiii
"Femininity" (Freud), 51, 55
feminism, 11, 20, 44, 49–50, 54–55, 57, 86, 96, 157–158, 161–162, 166–167, 171–172
feminism, American, 11, 86
feminist(s), xxiii, xxiv, 3, 15, 45, 49, 51, 79, 83–84, 87, 93, 101, 155, 162, 171
feminist scholars, 49
femininity, 51, 55
"Feminist Challenge to Western Political Thought, The" (Reimer), 40, 44, 51, 57
"Feminist Theories and the Science of Emotion" (Lutz), 45, 56
Fifteenth Amendment, 1, 4, 17, 19, 39, 183–184
Finding Our Way through the Traffick (Miles and Crawford), 127, 137
First Amendment, 179
Florida, xiv, xxvi, 32, 68, 187
For Her Own Good (Ehrenreich and English), 41, 49, 51, 55

Fourteenth Amendment, 32
Franklin Hall, 62
Freedman's Hospital, 7
Freedman's Village, 7
Fugitive Slave Act, 9
"Future of Psychology: Connecting Mind to Brain, The" (Barrett), 46, 54

gay, 96, 155, 195, 204, 211
Georgia, xxvi, 32–33, 71–73, 76, 103, 173, 175m 187
Georgia General Assembly, 71
Georgia House of Representatives, 71
Girl Scouts of the United States of America, 210
Girls Like Us (Lloyd), 131, 137
Global Gender Gap Report, 157, 172
Global Gender, The Gap Report 2018, 157, 172
government, xxi–xxii, xxvi–xxvii, xxix, 7, 26, 42, 59–60, 64, 67, 69, 71, 76, 84, 87, 91–92, 96–97, 104, 140, 144, 148–149, 152, 179–180, 184, 187, 197, 209
Grapes of Wrath, The (John Ford), 209, 216
Great Depression, 209
Great Troy Revival, 12
Greco-Roman, 42
grief, ix, 108
gun control, 75
gynarchies, 87

Hagar, 71, 81, 140, 152
Happiness Is Overrated (Bellioti), 40, 54
Haudenosaunee tribe, 83

Higher Heights for America, 60, 69–70, 76, 78
History of Women's Suffrage (Stanton and Anthony), 14, 17, 21, 39
homophobia, 49, 52
House (of Representatives), 33, 36, 71
House Committee on Agriculture, 67
House Committee on Education and Labor, 67
House Committee on Ways and Means, 67
"How Migrants Keep Italian Families Italian" (Rugolotto, Larotonda, and van der Geest), 133, 137
"How Sex Trafficking Became a Christian Cause Célèbre" (Graham), 124, 136
human trafficking. 119, 122–128, 136–137, 203. See also sex trafficking; sex trade
hunger, xxviii, 81, 139, 143–150, 152–154, 209

ICAP Global, 123, 127
Illinois, xiv, 26, 30, 32, 33, 36, 85, 99, 201–202
image of God (*imago Dei*), 40, 130
inclusion, 1, 37, 40, 45, 51–53, 151, 200, 203,
injustice, 12, 34, 49, 52, 55, 57, 74, 119, 125, 155, 162, 173, 205, 224
International Council of Women, 90
International Ministries, 126, 127
intersectionality, 19, 20, 73, 194
"Introduction: Theorizing Power and the Self," (Mageo and Knauft), 45, 56

Iroquois, 79, 83–84, 89–90, 92–94, 100–101
Iroquois Confederacy, 94
Islam, 143
Italian Americans, xxiii

Jamestown (Virginia), 60
Jesuits, 92
Jim Crow laws, 33
Junzi, 160, 161
Justice for Migrant Women, 70

Lady's Book, The (McConnaughy), 41
Latin South, 128
Latinx, 204
lesbian, 155, 195, 211
liberalism, 158–160
Liberator, The, xxii, xxix, 62
Liberia, 62, 140, 146–148, 153–154
Life of Harriet Beecher Stowe: Compiled from Her Letters and Journals (Charles Edward Stowe), 8
liminality, 173, 178–179, 185, 191
Louisiana, xxvi
"Love and Knowledge: Emotion in Feminist Epistemology" (Jaggar), 45, 55
"Luke's Soteriology: A Dynamic Event in Motion" (Kim), 114–115, 117
Lutheran movement, 193
lynching, 25–26, 36, 194

Make it Work campaign, 70
male superiority, 85
marginalization, 23, 34, 52, 199
men of color, 39–40, 194
 African-American, xxi, 62, 77, 186

Middle Way, 155, 162, 164–166, 169–170, 172
ministries, Christian, 130
missionaries, 92, 95
Mississippi, xvii, xxvi, 30, 71, 103
modernization, 157
Montgomery Bus Boycott, 29
Mujerista, xvii

Narrative of Sojourner Truth (Gilbert), 7, 15, 16, 20
National American Woman Suffrage Association (NAWSA), 26
National Association for the Advancement of Colored People (NAACP), 25–26, 29
National Association of Colored Women (NACW), 69
National Domestic Workers Alliance, 70
National Freedman's Relief Office, 7
National Union of Women's Suffrage Societies (NUWSS), xxvii–xxviii
National Women's Law Center, 70
National Women's Rights Convention (1850), Worcester, MA, 16
National Women's Rights Convention (eleventh, 1866), New York, 16
Native American(s), xxvi, 94–95
"Neural Regulation of Endocrine and Autonomic Stress Responses," (Ulrich-Lai and Herman), 108, 117
New England Anti-Slavery Society, 62
New World, 84, 90–91, 182
Nineteenth Amendment, xxvi, 29, 60, 94, 149, 174, 177
nineteenth century
North, the, xv, 62, 79, 85, 87, 177, 184

North Carolina, xxvi, 25, 36, 39, 57
North Dakota, xxvi
"Nubian Queens in the Nile Valley and Afro-Asiatic Cultural History" (Fluehr-Lobban), 142, 153

"Of Justice and the Conscience" (Theodore Parker), 173, 190
"On Emotion Specificity in Decision Making," (Zeelenberg, Nelissen, Breugelmans, and Pieters), 48, 57
Onondaga, 83, 93
ordination of women, 74, 155, 195, 196, 200, 207
Other Dreams of Freedom: Religion, Sex and Human Trafficking (Zimmerman), 124, 137

Pan African Women of Faith, 81, 139-141, 143-147, 149-154
Pan African Women's Ecumenical and Empowerment Network (PAWEEN), 139, 151
patriarchy, 49, 155, 193
patriarchal culture, 114
patriarchal oppression, 158
patriarchal order, 41
patriarchal principles, 40, 51
patriarchal society, 92
patriarchal system, 158, 166, 171
Pennsylvania Hall, xxiii
people
 enslaved, 24, 26, 38, 140, 146, 149, 198, 210
 indigenous, xiv, 79, 83, 85-87, 93-97, 99-100, 163, 171, 203
Philippines, 126
philosophies, 44, 51-53

police brutality, 75, 186, 187
polling sites, 73
post-traumatic stress disorder (PTSD), 128, 129
poverty. *See* Chapter 8
prayer, 109, 135, 179, 190, 197, 202
prejudice, 62, 90
Prostitution, Trafficking and Traumatic Stress (Farley), 128, 136

qi, 164-165
Quaker(s), 87

racism, xvii, xxi, xxiv, 1, 19, 34, 49, 52, 60, 69, 155, 193-194, 196-198, 199, 208
Rahab, 71
 Fundación Rahab, 128
rape, 214
Red Dress Movement, 97
reform
 healthcare reform, 75
 prison reform, 75
 social reform, 122
reformation, 178, 193, 206
religion, Evangelical, xvii-xviii, 11-12, 20, 124-125, 155, 193, 195-198, 203-204, 207-208
revivalism, Evangelical, 11, 12
 Evangelical-Pentecostal, xix
restoration, 127, 130-132, 136, 164
rights
 equality (see earlier entry, Subject Index)
right to vote, women's, xxvi, 60, 74, 79
Rising Daughters of Abyssinia, xxiii

self-cultivation, 155, 160, 171, 162

Senate, xvii, 8, 30, 33, 71, 77, 150
Seneca Falls Convention (1848), xxiii, 62, 176, 177
Seneca Falls, New York, 37, 177, 189
Seven Years War, 92, 100
seventeenth century, 74
sex trafficking, 75, 79, 119, 122–124, 129, 132, 136–137. *See also* human trafficking; sex trade
sex trade, 125. *See also* human trafficking; sex trafficking
sexism, xviii, xxi, xxiv, 1, 19, 23, 34, 49, 52, 60, 155, 193–196, 207
sexual exploitation, 79, 119, 124–127, 131, 137
slavery
 abolition of, xxiii, 177
 liberation, 8, 74, 86–87, 111, 136, 202, 75
social harmony, 157–158, 164. *See also* under Confucianism
social justice, xvi, 4, 15, 18, 20, 52, 72, 111, 159–160, 199
Sojourner Truth: Prophet of Social Justice (Richman), 4, 15, 20
South, the, xxvi, 8, 25, 29, 31, 66, 72, 75–76, 141
South Carolina, xxvi, xxviii–xxix, 175, 217
Southern Methodist University, xvii, ix
"Stacey Abrams' Concession Speech Is a Powerful Critique of US Civil Rights" (Timmons), 73, 78
states, northern, 25
Stopping the Traffick: A Christian Response to Sexual Exploitation and Trafficking (Miles and Crawford), 127, 137

Strategy for Authentic Diversity, 204
Student Nonviolent Coordinating Committee (SNCC), 30
suffrage
 for women, xxvi
suffrage movement
suffragist movement, 26, 87, 89–90
suffragists
 black suffrage, 183
suppression, 29, 60, 73, 186–187, 190, 216

temperance movement, 11, 210
Tennessee, x, xxvi, 79, 103, 187
Texas, xi, xv, 33, 71, 215
Thailand, 125–127, 132
The Psychological Construction of Emotion (Barret and Russell), 45–46, 54, 56–57
"The Six Nations," 92
Slave's Appeal, The (Stanton), 10, 21
theologian(s)
 Christian, 40, 51
 womanist, 198–199, 204
 pastoral, xvi, 51–53, 57, 110
theology(ies)
 Christian, 1, 51
 Lutheran, xviii
 pastoral, xv
Thirteenth Amendment, 19
Timaeus (Plato), 40
"Toward a Gender-Integrated Knowledge in Social Work" (Figueira-McDonough), 45, 51, 55
transatlantic slave trade, 199, 208
trauma, xvi, 49, 97, 107–109, 119, 131, 133–134, 188
tribes, 60, 79, 85–87, 90–94

Turning the World Upside Down (Sterling), xxiii, xxx
twentieth century, 26, 29, 41, 67, 77, 94, 111, 209, 216
twenty-first-century, 52
"Two Senses of Justice" (Erin Cline), 160, 171

Unbought and Unbossed (Chisholm), 66–68, 76–77
Uncle Tom's Cabin (Harriet Beecher Stowe), 9–10, 21
Underground Railroad, 25
United Kingdom, xxvii–xxviii, 210
United Nations Permanent Forum, 96
United States Congress, 32.
unity, 62, 151–152, 163
US Department of Justice, 32
US government, 7, 26
US Supreme Court, 32
Utah, xxvi

Vietnam War, 67–68
violence
 domestic, 97, 203, 210
 sexual, 70
Virginia, xxvi, 60, 198
Virginia, West, 187
Visionary Young Women in Leadership (VYWL), 147
voter registration, xxvii, 186, 213
voting rights, 25, 30–32, 36, 39, 69, 76, 91, 104, 149, 177, 225
Voting Rights Act (1965), 31–32

Walking Prey (Smith), 131–137
WCTU (Women's Christian Temperance Union), 210

"Why Men Thought Women Weren't Made to Vote" (Koren), 41-42, 55
Wisconsin, xv, xxvi, 71
Woman Suffrage Movement in America, The (McConnaughy), 41, 56
Woman's Bible, The, 12–13
Women, xxi, xxiv, xxvi, xxx, 1, 23–24, 26, 28–30, 32–34, 60, 69, 74, 78
 African-American, dedication page, xix, 32–34, 63–64, 77, 145, 199
 American Indian, 79, 86, 89, 94–96, 99
 black, xxi, xxiii, 23, 25–26, 29–30, 32, 36, 53–54, 59–60, 69–70, 73, 75, 76–78
 cisgender, 200, 204–205
 enslaved, 26
 indigenous, 83, 97, 99–100
 native, 90. 94, 99
 Native American, 79, 84, 91, 97
 Pan-African, 81, 139–147, 149, 151, 154
 poor, 126
 white, xxi, xxiii, xxiv, 24–26, 28, 39, 52, 70, 86–87, 94, 182, 200, 215
 womanist, xviii, 76, 78, 198–200, 202, 204–205; womanists, 49
"Women and Politics in Africa" (Tripp), 143, 154
Women in Western Political Thought (Okin), 50–56
Women's Convention in Akron, Ohio, 25, 36
women's movement(s), ix, xxi, xxii, xxiii, 11, 17, 19, 89, 97, 155, 158, 210–212, 214–215
Women's Right's Conference in Seneca

Falls (1848), xxiii, 15, 37, 39, 57, 62, 88, 176–177, 189
Women's Rights Convention (1851), 24, 25, 36
Women's Social and Political Union (WSPU), xxviii
"Women's Suffrage: Pros and Cons" (Clark), 42
women's suffrage (*see under* suffrage)
World Anti-Slavery Convention of 1840, 14
World Council of Churches, xix, 139, 142, 151, 153
World Health Organization, 107, 116
World War I, xxviii
World Wars/First and Second World Wars, 29

Yi, 160
Yin-yang, 163
Young Women's Christian Association (YWCA), 212, 221 (Appendix B)